Cinematographer Style

The Complete Interviews

Conducted from 2003–2005

Volume Two

by Jon Fauer, ASC

Hollywood, California

**Cinematographer Style
The Complete Interviews**

ISBN 0-935578-34-X

Published by
The American Society of Cinematographers
1782 North Orange Drive
Hollywood, California, USA

Edited by Milla Goldenberg
Filmed interviews transcribed by
David Forer, Jr. and Logan Schneider
Book design by Martha Winterhalter

Cinematographer Style *was made possible by contributions from many companies and individuals.*

Three major sponsors stand out for their most generous support:

Contents

Preface

I have had the pleasure of collaborating and working with Jon Fauer, ASC, for years. In our conversations, we often discussed the influence technology has on art and vice versa. For example, reusable metal paint tubes allowed expressionist painters to leave the studio and travel with their tools. Amplifiers and electric guitars have led to new styles of music and, of course, technology has and continues to influence the art and craft of cinematography.

As is often the case, there was no single instant or spark that triggered the decision to make a documentary movie about this. Rather, it evolved over a series of events and conversations about the concept.

It started when Jon was directing and shooting a promotional film on a new Arricam. He set out to interview a number of cinematographers to get their views on how this new technology could influence their approach to shooting and, ultimately, their cinematic style. These interviews, which began with a relatively small group, turned out to be so interesting that Jon and I decided to expand the concept and make an entire, separate short film on the subject.

Once we received approval for the initial budget, John Johnston of Eastman Kodak, who had been cooperating with us on the Arricam project, pledged his company's continued support by donating negative and print stock. Soon after, Charlie Herzfeld and Bob Hoffman of Technicolor, also excited about the project, came on board to give us Technicolor's valuable backing.

During this preliminary period, we were communicating with Victor Kemper, ASC, Richard Crudo, ASC, and other officers and members of the ASC who offered their enthusiastic support for the project as well. It was the sponsors' and Jon's intent that any net proceeds from this production would be donated to the ASC Building or sEducation Funds.

The subject of our film is the art and craft of cinematography. It is about how everything — from life experiences to technology — influences and shapes an individual's visual style. Given the tremendous impact that the visual style of a movie can have, this documentary aims to offer contemporaries valuable insight into the choices cinematographers make. And, of course, we hope that this material will have significant historical value as well.

All in all, the project took about three years to complete. It was impacted by all the usual production challenges of coordinating schedules of people and equipment, with the added challenge of working with a very busy staff that had to fit the demands of the project with its own ongoing business obligations. Over time, the project developed its own inertia, though everyone remained driven by the initial commitment we had made.

Initially, the idea was to simply interview as many cinematographers as we could, always being mindful of the constraints presented by Jon's work, which took him around the world for long stretches of time.

Over a two-year period, Jon filmed more than 100 interviews, resulting in a bounty of material that was overwhelming both in volume and content. Sorting through this material for the bits and pieces that would ultimately make an edit that featured everyone interviewed was clearly a most daunting challenge for Jon and our brilliant editor, Matt Blute.

The production was able to continue relatively unnoticed, which was my intention. I was concerned that the integrity of the project could change dramatically unless we kept a tight lid on it. Given the multitude of "creative consultants" we had on film and the ever-present marketing and PR interests of the sponsors and many contributors, the production could have been inundated with suggestions and demands that would have led to its creative doom.

For this reason, I insisted that no one outside of the immediate creative circle was allowed to see any images until we were

finished. Being a creative, collaborative and open individual, Jon was not always comfortable with this approach, but ultimately everyone recognized the need for such a restriction.

By the time we had almost finished editing the existing material down to our target length, we were still trying to coordinate a mutually manageable location to film Vittorio Storaro, ASC, AIC, whom I had contacted months earlier and told, "We will not wrap until you are in the can."

As fortune would have it, Bob Fisher notified us that Vittorio would be in Boston to receive the Coolidge Award and then travel to Italy immediately after to begin work on a film. This appeared to be the best and possibly only time to film his interview, so we went. After it was done and cut into the then-almost final edit, there was one more person left to get.

Gordon Willis, ASC — surely one of the most influential and brilliant cinematographers of our time — makes his home in Cape Cod, Massachusetts, which was very near the Vittorio interview in Boston. In the initial telephone contact, Jon outlined the project to Gordon and won his consent to be interviewed. Arrangements were made to take equipment and a small crew, which included Tibor Sands of Camera Service Center, who had been Gordon's assistant on a number of movies. We filmed at Gordon's home in Cape Cod. Clearly, Jon, Tibor and Gordon meshed well in those relaxed surroundings and the resulting material added to the film's intimate feeling.

The technical aspects of this film were also an important component of the overall concept. The sponsors intended to use every advanced technology at their disposal to demonstrate the best possible image quality that film and the digital-intermediate process are capable of producing.

The footage was shot with the latest Arricam 35mm camera systems and used what we referred to as our analog 4K user-interchangeable sensor, also known as Kodak Vision2 Negative.

Due to data-capacity and time limitations, we chose a 2K digital-intermediate process, which had to be divided between New York and Los Angeles. The negative was scanned on an Arriscan at 3K, down-rezzed to 2K, conformed, dust busted and graded by John Dowdell at Goldcrest Post in New York and then filmed out in 2K on two Arrilasers at our facility in Burbank, California.

All of the negative as well as the digital-intermediate processing was done by Technicolor, which also printed more than 50 beautiful, high-quality release prints in Los Angeles on Kodak Vision Premiere.

In total, we shot more than 200 rolls of color negative for this production. Assuming the equivalent of 4K digital resolution at approximately 65 megabytes per frame, there is a total of 206 terabytes of uncompressed, raw, analog 4K data — archived and safely stored in tin cans — for future use in whatever format may be required, be it analog or digital.

While the technology was important in allowing us to arrive at a quality product, the true treasures of this endeavor come from the many artists interviewed, for they provide valuable insights that we all can learn from. This book, with their expanded interviews, intends to provide the audience with a deeper knowledge of their creative process and brilliant minds.

Volker Bahnemann
New York, October 2007

Introduction

This book began in a backroom of the ASC clubhouse in Hollywood and fermented in the front of a bistro in New York. It started as a short film, became the glimmer of an unrealized coffee table book, transmogrified into a successful feature length documentary and finally emerges here as *this* book.

We are delighted to share 110 interviews of cinematographers from 15 countries. Over 30 hours of transcripts, used in editing our 90-minute film, *Cinematographer Style,* were corrected, edited, recorrected by each cinematographer and proofed yet again.

If we knew back then where we'd end up, we never would have embarked on this adventure; none of us would have had the guts. Intestinal fortitude was challenged by the enormity of the project, the historical implications of what we were attempting and the audacity of doing it bit by bit.

The award-winning film that emerged, and continues to be screened worldwide, is *Cinematographer Style.* It explores the art of how and why films look the way they do. With a cast of 110 leading cinematographers, it is, in fact, a narrative with a beginning, middle and end, cloaked in the guise of a feature-length documentary. *Cinematographer Style* is an inside look at what cinematographers do, why we do it and how we get there.

How we got *here* is another story...

A curious thing happened at Avid's 2006 Sundance Educational Summit, where over 50 educators responsible for more than 50,000 film students screened our finished film. Like Oliver Twist, they wanted more. They wanted the full text of all the interviews. So here we are, though our odyssey really began in 2001 as a search for more space.

In 2001, Victor Kemper, ASC, Steven Poster, ASC, Richard Crudo, ASC, and I were discussing ways to help the ASC Building Fund create more space for an ASC Museum. I was

working on the *ARRICAM Book* at the time. Volker Bahnemann, president of ARRI Inc., and Franz Wieser, head of marketing, agreed to donate proceeds from my forthcoming book to the cause.

Volker has always been a gadfly and a muse, not to mention patron of interesting projects. Whenever we met, we would bat around ideas for a film we both wanted to do about the intertwining of technique and technology. In March 2003, Volker suggested we produce a short, high-end, 35mm, eight-minute concept film to be called *The Digital Age of Film*. As a DVD, it would accompany the *ARRICAM Book*, and it, too, would be donated to the ASC Building and Education project.

The initial concept Volker and I wanted to explore was the influence of technology on technique. Or was it the other way around: technique influencing tools? More handheld shooting influencing lighter cameras. Faster setups — and more of them — resulting in larger lights. I was in a bookstore doing home-work before a fashion commercial and noticed an entire section on *Style: LA Style, Asian Style, New York Style, California Style, Thai Style, Japanese Style, Hamptons Style...* what about *Cinematographer Style*?

Certainly a film about cinematographers for cinematographers and the rest of the film community would have to be meticu-lously done. Not only would it have to look great, every element of production would have to be done at the highest level using the latest technology. This was not a run-and-gun production, nor could it be just a cinematography love-fest, and it was going to be very expensive to make.

By May 2003, Volker committed ARRI to providing the cash for funding the short film.

A few weeks later, the *capi di tutti capis* of production perfec-tionism convened at a crowded table in Greenwich Village. It was a choir of technorati and modern Medicis. John "JJ" Johnston (then head of marketing at Kodak), John Dowdell (then chief colorist at Technicolor Creative Services, NY), Charlie Herzfeld (senior VP of sales and marketing,

Technicolor Creative Services, East Coast), Michael Phillips, (principal product designer of Avid), Franz Wieser (VP of marketing for ARRI), and I sat down to outline the production logistics on the paper tablecloth. It was a massive flowchart, with 35mm camera negative, processing, digital dailies, Avid media files, scanning, DI, grading, laser film-out, release printing, DVDs and more. By the time dessert, espresso and Grappa came, the choir had converted from advisors to munificent sponsors and producers who pledged support with film stock, processing, dailies, editing, finishing and distribution. I think I asked JJ for a mere eight rolls of film.

A few days later, we consulted the oracle of cinematographer interviews, Bob Fisher. Bob has probably interviewed more cinematographers than anyone else on earth, for the ASC, ICG, Kodak and most of the publications on the planet. Lisa Muldowney and Sally Christgau, two of Bob's Angels, made phone calls to line up cinematographers. Bob graciously offered to help us get started with our first day of interviews, and continued as essential consultant throughout the production.

June 2003. It's the day before the annual ASC open house and Cine Gear Expo. Cinematographers have converged on Hollywood from all over the world. Patty Armacost, ASC events coordinator, Delphine Figueras, assistant to the president, Martha Winterhalter, publisher, and Jared Jordan have made hundreds of calls to round out the roundup of suspects for the interviews. Acknowledging that the clubhouse is an old and historic building, I assure Patty that we will treat it with great respect and tread very delicately.

I had promised "just a few small lights and a minimum of equipment." So why were there dubious pauses and muffled chortles on the other end of the phone? As word of the production got out, Hollywood's vendors eagerly volunteered.

At 7 a.m., our "few small lights" were delivered by Carly Barber's Illumination Dynamics, an Arri Group Company, in the largest grip/electric truck the world had ever seen, along with an enormous generator truck. Clairmont sent over not just one, but two of the latest ARRICAM packages — just in

case — inside an enormous camera truck. Fisher delivered dollies, and a sumptuous craft service arrived. The trucks were larger than the ASC clubhouse. Patty gasped, but I thought nothing of it as they maneuvered into the parking lot. The problem was there wasn't any space left for ASC members or interviewees to park. Lack of parking was a concept that didn't register with me, because I live in New York, and there never is any place to park, ever. Nevertheless, Bill Russell and others did a masterful job as ad-hoc transportation captains, maneuvering cars and trucks without a scratch.

We began filming at 8 in the morning. By 9, Jeff Laszlo informed me that we were running low on film. "What are we shooting, high speed?" I wondered. I had promised JJ to be frugal and wise, keeping it to one roll of film per interview, cutting for questions or when answers bogged down. Bob Fisher assured us that the historical value of what was happening here would be long remembered, well after the roll call was counted.

A few minutes later, what appeared to be the entire staff of Kodak Hollywood began wheeling in cases of Vision2 5205. I think we did more than14 interviews that day. Hopefully our "little filming" was not the cause of the clubhouse needing renovations, donations from this film notwithstanding.

The next day, we filmed at Clairmont Camera and other locations around Los Angeles. Although the topic was the *Digital Age of Film*, the questions about style, technique and technology were the ones that evoked the most interesting and passionate answers. We knew we were on to something — something that was very different from the film we intended to make.

August 2003. We began "piggy-backing" the burgeoning *Cinematographer Style* with other jobs. *Harry Potter* and the cinematographer, Michael Seresin, BSC, were not too far away at the U.K.'s Leavesden Studios. Joe Dunton arranged for us to get in and get Michael. Now things were getting really interesting, as the rate of dollar to pound and euro was plummeting.

October 2003. We were filming in Munich, trying to offset the effects of Oktoberfest with massive doses of espresso and Red Bull. Luckily, Red Bull is not banned here, as it is in nearby France, Norway and Denmark. A can of Red Bull has 80mg of caffeine, which is more than twice the caffeine in Coca-Cola, but about the same as a two-ounce shot of espresso. The last time I shot in Munich, craft service consisted of breakfast beer and pretzels, but technology in caffeine delivery seems to have influenced technique.

Franz Kraus, managing director at Arnold & Richter, had seen some of our dailies, and meets with Franz Wieser, Marc Shipman-Mueller and me in his office. He hands us several beautiful Camerimage books and says, "Why not use some of the interviews and frame-grabs in a book on cinematography?" He lends the support of the company.

At that time, we thought *Cinematographer Style* would make a good 30-minute documentary. We knew the discussions of style were much more interesting than the discourse on DI. So we kept going, asking for "just a few more truckloads of film," and "just a few more days of dailies." Our saintly sponsors never faltered.

The model for filming was the domestic policy of President William McKinley, who allegedly sat in his rocking chair on the porch of the White House and talked to anyone who showed up. *Cinematographer Style* was similarly democratic. Everyone who showed up was interviewed, and everyone who was interviewed appears in the film.

It's important to reflect on the evolution of the film, because this book is so contingent upon that work. Above all, we wanted to celebrate the art of cinematography and its often-overlooked importance to the success of any film. We stubbornly stuck to our thesis that every cinematographer has a unique style, sometimes deliberate, often unwitting, that shines through the work.

The style of *Cinematographer Style* is part of the story.

Having shot many documentaries, I never liked talking heads. But *Cinematographer Style* is a film with 110 of them. The trick, we found early on, was that cinematographers are incredibly interesting people who talk a universal language. We could quickly cut from one to the next, continuing the train of thought in a compelling progression. Matt Blute's masterful cutting created not only a dialogue, but also a colloquium of cinematographers discussing and debating common themes.

From the beginning, I resisted cutaways to clips of the films being discussed. It was simple math: 110 cinematographers in roughly 90 minutes... 110 divided by 90 gives us less than 45 seconds of screen time for each cinematographer. Because the interviewees were so articulate, it became clear that the audience would actually be able to "see," in their minds, the films being described. Just as in fashion cinematography, where we can often be more suggestive by being less revealing, I wanted the audience to look at the cinematographer and the lighting without distractions, without cutaways, without subtitles — with one cinematographer becoming the cutaway for the next.

Whether this monologic style would work was another matter. I had learned long ago to value the opinions of everyone on a production. And, although I didn't trust focus groups or test screenings, I was ready to show a rough cut to an audience of trusted colleagues and participants in the film.

"Don't do it," said Volker Bahnemann. He insisted that only our immediate production group be allowed to see any footage. "This is a film that cannot be guided by committee or consensus. We'll have a different opinion from each person who screens it and most of all, we don't want any commercial interests intruding on the process."

I think Volker's advice was crucial to the integrity and success of the film. There were no committees, no focus groups. Our test screening was, heart in mouth, at the film's premiere to a standing-room-only crowd at the Los Angeles Film Festival.

We wanted the film to have a narrative structure, with begin-

ning, middle and end. In the beginning, we're introduced to the cast of "characters," as each cinematographer gives his or her name. Next, we learn how most of them got started: in film school, not in film school, as artists, writers, doctors, mechanics, still photographers and assistants to the lowest assistants.

In the second act, we get to the theme: The style of every film, television show, commercial, corporate film or documentary is a cinematographer's individual choice, an almost ineffable thing, sometimes random, sometimes deeply researched. Often it begins with the script, but many times it happens by accident or evolves or is determined by external forces, locations and mood. Finally, the film gets into technique and technology — and the influence of art on the tools of the trade, how equipment and lighting can often change style and how evolutionary trends affect everything.

There were four common questions:

1. Who are you?

2. How did you become a cinematographer?

3. How and why does your work look the way it does?

4. What influenced your style?

In June 2004, we released *The Digital Age of Film* at Cine Gear as a short, eight-minute DVD.

Bob Fisher and others urged us to continue interviewing more cinematographers. Content got better. Bob kept sending us schedules of who was where. This may be the first film in history where the producers never said "no," instead saying, "Keep shooting" and "Don't stop now." Before long, we were hundreds of thousands of dollars over budget, and of course, we had no budget. Volker pledged funding from ARRI to guarantee completion, which was a huge commitment.

This pattern of invitation, generous donation and superb interviews continued to grow sporadically for three years, as content became more interesting. We fell into a familiar

pattern. Bob Fisher would call me up and say, "Jon, you haven't filmed Bob Richardson yet."

So I'd call John Johnston at Kodak and ask, "JJ, can you please let us have just a few rolls of film to interview Bob Richardson?"

We'd shoot, inevitably calling Kodak back for just another four cases of film because Bob Richardson wasn't available, but Bob Fisher or Patty or our production managers had wrangled another 20 cinematographers instead...

The next call would be to Technicolor to see if they could deal with "just another few rolls of film." The inevitable phone call the next morning from Technicolor's Joey Violante, or his equivalent at Technicolor labs around the world, would simultaneously confirm that all was well with chemistry and imagery, but not so with our arithmetic since a "few rolls" is not necessarily a good quantifier for 30 or 40 cans containing 1,000 feet of film in each.

Michael Phillips of Avid was our postproduction angel. Michael has been with Avid from the beginning — I think he was employee number 6. His private phone number is a prize accorded only to the chosen few. He gave tireless technical and moral support, invented software fixes for unique situations and arranged for Avid to provide us two of its Media Composer Adrenaline systems and two Avid Xpress Pro systems on desktop and laptop. We went through eight software updates over the course of the project; we also shared the same media files simultaneously, so a change in Los Angeles could be reviewed simultaneously in Boston, New York and on location anywhere in the world. Project files were e-mailed.

If Michael was our angel, Matt Blute, Avid and AFI alumnus — and also a cinematographer — was our hero. Matt was the masterful editor piecing together common thoughts, acts and transitions. He gave the film its progression and pacing, telling the story of how the cinematographers got started, how their styles evolved, how they related technique and technology, and where they thought we were going.

Matt figured out how to seamlessly cut 110 talking heads into 90 minutes. Matt was the unique combination of superb talents that made him preordained to edit such a film. As a cinematographer, he was "one of us." As an editor, he had the discipline to cut to the chase and discard the dross. He was master of both, talented in unlocking magical threads and navigating a daunting amount of material. As an Avid wizard, he could speed through shortcuts known to maybe six others in the editing world.

To expedite the editing, we had transcripts made of all the interviews. David Forer, Jr., and Logan Schneider spent over a year turning interviews into text. The text was an essential ingredient in making interesting sequences, and we used Microsoft Word and Adobe PDF search functions constantly.

Cinematographer Style makes a statement about the look of film. From the beginning, it was intended to be a historic record that would be carefully preserved for the archives. It was filmed in 35mm with ARRICAM Cameras on Kodak Vision2 motion-picture film, with processing and digital dailies by Technicolor, scanned to digital intermediate with ARRISCAN, Film-out with ARRILASER, processing and printing by Technicolor, and released on 35mm Kodak Vision Premiere. DVDs were mastered and replicated by Technicolor.

Ultimately, about 200,000 feet of film was exposed during production. Cinematographers are great storytellers and actors, and this was their chance to be in front of the camera. Their common bond was a passion for creating images that tell a story.

Many cinematographers professed to be shy or reticent about being on the "wrong side of the slate" for the first time. Well, if someone were casting for the part of a cinematographer, this would be the ultimate casting reel. We see 110 masters, not only of cinematography, but also of lucid, articulate, thoughtful comments.

One day, in the middle of production, Volker, Matt and I looked at each other and simultaneously said, "This could be feature length."

Enter Tim Spitzer, director of Goldcrest Post Production. Tim was our tireless and patient postproduction supervisor. Tim assembled, catalogued, coordinated and sifted through original camera negative, digital dailies of different origins, inconsistent protocols and timecodes and created order out of the chaos, because, after all, one's supposed to go into making a feature film knowing that it is a feature film and not a short subject.

John Dowdell, who was one of the instigators of this project, was now at Goldcrest as digital intermediate supervisor. He was not only our DI colorist, but is a true artist and an honorary member of our grip, electrical and art departments, using Quantel's iQ and Pablo.

From the beginning, we planned on going through a digital intermediate, which we knew was essential because of the archival nature of the project and the fact that cutting the negative would have been reckless. All of the uncut negative is stored at the film vault at The Academy of Motion Picture Arts and Sciences (AMPAS).

We shot in full-frame, silent aperture (sometimes called full-frame Super35), not only to use as much real estate on the negative as possible, but also to oblige us to go through the DI.

Music was an important ingredient to set the tone and highlight transitions. Matt Blute cut in a good scratch track. We tried titles for the three acts: "Beginning, Style, and Lighting and Tools," but Volker thought we could do better with musical transitions. Three maestros in Munich were engaged: Florian Schlagbauer, Thomas Schlagbauer and Christian Bischoff from ARRI Music. They sampled a live orchestra, stored the sounds digitally and then composed the haunting musical theme that opens the film with a piece we call "March of the Cinematographers."

Dana Ross, Jeff Smithwick and Phil Downey at Technicolor supervised and tweaked the release prints with incredible care — knowing how critical an audience we would have. In the days before our premiere at the Los Angeles Film Festival and

Academy's Goldwyn Theater, I had been having a recurrent dream in which Gordon Willis, ASC, calls me up saying, "Jon, it's not dark enough."

Cinematographer Style began, for me, as a sideline of simply shooting some extra footage while on location and became a full-time, three-year obsession... er... production. I think it was François Truffaut who said, "A film is like a stagecoach ride in the Wild West. You start with high expectations, and halfway through the journey, your only wish is to reach the destination." It was an amazingly smooth trip... until we reached 108 interviews. By this time, my only dream was finishing the project. So imagine my pulse rate when Volker announced that the film was not complete without Vittorio Storaro, ASC, AIC, whom Volker had apprised of our project months earlier.

A year earlier, Vittorio and I had talked about getting together, but our schedules never matched. This time, however, he was about to receive a Coolidge Award in Boston, and Elizabeth Taylor Mead, events director of the Coolidge Corner Theatre, graciously provided the theater as a location.

On Vittorio's Web site, there's a picture of him holding a light bulb. He and I discussed this and agreed it would be a good iconic prop. Gaffer Jim Hirsch took a bare 12-volt DC marine light bulb, soldered clear zip cord to its Edison base and ran the cord to a dimmer. It's important to note that Vittorio is holding a bare bulb with 12 volts DC running through it. As they say in the ads, DO NOT ATTEMPT this trick with standard 110 volts AC.

So we arrived at the Coolidge on a cold, rainy Boston morning and lit the theater with a backlight glinting off the tops of the antique chairs. For Vittorio, we had a couple of HMI PARs coming through a giant 216 diffusion frame. He arrived. We went over the bare light bulb on a dimmer gag, and he said, "Why don't we also put this big diffusion source on a dimmer, and also do a light change from cool to warm light?"

I hadn't ordered any Tungsten lights in the package from High

Output. But, of course, prescient president and gaffer Jim Hirsch saved the day by having them on the truck, along with a dimmer board. He wired four 5Ks to the dimmer board: two with full CTS (straw) and two with CTB.

A few months later, when I assumed (and hoped) we had wrapped the production with 109 cinematographers, we screened the final cut with John Johnston and Volker Bahnemann. When it was over, they turned to each other and then to me and said, "What about Gordon Willis?"

And I said, "What about Gordon? He's in Cape Cod."

"He is conspicuously absent," they said. (I think their actual words were more direct.)

"It's going to be very expensive filming in Cape Cod," I replied.

"Let's do it."

Cut to:

EXT. CAPE COD – EARLY MORNING, A FEW WEEKS LATER.

The second largest grip/electric truck the world has ever seen is backing down Mr. Willis' driveway. One slip of the High Output Lighting truck's brakes and the beautiful Willis house below will be reduced to toothpicks.

Now, the reason we have the truck and all the equipment is because we have been told that the house is new and it would be bad manners to mess it up, gouge the floor with light stands or get cable grease on the nice carpets. So we decide to light from the outside with big lights.

All the early morning commotion woke up Gordon, who comes outside in his bathrobe. He takes one look at the enormous truck and equally abundant crew and says, scornfully, "What is all this stuff?" (He may have used a more direct word for "stuff.")

Luckily, we had a secret weapon with us: Tibor Sands, who was Gordon's camera assistant on *The Godfather*, among many

other pictures, and was our production manager for this leg of the production. Tibor and Gordon are great friends, and the night before, we had dinner and listened to the two of them topping each other with production tales. Tibor replied, "Well, Gordon, we didn't want to bring any lights into your house."

"Nonsense," Gordon said. "You don't need all that stuff. Just bring a Kino Flo inside and let's go."

One Kino Flo it was — a 4-foot, 4-bank unit with a 4-foot by 4-foot frame of 216 in front. We plugged it into the wall; it couldn't have been simpler. Halfway through the interview, Gordon turned to our gaffer and asked him to turn off the key light, which had the effect of silhouetting Gordon in the window he sat in front of.

"There, that's better, isn't it? No light at all."

Yes, it was. As we wrapped, Gordon was heard talking to the grips about selling him some 20-foot by 20-foot solids to shade the exterior outside his picture windows, which afforded beautiful views of the surrounding landscape, but which, to Gordon, were "much too bright."

Interesting lighting and composition were essential to our story. Most of the "portraits" are lit with two 6K HMI PARs or two 10K Tungsten Fresnels (sometimes 20Ks): one raking from behind, and the other at 90 degrees to the side. These were softened with the largest diffusion we could fit in the stage: usually two 20-foot by 20-foot light grid cloths, placed as close to the subject as possible. We sometimes further diffused the light with a 4-foot by 4-foot 216 frame closer to the source. There was rarely any fill light at all — occasionally a 12-foot by 12-foot unbleached muslin to bounce back a tiny amount of the key. Most of the time we rolled in anti-fill: lots of 12-foot by 12-foot and 20-foot by 20-foot solids.

Jeff Laszlo and the other cinematographers on our side of the camera were meticulous in keeping the framing interesting and unbalanced by pushing the subjects to the edge of the frame and varying the frame size every time I asked a ques-

tion so we'd avoid jump cuts.

When we put the interviews together for this book, I was reminded why some were longer than others: it was mostly a random process. Sometimes there were five or six cinematographers waiting to be interviewed. Sometimes, the cinematographer had to run for an appointment.

In the beginning, I tried to keep it to two rolls per interview. But some cinematographers were more loquacious than others. That is why some chapters in this book are longer than others.

Despite our best efforts to include as many cinematographers as possible, conflicts in schedules prevented interviewing everyone who should be in this film. Perhaps this calls for a sequel.

Conducting interviews for *Cinematographer Style* was democratic and fair. We grilled anyone who came. That was the easy part. Editing was the challenge. We vowed to include everyone in the film. To avoid favoritism and rivalry, we hired an independent team of auditors from … ah…. we hired independent editors. It seemed that every cinematographer was a natural born storyteller, with many stories just itching to get out.

In search of the elusive, short "sound bite," editing often became of process of natural selection and excision of the run-on sentence. I always wondered what a sound bite was. It was a term often heard in news and documentaries. Was it a delicious appetizer? A dental problem? An animal attack? After the film, I know.

Since the film is 90 minutes and features 110 cinematographers from 15 different countries, the math was pretty clear: We would have to extract just the best bites from each interview. The rest could be printed in this book, but for the film it had to be short and to the point.

In his interview, Henner Hofmann, ASC, said, "I think it's a great approach for a filmmaker to approach reality the way you can in documentaries. Your perspective of life changes and you see things that you don't even imagine exist. It opens up

a feeling that enriches you in all directions — visually, cultur-
ally. It changes your point of view. You are more aware about
what the planet is all about, and I think that's important."

Henner was right. This film changed our point of view about
all kinds of things, not just the relationship of technique and
technology or the origins of style.

Wally Pfister, ASC, flew in from Florida after shooting all
night, managed to stay awake, did his interview and finally, at
the end, said, "Where do I think cinematography is going? I
think it will always remain as an art form that's necessary and
part of the storytelling process. There's a sound bite. Finally."

Good sound bites made for a delectable film. With this book,
we have the entire feast. I hope you enjoy it.

Jon Fauer, ASC
New York, June 2008

Peter Anderson, ASC

What's your name and what do you do?

I'm Peter Anderson, not related to Howard Anderson, Jr [ASC,] or Howard Anderson, III [ASC,] but proud to be one of their friends. I'm a cinematographer. I specialize in high-tech, 3D, large format and visual effects.

Tell us how you got started.

When I was 7-years-old, I was given a 16mm projector for a Christmas present and also some W.C. Fields, *Laurel & Hardy* and animation films. I would run them forward and backward and look at the still frames. I just loved them. By the time I was 10, I had a full darkroom and was shooting pictures for the local schools. By 13, I was shooting 8mm films for church groups and taking the projector on the road with them.

You were the AV guy.

I was the AV guy. I was the town projectionist. I was also the school projectionist at every school I went to. There wasn't much television at that time, and I was shooting high school and college films of football and basketball. Nobody wanted to process my film on the weekends, so they gave me the keys to the lab. I went to the lab and marked the roll of film I thought had the best action and processed that one first. Then I went to the television station, put it on the Telecine and grabbed B-camera for the nightly news. They also gave me the keys to the university lab.

My high school science project was originally going to be a particle accelerator. At that time, they were redoing the television station and I got a lot of wire and built a cloud tank. Then I found out I was about 100 miles short of wire, so I built a movie studio instead. This was back in Wisconsin. I had never been to a movie studio; I only learned from books and friends and by reading *American Cinematographer*. The studio covered three tabletops and the arc lights were battery carbons. I used a ballast for the resistors and dollies that armed up and down. The processing machine ran 4mm film, so I cut 8mm in half to miniaturize it. I also took an old shortwave radio and turned it into a recording lamp, so I could talk into it and see the sound inflection.

After all that, I was supposed to go to university for two years in Wisconsin. My parents were educators, not from a photographic background, but they allowed me to do everything my heart desired. I ran the linotype, I ran presses, worked making graphic art plates and worked in processing plants. I was taking typing over summer school during high school, and they actually pulled me out of class because the gentleman who worked at the local lab that processed all the film for stills had left, and I was the only other person in town who could do it. I shifted my studies in both college and high school around, so I could work in the morning and afternoon. I loved what I did.

I came to Los Angeles in 1962 on the Santa Fe Super Chief. The Art Center was on 3rd Street at the time. I had enrolled in their motion picture division, got here and found out I was the only person enrolled, so I went to Pan Pacific Camera and, on credit, bought a 16mm camera and then borrowed projectors so I could start shooting motion picture film. I also shot a lot of stills. After two semesters at the Art Center, I dropped out and went to the University of Southern California, where I met Herb Farmer, who was a professor there. I took a lot of neat classes but couldn't afford to go full-time. I did get lab rights, however, so I would often sneak down to 'SC and they would process film for me.

In 1967 I graduated. By that time, I had a studio in the Bradbury Building in downtown LA, with a lab in the La Fonda Building on Wilshire. I was working mostly for adver-

tising and doing lots of fashion photography. Then Lockheed came out with the L-1011 aircraft, and I did all the still and film work for it. In 1970, Macy's bought my company under a two-year contract, which extended later to a third year. I then moved to San Francisco and set up an advertising unit doing commercials. I am probably responsible for all the catalogs you get in the mail, except for Victoria's Secret. At that time, they were doing three catalogs a year, and we turned it into a cash cow with a catalog every two weeks. They then moved me to New York, but I didn't like it there so I came back to Hollywood in 1974. I started working with Dick Spees at Reel Three. We did projects with Jane Goodall for Pyramid Films, and *Race with the Devil*, which had early computer graphics.

Then I got a call about a movie called *Mahogany* that was starting in Chicago and finishing in Italy. They had act one and act three done, but needed act two, so I went to shoot act two, which was basically a long-form music video. David Watkin, BSC, was on camera, and I was brought in because of my fashion-lighting experience. Tony Perkins used my Hasselblads, Nikons and view cameras to take the stills, while I did the lighting on Diana Ross, who was the star of the film, and just had fun. I used strobes, Mylar reflectors and turntables, which turned it into a hoot to work on. Then I got a call from the MGM lab saying, 'This stuff doesn't look normal.' So I said, 'Thank you.' At 4 o'clock in the morning, the calls really started coming in.

In about 1975, I did motion control for the Apollo-Soyuz moon mission. I did simulations for CBS and Ralph McKorey shot backgrounds. We did them with an old Mitchell camera that had a fisheye lens, and we also did early motion control of the Soyos capsule and the Apollo capsule linking up. That Mitchell number 29 camera started my 35mm camera collection. I'm up to about 100 35mm and 100 16mm cameras.

From there, I wanted better tracks, so I made a barter deal to get some tracks that belonged to Doug Trumbull. Doug needed them back for *Close Encounters of the Third Kind*, so I took them back to Doug's company Future General and started working on Super 70, which turned into Showscan. We called it '60 frame,

65mm.' At that time, Doug was experimenting with different
frame rates and formats and even shooting on 35mm
Kodachrome. When they came back as individual slides, it was
quite interesting, so we stayed with motion picture film. I
helped build the miniatures and smoke rooms, and worked with
the night crew for *Close Encounters*, working hand in hand with
Richard Yuricich, who did the visual effects photography, some
of which was very interesting. It was all on 65mm. The director,
Steven Spielberg, said he wanted a bit more human life toward
the end of the film, so I grabbed a red light bulb, which Doug
sanded, and within a day, we had that red look that wraps up
the film.

I then worked on *It Happened One Christmas* with Marlo Thomas
for Universal. We did all the effects for that. In the meantime, I
had taken over Future General and started a feature called *Buck
Rogers in the 25th Century* that went into hiatus. We were losing
the facility to *Star Trek: The Motion Picture*, so we built a facility
off-lot for Universal called Heartland that I ran for about four
years. There, we did work for *Buck Rogers, Battlestar Galactica,
Airport '79* and about 200 other projects. We did matte paint-
ings, had four stages and built our own cameras. If sleep didn't
count, it was wonderful.

At the end of that, there was a regime change at Universal: It
was no longer vertically integrated. It had turned into a for-hire
company. I was loaned out to Disney to work on the EPCOT
project, *Something Wicked This Way Comes* and *TRON* as well as
helping with the animation camera. I worked with Albert
Crookshank — one of the greats — and his friend L. B. Abbott
[ASC] whom I'd met at Fox. We were building our own 65mm
cameras and reinventing animation. *The Black Cauldron* was
being shot with a multiplane camera. We were building triple
65mm, which is when I really got into 3-D.

They wanted to do *Battlestar Galactica* in 3-D, so we redesigned
the motion control systems at Heartland to do right and left
eye. Once we proved that we could do it and scale the ships up,
they lost interest because they couldn't do the live action prop-
erly. One of the incentives at Disney was to come up with 3-D

technology, so I worked hand in hand with Don Iwerks' team to develop the 3-D Disney camera systems. Five of them were used on *Magic Journeys*, and the bulk of that show was shot at Laird, which is now The Culver Studios, where we took over a bunch of stages. The bed used in one of the scenes was actually Rudolph Valentino's old bed, which we took out of the prop room. We also used lots of lights — 120 10Ks plus arcs were used on one setup just to hold focus.

Paul Ryan [ASC] was actually the head cinematographer on *Magic Journeys*. He had never worked on 65mm, so I was the supporting unit. At the same time, I worked with Stephen Burum [ASC] on *Something Wicked This Way Comes* while Steven Lisberger was doing visual effects for *TRON* with Bruce Logan [ASC]. All the while, we were inventing new technology. I'm sure you can tell by my enthusiasm that life has been wonderful to me. It's included long hours and hard work, but I would not trade them for anything else in the world. Cinematography is the most exciting thing anybody can do.

Why?

Because we create our own vision, get to put it on film and show it to the world.

It beats working for a living, right?

There's nothing harder than being the DP on a technical show. As I said, sleep doesn't count and I can never turn my mind off because something is always happening.

Tell us about the technology behind *Captain EO* and how you got its look.

That was an interesting show. We had done *Magic Journeys*, which was the first of the major Disney theme park 3-D attractions. They had actually done *The Mickey Mouse Club* prior to *Magic Journeys* in the Natural Vision 3-D process and also some animated cell-shift cartoons, but those were in twin 65mm. We designed the beam-splitter camera and helicopter rigs from the ground up. Jordan Kline built us an underwater housing, which

we took to the Caribbean. Disney has built up quite the system over the years.

When *Captain EO* came along, I worked on the look and lighting. Francis Ford Coppola was the director and I got to meet and work with his son, Gian-Carlo Coppola, who was incredible. At various stages in the show, Walter Murch and Joe Johnson came on — talk about a wonderful experience. Francis Ford had lost Zoetrope Studios around that time, and Vittorio Storaro [ASC] — who was doing consulting work for *Captain EO* — Francis Ford Coppola and I were walking down the studio lot and Francis said, 'I bought the wrong studio. If I had bought this one, I'd be able to do everything in the world that I want to do.' *Captain EO* probably had the biggest crew I'd ever worked with. When I did the cast and crew list, I came up with 650 names and I'm sure I missed people. It took about three years to make, from the time we conceived it to when it opened at the park.

Tell us about 3-D.

What we did with the Disney rigs that nobody else had been able to do in modern 3-D was control the interocular and the convergence in real time, meaning that the show was built dynamically and spatially independent of the camera movement, focal length and actor's position. We could determine what would play behind the screen, where the screen plane was and off the screen. We did that while the camera moved and dollied and also while the talent moved. That was done by literally using a beam splitter to get the interocular; the distance between the lenses was so close that they physically couldn't fit, so we lost half the light. But by making the lenses overlap each other, we prevented eyestrain and problems in continuity.

We basically had two 3-D shows. We had a 'documentarian' as the camera assistant, because we had to have somebody who knew cameras and lenses and all their details. We recorded it in log form and then did it in metadata with great minutia so we could build the show in continuity. We logged all of the lighting, the interocular convergence and the amounts of camera distance. We also did head-and-tail claps, which allowed us to keep the cameras and sound in synch. That was a bit unusual, but it was useful in postproduction.

How does that all come together in the end?

Ultimately, we take two projectors and make the film appear in 3-D so it can be seen in a special theater. Up to then films in 3-D hadn't really played in conventional theaters since the 1980s because they took the second projector out of the booth, but they're alive and well in theme parks. Imax is also running with 3-D, and given the emergence of digital cinema, it's destined to make a comeback.

Our eyes are roughly 2.5 inches apart. For 3-D films, we do a lot of cutting and change the focal lengths of lenses. If those things are not done properly, that's when the headaches in the 3-D world occur. Our eyes don't go outward, they are not walleyed, and they do not diverge. Our eyes can converge on something close to us. For 3-D, we need to work the cameras in a special way for the audience. We shoot with two cameras side by side, though one of the problems in doing that is, as we change the focal length, the background starts getting wider and narrower. Independent of what plays on screen, our eyes naturally tend to want to go wide and also narrow, which is the first thing that gives people a headache when they're watching something in 3-D.

The other thing we want to do is play with the 3-D in the same way we might cut a movie or score the music. We want to play with the planes on the screen and out in the auditorium. The producers always want what we call the 'tonsil grabbers,' where the kids will reach up and try to grab at objects. That's where a lot of the fun is, but that's also one of the harder things to create, because we have to set up the math. What we do for that is take two cameras and also a semi-silvered mirror called a beam splitter, and we aim one camera through it and reflect the other camera off of it so that we can actually control where the cameras are in relation to each other. This is an example of interocular, interactual distance that can control where the cameras are pointed. This also creates that convergence, so we can determine what is going to be behind the screen and what is going to be in front of the screen.

Pretend you want any object to be the background for a shot in 3-D. You wouldn't want the viewer's eyes to move too far out, so you'd have to first do the math to work it out and then pull

your focus and pan and zoom the shot. It's important to figure out how far you want the background to go out, which becomes this distance, magnified up on a screen that's 50 feet wide. When something from the background crosses over and comes toward the viewer, you have to decide what its distance will be and where the crossover will occur, because that's where you put your screen plane. As the object moves, you have to change the distance between the two lenses you're using to shoot. This is where the interactual comes into play, because the interactual is what allows you to converge deep or close and not have the eyes rip apart. We actually do this just like a dolly move, just like a focus. And by the way, all cameras love the 2-D perspective. And I think Orson Welles' *Citizen Kane* is one of the best 3-D movies never shot in 3-D.

Why do you think that?

Because Orson Welles and Gregg Toland [ASC] shot *Citizen Kane* by using the deep focus and close dynamics of camera movement in the cinematography. The way they shot it told the viewer about the perspective, scale and scope of all of the sets. All of those things are really what 3-D is about. Shooting just a static 3-D shot can be shot perfectly but it would look boring. It's the perspective, dynamic lighting cues, characters and focus pulls that really tell the story. It's similar to how we work in the real world: We can be driving a car with the windshield wipers going and have our glasses on while talking on the phone, and we can ignore all this technology that would otherwise be interrupting us in that moment. That's also the goal in 3-D — to make the shot feel very normal. We take away the focus and continuity in 3-D and give it back in a way that the audience can enjoy. But it's hard to do and if we do it wrong, the audience is taken out of the show and made aware of the technical world, which is when the headaches appear.

Speaking of the technical world, can you talk about the relationship between technique and technology?

One of the things I really love to do is light. When I was in junior high, I had a view camera that I traded for lights because, although the camera was great, I grew up in Wisconsin and in

the wintertime, the light was always low and hard to work with. So I got rid of the first love of my life, my view camera, and traded it for lights. I borrowed my dad's camera after that and would light up my subjects and elements and hopefully not blow out too many fuses. During that time, I used small Smith-Victor lights, and I well remember the expression on people's faces when the handkerchief I was using for diffusion would suddenly catch fire.

Today's good lighting, which harkens back to the old Technicolor days when they used lots of units, is seen in Showscan, Imax and 3-D. The cameras used for those are 65mm, meaning the focal lengths are longer and require more depth of field to hold them, particularly if they're running at 30 frames per second, which is what we run a lot of the theme park 3-D shows in. We lose light with the longer lenses, but get the same angle of coverage in a bigger film format. I also lose light with the beam splitters; plus, I'd want to hold and control the depth of field, so it's not unusual for me to work sets that have 500- or 600-foot Lamberts. But unlike the old Technicolor look, which was relatively flat, we can make the images look contemporary, though they've got to be cut dynamically. The bigger lighting units allow me to have the stop, but the art of cutting and dressing the images are what give a film a look that's comparable with the good cinematography of today.

The mentors I've had over the years have helped me develop my own style of photography. Today, cinematographers can create just about any look anyone wants to create and see. On parts of *Turbulence*, I used 127 C-stands for just one shot, which I think is a record. That was a 2-D show with a lot of detail in color, and we were lighting white sets. I get to work with really big lighting crews. I also get to share sets at times with the likes of John Hora [ASC], Russell Carpenter [ASC], Isidore Mankofsky [ASC], Hal Mohr [ASC], Linwood Dunn [ASC] and a lot of other great cinematographers. By working together, we get the experience of working with the best of the best and providing input, which helps the show look spectacular.

From you're saying, 'If you can imagine it, you can shoot it.'

Yes. Back when I was doing *Buck Rogers* and *Battlestar Galactica*, there was no concept of us not delivering the show, even though nobody had attempted that look before. We were working under the mandate of delivering it with the color print, so there were no short cuts. We honed the art of all the opticals and all the technology, and we built our own cameras and motion-control systems, so we could deliver two hours a week of high-end television and never miss an air date. The optical output we had for those was 1.3 put together: In other words, for every four dailies we screened, three of them were finals. We could do that because we had the discipline and control, and we did things right.

The other great thing about large format and special venues that I enjoy — though this happens somewhat less in the theatrical world and much less in the television world nowadays — is I get to travel to exotic places. If we need to film pirate movies, we go to the Caribbean, or if we need to do other exotic things, we might go to China. We get to shoot in the Duke of Northumberland's palace in the north of England for *The Haunts of the Old Country*.

I remember once we were sitting in an old palace in England with 10Ks and building the stop up and getting the look of the show. The staff was running around with thermometers on fishing poles telling us that we had to turn the lights off when the temperature rose to 90 degrees. Otherwise, the heat would have damaged these beautiful paintings and tapestries and details of the wood that were in the palace. They had never had that temperature before in that part of England. But the staff also came in and saw the details of the palace beautifully because of our light levels. We were sitting there with cranes and dollies. Chapman had built me special hybrids that could handle a 200-pound camera, and the VistaVision gear heads also worked perfectly with those large format cameras.

I remember another time I was filming shows of the Las Vegas speedway for the Sahara Hotel, for which I got the fastest camera cars in Hollywood to do a 3-D series of films, though the cars could only get up to about 180mph. Then we went over to

the Air Museum in Palm Springs and got some Nissan ex-Indy cars that couldn't race anymore. We took their front ends off, built 3-D rig systems into them, and drove a little over 200mph because our displacement was higher than any other car that is out there right now.

Go to the Orinoco River and Angel Falls and Canima, because there is no other place that looks like that. I've had some great experiences. I like to go to where the excitement is, where the environment is. But I also like to create artificial environments and work in the CG world, which is exciting because it moves the craft forward. The industry is continually changing, even though the eye of the cameraman, the lighting and camera movement still have to work to make it right.

Talk to me about film.

One of the great things about motion picture film is that I can take a big fat roll of it, put it into cameras I have at home that are 100-years-old, and the negative will fit and work. It will still look beautiful. Another great thing about motion picture film is that I can open up a magazine and get an aroma that is just perfume to me. It's a smell that doesn't exist in any other medium in the world. That aroma gets into the blood and is absolutely incredible. I work in a lot of different media — direct to digital, direct to tape, direct to hard drives — and it's all exciting. The only problem is that certain shows I did 10 or 12 years ago can't play back today because the format has become obsolete. But film plays the same way it did when they first started rolling it through the modern 35mm cameras in the early 1910s.

Tell me about your collection of antique cameras.

Over the years, as studios have closed down their camera departments, I've had the opportunity to go in and buy them out, so I've ended up with a great collection of motion picture cameras. Also, by traveling the world, I found unique cameras in Europe and elsewhere that have been added to my collection. I have an Akeley 'Pancake' Camera from MGM Studios that is about 80-years-old and has never had film through it. It ended up in another room after its assembly, and I've been gathering the

parts for it. One of these days I'm going to celebrate by filming with it. The oldest working camera I have now is a Mitchell number 29, which was sold to Mr. Smith in 1930. I used it on the Apollo-Soyuz mission with a remounted lens on it.

If you could just say what's so great about that you can run film through that today.

The Mitchell I have from 1930 just has the most beautiful movement. I used it last for the original space shuttle launch. The footage everyone saw on television was shot in-camera bi-path on the Mitchell, as we didn't have cameras in outer space. The footage was also done with that camera, and the registration and optics are still perfect.

What's so great about film cameras running film today?

Of the 100 or so 35mm cameras I have in my collection, I can take any roll of film, load it into those cameras and it will work perfectly. I can process it at the lab and take it into the dailies screening room and see it in the same format it was shot in. The legacy of that is just marvelous. Films and technology have gotten better, but the core technology from when Bell + Howell started building their cameras is still with us today — and has grown. Arriflex brought us the spinning mirror, among other improvements, but it's still from the root. If I go back and look all the camera effects in a Buster Keaton film, I cannot get better than that. If I look at the lighting Hal Mohr [ASC] did in *A Midsummer Night's Dream*, it is splendid. If I look at our whole history, it is incredible and gorgeous and stimulating. Our collective goal as cinematographers is to keep this going forward and to keep the audiences coming back.

Peter Anderson, ASC was born in Eau Claire, Wisconsin. He attended film school at University of California at Los Angeles, University of Southern California and Art Center College of Design. His specialized 3-D photography credits include U2 3-D, Godzilla 3-D *and* Star Trek Experience – Borg Invasion 4-D.

Bill Bennett, ASC

Tell us who you are and what you do.

I'm Bill Bennett and I'm a freelance cinematographer based in Los Angeles. I specialize in shooting TV commercials.

How'd you become a cinematographer?

After I graduated college, I arrived in Los Angeles and sought work. Initially, I couldn't get the time of day from anyone, so I started working as a carpenter since I'd had some experience building sets. In the process, I ran into a wonderful man who eventually became my mentor, Ron Dexter, [ASC]. Over a six-year period, I started working for him as a grip, then a key grip, then a camera assistant, and then eventually a camera operator. It was an incredible experience.

Why did you want to get out of carpentry to become a DP?

Ever since high school, when I started shooting photographs for the high school newspaper, I knew I really loved making images. Back in those days, the late '70s, multimedia projects were all the rage, and I started making those for various school projects. I really enjoyed it and decided I wanted to work in the film business, so I moved to Los Angeles to fulfill that dream. And luckily for me, it worked.

Tell us about Ron Dexter. What were some of the things he did with band saws?

Ron Dexter was an amazing person. One of the most important things I learned from him was that I never had to accept the equipment as it was built by the manufacturer. I distinctly remember watching him bring home a 2C body that he had just bought, walk over to the band saw and cut it in half. Then he used tape to glue parts of it back on and modify other parts of it with tape and sheet metal to make a camera body small enough to fit this particular shot we were trying to do. The most important thing is to never accept what the manufacturers build and to always push for something we need. A lot of cinematographers say, 'We can't do that shot because the equipment doesn't exist.' But if it doesn't exist, make it.

How does technique affect technology?

It runs both directions: Technique affects technology and technology affects technique. I'll often see a need for something and start talking to manufacturers about fulfilling the need, whether it be for a lighter camera, smaller camera, smaller magazine, faster lenses or the ability to speed-ramp more quickly. I'll mention it to a manufacturer and they'll maybe poll other people to see if there's many of us who have the same need, so it's worth their while to build it. Then they'll build it. People like you and me actually influence the equipment we use, and it's great to have manufacturers respond to our requests.

The opposite influence is when the availability of something new creates a desire to use it. For example, when Arriflex had the bright idea to integrate the way to change the frame rate and compensate the exposure with the iris or shutter angle, we were able to do that easily on set. That comes from the era of Ron Dexter cutting apart Canon 800mm lenses that were intended for still cameras and sticking them on the front of motion picture cameras, which revolutionized how commercials were shot and later, music videos and feature films.

Give us some other examples of how technology can influence technique.

Another example is when swing shift or tilt focus lenses became available, it gave us the possibility to lay the plane of focus across

two people sitting in the front of a car, so we can carry both of them in focus even when there isn't enough depth of field. We can use it to help our focus situation, or we can use it to swing the plane of focus the other way and isolate a particular character or aspect of a product that we want people to look at.

How did wireless devices evolve?

It was an interesting evolution that began with motion picture cameras. When cameras first came into being, the operator literally had to look through the camera until video taps were invented. I remember the day Ron Dexter bore a hole in the top of his BL camera and stuck a video camera in with a beam splitter so he could look at the viewfinder image. Soon after, we didn't have to look through the viewfinder anymore. We could put the camera on a remote head or mount it on the side of a car or put it in underwater casing and shove it underwater. It freed the operator from having to put his head next to the camera to look through the viewfinder. It gave us more flexibility on where the camera could go and how it could move. It also enabled us to do shots that would be dangerous otherwise, where the cameraman could get hurt if something like a whizzing car sideswiped the camera during a shot.

Then we realized we wanted to control aspects of the camera from a distance, so they invented the wireless lens controller, which allows us to control focus, aperture and zoom without cables connected to the handheld controller or the camera. Later, they integrated full control of camera functions into that device, so now we have complete control and feedback of the camera when it's operating. We know when it's rolling, what speed it's rolling at, and we can cause speed-ramps to occur and change focus and aperture — all while the camera is rolling on the end of a 50-foot crane arm hanging over the edge of the Grand Canyon.

How did lens control systems evolve?

Since we had to have some way to control the camera from a distance, preferably without wires, lens control systems allow us to not only control iris, focus and aperture, but also certain

aspects of the camera operation, like shutter angle, speed ramps and camera on/off. Plus, it gives us feedback, letting us know whether the camera is rolling and how much film is left in the magazine.

Some people say that film is now in the digital age. What do you think will happen with film?

Right now, originating on film is still the best way to capture images. The digital influence in our industry is on the electronic control of the cameras. For instance, with the wireless lens controller, the data going back and forth is all digital. Camera control systems internally are also digital now and can be controlled by computers.

Why is film the best medium on which to originate?

Film is an excellent originating medium because it is an organic process. The world around us is analog, and film records in an analog manner. It's chemistry, with photons hitting emulsion and chemistry developing this emulsion. It better emulates the way our eyes see, and there's a long history of people feeling comfortable with the way film looks. So film is going to be an excellent imaging solution for quite a while. Digital has entered our industry in the manufacturing processes for the film itself and also for the postproduction processes, because after we photograph, the images are scanned into the computer and manipulated digitally and either broadcast on TV, or maybe even digitally projected, or printed back onto film and projected in a conventional manner. Tremendous gains are being made with digital-capture cameras and I am excited to be working with them as well.

In the world of commercials, how does film help us to originate?

In commercial production, film is very useful because it allows me to work quickly. I know that the latitude built into the film allows me to make a setup, quickly put the lighting in place and shoot. I also know I don't need to make it perfect, because I have the capability in postproduction to digitally manipulate the images.

I hear various assistants often complain that we don't have enough time to reload.

That's one of those things when the sun is going down and the assistant tells me we have to reload, I might say, out of frustration, 'There's no time to reload. Just roll!'

What's the difference between features and commercials?

In feature films, oftentimes the director and cinematographer conspire to make the cinematography as transparent as possible so it doesn't distract from the story or the telling of the story. In commercials, it's all about the cinematography. That and the story is what grab the audience in the first five seconds. Commercials have only 30 seconds to tell a story and if they don't pitch heavily enough in the first five seconds, viewers are going to surf off to another channel. So the cinematography is incredibly important and very dominant.

When cinematography is the story, how does that influence technology?

Commercials and music videos are typically the areas that bring innovations to our industry. People will see things in them that have never been done before, and that leads the industry to change the way images are created.

What are some examples of technologies that have been created for commercials?

A good example is the use of laser-focusing systems. A relative of Ron Dexter, actually his brother in law, Howard Preston, invented a laser-focusing system that, over tremendous distances, can focus very long lenses accurately. For instance, in a shot of cars rocketing toward the camera, we can actually select which car or even tire that we want to be in focus.

Howard designed the Micro Force zoom control, because prior solutions were not very elegant, and as an assistant, I was getting yelled at by the director or the DP for bumpy zooms, a jerky start or jerky stop. The zoom control technology already

existed, and parts were inspired by the aerospace industry. The little joystick is actually the trim tab control on an FA-18 fighter jet, so we used that part and built a set of servo electronics for it and made this destruction- and bulletproof zoom control called a Micro Force. And it has become the standard for the industry.

Do you own your own equipment?

I own all my own equipment, mostly because of convenience. I want to be able to respond to producers who hire me and provide them with a wide range of equipment without concerns about the equipment's availability or quality, because I know where it was last week and what happened to it. If I shoot in a very dirty or dusty environment, I take the camera and thoroughly clean and overhaul it afterward. I know how my lenses are treated. I know my lenses intimately — which ones are extremely good and which have a little bit of flare and shouldn't be used in a strong backlight situation. Owning my own equipment has had tremendous advantages.

Are cameras just tools?

I know that some cinematographers merely consider a camera a tool, like a carpenter might consider a hammer. I see it more like a concert violinist who aspires to have a Stradivarius violin, which is the very best violin that is finely crafted, finely tuned and carefully maintained. That's how I see my equipment; it's what I make my living doing, so it needs to be phenomenal. It needs to perform phenomenally, and it needs to be incredibly reliable.

Let's talk a little bit about nuts and bolts. How do you organize and store your equipment?

I store it in a vault that I had built behind my house. My insurance company told me I couldn't store it in my house, so I made arrangements to have the vault built. It looks like a bank vault, with a vault door, and it's controlled for temperature and humidity. My camera assistant Craig goes in a couple of days before a show and organizes everything. He makes sure everything is operating properly, and if it isn't, he has it fixed,

repaired or adjusted. I have a camera truck with air-ride suspension, so the camera actually gets better treatment than I do! On location, it's really well cared for as well, because if it doesn't work, we don't work.

Talk to me about the evolution of the Arriflex 435 and how you, as a cameraman, gave input in its creation.

The development of the Arriflex 435 was a very interesting process. For the first time, Arriflex actually came to us, cinematographers like myself and Jon Fauer [ASC] and asked us what we wanted. Not only did they ask what we wanted, they showed us prototypes along the way. First they were wooden, and later they were working prototypes. Early on, I remember the camera being twice as large as the finished camera is today, and I totally rejected it, telling the designers who were sitting across the table from me that if they built that camera, nobody would use it. They took that to heart, went back to Germany and Austria and spent an extra year redesigning the camera. They came back with what we now know as the 435, which is extremely rugged, small and very lightweight. It's pretty much the most versatile camera on the face of the earth.

Tell me about the Arricam.

The Arricam was also developed with a cinematographer — as opposed to an engineer designing something while sitting behind a desk and never really working in our world — and that is why it has been accepted so readily by the industry. The camera functions incredibly well, because the people who designed it are the people who use cameras.

What about the relationship between cinematographer and rental house?

That relationship is extremely important. And Denny Clairmont, who owns Clairmont Camera, which is a large and distinguished camera rental house in Los Angeles, probably does it better than anybody else. I remember when I was a young, up-and-coming assistant, not even operating yet, I went to Denny and he told me that no matter what I needed or when I needed

it, he would be there. That was 25 years ago, and it was true then and it's absolutely true now. The support that Denny brings to us is absolutely astonishing and I really appreciate that.

Bill Bennett, ASC, was born in Bourne, Massachusetts. He is the first predominantly television commercial cinematographer to be a member of the American Society of Cinematographers. Some of his commercial clients include Mercedes Benz, Honda Motorcycles, Sprint Communications and Hallmark Cards.

Gabriel Beristain, ASC, AMC

Who you are and what do you do?

My name is Gabriel Beristain and I am a cinematographer. I am Mexican by birth, British-educated and American-improved.

How did you become a cinematographer?

I came from a family of actors and filmmakers, so for me it was a natural process to be involved in films. In Mexico, I tried to expose myself to the various disciplines in filmmaking. I was very keen to tell stories through the language of film.

I was very much part of a strong Super 8, independent film movement in Mexico. When I moved to Europe, I went to film school and, by necessity, had to pick a specific area within film-making to study, and since cinematography was my strongest skill at that time, I specialized in it — for the time being, I thought. And the rest, as they say, is history.

Did you go to film school or did you teach yourself?

For me, it's always been a mixture of both. While I was actually a member of the first generation of students from the Centro de Capacitación Cinematográfica, the school founded by Luis Buñuel in Mexico, and later I graduated from the National Film and Television School in England, I've also done a fair amount of empirical learning. I had worn many hats in my life as a film-maker, so most of the time my knowledge has been more a product of life's teachings than academic learning.

Tell us about your classmates and how your lives have intertwined.

Obviously our biggest star is Roger Deakins. He is my senior and one of the great cinematographers, certainly the shining star of the school. A good bunch of directors came out of the National Film School: Michael Radford, for instance, Bernard Rose, and a lot more. They were a good bunch on the whole, many of whom are now part of the Hollywood film industry.

I also receive the newsletter from the school, so I've learned that the newer generations are coming out equally strong. I have no doubt that I will end up working with one of them very soon.

Tell us about some of your own work.

Apart from the films I did in Europe, perhaps the most famous was *Caravaggio*, which I shot for Derek Jarman many years ago. I did also K2 for a British company. When I moved to America, I shot films like *Blood In, Blood Out* [a.k.a. *Bound by Honor*]. Perhaps my favorite film is *Dolores Claiborne*, with Kathy Bates, the one I shot for Taylor Hackford.

Recently, I've done a fair amount of thrillers, semi-horror and all kinds of mainstream films, although my heart will always be with the more independent, story-driven films like *The Spanish Prisoner*, which I did for David Mamet, or my most recent film, *The Night Watchman*.

Why is *Dolores Claiborne* your favorite?

Dolores Claiborne is my favorite because the light and the camerawork were very important in telling the story. The past and present sequences, the juxtaposition of images and of time frames within the unfolding story of the film make a unique use of lighting and camera techniques. Also, we were among the very first films to use digital effects, though it was important for the film not to be identified as visual effects-driven, because the goal was to reproduce reality, as opposed to affect reality.

What is your philosophy on style and the art of shooting? How do you establish a look?

I certainly follow those areas. For instance, *Dolores Claiborne* was heavily influenced by the paintings of René Magritte; *Caravaggio*, naturally, was influenced by the art of Caravaggio. I tend to follow some type of visual art school in every project, though not always. It can give us plastic ideas to work with. I like to believe, however, that I lack a signature style. I would rather think that I work from the story. I once said that there are cinematographers who are cinematographer-painters, cinematographer-engineers and cinematographer-editors, and that I thought I was a cinematographer-writer in that I try to penetrate the intent of the script and find a way for the light and the camera to become a character in the story.

I try this in my talks with the director, and some are sensitive enough to incorporate that into their work. David Mamet, for instance, in *The Spanish Prisoner*, was absolutely brilliant in letting the lighting and camerawork be strong characters in that film. Other directors, however, are oblivious to these matters, which is fine by me, though I still try to get the camerawork to act as a character in the film, so that the style I introduce resembles what a character would think or do.

Tell me how the technology, whether film stocks or lights, affect your art form?

Basically, every time a new film stock comes out, we need to adapt. I often say that when I started my career, I had to light to reduce contrast and now I have to light to create it. Obviously, film stock is getting more forgiving and gives cinematographers a wider range of latitude. We need to adapt to the new situations that emerge from that. Producers and directors never hope to have a lighting situation where they have to be protecting their project from film stock problems. Film stock cannot handle the difference between light and shadows. The manufacturers of film and film equipment have actually helped us by giving us wider ranges. Our job, then, is to use and understand technology and adapt it to the styles we are trying to create.

What is right? To make a film with high contrast or to make one that is very flat? Nothing is right per se. What is very important — and again it depends on your style and what works for you, or, in my case, the way you want to adapt the camerawork to the story — is understanding what that film stock is giving you and what the camerawork can achieve.

For instance, in *S.W.A.T.*, the director wanted a tremendous degree of reality. He wanted a feeling of high hell, of being where the action was, so I used many different types of cameras. I even used lipstick cameras on the helmets of some of the swat team members. I used the technology available to our advantage. What is important is to have understanding of this. Nothing is right or wrong as far as technology is concerned, because in the end you are adapting it to your needs.

There are some people for whom a Vision stock, with its incredible latitude, really works because it is gentle and works extremely well for some stories, since it can be very true to a practical location. Perhaps it gives a very even image, and some cinematographers welcome that. Others will want to use some degree of lighting and, through an understanding of the sensitometric curves in the film stock, manipulate a degree of contrast that makes the film more dramatic. If one understands the film stock and its characteristics, one can produce very unique imagery.

Along those lines, talk to me about digital intermediates.

Digital intermediate is a wonderful tool that has been given to us, so the question now is what can we do with it? Nowadays, we can make things that seem very even, so basically any person can grab a beautiful film stock, stick it inside one of those incredible cameras, put on one of the amazing lenses — Panavision, Cooke or Master Primes — and shoot a very pretty picture. What makes the difference from one cinematographer to another, what makes the style different and unique, is to add that element of creativity and artistry, to work with the capacity we have to manipulate those constants.

Digital intermediate is going to give us the extraordinary chance to go deeper within layers of film, to bring out things like

secondary layers of color correction that before were impossible to manipulate in the photochemical process. Now we can go into these secondary layers, isolate specific areas and correct those sections without affecting the composition as a whole. We can pick up a color; we can use luminance mattes, meaning we can separate those areas of luminosity within the image and color correct it to give it more density or contrast. Those elements are going to help us do something that is very important. If you allow me the analogy, it's as though we're back in the early period of filmmaking when people used to hand paint each frame in order to give their films a more distinctive look. Going into the digital bay and using digital intermediate, we are hand-painting our films as well and giving our art a more personal look. And that is very important to preserve.

What are your thoughts about the future of cinematography and the role of the cinematographer?

I think cinematography will continue to be what it is. I think film, as a celluloid stock, photochemical process might go through transformations, but it is not going to affect the art of cinematography. The art of cinematography will remain. For all intents and purposes, we are still going to be shooting film. I think we're always going to be looking, in digital technology, for that aspect of celluloid film. For us, it will remain a discussion about light ratios, controlling our contrast ratios, our faces, trying to get enough detail in the show areas and trying to get enough detail in the highlights. For us, the art and technique of cinematography will continue. Our palette will still be there. Maybe our colors will change, but the film look will continue. Cinematography has not essentially changed in 100 years and it is not going to change. It is the process and the artistry that will evolve.

Gabriel Beristain, ASC, was born in Mexico City, Mexico. He attended film school at the Centro de Capacitación Cinematográfica in Mexico and the National Film and Television School in the United Kingdom. His credits include Caravaggio, Dolores Claiborne *and* The Spanish Prisoner.

Larry Bridges

Who are you and what do you do?

My name is Lawrence Bridges and I started a company called Red Car. I became an editor because it was the next best thing to writing. My first interest in the movie business was writing, and editing was a way to make a living, and it seemed to be a good way to express the storytelling of filmmaking the best. I've found myself to be pretty good at it and very interested in the effects of it, such as the tricks you could play and the things you could do beyond what was on the written page.

As an editor you look at a lot of cinematographers' films. What do you consider good cinematography?

I have been lucky enough to work with some of the best cinematographers around. When I started my career in editing and started my company Red Car, one day working with Allen Daviau's material and the next day with Vilmos Zsigmond's, Jordan Cronenweth's, Ernest Holzman's and on and on. John Toll was somebody I worked with — actually, I cut his first demo reel and when I started directing commercials, John was the DP on a lot of them so I got to see a variety of looks and approaches.

I was very impressed by the pure inventiveness of everybody's technique. What happens after you look at a lot of dailies, you see confirmation of "readiness." In other words, when you see dailies, you are seeing a moment in time pass when everything was ready on the set and the director was willing to call action. The editor then is seeing perfection in preparation, at least.

Great cinematography can be seen at this point, when the elements start to flux.

The editing eye is attracted to the beauty of motion and finding some way to tell the story, advance the storyline and get the message of the particular commercial or film across. The issue for the editor is to find the musicality in the action, in the operating, in the preparation, in the staging, the blocking and everything that happens after we hear "Action!" With all the cinematographers, I saw this beauty and yet a mute potential, in terms of what was in the film, and I kind of grasped my job or my calling, which was to find the most amazing and poetic pieces that could be put together into a narrative.

Are they all different?

They are all different because there is a spirit in each cinematographer that is not comparable to others. The techniques appear to be the same and you see the same approach to lighting, but there is always an ineffable quality in the actual film when it comes out of processing or onto the Avid that is almost indescribable.

After going through a 12-year process making your own independent film, what did you learn?

The editor spends a lot of time selecting takes and finding virtue in a piece that you are going to use in a narrative. I think editing made me a great operator because I was so compelled to find the best pieces that would be what would make or break my edit. I could pretend that the best things were actually in the film. In operating my own film — since I was the operator and cinematographer on my film *12* — I always said to the crew that I was selecting takes. I was sitting as you are now behind the eyepiece selecting which pieces I wanted to use in the final edit. So the connection between cinematographer and editor was a direct one. This connection is direct and immediate when you look at operating in that way. Once again, the mute potential of the dailies is there before you as you shoot, as it is being recorded; you can't do anything about it once the camera starts rolling. What you're hoping for, as an operator, is to find the

pieces that you know will be great. If you don't find them, you can't move on, so the strength of being an editor/operator/cinematographer/writer is that you can be much more efficient because you can see the pieces fly by. Then you start asking for other people's views. You show a take to the actor and ask what you could do differently and how you could make it better. You can get to that point a lot quicker without the intermediary of an operator or another editor because you are all in the same flow of the process.

Lawrence Bridges was born in Burbank, California. His credits include 12 *(director and cinematographer) and Michael Jackson's "Beat It" video (editor).*

Jonathan Brown, ASC

Who are you and what do you do?

My name is Jonathan Brown. I am a cinematographer.

How did you become a cinematographer?

I started out as a production assistant working with my father, Garrett Brown on commercials in Philadelphia and New York. From there, I started hanging out in the camera department, because that was the place to be. When I was a kid, I always played with cans, film cores and the editing rewinds, since that kind of stuff was lying around my dad's house. Having the chance to be on the sets of various films as an 8-year-old — including *The Shining*, with this huge set and huge house and huge maze — was the greatest thing ever. It was so cool to be there and hang out. For me, it was just my dad going to work, and I thought he had the coolest job in the world, to be able to make-believe all the time. As I grew older, I became a fan of images and always thought in terms of composition, light and shade, and knew I wanted to pursue that. I thought I would become a foreign photo correspondent — taking photographs around the world. I also studied literature and wanted to be a good writer. I wanted to travel the world and document stories.

Tell us who Garrett Brown is.

Garrett Brown is my father and the inventor of a device called the Steadicam, which is basically a camera mount that allows cinematographers to move through a set or scene without having to worry about dolly track or the jitteriness of handheld.

It creates a fluid motion for the camera without the distraction of camera movement. The person would wear the camera mount and have the mobility of a handheld shot with the smoothness of a dolly shot.

Why did you choose cinematography?

One of my dreams was to travel the world and tell stories visually and through writing. I had studied literature and was fascinated by photography and images. Growing up around my dad, visiting sets around the world and being involved in things that are created and are not reality opened up an even greater interest in me. Better than photographing something that is real is creating it from someone's imagination with the tools that are available to us.

I was in the 11th grade when I went to see *The Last Emperor*, which Vittorio Storaro [ASC] shot; he is a hero of mine and a fantastic guy. I remember sitting in the movie theater with my buddy — we were supposed to be in school and were just skipping class — watching this movie and it dawned on me that this was somebody's job. These images that were being presented so beautifully on the screen was somebody's job, and I thought to myself, 'This would be a great job for me.' It involved everything that I loved: camera movements and images. Even though my dad was in the business, the job of cinematographer only dawned on me when I was watching *The Last Emperor*. That was the start for me.

That's interesting. I went through the same thing, but the film that got me started was Haskell Wexler's *Medium Cool*. It's funny how different films spark that for different people. Can we fast-forward it from college? How did you get into the business?

When I graduated college, I was kicking around Philadelphia when somebody called the house, asking about my dad who was working on a project. The caller said, 'The camera guys are at Panavison, and they are getting the package ready.' I had never really gotten the chance to play with one up close, so I went to Panavision and started hanging out in the camera room

— cleaning cases, marking them and carrying stuff. The guys there began teaching me by putting me in the darkroom and making me load test film.

One thing led to another, and I ended up as the camera PA on that film. I went right into the fire and did the entire film while learning an enormous amount from these guys and a wonderful cameraman named Juan Ruiz-Anchia [ASC] who shoots in a style that is very natural and beautiful. It was an anamorphic film and I remember being mesmerized when looking through the lens. They were kind enough to let me, as an assistant, look through the lens and see these lighting setups and how beautiful they were. The compositions were so strong, and Juan Ruiz-Anchia was good about explaining how he used the composition or the type of lighting to help tell the story for the director. I was just the assistant wandering around, but he really enjoyed what he did and shared his enthusiasm for how he told a story.

That fed the fire of my desire to make beautiful images and I started working from that point on as a loader and then as an assistant. Even though I hadn't gone to film school, I found that the fastest way to move up was by working for free. I made my living doing a union job as a first assistant, but on weekends, I worked for free shooting or operating for super low-budget student films at New York University, Temple University or Columbia. When I started getting paid to operate, I shot films for free as the DP, like spec commercials and low-budget shorts. That was the greatest thing. I always tell people, when they ask me how to get ahead in the film business, to work as much as possible, even if it's for free, because the people you work with on the way up are the ones who'll be the producers, directors and production managers five or 10 years down the road. They'll be the ones who will hire you because of your reel and will continue to be your friends in the business, because five years ago, you were working for them for free while all of you were coming up together.

It's also important to have a reel, isn't it?

Having a reel as a cameraman is a way to set ourselves apart from other cameramen. If I have a certain style, the reel is the

way for me to prove that I know what I'm doing and that I can execute my style. The bigger anyone gets in the business, the less they need a reel, but it's something everyone needs to create.

You said the magic word and we can segue right into it. Style — what is it?

Every cameraman has a different style, and every cameraman's style changes throughout his or her career with more experience, learning and growth. I have been working as a DP for probably six or seven years, and I've already gone through different styles. It's almost as if, the more time goes by, the more I get to shoot, the more I perfect my style.

Right now, I'm at a point where I'm into very natural light and minimal camera movement. The more I learn, the more I try to re-create what happens naturally in the world as beautifully as possible — the light I might see while driving down the street or the light that comes through the pharmacy window at midnight or the light that is cast by the reflection of the sun off a glass building in a courtyard. Those are the most interesting, and somewhat most difficult, things to capture because they're real.

Where does style come from? Where do you get these ideas?

My style developed from a love of still photography and realist art. I've always been interested in composition and in the slice-of-life type of photography and painting. Edward Hopper captured this feeling in his work: It's as though he takes a frame from someone's everyday life and creates this beautiful composition. It's nothing overly stylized. The same holds true with a lot of photographers such as Walker Evans.

How do you achieve the look you want in a picture?

Even though I might have a certain style that is close to my heart, a lot of times when I meet directors and work on a project, I want to somehow use that style to help them tell their story. Hopefully they've seen something in me that they want to harness, so that they can use my talent to tell the story. It

would be horrible to hire a guy who does super stylized work to do something that is incredibly natural and vice versa.

You talked before about the Steadicam and how tools and technology can affect style. Let's talk more about that.

In the example of the Steadicam, that tool was developed to achieve a shot that had been imagined beforehand. There was a shot that Garrett Brown wanted to get and couldn't, so he developed, over the course of several years, an object to be able to achieve that shot. The technology came after the vision in that case and, subsequently, now that the object exists, people say, 'Hey, look at what we can do with this object. Let's try to apply it to this or create a scene around that.' Technology goes both ways. Sometimes a person has a strong vision, but the device to achieve it doesn't yet exist and needs to be created. Sometimes, there is a fantastic device already out there and we'll say, 'This device might help us get something really interesting for this particular scene. Let's try it.' So it goes both ways.

Let's talk about Storaro.

I had the opportunity to work with Vittorio as an operator in Los Angeles, and I would pick him up at his hotel on Sunset Boulevard every morning and drive him to work. I would ask him a question about composition or a certain scene that we were doing that day and get a 30- or 40-minute lecture that felt like a doctorate on composition or color or Yugoslavian primitive art or whatever it was that was his inspiration for the film. I realized that he searches everything in the world — religious art, photography, old films, things he sees out his window — for the inspiration for his films. He has a very strong vision that he creates through his love for images and color, and he harnesses that enthusiasm and gives it to the director to help tell a story. That's a special gift.

Where are you getting your ideas from for your next project?

The project I am working on now is an interesting mix of styles, because we want the camera to be invisible. We want it to be as

though the audience is in the room with this family, in this house. We're not photographing it as a movie — it's just people who live down the street and are as quirky as anyone's family, with the audience being sort of a fly on the wall capturing their life as it unfolds. We have to mix that with the fact that we are shooting it out of order and on a stage with a variety of actors and actresses who need different things, in terms of their lighting. We are taking this incredibly artificial setting and trying to tell a story that looks like it just happened naturally in front of the camera.

One of the great challenges of cinematography is shooting things in a way that doesn't draw attention to the cinematography. We want to think about what the project is telling us, what the characters are feeling at that moment. That's why the great movies are ones where the images, movement, composition and color just accentuate what's on the page, what's coming out of the actor's mouth and how they are placed in frame.

Jonathan Brown, ASC was born in Philadelphia, PA. His credits include School for Scoundrels, Mama's Boy *and* The Family Stone.

Stephen H. Burum, ASC

Who are you and what do you do?

I am Steve Burum and I am a cinematographer.

How did you become one?

I became a cinematographer, more or less, by accident. I was very interested in making 8mm movies when I was a boy in high school. Then I went to the UCLA theater arts department and film school during the late '50s and early '60s and I did a lot of student films. I spent time being a teaching assistant to Charlie Clarke [ASC] and James Wong Howe [ASC] and I just got into it.

How do you know Ron Dexter?

I know Ron from UCLA. He was a student there but not fully, because he was putting things together for the department and was a very technical guy. He was a little bit older than we were, but was always around, helping us out.

Tell me about your big break.

Actually, Ron gave me my big break. I had been in the army and I came back from having spent two years in New York and was looking for a job. He gave me one as his assistant. I worked as his assistant for a while, and one day he said to me, "You don't need to do this anymore. You don't need to be an assistant because you are a cameraman." I was over at his house and he got a call from an outfit called Winters Rosen and couldn't do

the job, so I went over and interviewed. From there, I went to Sweden with Ann-Margret to shoot her television special and that kind of got me on the road.

Let's talk about style.

Style is always a very funny thing to talk about because, in art, it is always a matter of opinion, and many people have many opinions. What you try and do, as an artist, is communicate a story to people. In our business, we communicate with pictures. We use light, lenses and composition to tell the story. Personal style evolves from personal experience, assignments you have been given, and your craft skill. When you look at what your dramatic mission is, you come up with a plan of how you are going to execute it. Exposure, lenses, composition and staging all contribute to how effectively you tell the story, which is what the style really comes out of. Style is just your point of view.

Give me some examples of style.

What I always do when I start a picture is, of course, read the script and start imagining what the picture should look like. And then you start figuring out how you are going to accomplish that and what techniques you will have to use. Art is based on two things: It is based on craft skill and inspiration or talent. All arts have craft skill. In writing, you have to learn how to spell and form words and sentences. In drawing, you have to learn to draw things. And in music, you have to learn to play an instrument. Photography and cinematography are exactly the same — the more you do it, the better your skill level becomes.

One of the things you always like to do is test your skill level. So when you imagine what the scene is going to be, you assemble your craft skill and experience and apply it to the problem. It is sort of like doing geometry. I just keep lighting, composing and working to make the picture in my head match the one on stage. Some people are more like jazz musicians and will respond to the situation, where there will be a few notes and then you answer with something that reinforces that; sometimes, that is a very good technique. A lot of times, when you see a rehearsal, you get a new idea for the scene, or something

is revealed to you that you hadn't imagined. You have to respond to that if you are going to get across the story idea. It is a mixture of craft skill, inspiration and paying attention to what the actors, director and production designer are doing. And, hopefully, you are all working toward the same goal.

That sounds very organic.

I think it always is. There is the person's emotion, feeling, experience, talent and understanding of life. All of that impinges on what you are doing and how well you can execute your job. Some might say a cinematographer is more of a technician than an artist, but I would say that a cinematographer is more of an artist. The technology serves communicating the ideas and how they are filtered through your mind. Art has to do with showing things to your audience, how we see things, and the artist's interpretation of what they see. Sometimes, it reflects what is happening now and sometimes it has a universal theme that could be true forever.

Where do you think style comes from?

I think it comes from all things. It could come from education, it could come from experience all the things you've read and seen, all the places you've been, all the things that have happened to you. It's a way of solving a dramatic problem. When you have a dramatic problem, you say, "How am I going to solve this?" A director might say to an actor, "In this scene, I want you to be sad." So how is the actor going to communicate that to an audience? Are they going to make a sad face or slump down? They know from observation that when people are sad, they have body language like this, and they know that on a stage they are going to have to exaggerate those things to make them read. In a movie, if you are close you don't have to do very much because the magnification is so large that a little eye droop or mouth droop will convey the sadness.

Is the technology of cinematography like a painter's brushes?

Yes. The key is to use the technology to communicate to other

people. You must practice your craft until it becomes second nature. That is the important thing because then you don't have to think about it. There is no piece of equipment that can make an idea great; you have to have the idea. If you just hand somebody the fanciest and most technologically advanced camera, it won't make great pictures or tell a story, because it is the people who tell the stories and the technology is always is always in service to the artist.

But you have to understand the technology.

That is the practice. You understand the technology and make it your own. The shocking thing is that I am not very interested in photography. I know how to do it and studied all my life to be very proficient at it, but it is not the interesting thing. I am more interested in telling a story and watching the actors act than I am in any photographic system. It is just a means to an end.

Can you give me some specific examples?

You were asking about *Mission Impossible*. It is a spy picture, which is set in Europe and the United States. To me, Europe has always been a very romantic place, so I did a very romantic version of Europe with a lot of soft light because, in the northern latitudes, the shadows start to fall away gently, and there are not many sharp shadows. Then there was a section that's supposed to be CIA headquarters in the United States, which I lit with very hard light to show the difference between the two places. About a year after making the picture, I was on a soundstage and Jon Voight was visiting, and we talked about the picture. He told me that, when he saw it, he thought it was very romantic and that he thought it would be more hard-edged. I told him that, to me, the story was very romantic, so I did a romantic version.

Any other examples?

When I went in to meet with Brian De Palma for *Untouchables*, I brought a lot of still pictures from that time period I really wanted to do it in a black and white, make it a German expressionist kind of film. I had done a couple of pictures with him,

and he asked me what I wanted to do. I told him black and white. He told me not to break my heart, because they wouldn't let us. He asked what my other idea was I told him that, when I think about that time, there was a big emphasis on glorifying industry and mass production during the depression, so you had a lot of these *Life* magazine photos of things on assembly lines being photographed in sequence, such as Ford cars. You see that in a lot of the work from photographers of that period, so I said we should do something with a lot of repetitive images and that was what we did. We got together with the production designer and came up with things like always having the same cars lined up, having people dressed the same way or having things stacked up in the background. The other thing was that there were not as many cars — things weren't as busy — so I tended to have a lot of open space to give it that period feel.

How about *St. Elmo's Fire*, which had lots of elegant camera moves?

Because *St. Elmo's Fire* was an ensemble piece with seven kids with a lot of rapid-fire dialogue, I thought it would be more interesting to always have a group. We shot in scope, so you could fit all seven people across the frame. It would be a waist figure so you could see them really well. They were all good actors, and it was good dialogue that they could just spit out like crazy. I find it more interesting to see actors take their pacing off one another than having it forced by the cutting. If you have good dialogue and good actors, it can be a joy to watch. There are certain kinds of sequences where, in order to tell the story and create another kind of mood, you want things cut together. But this was people in and acting like a group as well as acting as couples, so you always wanted two or three people in the frame.

If you do a different movie with the same director, how does the style change?

The style does change with different stories, actors and directors because there is a new mix. An actor may feel that his sadness is best portrayed by using a lot of body language so, if you see that in a rehearsal, you say to yourself, " "I must respect the actor's performance, so I've gotta shoot a wider shot." If you've got

somebody who isn't going to do it with body language, but with his face, it is incumbent that you shoot a tighter angle. Sometimes the directors will ask the actors to do certain things a certain way, and that is what dictates the way things are done. Everyone is trying to add to the story.

For instance, let's stay with this sadness thing. The director says, "You are going to be sad; you are going to be sitting in this room, and I want the room to look sad." There are a lot of approaches to that. One is to put them, compositionally, in a place that is lonely and uncomfortable, like a little figure in a large, empty room. So what you are doing by that is trying to mimic what the characters are feeling. The lighting would do exactly the same thing. Maybe you'd hide them a bit or obscure them; maybe they would be in silhouette and you wouldn't see any detail on their face until you got closer; maybe you would have the whole room dark and have them in a little bit of light. There are all kinds of ways to get to this kind of feeling. You do this by observing what the actor is doing, knowing what the story is and talking to the director. You come up with a method or style of how to portray that emotion, portray that emotion to affect the audience with your technique, with your storytelling skill using compositional placement, lighting, the actors' bodies and expressions and while director is watching and picking out the things that he thinks are best communicating the story to the audience. It's like you are a child trying to please your parents, "What if I do this or what if I do that?" That is what the director is doing. He is cheering everybody on and making sure that it all goes a certain way, which fulfills what the task is. It is very difficult to recognize what you are doing at the time. Afterwards, when you see something you've done, you can give all these reasons, but when you are in the throes of doing it you are just responding to it.

You have worked with Brian De Palma quite a lot. Can you talk about that experience?

Brian De Palma mostly does pictures that are not hire-out pictures, whether if he has written his own picture or chosen his own material. He always does pictures that have a moral theme:

Somebody has done something, witnessed something, not acted in a proper way, or they have gotten themselves into some circumstance that requires they have to redeem themselves.

In *Body Double*, you have the lead actor lured into watching a girl do a striptease and, if you've seen the picture you know, it was a different girl so the husband will have an alibi and he was the alibi for her murder. In the picture, the policeman says to him, "Iit's your fault that this girl was killed; you're nothing but a goddamned panty sniffer." And that is Brian's message, saying that because you didn't do the moral thing, you are to blame, and you have to clean the slate to have redemption by solving this murder, but when he does this in his pictures, it is always very smoke and mirrors. In *Casualties of War*, it's the same moral theme.

How does that relate to style?

Style in that case is trying to display the scene that explains what the moral problem is in a way that makes the audience feel guilty, too.

Let's talk about *Hoffa*.

I was very lucky to do this picture with Danny DeVito and Jack Nicholson played James Hoffa, and the script was written by David Mamet, who writes the greatest dialogue in the world. We but we had a scene in a courtroom that was written in a very long and drawn-out fashion. We compressed the action with a series of match dissolves, from one person to another. The way Dan and I used to work was we had a couple of big chalkboards we would draw the scene out on and talk the whole thing picture through. When we got to the trial, we staged it out the normal way and it was just too long. We felt that it needed to be collapsed, so what we did was a montage style where shots would drift into and out of the frame that were symbolic of people's psychological conditions and their relationships with the other characters.

One of Hoffa's henchmen was the squealer; he was sitting with Hoffa's family. When it was time for him to testify, the way we moved him from one place to another was to do a dissolve

where he disappeared, leaving a space. He was no longer with the group, which was supposed to symbolize that this was the guy who was the stoolie and then we slid him into a new shot. That is where style helps the story in a more abstract way.

The most interesting thing about doing movies is that you can use this sort of abstraction to get your point across. Silent movies were fantastic, because they didn't have the spoken word. They had to put a series of images together that meant something. Pudovkin did that wonderful experiment in the 1920s where he has a neutral shot of a woman looking and then he juxtaposed that with a baby, then the woman, then the baby. He would use the shot of the woman juxtaposed with somebody pointing a gun, the woman, the gun and when it was shown to audiences he asked what the woman's psychological feelings were about all of this. Everybody said they saw love in the woman's face with the baby and fear with the gun. That series of images put together was making a word in people's minds. If you have the letters T, C and A, they don't mean anything, but if you put them together in a certain order they spell the word "cat." That's the great montage power of movies. When sound came in, things kind of slipped into a situation where they were doing photographed stage plays. Very quickly they took these two elements —montage and dialogue — and put them into a new form. You see that a lot in action pictures now where you have a whole series of little tiny pieces that add up to something.

One of Brian De Palma's key techniques is point of view. The way he does this is he will show you what the character sees, then he will show you the character. When he does this, it always has to be exactly on the characters' eye line. The main thing about what we do in the Steadicam shots is the way the camera moves. For instance, if somebody is going down a hallway, looking through rooms and they are not agitated, the camera movement will be smooth. But if there is a noise, the camera moves more quickly. It basically mimics what the person is doing so that is really literally subjective. Brian is the master of using that technique, and I understood that about him the first day I worked with him. That is an interesting thing about

some directors: Some of them you just get immediately; you get exactly how they think and you can really back them up.

There are some directors who take longer to understand. You have to pay attention to what they are doing, what they say and you have to ask them questions, because it is your job to service the story. Once you know what the director sees in the story, you can make suggestions that will help tell the story best, and it is your job as a cinematographer to figure that out. It's the same thing with actors. The actors have to figure out what level of performance they are going to give that is going to please the director and best serve the scene. It is also incumbent on the director to help everybody out and to explain what has to be accomplished.

When using Steadicam, how do you avoid making things look flat?

Steadicam shots are always very difficult to light, because you go around 365 degrees and, you go high and low. and I was talking to some Steadicam guys, and they said everybody likes to light the shots with a soft light to avoid shadows. They noticed in my stuff that I didn't do that. I don't because I am not worried about the technique of the Steadicam. I want the lighting to look the way it would normally look if you didn't have this mechanical problem. There are ways to solve these problems and the simplest way is you break off each setup into sections. You don't try to light the whole thing; you try and break it up, and if you come around and a light becomes flat, you use dimmers. If you do it on the move, you never see the dimmers change as long as you keep the volumes of light and dark the same. People accept that. Even though a light might be over here in the beginning, at the end of the shot it's over there. The important trick is to still have the same volume of light and dark.

When you show up at a location, what goes through your mind first, in terms of lighting?

How would I light this scene? The great thing about this setup you have here is it harkens back to the beginning days of

cinema. We don't have any artificial lights at all, just one big, soft source over there that is diffusing the sun. Then you have what everybody calls a negative fill, which is black and keeps the bounce off of the boards, so I have a dark side of my face and a light side. This is the same technique old renaissance painters would have used. They would have gone outside and silked people, put a series of reflectors and negative fills around to get their effect, and that is exactly what the first movies did. When movies started out, they were outside and needed a lot of light just to get a basic exposure so they used those techniques because they were the only ones they knew.

Once it became a real manufacturing business, you had to extend the day when, the sun goes down and, suddenly, you have to do something to get that extra light in there. In the beginning, they used mercury vapor lights called Cooper Hewitt lights. They were big, soft sources that were very blue-green because the film was very sensitive to blue light. They also used arcs and then there was a bigger manipulation of light than ever before. The other task the cinematographer had to do was to make the actors look good and also to make them look like the character they were supposed to be. The bad guy had to look bad and the good guy handsome and clean. The girl had to look wonderfully beautiful, so you needed all these tools. The other thing that is critically important is the manufacturing aspect. You have to be able to do this no matter what the weather is. If the sun goes out, you have to make it look sunny. Any cinematographer would like to shoot only during the perfect light of the day, like the way painters used to go out really early in the morning and capture all their effects. People asked why did Constable have better effects than Turner? And the answer always was, "Constable got up earlier in the morning." So the cinematographer has that problem as well, because once the light is no longer good, you have to create the light that is good.

So it sounds like the key to being a successful director of photography is getting up early in the morning.

That sounds good to me.

Tell me how style is served by technology.

All artists borrow from each other. What we have done is taken the best of everything that has been done in the past thousand years. Right now, cinematography has been able to benefit from the sculptors, painters and still photographers. We have been able to study their techniques, use their techniques and modify their techniques so, with the equipment we have today, we can mimic those styles in a much more efficient way. And we can create new styles. Every step is like a metamorphosis to the next step. The new equipment allows you to really execute what is in your mind.

So basically, now, if you can imagine it, you can shoot it?

If you can imagine it, you can shoot it, because there are tools and combinations of tools available or tools that you can request people build for you. Arriflex has a new digital camera; Panavision has a new digital camera, and those cameras do the same old classic things that all cameras do. We just have to make sure that they do it better. Right now, electronic cinematography has a way to go.

Stephen H. Burum was born in Visalia, California. He attended film school at the University of California, Los Angeles. His credits include Rumble Fish, Hoffa *and* The Untouchables.

Bill Butler, ASC

Who are you and what do you do?

My name is Bill Butler or at least that is what appears on the screen. When I first started out, my real first name was Wilmer, and I didn't think that sounded too cool so just told people my name was Bill. And I am a cinematographer.

How did you get started in cinematography?

I started out as an electrical engineer, and until I was about 40-years-old I was working in television, having helped build the first TV station in Chicago.

How did you get into Hollywood movies?

Bill Friedkin was working at the same TV station, and after being at WGN for 15 years he said, "Let's shoot some film." We thought that would be a cool idea. Neither one of us had shot a foot of film, so we did it.

Let's talk about tools and things you can dream up.

I think it is interesting that today, while we are doing this, there is an expo of all the new equipment they want to show off — the latest things of today. It is very exciting for someone like myself to simply walk through and, immediately, when you see a new piece of equipment, it inspires something new and different that you can do with film. For me, there is a great kick and joy in just using a new piece of equipment. That includes Kodak film, which I have used all through my career,

and for the reason that they do such a wonderful job of making it, and it performs so well that when you sit in the screening room and watch your dailies, you just wonder at their ability to capture something as close to reality as possible.

Let's talk about previsualization.

When they first send a script to you, the first thing you do is sit down and read it. What you see in that script has a lot to do with what you do if you eventually take the film. You do this whether you want to do the film or not and you, as a cinematographer, can't help but previsualize how you might shoot the scenes. You might not even know the actors who are going to be in it, but at the same moment, the setting, how you would approach it, all takes place in your head. I have found, over the years, that not everybody can do this. Many producers I have worked with have expressed jealousy that they can't do it, that they don't see things the same way someone like myself does. So I think everyone who gets into my end of the business, probably at some point, suffers from the same disease of daydreaming and visualizing fantasy scenes that simply do not exist.

Do you think directors are able to do that?

I think some directors have that same ability and some do not, and I have worked with both kinds. It is very satisfying working with a director who has what you feel is good taste or who appreciates a good piece of camera work when he sees it, or good composition or lighting. I can remember Mike Nichols sitting in the screening room when I was shooting with him once looking up at the screen and saying, "That is as good as it gets!" And that is a great compliment from someone of his stature, but when you work for someone like that, you do anything you can to get them what they want. You certainly try your best on everything, because you know it will be appreciated if you succeed, and you don't succeed every day.

Can you provide some specific examples about a picture and how a piece of equipment can help it?

I love to see new equipment. As I walk down the street, I am amazed at how they have taken the equipment and made it smaller and better. They have made it so vibrations won't affect the picture; even the round ball you'll see on helicopters these days has shrunk. You look around and you are thrilled that people are inventing new devices to shoot with. I've come up with many new devices along the way, because part of being a cinematographer is the ability to be inventive, because you have to invent how you are going to do something, maybe on the spot.

For example, in *Jaws*, to get the camera to where it would look just under the water to create that psychological tension, I had Panavision make me a water box, which I think they still rent, and it was a water box in which a dry camera would sit, so I wouldn't have to go to an underwater camera in order to just set the camera on top of the water. You could also go a bit under the water in the box and see the legs of the swimmers, so it turned out to be a very useful device. Another thing we did on *Jaws* that was a first was we got rid of the gimball — the big heavy gimball that weighs about 400 pounds and is hard to move around and set up. I had discovered, playing on the ocean and in fishing films, that you could stand on the deck and use your knees and take the roll out by just handholding, so about 90% of *Jaws* was shot handheld.

How did that handholding lend to the story?

The term "handheld" is misleading because it refers to a person on land. On the water, it is much smoother. You just look in the corners of the viewfinder and you see the horizon, and the person looking through the viewfinder can adjust and have a little bit of roll, or a lot, or have it very steady and let the boat move underneath him. That ability is very fast and puts you places where you couldn't get a gimball or another huge piece of equipment. You could be hanging on the gunwale and still get a decent shot.

You have said that when you are shooting you are a bit like a wild horse, in that you are not always in control and improvising a bit.

Sometimes shooting film is like trying to hold onto a wild horse. I can imagine what it was like the first time someone captured a wild horse, trying to control it. Film is something like that. You can read the script and make up your mind on what you think you are going to shoot, and when you have it all going for you and arrive on the scene, the day you hope to shoot a certain thing and find that maybe it is raining, or perhaps the director wants to try something new, or an actor doesn't show up so you have to shoot the whole scene without him over a stuntman's shoulder or something like that. Shooting film is not all that predictable. People like me do interviews and tell you how cool it is, but it is not that easy and cool. You have to be flexible, inventive and go with the flow in order to get your film made.

Did you experience that sort of thing while shooting the *Rocky* films?

I shot *Rocky II, III* and *IV* with Sylvestor Stallone directing, and I got along with him great. He is highly intelligent, unlike the character he plays on screen, and a wonderful person in my view. I was very successful in working with him, not just in getting a good image, but improving the way he wanted to shoot fight films. He got better and I got better, with both of us trying to improve the things we thought could be improved, including even the amount of time he had to spend in the ring fighting. Because the better I got capturing it with him — and I got up to eight cameras capturing him at once before I quit — then he would have to spend less time in the ring. The major fight scene went from taking a week to shoot to a single day by the last one.

Let's talk about style and lighting.

Whenever I am asked about what my style of lighting is, I have to stop and think about where it came from. Very early on, when I arrived on the West Coast, I was shooting features. I was never an assistant, operator or loader. I just arrived in Hollywood and said I was a DP. During that time, I can remember there was a great earthquake, back in the '70s. I had a couple

of young daughters at the time, and we were living in Westwood on the third floor of a big building and the bookcase came down in a room adjoining the one where my daughters were staying. It sounded like the roof had come down; I was sure we had had it. I went to my daughters' bedroom and opened the door, and during all this tension I can remember looking in there and seeing the most beautiful light coming in the window and affecting the look of the room. It had to be a split second. I got my daughters out of the building, and that was all that happened that day.

It wasn't until just a couple of days ago when I was working with some lighting that I remembered that moment, and I realized then that my style of lighting came from what I saw in that split second — that I like the way light looks when it comes from behind a scene. I think we generally call it back-lighting, and so it has affected everything I've done since. I have always copied that look unconsciously. It is amazing what things affect what you like in lighting, but it all comes down to your taste, talent and what you think is beautiful. It might be entirely different from what someone else thinks, but if you communicate what you think is beautiful and it appeals to a lot of people, your style becomes popular and you find that it is easy to get work. When I arrived in Hollywood, without really thinking about it, I was always in demand and it has been a long time. To have someone want what you can give, what you can do all your life, is very satisfying.

Where does the style come from?

In my case, I have to credit live television for much of how I see lighting, because I first practiced it in television. When I came into the motion picture business I was fighting a lot of old ideas about lighting and hard lighting, all of which I had to study and learn, because before my time, it was very impor-tant to make ladies' faces look beautiful. Some of the great stars controlled who shot their picture, and a lot more, so the light they would use would normally be very high over the camera and probably a hard light. It would come right in and wash away all the wrinkles and faults that might show up in a

lady's face, so a great many cameramen gained a reputation for their ability to make the ladies look glamorous.

Then glamour went out of style around the '70s, around the time I started shooting, and realism came in. It even affected a film like *Grease*. When they first wanted to do *Grease*, they hired a director named Alan Carr, who had seen my work and hired me, so I came back to town from shooting another movie in the desert and found out the director had quit because he didn't have enough rehearsal time. So all of a sudden, here is Alan Carr, who had not shot a picture as a producer at that time, so he sends me to New York to take a look at *Grease* on stage, and it immediately occurred to me that you do not want your movie to look like a stage play, because too many people have failed at that. Many people have tried to make a stage production into a movie and failed because it still looked like a stage production. So in deciding how to make the movie with Alan, I came up with a design for *Grease*, which is unusual for a DP to have this opportunity, but it was more of a necessity because we were not going to get the money to shoot the picture unless we came up with something that sounded intriguing to the man supplying the money.

We were in Philadelphia talking to Anna White to see if she would direct it, but she didn't want it and the man with the money was coming down on the train to Philadelphia, so I sat down with Alan Carr and shown him on a tablecloth what I thought the right way to make *Grease* was. It included just a few simple things, some of which were very important to the making of musicals and other pictures, and that was that you motivate the transition, because in singing and dancing and talking, you have so many different ways to communicate that if you don't lead them from one into the other as you go along, you will lose your audience. They may think you did a great dance number, but then they forgot what it was about, so to prevent that from happening, I drove them crazy through the making of *Grease* to make sure they remembered that rule, because many musicals were failing at the time. It must have worked because *Grease* turned out to be the biggest money-making musical of all time and, to my knowledge, still is.

When you show up on a location or set first thing in the morning, how do you decide on the lighting?

Usually when I show up on a set, I have already lit the set in my head. The usual routine is that I've been on the set with the lighting person maybe the day before or maybe three months before, because I like to pre-light and decide all of this ahead of time. It is my practice, unless there is something to prevent this, to have already lit it in my head and to pre-rig it ahead of time. This will not work with a director who changes his mind. If you have a director who comes in and reverses the set at the last minute, you will fail trying to do this.

What do you do then?

Punt, like in football. You start all over again, and it costs time and slows production. You simply do whatever you would have done if it were reversed in the first place.

Say you are coming to shoot an exterior with noonday sun. How would you handle it?

If the director wants to shoot in noonday sun, that is what we do. You know from experience what that means — how it is going to affect the look, the lighting and everything. If that is what you have to do to get the job done, you make every compensation you need to for that kind of light if you can't change it. If you can change it, especially around buildings in the background and you can fly a silk over the actors, you are doing yourself a great favor. If not, you rely on Kodak film, which is getting better all the time in its ability to capture highlights and dark areas in the same piece of film. Kodak film, at the moment, handles more information than any electronic device.

So is it fair to say that, nowadays, if you can imagine it, you can shoot it?

Quite honestly, they are going far beyond the imagination of one person. Films can do anything now. They just released a film where they wipe out the world — they flood it and freeze

it and most of this is done electronically. And someone had to visualize all of it because it does not and never did exist and hopefully never will.

Bill Butler was born in Cripple Creek, Colorado. His credits include Jaws, The Conversation *and* Grease.

Bobby Byrne, ASC

Who are you are what do you do?

I'm Bobby Byrne and I'm a DP, a cameraman.

How'd you become one?

I went through a long process of learning various types of camerawork. I did still camerawork, I worked in still labs, I shot architectural and fashion work and got in the I.A. shooting animation for Jack Buehre at Anicam in Hollywood.

How did you get your big break shooting movies?

After many years as an assistant and operator, my big break came when Burt Reynolds and Hal Needham offered me *Smokey and the Bandit*, my first film as a DP.

What's the funny anecdote about that?

The funny was all on the screen! Hal and Burt were patient with me and we had a lot of fun making the picture. The cast was great and the picture was a big success. It was the first *Smokey* and the only one I shot.

Talk to me about previsualization.

When I first get a script, I try to read it just for the words and the overall feeling of it, but I end up previsualizing no matter how hard I try not to. Preconceiving a look before scouting sets and locations is a trap that I often fall into. I've learned to adapt to what is in front of me and what is best for the storyline.

How do you approach lighting?

The approach for me is finding what the best way is to express the director's thoughts with light that serves the scene and story. Generally, a few words will give me enough clues. A set to me is like a small workshop. Technically, it's about selecting the right lighting units and setting them correctly, be it day, night, dawn or dusk.

What about locations?

Locations must be carefully planned. Shooting exterior day will bring the sun into play and make you figure out where the sun will be and at what time and what the best time is to shoot. If the sun is out, you can have backlight, cross light or awful flat light. Exterior nights can be very time-consuming unless you do your homework by previsiting a night set and doing a lighting plot. Planning ahead is a must.

Is there a relationship between technique and technology, the tools of the trade and the style of the picture?

We know that the style of a picture can vary greatly. Tools just remain tools!

What about lighting and style?

I think we get there by osmosis, the continual exposure to and the study of the photographic innovators of our time and great painters and photographers of the past. In preproduction, a stack of stills and some movie clips are sure to fire up some ideas. Light is a fascinating subject. I tried to paint for about six years, some good, most bad.

Can you give us some examples from your work?

The look of action and stunt work has changed quite a bit with the aid of CG manipulation in post. Depending on how big a stunt is and how many cameras are available, I think the most important thing is camera placement. Where you dare put the cameras is vital to the excitement of the shot.

Is there a difference between how you approach a comedy versus something serious and dramatic, in terms of lighting?

I try to light comedies with a more natural light —light that is not dramatic but has a natural everyday look. The dramatic look would have deeper blacks and darker shadows and maybe a little more contrast. There really are no hard and fast rules here. I once tried to light a comedy sequence a little down, a little darker, but after a rehearsal I found myself adding light and bringing it up a bit.

Why do you think that is? Is it a psychological thing?

Yes, I think it must be somewhat psychological. A really funny scene like a side-splitter played in half darkness somehow feels odd; it doesn't ring true. As I've said before, I generally will bring it up a little. Maybe I've seen too many movies from the '30s and '40s.

You mentioned you were a painter. What about color? Is there a psychology of color?

Yes, I think to some extent color can cause mood swings, although I'm not sure it affects everybody the same way. Overuse of color, to me, is like the overuse of camera movement. I think when the camera is constantly in motion, the audience becomes distracted from the scene on the screen.

That's interesting. Can you expand on that, because a lot of beginning directors and students seem to think of the camera as another character?

I'm not sure when or where that idea started. The camera as a character seems to make the camera intrude on the film. I've shot films for eight first-time directors and can attest to the pressure of time and budget on them and me. Generally, beginning directors are not sure of the mechanics of making a film, of knowing screen direction, how or where to make a good cut. Complete reverses or looks around a table of six or eight can be time-consuming and hard. To start on the right track, I always suggest simplicity.

It's very important that a first-timer make his or her day, that is, finish the day's work as dictated by the call sheet. By the third or fourth day of shooting, if we are behind, we can expect a friendly visit from the studio bosses who will urge us to pick it up. If that happens, I try to simplify a few of the complicated shots. I always stay with and defend the director and give him or her as much help as I can so we can finish our day's work.

So you're a diplomat as well.

I try to be. I try to please the director's vision without taking an extraordinary amount of time. Sometimes, it's tough.

Have you been in situations where the director leaves all the visuals entirely to you?

Totally. Some of them don't even look in the camera. If I urge them, they will ask the size or where the cut is. I'll ask, 'Head, waist or full?' And they'll say, 'Oh, whatever is fine.' Some directors will really leave a lot of things to you and concentrate on the actors, the lines, the script, which some directors see as more important. In these situations, the director knows you well enough to know what he's getting and will use his time with the actors. Sometimes that can be a very pleasant and time-saving way to work.

Bobby Byrne was born in Jamaica, New York. His credits include Blue Collar, Sixteen Candles *and* Bull Durham.

Russell Carpenter, ASC

What is your name and what do you do?

My name is Russell Carpenter and I'm a director of photography.

How did you become a director of photography?

I grew up in Southern California and was influenced by films both ridiculous and sublime. I loved monster movies, the cheesier the better, and that's how I'd spend my Saturday afternoons. When I was about 14, the mother of a friend of mine, Joan Miller, a high school teacher, was running a special program for people interested in the visual arts, and I got coaxed into going to this class. They showed some of the films of Ingmar Bergman — *Wild Strawberries* and *Persona* — and I didn't understand them at all, but the imagery positively took hold of me. I was fascinated by the poetry and power of those images though I still loved my stupid monster movies. Somehow I've been able to enjoy both worlds.

Did you go to film school?

I didn't go to film school. My family didn't have a lot of money and I was totally intimidated by film schools. USC and UCLA were out here in Southern California and they were worlds I couldn't afford to enter so I went south to San Diego State University to become a television director. After three months of doing that, I discovered that wasn't really for me. I became an English major and read books for four years. I had to make some money, so I took a job at the college-run public television

station KPBS and when an opening came up in the film department I auditioned for a job.

What happened next?

The people running the station called down a number of candidates and gave them a 100-foot roll of black-and-white film. The idea was to tell a story with that film as it came out of the camera without any editing. So my friends and I decided to tell a story about a man who takes a hair raising ride on a roller coaster. In order to tell the story as we wanted to without any post-editing, we had to ride the roller coaster about 40 times that day, because we would shoot two seconds of his point of view; then we would get off the roller coaster, shoot an establishing shot, and then we would do a close-up of him on the roller coaster, and then another point-of-view shot. It became a physically stressful and nerve-wracking experience, but it did get me the job. Paul Marshall at KPBS gave me my start and my training in films as well as Wayne Smith and I owe them a lot. I made every mistake that could be made and they were very patient with me. I made small films telling political, artistic and cultural stories in the film medium and I became definitely hooked.

How did you make the switch to motion pictures?

Growing up, I learned two things about myself that seem to be "genetic" in most of the filmmakers I've met. After four years of working for this public television station in San Diego, I realized that I couldn't go into the same place day after day. I just couldn't do it. I thought I'd crack up, so I quit my job, went to Hawaii and slept on a beaches for several months. One morning on the north shore of Kauai I woke up and there were these helicopters descending out of the sky and landing around me on the beach — it was like an invasion!. All of these people got out and they had these Panavision cases. This was back when they were making the Dino De Laurentiis remake of *King Kong* with Jessica Lange. Richard Kline was the Director of Photography. I took that as a sign that it was time to get back to the mainland so after a

few days I hitched a ride back on a helicopter to the trailhead eleven miles away.

I found work for another public television station in Orange County, KOCE, where I met a director, Thom Eberhardt, who was a little bit over making edifying and educational films and wanted to write and make a horror movie. He conned a furniture czar in Orange County into bankrolling this low-budget zombie film by saying that the banker's wife could be a prominent zombie in the movie. So we made the film and miraculously it got out in theaters for three weeks. That was the miracle for me — and of course I blew its significance way out of proportion.

I moved to the Hollywood area and did more documentaries. I proceeded to starve for two or three years and did a number of other things to try to support myself while that was happening. During that time, people I had worked with on the documentaries also began moving up to Los Angeles. They would bring me to interviews and, over a period of many years — which seemed like another lifetime — I went from doing zero-budget movies to no-budget movies to low-budget movies. I wasn't able to get into the union, but I did become became fairly well known in the nonunion world. By that time I had accumulated a body of work to show directors. Some of the films were total disasters otherwise but I always tried to salvage something from the project that looked good and I could show. As I moved along in my career, there were projects that just went nowhere, but I tried to take whatever I could from them, even if that meant getting the film transferred and altering it to the way I wanted it to look, so I had something to show a potential director.

One Hollywood "truism" that I fought internally at first but realized that I had to but came to accept and see it's value was this : "It's not what you know but who you know." I had to learn to see that as important as it is that our work be good and that we keep learning, it's just as important to keep fostering healthy working relationships. I had to see eventually that our business is one of relationships and "families." What we know is important, too, and we spend all of our off-time getting as good as we

can and doing what we do, but it's equally important to know the right people for each of us and the right chemistry. Everybody I met on the set widened my sphere of influence, so I tried to be aware of how I was perceived and how I treated the people I worked with, making sure those relationships were good ones. I find that, at the end of the day, there's the work that appears on the screen, but there's also that day-to-day experience of going to work and being with the people you really want to be with and care about. That's tremendously important.

Talk to me more about those relationships.

I came out of a documentary background where the cinematographer pretty much does everything himself — loading the camera, putting up lights and lugging everything around. I came into low-budget feature filmmaking wanting to do pretty much everything myself. It took me a while to realize that I was applying 200 pounds of force to go two feet. As I went on, I became aware that there were wonderful and talented individuals out there who were willing to support me in my efforts to make a film, allowing me to apply two pounds of pressure and watch the entire vehicle roll 200 feet. The proportion of effort to outcome completely switched.

So now what I do is basically find people — gaffers, first assistants, camera operators, key grips — whom I just love and admire. I work with these people, and beyond my conversations with them on the aesthetics of the film, the only time I really step in is when I see something happening that is not helping the look of the film. But if it is helping, I just watch this wonderful machine and let it happen. It's a great thing.

How did you get from making low-budget zombie movie to _Titanic_?

The path from the low-budget world to a movie like _Titanic_ is not as complex as one might think, particularly if we look at everything that we do as widening our sphere of influence. I did four episodes of _The Wonder Years_, got fired and decided that I was not cut out for television. I had no money at that time and went to work on a remake of _Pet Cemetery II_, which I desperately

did not want to do because I did not gravitate toward the material. Still, I met some really wonderful people on the film.

Eddie Furlong was in that movie, and his people knew Jim Cameron because Eddie had just done *Terminator 2*. They felt there was some chemistry that might work out really well between Jim and me. Also, one of my agents at that time knew people who worked with Jim Cameron and she sensed there might be a chemistry there. What happened was that Jim was doing a very low-budget nonunion feature called *The Crowded Room,* and he was looking for a nonunion cameraman. We met and I showed him some of the things I had done, and he seemed to respond to those things, but the project collapsed over ownership rights of the original material. At the time, I thought, "Well, that's the closest I'll ever get to the big budget world."

So I went to New Orleans to do John Woo's first film in the United States, *Hard Target,* and while I was there Stephanie Austin, Jim's producer, called me up and said that Jim was interested in talking to me once I got back; he had a project coming up and thought of me. So I immediately started reading every *Variety* I could get my hands on in New Orleans, and the only thing I found was that he was doing this huge budget picture called *True Lies* with Arnold Schwarzenegger. I couldn't get myself into the same box with that picture, so I just assumed there was some other project Jim might be producing that he wanted me to do.

When I got back to Los Angeles, I met Jim for lunch and *True Lies* came up, and I couldn't believe that he was even talking to me about it. Then halfway through the lunch, he starts using the word "we," as in, "we're going to do this, and we're going to do that." Fireworks were going off in my head, like I think I was just hired to do this picture. So I went off to do *True Lies,* which turned out to be one of the toughest experiences I've ever had. It was a baptism by fire, but still a great experience. That was my first big budget film seen by millions of people.

I did several projects between that and *Titanic,* which Jim had offered to other cinematographers. He actually started off with

another person, a hugely talented and gifted cinematographer, though the chemistry between them didn't work. So at what seemed like the 11th hour, after *Titanic* was already in production, but before the "period" work begun, I was brought on to do the picture. It was very interesting for me, because with so little prep on it, I had to get up to speed in a heartbeat. I asked Jim, "What do you want a picture like this to look like?" And he said, "This is a period picture; you know what they look like." So I ran off to the art department and to the visual effects department to look at all of the artist renderings they had. I also looked at the source materials that Jim had been working with and I also looked at pictures I liked that influenced me. That's how the look of that picture was determined.

That's a great segue into our theme — the look of a picture. How do you arrive at the look of a picture?

The look of a picture is given first and foremost by the material and then by the director's approach to the material. After that, there are discussions with the director, the production manager and sometimes the visual effects supervisor. I'm always researching visuals, sometimes music, but usually visuals from all the arts, and bringing them together into what I call my "brain book," which, before we begin shooting, sometimes becomes one or two volumes of photographs, drawings, diagrams and thoughts that I have about the look of a picture. The idea is that usually by the sixth week of production, everybody's exhausted and somewhat "brain-dead", so having done that work during preproduction in a coherent state, I have a bottom line of quality, a safety net that I can descend to by looking in that book.

Everything else is icing on the cake, so I'm a firm believer in preproduction. The style is so much determined by the cinematographer's life experiences. My style has changed. Lately, I've been gravitating from one style of film to another. I used to be associated with big-budget action pictures, though I find myself gravitating toward smaller pictures nowadays where I get to light women. That's a whole new world for me. I did a picture with Jennifer Lopez and Jane Fonda called *Monster-in-Law*, and before that I did a picture with Susan Sarandon called *Noel*. I

love the type of picture where I get to work with the Jane Fondas and Susan Sarandons of the world. I think that's how I'd like to proceed in the future.

I'm basically a dreamer and I love so much about the dreams spun on celluloid of old-time Hollywood. I love the idea that when somebody goes into a theater, they lose themselves in a world where people do look better than we usually do 99% of the time. There's a reason people glamorize stars. It's part of the cinematographer's work to help create an icon and I enjoy doing that. And I know that the stars who I work with enjoy knowing that their cinematographer who is very concerned with how they look.

How do you address the lighting of these female characters?

The human face is an infinitely changing landscape. The first thing I do, as a cinematographer, is pay attention. I pay attention to what's happening with the artist, actor, on that day. How a person looks on Tuesday could be very different from how a person looks on Thursday. It's an amazing thing that I can't account for. So I need to be pretty vigilant, and I usually sit very close to the camera and look at what's going on.

The thing about lighting, especially for women, is driven off the shape of the face — whether the person has an angular or round face. I find that sometimes film students or beginning cinematographers will think, "This woman is so beautiful; I'll just stick up a light and away we go." That's not how it works. Every face has its plusses and minuses. A beautiful actress with a bit of a fuller face wouldn't need the same soft light as someone like Cameron Diaz, who has a beautiful angular face. So everything starts with the face. Usually, I start with a double-diffused source, sometimes a triple-diffused source.

A rule of thumb when I'm lighting several actresses at once in a large space I'll start with a large, soft but somewhat directional source from off to the side of the camera which creates dimension and shape but is soft enough to be very flattering. Technically this is achieved by stacking vertically two 12'-by-12'

layers of diffusing material in large frames. This material is much like frosted shower curtain but more durable. In the business of making films these are called "Full Gridcloth" and "Half Gridcloth." I then shoot a fairly large light through the material with the light placed far enough away to fill the frame. What I'm describing is a basic start. Usually the light is cut and modified to shape it in some way.

For closer work, I might use one or two smaller frames of 4' by 4' size much closer to the actress or actor, just out of the view of the camera and placed near it and just off to the side of the lens. Even though I'm working with softer sources, it's still important to to be careful about the direction from where that light is coming. Even though it may be a large soft source, the difference between a foot or two toward or away from the camera can make all of the difference. I really look at the scene and how it's being rehearsed.

Sometimes, the light is great for an actress when she's looking one way, but when we come around or she turns the other way, we run into trouble. Very often, after I have one source placed, I might use an additional light like a four-foot Kino Flo or an eight-foot single bar that rolls around over the camera to help the actress out as she turns away from that large source, and then I might take a Xenon flashlight, that I usually color correct back to Tungsten if I'm using Tungsten. It has a tube on it about the size of a large pancake. Somewhere in between its path I place two layers of fairly soft diffusion. What that allows me to do is be just off camera, out of the field of view, where I can put a source of very soft, but very controlled helper or modifier light into the actress' eyes to remove the wrinkle or line she might have there. That can go a million miles toward solving the problem.

Would you use the diffusion on the lens?

I don't believe in covering up an actress' flaws with lots of diffusion. I try to do it with the lighting and just a bit of diffusion. The tools that are being developed in the world of digital-intermediate technology allow me to go in on a case-by-case basis and modify that little thing that went

wrong. Now I can go through and use a slight blurring effect, like a Gaussian blur in Photoshop that lets me take away something that might be distressing.

Can you do that selectively?

I can do that selectively, and I can track an actress as she moves. I can bring the effect in and bring it out where it's invisible. Every digital intermediate house in Los Angeles and New York probably has its own proprietary way to handle these things, but Digital Intermediate is going to be a tool that almost everyone uses.

At a certain point in your career, did the lighting become intuitive?

After a certain point, I found myself having a sense of knowing what would work. I sometimes have that experience where on Monday, Wednesday and Friday, I feel like a total genius with the world in my control, and then there's a moment on Tuesday where I look through the camera with everything ready, I look at the actress and go, "That's not working." I have little euphemisms with my gaffers and crew that make it sound like we're just going to adjust a little light here or there, but what it really means is, "Code red, code red; we're going to do a stealth relight and not make anybody crazy about what we're doing." But again, that's part of being an assured presence on the set, because everyone is looking to the cinematographer, because he or she, along with the first AD, is really running the set and creating the environment.

How do you deal with second units to maintain consistency?

Working with the second unit is very important. As a first unit cinematographer, I can't just bless the second unit and assume it's going to run off and get brilliant stuff, because although it might run off and get brilliant stuff that may not match what the first unit has been doing. The second unit needs to hook into the vision of the film, and as a first unit cinematographer, I have to make sure that I have one movie and not two movies.

We talked about the relationship between the cine-matographer and his crew. What about the relation-ship between cinematographer and actors?

One of the most important things that cinematographers have to learn, even brilliant cinematographers, is that they live in a world filled with people with different agendas. The cinematographer not only has to be a scientist and an artist, but also a manager, a politician and a people person. The greatest gift a cinematographer can give actor is to create a comfortable arena for the actor to be stellar, to do his best work. And when actors feel like they're cared for by the cinematographer, their work is indeed going to be better. They're going to take bigger risks than they might have otherwise.

So my crew — especially my camera operator and myself — create a relationship with the people we work with, so they know they can trust us. We will tell them if there's something that is not working out, and we try to work out a way to make the photography better and their appearance better. It is so important that cinematographers don't neglect that relation-ship with the actors. When I first started out, because I was so gung-ho about what I was doing, actors just seemed to me props that I moved around the set, and now my attitude has changed completely. I want to create this space where I can sit back and marvel at their performance, because that's the kind of movie I want to see.

Russell Carpenter, ASC was born in Van Nuys, CA. His credits include Titanic, The Indian in the Cupboard *and* True Lies.

Peter Collister, ASC

Who are you and what do you do?

I am Peter Collister and I am a director of photography.

How did you become a director of photography?

I grew up in Ohio and had a very good friend named Dwight Little whom I went to high school with. He started making Super 8mm movies and asked me to help him. We both came out to the University of Southern California film school together, and he went on to become a director, doing *Murder at 1600*, *Free Willy* and *Anaconda 2*.

Take us through the circuitous route of your career.

I met a director named Randal Kleiser and started working for him as a production assistant on *Grease*, which was shot at Paramount. He let me do some camera work on an after-school special and then I did some second unit on *The Blue Lagoon*, which was shot in Fiji with Néstor Almendros [ASC] as the DP, which was a great treat. Then I went backwards a bit and went to Paris to do some assisting on a number of commercials with Néstor. After that, I did second unit for a number of years and was not in the union, but since I had a camera package, I could just go out and shoot anything the studio asked me to.

Eventually, I did a lot of low-budget movies that I probably shouldn't mention, such as *Halloween 4*, with Dwight Little again, *Avenging Angel* and *Can't Buy Me Love*. That led to a film at Universal that was called *Problem Child*, which was a comedy

I did in Texas. That was my first big studio picture. From there, I continued to do some second unit and commercials with Michael Bay and hooked up with a commercial director friend named Antoine Fuqua, and we did a film at Columbia called *The Replacement Killers*. Recently, for better or worse, I have been doing a lot of romantic comedies with people like Adam Sandler. I did two romantic comedies at DreamWorks, which were *Win a Date with Tad Hamilton* and *Surviving Christmas* with Ben Affleck.

Where does style come from?

Style starts with the script and leads directly to the director and production designer. I grew up watching a lot of movies, went to film school and studied film history, so I like to reference movies. I did a film called *Higher Learning* with John Singleton before DVDs came out; this was during the laser-disc era, and I remember both John and I had a laser disc player, and we were on the phone talking about what we were watching, and we had the ability to reference individual frames. It is nice to sit down with the director and use common references to make style decisions. That way, I can quickly grasp what the director wants and then I can bring what I have to him.

What is the relationship between technique and technology?

The advancing technology of the tools we use is making story-telling easier and faster for DPs, production designers and everyone else involved in the creative process. In film school, I moderated a panel of well-known DPs, some from the Technicolor era, and when I asked how many foot-candles were needed to light an interior, they said 3,200, which is a lot of foot-candles.

William Fraker [ASC] had just done *Looking for Mr. Goodbar*, and I asked what his key was. He told me it was four foot-candles, and some of the older DPs nearly had coronaries because they did not realize this advancement had taken place. Kino Flo lights are another example. When Frieder Hocheim was a gaffer on *Earth Girls Are Easy*, he had a prototype fluorescent light that

he was using. If you look at the film *Seven*, the whole film was lit with Kino Flo lights, which allowed us to hide lights and to work with textures and at levels we never thought of. Also, as Kodak comes out with better stocks, new lighting will come out to better light them. Nowadays, we can worry less about having the right tool and more about what we can do with it.

Can cinematographers be categorized by the material they have done?

Getting pigeonholed as a DP happens. I started out doing low-budget action movies and then went on to do mainstream action movies. Lately, however, I have been doing a lot of comedies and romantic comedies. I think some of my best work is my action work, like *The Replacement Killers*, but now that I have been doing romantic comedies, it seems like that is the sort of script I'm being asked to do more and more.

I love working and I am passionate about everything I do and I can do a number of different types of films. Cinematography is more about the script, the telling of the story and what we can do with the light and camera. I don't think anyone is less qualified at that because they have done more of a certain type of movie. I understand the psychology behind it, but I would ultimately like to do a broad body of work and let that speak for itself.

Look at Dean Semler [ASC] as well as Oliver Wood. Dean has done amazing work on Westerns and action films as well as comedies for Adam Sandler. Oliver has shot action on John Woo films and the *Bourne* films, but has also photographed for Betty Thomas comedies. As DPs, we are entrusted to help the director interpret the story visually, whether that story is a thriller, a comedy or a romance.

In talking about style and its effect on film, sometimes there is this concept that an action movie should look a certain way and a comedy should look another way and so on. DPs can get pigeonholed into a certain genre based on their previous material. I hope to educate producers, directors and writers that they can mix these things and that DPs who are good at doing a

romantic comedy can also do a good action film.

When I met Adam Sandler and his production team — who made millions of dollars on their early low-budget films, which were full of sweaty faces and were overlit — they thought that was the key to making $1 billion at the box office, which I told them was not true. I showed them some other films that were not like that. For example, *Amélie* is a film in the romantic comedy vein, and it's a beautiful film with lots of beautiful color, camera movement and texture, yet it remains true to and contributes to the telling of the story, which is something I try to show people the success in doing.

Peter Collister, ASC, was born in Cleveland, Ohio. He attended film school at the University of Southern California. His credits include The Replacement Killers, The Amityville Horror *and* Mr. Deeds.

Ericson Core

Who are you and what do you do?

I am Ericson Core and I am a cinematographer.

How did you become a cinematographer?

I started out just wanting to be an artist of some type, though I wasn't really sure what type. My father was a painter and sculptor, so if I became a lawyer or doctor I probably would have been disowned. I remember going out and seeing Akira Kurosawa's film *Ran*, and I was really blown away. I thought if that was something someone could do, I wanted to do it. I felt that film was closer to dreams than the rest of the artwork I was doing.

Where did you go to school?

I went to film school at the University of Southern California and I also attended the Art Center College of Design. They had to pry me out of school with a crow bar. I really love school.

How long did you go to school?

All the way through to my master's degree, so a number of years. One of the things I love about being a cinematographer is that I am always doing my homework, and there is always an endless amount to discover and then apply to my work.

How did you get into the business?

Like most of my comrades in the early '90s, I fell into it by making music videos. In some ways, music videos were like the

French New Wave of our time, as so many were being made. It was a great training ground because, for the most part, the idea in music videos was to always do something new and different. That created quite a challenge because there was a lot of material being produced. Everything was very style-based, and we were at the forefront of it.

It was a great place to start because I had been studying a lot of different techniques and was always trying to look for the new thing, so it gave me a broad quiver of things with which to experiment. Another great thing about music videos was that, because they were so short, I was able to make some brilliant mistakes because that is how I typically achieved great work. Ultimately, I was able to take chances without affecting an entire film. I definitely got to push the limit.

How did you get into features?

I made the transition to features on a film called *187*, which was a movie Kevin Reynolds directed. He had just come off *Waterworld*, which was the most expensive movie at that time, and he wanted to do anything but have the typical filmmaking experience. Coming from music videos, I was someone outside the box of Hollywood, which is what he was looking for. I guess he pulled me in because I didn't know features and didn't know what I was getting into, and for the first and only time in my career, I got to work with complete ignorant bliss. The very first feature set I stepped foot on, I was the cinematographer, which I do not recommend to anyone. However, it was a great experience, because I had the safety net of a very experienced director and production company supporting me, and they gave me a very long leash. It is still some of the best work I have done, because I was working purely from instinct.

Where does your inspiration for style come from?

Style is such an extraordinary part of our job as cinematographers. Style in cinematography is the way we express and reveal story and character in a very visceral way. It is not the intellectual side of the dialogue. It is not plot-driven, and it is not about the landscapes. It is about how we feel watching the movie. The

visual style can affect us emotionally, and it is a language of its own. I am very much in favor of looking at the characters and seeing what I can convey about them viscerally to help the director tell the story and reveal what lies beneath the intellectual concepts.

In some instances, there have been directors I worked with who wanted something in particular. For instance, Brian Helgeland, whom I worked with on *Payback*, really wanted to make that movie a black-and-white, 16mm, rough, documentary-style piece. Then Mel Gibson got involved and one thing led to another with the studio until it had to be a 35mm color feature.

Brian asked me how we could make it look black-and-white, and that was a challenge for me. I tested every bit of film out there and found that, ultimately, the resilience of film is extraordinary. I can tear it, stomp it, overexpose it and do anything I want to it and still get an incredible exposure. It is very hard to rip an element from it. One of the key things about style is to say something very specifically, and film gives us such a wide net to catch everything in. Sometimes, I feel that the role of the cinematographer is to get as narrow a slice of that pie as possible, so we can have a very clear point of view of what the story is visually.

For *Payback*, after testing the film to get a black-and-white quality and finding that the film was too resilient, I had to do it in the lab during processing. Deluxe was very helpful, and we ended up doing a full bleach-bypass on that movie, which was the only way we could reduce the color to the level we wanted. As a result, we picked up grain and contrast and that spoke to the language of the film, which was great, as it created the look we wanted. We weren't after something pristine for that movie; we were after something with grit and limited color content and bleach-bypass helped us.

What about digital intermediate?

Digital intermediates are pretty amazing. When *Payback* was shot, it was not yet a viable option. But now, they are pretty

much standard and everyone knows about them. It is not a risky thing as it once was, and most studios plan on it.

I did my first digital intermediate on *Daredevil*, which we had planned to bleach-bypass. Like I said, I had experience doing that on *Payback* as well as *The Fast and the Furious*. I did the dailies with bleach-bypass for *Daredevil*. At the time, the studio was nervous about doing digital intermediate, because it was a fairly new process and they wanted us to do it traditionally. As we got into post, however, digital intermediate had become more popular, so we went to EFilm to do the digital intermediate. But because the studio was still unsure of how the digital intermediate would turn out, they asked us to finish on film, though we also did a print in the digital intermediate.

It was nice to see a direct comparison between the two. What was extraordinary was that the Deluxe print looked as good if not better than the digital intermediate from EFilm, although EFilm did an excellent job as well. The only thing that made the difference was the amount of CG work. The digital intermediate helped balance that slightly better than the Deluxe print. The quality of film and what we can do with it is extraordinary to this day. I have such a respect for the color-timers at Deluxe.

Let's talk about technology and technique. How do the tools of our trade affect our style?

Technology is extraordinary if we use it wisely. It is important to break down all the different techniques available to us and pick only the ones we need for the film and no more. When the technique overtakes the story, we are doing the wrong thing. We are in service to the story and no technique should become a bolder statement than the story.

What are some examples of how you might use the tools?

There is a multitude of things available to us, in terms of lighting, camera and film stocks. I am a big believer of doing things in-camera as much as possible, because it affects the process. There is always the ability to do more work in postproduction — and that's becoming more the case — but I find that when I

am very involved with the process and talking to the director about the story and characters, I get an instinctual and intellectual feeling of what needs to happen and how I might help the arc of the story at any particular point. If those design elements are put into the camera, the way the story should work visually will be more apparent to the editor and director.

What advice would you give to film students?

To this day, I still feel like a student on the set, and I hope students never forget that they are always students as well and there is always the opportunity to learn. If I were painting, for instance, there is a multitude of colors, paints, brushes and types of strokes I could use. I need to know what brush I am using and for what purpose. Similarly, in a film, it is great to plot out and understand what the tools can say emotionally and how they can help reveal the story.

In painting, there is a direct connection between you and the canvas, whereas in film, you are working with a crew. How does that impact the situation?

Still photography, painting and sculpting are incredible art forms, but they are also very isolated media. Filmmaking is a communal art form; it is a village of people collaborating toward a common goal. That's why it is always so extraordinary when a film turns out amazing, because there are so many different visions. But the one singularity that comes across in great movies is the director's vision. For cinematographers, of course, if they were cast correctly for the movie, it is all about their instincts. We should never forget our instincts.

Can you expand on 'casting of cinematographers'?

Just as a director needs to cast actors or any member of a crew, it is very important that he or she casts the proper cinematographer as well, in terms of that cinematographer's style and sense of the story. The best part of being a cinematographer is being a filmmaking partner with the director and putting on the director's goggles to see the world as he or she would to help convey that vision. That doesn't mean I take away my own vision, but

I expand it based on what that director wants and needs.

What do you think is the future of cinematography?

Cinematography has a brilliant future. We are always going to need to tell stories because we are a very visual culture. I feel that one of mankind's greatest gifts is — not the opposable thumb — but the ability to interpret and share our dreams through story. Cinematographers are the ones responsible for telling those stories in ways that not only affect us visually, but emotionally as well.

Ericson Core was born in California. He attended film school at the University of Southern California and Art Center College of Design. His credits include 187, Payback *and* The Fast and the Furious.

Dean Cundey, ASC

Who are you and what do you do?

I am Dean Cundey and I am a director of photography.

How did you become one?

My route to cinematography was fairly direct. I knew I wanted to be in film even before high school. I was always fascinated with the world that film created and the places that it could take the audience. My first real thought was to become a production designer, because at that early age I was fascinated by the world around the actors and how it was created. So in college, I started to study architecture in addition to my film studies, because I had been told by the art directors' union that it would be wise if I had a degree in architecture.

When I was at the University of California, Los Angeles' film school, however, I took a class taught by James Wong Howe [ASC] of which my colleague Steve Burum [ASC] was a part. Howe's way of teaching was fascinating. We had a very small set and a few lights, and he would create the look of the set not with the walls, but very often with just the lighting. I realized then that that was the dynamic storytelling way with film — camera, lighting, lens choice and camera movement. Because I was visually oriented, I knew that was where I wanted to focus. At that point, I made the decision to switch from production design to cinematography. The production design and graphic arts classes I had been taking up to that point have, maybe not surprisingly, taught me valuable aspects of what cinematogra-

phers do, because we create images that are not just stills or graphics because they move, but we also bring out the architecture of a set with lighting and textures. So I think all the classes I took were valuable and, as a matter of fact, any class I have ever taken, whether it is history or literature, has helped in my work with film. My science, surveying and drafting studies have also been very useful for me, because film encompasses so many aspects and disciplines of other arts.

How does your architectural background help influence the look of a picture?

My architectural background has been valuable because, first of all, I can relate to the production designer and the choices he or she makes. I am familiar with their language, and our sensibilities are heightened by the architectural language. This has enabled me to really work with the production designer as a collaborator and to provide him or her with insights that are valuable to me — such as if we plan to have windows in the shot or if we'll need an archway or header to hide the lighting equipment in the background. I can communicate those architectural production design needs, which can then help me realize the director's vision for the film.

What's the relationship between technology and technique?

Cinematography is a very technique-heavy art form. More than any other discipline in filmmaking, cinematographers have to be aware of the technology, equipment and science and be able to apply it to the art. We have always responded to technology, and that technology has affected our technique. There are the obvious advances like the introduction of color or sound but, more recently, technology allows us to use moving cameras, smaller cameras and lighting equipment that allow us to put lights in places we couldn't before because they were too big. And, of course, the computer advances with compositing and digital intermediate, which are becoming our tools after the fact. The things we do when we are shooting are affected by the equipment. Now we have even more at our disposal, which,

gradually, as technology develops and becomes more budget-friendly and more standard practice, we will be able to use it as another way to improve the image, or even achieve an image that we only had in our imaginations.

How about some examples?

An example of technology affecting style would be *Apollo 13*. For that film, we were interested in creating a look of the space program that most people were familiar with. There were certain aspects of it that we had seen from television and on the rather poor video of the time. As director Ron Howard and I analyzed it, we realized that a lot of the images involved this moving sensation of a camera that was in the capsule at the time, which was a weightless and relatively small camera. So we elected to always have the camera loose and floating. We developed a technique that suspended the camera from a long cable to the permanents overhead and to a counterbalance off to the side. For the operator, the camera was, in fact, weightless. He was always able to apply just a slight movement to it, and it created something different than the panning and tilting movements always seen in commercials. We also elected to never be outside the fourth wall, because we had always been inside the capsule with the astronauts. We built the set so that the walls could come out, and the lens was always inside, which meant using wider lenses.

Also, we used spherical lenses, which allowed us to focus closer and had a better depth of field than an anamorphic lens. We also took advantage of the periscope cameras that were available, so we were able to put the camera at the instrument panel. Then we used fiber optics to put very small lighting sources in places like the control panel. We would sometimes remove a gauge from the panel and create little spots for these light sources that even had little barn doors to control the light. We also used available or apparent light sources as much as possible. For instance, I added additional fluorescent lights to the capsule. All of the technology that was available to us was applied to create the illusion the audience sees of the reality of guys in a space capsule.

What is style to you?

Style is something that is generally dictated by the film and I always search for one that is appropriate to the story. Sometimes I have to search on my own and sometimes the director is a big part of it. For example, on *Hook* — which was the first film on which I worked with Steven Spielberg directing — the original concept was to shoot much of Neverland on an actual island in the Caribbean. But at some point, Steven decided that he didn't want too much reality because it was obviously a fantasy Peter Pan story. He wanted to have reality but with a certain theatricality to it, so he elected to shoot everything on soundstages. So we built big exteriors on a soundstage, which are sometimes the hardest to build for creating a sense of reality. What happens is that the sun, which is normally a single source of light, becomes many sources for us on a set, so trying to create that sense of reality is often a tricky thing.

Steven and I sat and looked at films, and there were certain ones that Steven felt had really achieved that sense of reality. One of them, *Greystoke: The Legend of Tarzan, Lord of the Apes*, had been shot on stages for the jungles. When we looked at it, there were attributes that made it look real, and we discussed what it was we responded to in it. A lot of it was the fact that there was a very harsh, sunlight feel coming from the leaves.

As cinematographers, we try to balance the light to fall within the latitude of the film, and I think that has been done almost too well in the past. Very often, the artificial look comes from having too much control. We were able to take cameras outside, which is why there was more location work done in the '60s, and the mistakes that we couldn't overcome then, such as the huge contrast of sunlight and shadow, became things that the audience grew used to seeing.

So on *Hook*, we deliberately avoided making things perfect by creating a lot more sunlight coming through a window, bouncing around the small set to create an illusion that gave a feeling of reality to the fantasy. That basically became our look for the film. We tried to create an ambience of light, which was the soft

light that came from the sky and illuminated evenly on the exteriors. Then we used overly sharp or overexposed backlight and sometimes sidelight, which was obviously not real looking. Also, we added a diffusion filter to smear some of the highlights and make viewers more aware of the sunlight. There are a lot of shots in that film where I think we successfully created that feeling. I know it was slightly artificial, but it accomplished what we wanted to do.

Where do you think cinematography is headed?

Another technology that has changed substantially and affected our work is visual effects and digital and composite work. I remember doing bluescreen early on, which involved a very meticulous and rigid kind of job. The screens had to be lit very evenly, and we couldn't include any blue color in the lighting. We also had to artificially put yellow light on the actors so it could be modified later to white light, and the remaining light would be blue, leaving us with a bluish shadow. We were always warned about that, and it was another case of technology dictating what we, as cinematographers, could do.

That has changed substantially. Nowadays, the computer processing is so much more forgiving that we typically run a piece of bluescreen into a scene to separate the actor so that we can modify the background. 'Motion control' used to be a terrible thing to say because it implied a big truck, lots of equipment, a bunch of guys and a lot of time. But to composite moving shots together now, we don't need the motion control nearly as much as before. The computer can take any kind of moving shot — whether it is tracking, dolly or panning — and can use the information it extracts to make the composite.

We are getting more and more freedom, as cinematographers, to do what we need to do for the storytelling to work and to still have compositing that helps us out — to the extent that we can replace entire skies if we want. If we can convince production to let us, we can shoot in a white sky and know that we can enhance it later. The digital intermediate process, along with Telecine and the abilities we now have to manipulate our

images, which were stuck in the video world at one point, are translating into film. So we are going to be able to do a great deal more. As the technology changes and as computers become friendlier, it will give production designers, directors and cinematographers an additional tool to help with our storytelling.

What is the difference in style between a commercial and a feature?

Commercials have always been the area that allows us to experiment. This is not true if you have a very straightforward product or client who wants a straightforward look. But more and more, to grab the attention of the audience, visuals in commercials are becoming pretty amazing and extreme. It's always classically been the area where cinematographers and directors are able to experiment, and it was certainly the area where I began learning how to modify images electronically. That's, unfortunately, bled into feature filmmaking, where people are seeing feature films told with some visual trick that was developed in a commercial. Sometimes it is effective and other times it is not. But commercials have definitely had an effect on the style of feature films.

Dean Cundey, ASC, was born in Altadena, California. He attended film school at the University of California, Los Angeles (UCLA). His credits include Who Framed Roger Rabbit, *the* Back to the Future trilogy *and* Apollo 13.

Caleb Deschanel, ASC

Who are you and what do you do?

Caleb Deschanel. I am a director of photography.

And how did you become one?

It's a long story. I was supposed to be a doctor. I went to Johns Hopkins as an undergraduate to become a physician and got interested in photography. In my junior year, I had a couple of friends who were a year ahead and went off to film school. They were Matthew Robbins and Walter Murch. Then when I was trying to decide what I wanted to do, I decided to go to film school, even though, in those days, there was no hope of ever becoming anyone in the movie business unless a person was well connected. But I came out to California and followed my friends.

Because I had a background in photography, Matthew asked me to film some of the movies he was working on, and he introduced me to people whose films I also shot. At the end of my first year in Los Angeles, I was at the University of Southern California and had filmed most of the movies that were shown in their yearly showcase. Then I started working for Britannica Films and educational film houses. Through that, I met people like Carroll Ballard and Ron Dexter [ASC] and started doing commercials. That's how it started.

Let's talk about style. Why do your pictures look the way they do? Where do your ideas come from?

I like to immerse myself in the story. If I get a script I really like,

I will read it at least 10 times. There's a really wonderful film about director Jean Renoir in the UCLA archives called *The Italian Method*. The film is more about acting, but he works by having the actors perform without putting any emotion into the characters initially. For a long time, he resists letting them put any emotion into it until they understand the script really well. I find that if I jump to conclusions and start making decisions visually about a story before I've really immersed myself in it, I'll tend to make clichéd, obvious decisions. And lots of times, the right emotions might be contrary.

For instance, there might be someone who has gone through some great grief but doesn't necessarily show grief right away. Instead, that person might laugh or have some other emotion come out, because that grief is deeper and more profound than what we might initially come up with. I find that to be true about visualizing a film. It's important for me to not only immerse myself in the story, but really go deep and let it become part of my subconscious and psyche before I develop an idea for how to visually represent the story.

Once I am familiar with it and know all the characters and situations, I start looking at paintings and photographs or, if it's a period film, I look at paintings or photographs that were done in that particular period of time. I let that be the jumping-off point. Then I talk it over with the director, though I avoid talking with the director until I have that deep understanding of the story and have done my research, because I don't want to be swayed too much one way or the other. I end up reaching a certain meeting of the minds with the director. I've been fortunate in that most of the directors I've worked with I've gotten along with really well. The greatest collaboration that probably exists in any art form is that relationship between director and cinematographer.

Can you expand on that relationship? Where does the visual idea come from?

It really depends. There are some directors who are very visually oriented and others who really don't think about the visuals

and are more concerned with performance and the elements they need to tell the story. I've worked with both types in varying degrees. For example, Carroll Ballard is very visually oriented, so with Carroll, I can use a shorthand to develop our visualized idea for the film — pointing and grunting seem to work best with us. Other directors sometimes want more of an explanation of why something should be done a certain way. Fortunately, I've worked mostly with the directors who appreciate that I have an instinct for something that is more instinctual than intellectual, in terms of why things should be done one way or another.

Most of your films have a very striking visual style. Where does that come from?

I like to do plenty of research to get a clear idea of what I'll be doing. Yet I also like to respond to what happens at the moment. An actor might come in with a performance that is overpowering and makes me realize that what I imagined for that actor no longer works, because he gets lost in the setting, for example, when I should really be going in for the close-up because the performance is so extraordinary. There are so many factors and events that can happen along the way that affect choices.

To some extent, I have to learn everything I can and be well rehearsed, but when it comes down to the main event, it becomes like jazz where I need to respond to the ebb and flow of everything that evolves on the set throughout the day. It's just like storyboarding, which is something I like to do but not necessarily follow religiously, more subconsciously, so that I always know what I have in case I need to fall back on it because better things didn't show up during the day. That's the important thing. I stay prepared, but don't ignore the fact that things can actually become better than what I imagined them to be.

Are you referring to the 'happy accidents' from the location or the weather?

Absolutely. All cinematographers take the credit for those wonderful happy accidents that come along the way. I'm

certainly one of them. Sometimes the clouds will come in and create this amazing light for a brief period of time, or the clouds will suddenly blow over. What I always try to do with the photography is be in sync with the emotional thrust of the story — the images should complement or amplify those emotions. Just as music can be scary or melancholy or exciting, the visual style of a movie can be all those things as well.

Were you the one who said that you plan 100% of the time but are lucky if the planning becomes reality even half of the time?

I might have said it, though I don't remember saying that. I certainly want to be prepared for everything. There are a lot of cinematographers who will plan something out and stick to it rigidly. That's important to some extent, because in the heat of filming, we can lose track and get swayed into doing something differently that will affect a film's continuity within its overall visual style. That's why preparation is important.

The other reason I do a lot of research and collect paintings and photographs is because those images become a really good way to communicate with the director and production designer. On *The Passion*, I used lots of paintings as references. Of course, since we were filming in Rome, we had access to the real paintings so we didn't just use photographs of the paintings, which tend not to be representational of the paintings themselves. Within a 15-minute walk of where I was living in Rome for the shoot, there must have been about 17 Caravaggios, which were really good references for what we were doing.

What about *The Black Stallion*? What inspired its style?

The Black Stallion's style really came out of educational documentary films that the director, Carroll Ballard, and I worked on together in the past. Carroll's directing style is to set up a scene as if it's really happening, and then I come in to photograph it as though I were making a documentary of that scene, which brings out an interesting reality. We repeat that technique over and over again for the whole film. If you look at his films, they all have that style. Sometimes the visuals seem controlled, but

that's because Carroll has set up the situations, and since we both came out of an educational films background, we are able to think on our feet.

There were plenty of times in *The Black Stallion* when an actor would hit his mark and say his lines and then move onto the next scene. One of the best examples is when the boy was feeding the horse on the beach. That shot just happened. We kept hoping that the horse and the boy wouldn't go out of frame, and it turned into one of those happy accidents that was perfect. I say it was an accident, though outside the frame was the horse trainer signaling the horse to back up and come forward and do all these things that the horse did in that particular scene.

Carroll and I were really good at responding to all of those moments that he created. He would create whole scenes to shoot, not just a scene where he would say, 'We need this close-up and then we need that close-up.' It would be the entire scene which I'd watch and figure out where I should be for the shot. It would ebb and flow. And since we were dealing with animals and children, we never got the same thing twice, so we had to be able to respond to changes and capture everything on film. That's what gave it that reality.

How did you have the time to light it so meticulously, or was that a happy accident, too?

The shots of the island were pretty much not lit at all — we were outside. The lighting came from looking up at the clouds and saying, 'Let's roll now.' In terms of the shipwreck and the scenes we did for that, we used Cinecittà and their tank. The shipwreck and the fire lighting were determined by the reality of firelight and the drama of what was going on onboard the ship. But again, we shot it as though we were doing a documentary. A lot of it was planned, in terms of the beautiful compositions, which were all designed, but things evolved. Carroll and I have to take credit for being in the right place at the right time. We knew from watching the situation where we should place the camera to get the best view.

Let's get into technology, technique and the tools of the trade.

My feeling about technology and all the tools that we use is that there's always an initial phase when something new comes out and gets abused, overused and used in the wrong way. Eventually, some person with good ideas and real talent will take that technology and use it the right way. For instance, today we use the Steadicam all the time, but not necessarily to show off, whereas, initially, every shot was this amazing Steadicam shot. Now we realize that it's a tool that's valuable. I use it just about every day on a lot of things that I do, but I don't use it all the time. We have to make choices about these things.

It's like the Internet, which was originally created for communication between universities and the defense department. Then the people who worked for those organizations realized they could write a friend to say there's a good party on Friday night — it became democratized. It's the same thing with technology. Something will come in and we'll use it one way initially and then it will evolve until we find better ways to use it. The way we shoot is affected by the equipment available to us.

Certainly the Technocrane has also revolutionized shooting, not always in a good way, but when used properly, it's really great. In *The Black Stallion*, we used a lot of the Eclair cameras, which both Carroll and I have used – and actually Haskell, another big user of the Cameflex. It's a great camera for hand-holding. It's the best camera, although the Aaton is also pretty good now. But I used the Eclair on *The Black Stallion* and then again on *Fly Away Home* and also *The Hunted*, which I did with director Billy Friedkin. We used it because Billy liked the style I could get out of the Eclair — I could shoot with it and do the zoom and focus at the same time, which gave the image a certain nervousness that Billy wanted. Of course, the tools make a difference. When I have a big studio camera, I tend to do different kinds of shots than I would with a smaller, light-weight camera. And if I have the camera on a dolly, as opposed to handholding it or putting it on a big Technocrane or a Titan Crane, all those things provide something different that helps define the style of the movie.

Tell us about Elvis and how it helps production.

The Preston Cinema Systems FIZ, or Elvis, as we call it, is a device that basically sends microwaves out to the motor, which is on the gears of the lens that follows focus or F-stops. When I change the dial on the FIZ, it's changed equally on the camera, and it's also wireless, which makes it really great. In the early days, there was a wire between that device and another device that I would use to change F-stops. I like to do F-stop changes when I'm shooting, which saves me from doing extra lighting because I can pan around and open up two F-stops if I pan into something that makes the shot darker. Now, with the wireless FIZ, the Elvis, I can sit a long way from the camera and change the F-stops by watching the monitor.

When my assistant, Jamie Barber, who's the director of photography for *The O.C.*, and I first got the FIZ on *Hope Floats*, we used it only occasionally. But by the time we got to *Anna and the King*, which we filmed in Malaysia, Jamie was determined to use it on every shot. The regular actors, like Chow Yun-Fat and Jodie Foster, saw us use it all the time and were used to it, but there was one time when a new actor, who was playing the captain of the ship, came in for a few days to do some scenes, one of which had him coming through the door of his stateroom.

The great thing about the FIZ is that the assistant can stand anywhere he wants to figure out the best focus, and sometimes it was a matter of determining how far an actor was from a doorway. So Jamie was standing inside the doorway and following focus as the door opened, but the actor didn't expect anyone to be there. He was thrown off by Jamie being there, but we explained that we could follow focus from any place on the set, which is great.

Let's get into lighting. When you walk onto a dark stage at the beginning of the day, how do you approach lighting?

Of course, the key thing is the time of day the shot is set in. If it's nighttime, I don't want to have sunlight coming through the windows, and if it's daytime, I need to decide whether it

should feel sunny and bright or more moody on an emotional level. I usually do some preliminary setting up, but I honestly don't finalize anything until I see the actors rehearsing, because their performance is really the key to where the lighting will end up. Sometimes, I want a scene to evolve from a wide shot where the actor walks into a close-up and maybe I might show his face or silhouette it against a bright background.

A lot of these decisions are instinctual and obvious after the fact. I always find that when I look back on a movie I did, a critic might note something that I wasn't aware of at the time, but I was aware of it subconsciously. I'll go, 'Oh my god! That's really great!' Maybe I took the actor from the light into the shadow that seems to represent his fear of the situation, even though I didn't know it then. I don't like to be obvious about these things; it's better that they come from instinct than something forced. It's like how shooting at low angles makes someone important and high angles makes them little, and how certain colors represent different things. I appreciate that people have those opinions, but I don't necessarily believe them all myself.

So it comes from instinct or gut?

I try to define my own visual criteria as I'm making the film. I can make green envy or red envy. I don't think there's a collective subconscious when it comes to certain visual ideas. There are probably some colors that are more soothing than others, and certainly bright reds and yellows seem happier than more somber colors. But we can play against that, too. For example, *Being There* was a comedy that we photographed in a way that would not indicate it to be a comedy. If you turn off the sound to watch it and don't know that Peter Sellers is a funny actor, it looks like a film about power and politics. And yet, if you watch the movie with the sound on, you realize that the whole point is really not that serious — it's a comedy. That was very deliberate, and we have to use those elements to our advantage.

Tell me a little more about *Being There*, the first well-lit comedy I had ever seen.

If we took Peter Sellers out of it, it'd be a whole different story. We didn't want to give away the fact that it was a comedy. We wanted the comedy to come from the audience's realization that Peter Sellers was way out there. The director, Hal Ashby, and I had long discussions about that. When we went in to make it, we decided to make a kind of *Godfather*-esque movie that was not *The Godfather* at all. We had this character who was mistaken for being a genius when, in fact, he was really simple-minded. It's one film that holds up well, and it is certainly one of my favorites. Doing that film was one of the best experiences for me, because I had a really great time.

What made it so great?

Everybody involved was really respectful of everybody else. Hal was a great director to work with. He had good instincts and was very sensitive to the actors. And he had a sense of humor that was totally in tune with that movie. The actors were also great — Melvyn Douglas, Jack Warden, Peter Sellers and Shirley MacLaine. Anytime I am on a movie where I get to experience a great performance from an actor before anyone else has, that's great. Luckily, I've had that experience a lot, and I cherish it. When I go to a movie I've worked on and sit there with an audience that's thriving on some performance, I think to myself, 'I was there when that happened.'

Where does the look of a film really come from?

The director has the greatest amount invested in the movie, because he's probably spent many years getting it off the ground. At the same time, he's hiring a cinematographer. My feeling is that when someone hires me, he or she wants me to make a contribution to the film and not just follow orders and do exactly what is said. It's the same thing with the actors. Sometimes, I'll read a script and there'll be a scene that I can't figure out. Then the actor will come in to perform it and I'll go, 'That's what it is!'

I try to bring a visual style to the film that may not be the expected style from a lighting or camera movement point of

view, but it's the appropriate style nonetheless. Someone might go into a set, look at it and say, 'It's too bright. What's going on?' And I'd go, 'When we expose, it's going to look moody and will be alright.' Then, sure enough, we'll look at dailies and everyone goes, 'That's right; it looks great.' I worry about losing that separation with the advent of digital.

I'm convinced that there were decisions made about movies in the past that might be made differently today. For instance, I wonder if *The Godfather* would look the way it does if someone had sat on the set with a video monitor and looked at what was going to come out on the screen. Everybody would have chickened out. That's the problem with making decisions on the spot. We really have to take a broad view and look at the whole picture and realize that within the context of that picture, there are going to be quiet moments that build something very powerful, just like in Brahms's Third Symphony. We need those moments. The problem with having monitors on set — that's different from just having a video monitor that shows us what's going on in frame — is that people are going to make bad decisions. It might take a while for that to evolve. Technology gets misused in the beginning, and it will take really talented people to visually understand how digital images will translate onto the big screen.

Let's continue that tangent. Where do you think cinematography is heading, and how should the cinematographer maintain control?

Inevitably, the cinematographer is going to lose a lot of control, because we never know where things will land until we actually see them on film. The set is the one place where we actually have visual control over what the film will look like. That creates an immediacy that is dangerous, because it puts the burden on us to make a decision about what the overall look ultimately will be, which takes us away from what we should be concerned with on set, which is making sure the storytelling and performances are what they should be. That adds an extra burden for the director, cinematographer and everybody else. But we can't turn back the clock. Digital is happening, and it's

inevitable. I think more obvious — rather than more profound — choices will be made, at least initially, in the process of going to digital.

Now you serve as both a director and cinematographer. How do you deal with that schizophrenia between the two jobs?

As a cinematographer, I am also a filmmaker, in terms of not limiting myself to just one role. I think about how a film gets edited and I pay attention to performances. It's not like I impose myself, but I feel that I can be most valuable to a director by acting as another set of eyes in the process. Most directors I have worked with have appreciated that. In terms of acting as a director, I've begun to understand the director's impatience with his cinematographer for taking more time than I think he should to set things up. I do find myself getting impatient when I work as the director.

But the greatest thing about directing is that I can then go back to being a cinematographer and truly appreciate the director's point of view. That's really valuable. I've been lucky to work with so many wonderful directors and have developed great relationships. That relationship is exciting because what we do in the moment gets committed to film. It gets fused onto the emulsion and ends up on the big screen at a later date after being edited together, and everybody gets to experience what we've experienced in that moment.

What word of advice would you give to film students about cinematography?

See as many movies as you can. Expose yourself to as many visual ideas as you can. And if you want to be a cinematographer, shoot as much as you can — shoot everything under all sorts of circumstances. Don't be discriminating. If you can shoot, shoot. When I find myself going to a restaurant or anywhere else for that matter, I'm always making notes about the way light falls on objects and the way certain kinds of lights create a certain kind of color.

Do you bring along a little restaurant lighting kit?

It's not necessarily restaurants — it's just sitting on a park bench somewhere or in the middle of nowhere. I don't think I can go anywhere without being aware of the lights and colors. When I go on vacation, I love getting up early in the morning. I don't understand people who go on vacation and get up at 10 in the morning. Many years ago, my wife and I were in Egypt, and we got up at four in the morning and went running around the pyramids. It was almost as if we were there 3,000 years ago, because there was nobody around before sunrise — it was dark and mysterious. After about 45 minutes, the police found us and told us it wasn't safe before 5 a.m, so we went back to the hotel and had breakfast. It was great.

Caleb Deschanel, ASC was born in Philadelphia, PA. He attended film school at University of Southern California and American Flim Institute. His credits include The Passion of the Christ, The Black Stallion *and* The Right Stuff.

Ron Dexter, ASC

Who are you and what do you do?

I am Ron Dexter and I am a cameraman, mechanic, director, producer, teacher, and now I am actually back to shooting again.

How did you get to where you are?

While in school at Berkeley, I was just squeezing through, and I had a girlfriend who told me there was nothing wrong with being a photographer. I had seen a lot of French and Swedish films and thought it was terrific stuff. I had done a lot of stills but, somehow, thought that motion picture photography was something bigger. So I went to UCLA, applied to graduate school, didn't get accepted, which was really lucky, because I didn't have to take English 136B and all that other stuff that would have been deadly, so I just audited courses, and I got a job in the department because I knew electronics, electricity and I could build a house. Also, I was older than a lot of the kids, because I was in the service for four years, so the gal I was working for in the department, Daisy Sickles, got me my first three jobs. On the first, I was working on a Disney crew and went to Florida and shot animals.

The second was at Film Effects of Hollywood, working on *Mad, Mad World*. I worked on fine-tuning the stuff they had already shot during production that didn't work, so I spent sometimes a week fine-tuning a ladder, if you remember the scene with all the ladders. During original production, the ladder rigs didn't work very well, and with the whole crew on the clock and with all the pressure, they got a shot but it wasn't very good. After the

regular production was over, we took each questionable shot, made a continuous loop of it to study over and over to determine what the problem was and then figure out a solution. We had a crew of about four instead of 40. In the middle of that, Norman Dyhrenfurth asked me to work for him on a film he was doing for the park service in Alaska, and he took me as his camera assistant. We went up there and I set up the first camera position for him he told me to go ahead and shoot. He had seen my stills; he knew I knew the camera, so I ended up shooting about 70% of the film, which became a National Geographic special. So that was sort of like starting at the top or something.

From there, I did a lot of TV, such as Pepsi-Cola type specials of 13- and 14-year-olds bouncing around in different places around the world, and it got me a commercial-type reel. Jerry Broderson, while at Fotokem processing our film, said to talk to John Urie, who shoots commercials. So I got into commercials and shot them for about 30 years. What helped was the fact that I knew my photography, especially exterior photography and I knew the cameras as well.

When I had enough 16mm work, I bought an Arri. Having a camera is important because you learn how to use it on your own time, and it sort of establishes you as a cameraman. I then went out with Carroll Ballard on *Harvest*, which was shot in 35mm color, and I bought an old Arri 2A for that. So then I was a cameraman with a camera, and I shot a lot of low-budget, third-camera type of stuff. Then *Harvest* got an Academy Award nomination, which, if it had won, would have made Carroll's and my life very different.

I got a name as a hotshot cameraman at a time when there were not many around. There were a lot of studio cameramen, but in commercials, nobody was using wide-angle, handheld or 300mm lenses on the ground, on a sandbag; it just wasn't done that way. We were just doing something different and the budgets were unbelievably high, so if we didn't get something one day, we would get it the next. Also, there weren't many hotshot cameramen. There was Mike Murphy and just a handful of us, which changed with time, of course. They wouldn't let me

shoot on stage because I had no stage experience; I didn't learn on a sound stage, I learned outside. So I would go out and shoot everybody's outside jobs. Finally, they let me do a pre-light day and look at dailies and, from then on, they let me on the stage. I often worked with best boys who wanted to be gaffers. We would try different things instead of the attitude that "this is the way it's done." With a pre-light day here and there, I learned in the process.

Tell us about being a mechanic and cinematographer.

I love mechanics. In the business, on the way home thinking that there has to be a better or easier way to do something. For instance, a high-hat on a board is 1930s technology, but I'll bet you've got one on each stage. My first one was a 150mm bowl with fixed legs, and it allowed you to get down on the ground and leveled, but it still had three-point suspension. What I did was get outside the movie industry and look at how other people do things. I looked at catalogs, bounced things off of people and found incredible tools that other industries use and said, "Why aren't we?" I wasn't the first to find it in the business, but I was using lots of Speed Rail and bought tons of pipe from Kaiser when we were making dolly track. There were so many things that other industries had that we could really use.

What about the relationship between technique and technology? In terms of creating a look, which comes first?

In our business, I think basic photography is number one. In films today, there are a lot of great shooters, and I think they know their basic photography inside and out and that is why their images look good and their compositions are so good. Films today have been helped by technology. When I first started, we were sometimes shooting on ECO at ASA 16 and still film at ASA 10. Now it has gotten a lot easier in that vein, but I don't think the fancy cameras of today shoot any better images than the old clunkers that were state of the art once upon a time. A lot of great films are shot with Arri 2Cs, 2Bs, 2As, old Mitchells and so forth.

It is easier with the new equipment, but I don't think the new equipment is the big difference. The films are the people behind the camera — that is where it is. How do you learn it? You shoot and shoot and shoot. I just went to Cuba with the editor/publisher of *The Hollywood Reporter*, and his advice for people who want to be cameramen or just want to get into the business is: 1) You work for nothing; 2) It is your whole life, you have no other life; and 3) You are willing to work 24 hours a day. That is pretty much it and the competition is stiff. How do you learn camera? I think shooting stills can teach you about every film stock out there.

The other incredible tool that we have is the consumer camcorder. You can learn everything about contrast control once you have the camera and you don't need a fancy camera. I teach up at City College in Santa Barbara, and they bought these $600 cameras that are now down to about $350, which have a black-and-white viewfinder and a color, flip-out screen. With a good tripod, which won't go obsolete as soon as your camera does, you can learn almost everything there is in composition, blocking and all of that. The big difference is the depth of field. I think that is the biggest difference between video and film.

Why do you cut lenses apart?

First of all, when Carroll Ballard and I were shooting *Harvest*, we were using Éclair CM3s, which we put Nikon mounts on and used Nikon lenses. So when I got my first Arri, which had that old, straight mount, I scored a bunch of old lenses and had to mount them on an Arri mount, which meant pulling part of the existing mount on the Nikon lenses and remounting them with the straight mount for the Arri. When it came to longer lenses made for still cameras, you had to saw off part of the lens to put a different mount on it. Century Precision now does that and you can put any kind of mount you want on them, but it took the modification to do that. I had some of the first 400, 600 and 800mm lenses around that were modifications of the existing still glass, which was very good stuff.

You are known as a mentor to a whole generation of filmmakers. Tell me about that.

I taught all along and once I knew something I would share whatever it was. I didn't have many secrets, but I had a few, because people would try and use my close-up technique with a cheaper crew in Dallas, or somewhere like that. I tried to keep ahead of things far enough that I didn't have competition. Like I said, the challenge is that there has to be an easier and better way to do it. Somebody came to me and said to build a snorkel lens. Paul Kenworthy did a lot of research and came up with snorkel lenses, and I started playing around and ended up with, what I would call, a periscope lens. It made shooting a lot of things, like diamonds, much easier. I did it by playing with things enough and learning enough about design principles to build things from scratch. I don't think people know enough about optics and how they work, but there are great books out there. For instance, Sidney Ray has his book about optics, which is not about theory as much as it is about the systems that are out there and how and why they work. That is something that camera assistants ought to start with and should know by the time they are cameramen.

What affects the look or style of a particular film or commercial?

Elbert Budin was the tabletop food guy, and he shot with a 35mm camera on an arm, with a 16mm lens, some soft light on the side, and the food looked delicious. His secret was not Elbert's lighting, it was his propping. I had a look and everybody thought I had special filters, but all I did was shoot with longer lenses. I opened up my lens to soften the backgrounds, which I was very careful to design the scene by moving things that didn't belong and finding a camera angle with the right lighting at the right time of day — that was what made my look. I remember a guy who had a special filter that gave a special kick off of car reflections and nobody knew what he was using, but that was his secret.

It sounds like scouting is an integral part of what you are doing.

Location scouting is incredibly important. You have to know where the sun will be and how it is going to look at a certain time, I think that is something that has only really been considered in the last 20 years. The other thing is that I have always shot film stills of a location, and I take that with the picture of the talent and then, most importantly, a shot that captured the feeling of the spot. When it came to the storyboard, I had the feel, the talent and the location itself. So then, the question would be: How do we create this feel? The answer might be putting up in a piece of a wall or a certain prop that gave it the right feel.

When prepping commercials with ad agencies or art directors, do you look at pictures?

We absolutely looked at pictures. A drawing on a storyboard is only a drawing on a storyboard. Years ago, when agencies started cutting together different commercials made up of Stealomatics out of $3 million worth of production when they have $40,000, and they take the best from here and there, and the client says, "Oh, wow. That's great!" But they can't produce it, because this is 14 different locations and so forth and so on. The challenge was always to ask the questions of what feeling do we want here, what are we trying to say and what is the best way to do it with the money that we have?

What do you do next to execute that?

You put together way more than you can shoot — put it all up on a board and decide which shots we can do and which we have to replace. You have to figure out what you can do well within the given time and budget. On location, being in the right place at the right time is very important. You also have to be able to determine when the light is right, and hopefully shoot a still, or just know what it is going to be, and then you can do your close-ups and everything else. The key time, when the sun is going down, is when I might sometimes shoot half of the spot. Knowing what to expect and being able to predict it are really important. I got into sun location finding, but now you have programs like SunPath, but you have to know how to

use it, how to read a map, how to measure the angle of the sun. To really get a feel for it, after a while it becomes automatic.

On the last show we did, David and Goliath go snowboarding with their Jewish and Muslim friends. We had a lot of miniature sets; we had four sets on a 24-foot-by-24-foot stage and one frame per second gave us a lot of exposure time. We were out of town and could only afford to get dailies once a week and would break down a set before we saw the dailies for its scene, so we brought a few of these Nikon digital still cameras as our instant dailies to check contrast and the feel of the shot. I am getting it really fine-tuned, in terms of adjusting the tone, which is the contrast range to match the film. It was a great tool to see instant dailies. You have to use hard lenses because the automatic lenses change stop. Also, we were using the same Nikkor lenses on our Mitchells. The histogram that it has is also great and is like a printing light, but when you get into really high contrast, it won't handle some of the new films.

Rob Dexter was born in San Bernardino, California. His credits include "Lean On Me" (for Chevy Trucks), "I'm a Toys-R-Us Kid" and "Pepsi Puppies."

Ernest Dickerson, ASC

Who are you and what do you do?

I'm Ernest Dickerson. I have been a director for the past 10 years, but previous to that I was a director of photography.

How'd you become a director of photography?

I went to graduate film school at New York University, where I majored in cinematography. I was lucky enough to shoot my first film a year after graduating. That was a movie called *The Brother From Another Planet*, which was directed by John Sayles. The reason I got that is because, in film school, I had met a young gentleman by the name of Spike Lee. I shot all of his student projects in the second and third years. John Sayles saw Spike's graduate thesis film, *Joe's Bed-Stuy Barbershop: We Cut Heads*, and because of that, I got to shoot *The Brother From Another Planet*. That was my first professional gig and I have been working ever since.

Tell us how you progressed, you know, after you did your first film?

After my first film, I did several music videos. My next big job was a TV series called *Tales From the Darkside*. It was an anthology show. We usually had two crews working concurrently: While one was prepping, the other was shooting. That series was shot in both New York and Los Angeles, with two camera crews in each location. I did the first season and part of the second season.

At that time, I had gotten into the union with a film called *Krush Groove*, which was one of the first rap musicals for which I was the director of photography. That same summer, I photographed a little movie called *She's Gotta Have It* for Spike Lee. It was a movie we did in 12 days on Super 16mm and blew it up to 35mm. That started my career with Spike.

Tell us about style.

How does style happen? That's a good question. I first start addressing the style of a film as I read the script. Since I was a kid, I've always had a little movie projector play in my head, and I just start to visualize the movie from the script. On the second reading, I start to get into the rhythms of the film, addressing such things as camera movement and color style. Something I've always tried to do throughout my career is to use color in an expressionist way. I don't believe in a realistic use of color — color should be used to heighten the emotions of a scene and emphasize what a character is feeling. I guess that came out of studying the approach to color that John Huston took. He worked with cinematographer Oswald Morris on films like *Moulin Rouge* and *Moby Dick*. I read an interview with Huston, where he said that every film should have its own palette, which is like its own personality, and I agree with that. On every film that I've ever done, I've tried to come up with an approach to the color to help tell the story.

Can you give us examples from your own work?

The best example I can think of right now is a movie I photographed called *Do the Right Thing*. The story of the film happens all on one day on the hottest day of the summer. My problem was how to visually represent that heat. Having been a student of color psychology, I felt that I needed to help get that feeling across by limiting the color scale of the film, so I stayed with the warmer tones: reds, yellows and earth tones. I stayed away from blues, because blues are a cooler color. I wanted to really bombard the audience with these warm colors and get them to feel the heat of that day.

Also, for the first time in my career, I had to re-create sunlight. One of the problems in that movie was that it was set in one day, though we were going to shoot it over eight weeks. There were days when we had sun to shoot part of a scene, and then the next day it might be raining, and we had to continue the scene. Rather than use HMIs, I decided to use arc lights. My gaffer, Charles Houston, actually had to train the young electricians who did not know how to use arcs. I felt that the arcs would be a closer approximation of sunlight, because the quality of the light is somewhat thicker.

I also had to work with the production designer to continue the style of the colors we put in front of the camera. There was this wall that was a hangout spot that the characters were supposed to be leaning against and talking in front of. The original color of the wall was a really nasty gray and, on a whim, I said to make it red. So whenever these guys are against this wall, there's a red surface behind them. Where that came from, I don't know. Another thing about style is that it's sometimes unconscious. It's often just a feeling about something.

What about technique and technology?

Everything we use creates a different feel. A Steadicam feels very different from a handheld camera. The last few films of mine have been done in a handheld style. There's something about the immediacy of that — the nervousness of it. Even if it's not a moving shot, even if I'm just holding onto something, there's going to be motion in there. It imparts some nervousness to the frame, as opposed to a Steadicam, which glides and gives us a smooth feel. Technology should be at the service of style. Every film has its own personality, and every creative and logistic decision we make as cinematographers should be at the service of the film, like the kind of lights and cameras used.

When I did *Do the Right Thing*, I stayed away from HMIs because I felt that using arcs was the best way to go to re-create the sunlight. It was a culmination of arcs and a combination of exposure. I used half 85s, because they emphasized the warmth and shifted everything in front of the camera to the warm side. I also used a Harrison number 2 diffusion because I wanted the

hotspots to glow. I wanted the audience to really feel that heat. So the technology was at the service of what I wanted the image to be.

How do you prep for a film?

The most valuable time is preproduction. It's also the most fun time, because I get to sit down with my director and all my collaborators to find a common reference point for the film. We look at books of paintings, books of photography and other movies, so that we develop a common language that addresses the style of the movie. Every time I start a film, I go shopping at Hennessy + Ingalls Bookstore in Santa Monica. I go through their photography section looking for reference books, which I use with my crew. I spend a lot of money collecting photo-graphic books. I have a pretty extensive photographic library that I'm always referencing and pulling things out of.

On a recent film I did, the style was an immediate style. I wanted to let the individual color temperatures of different lighting sources speak for themselves. I didn't want to correct anything. I wanted the fluorescents to go blue-green, I wanted sodium vapors to go orange with a green spike, I wanted every-thing to show its own color. Even the Tungsten lights I wanted to be warm. I sometimes use mercury or sodium vapor lamps to light a scene instead of photographic lights, because the style of the film calls for it.

What do you think of digital?

One of the best things that has happened in the past few years is the development of digital technology and the digital inter-mediate. I just got through timing my latest film, which I shot in ways that I wouldn't have if I weren't going to do a digital intermediate. It was a film I only had 18 days to shoot, so I had to move very fast and put the camera in some really hard-to-reach spaces. I decided to shoot the film in Super 16mm with a 2:3.5 aspect ratio that we were going to blow up to 35mm.

I shot a lot of tests, and the reason I felt confident that we would have a great image was because we were going to do a digital

intermediate. The producers had already calculated that into the budget, so it wasn't even an afterthought. I would have been a little worried if we were going the traditional route of a photo-chemical blowup. The film was shot with different color temperatures, and we shot with available light on streets at night and didn't correct for the sodium vapors. During the digital intermediate, we amped up and saturated the color a bit more, so we made those light sources and their individual colors really stand out.

That was my first time doing a digital intermediate. I had been dying to get my fingers on it for so long, and it was amazing and great. I have experience doing still photography and I've always thought to myself, 'Wouldn't it be great if we could come up with a way of dodging and burning like we do with a print?' In the digital world, we can do that. The degree of image control in post is amazing. Then there's this thing called Power Windows, which has got to be the best thing since the wheel, because it enables us to isolate an area of the frame and just work on it alone. We couldn't do this 10 years ago.

Ernest Dickerson, ASC was born in Newark, NJ. He attended film school at New York University. His credits include The Brother from Another Planet, She's Gotta Have It *and* Do the Right Thing.

Richard Edlund, ASC

Who are you and what do you do?

I am Richard Edlund, and I am best known for digital effects. I basically have a photographic background, like most other old-timer visual effects supervisors.

How did you get started?

I got interested in photography when I was in junior high school. I had a friend whose father was the American distributor for Minox and he lent me one of their cameras, and I took some spy pictures in school. My friend sent the film to his dad and when they came back, many were pretty good. After that, I was hooked. I started making prints in the garage with an enlarger and an old 4-inch by 5-inch camera I bought for $25. When I was in high school, I shot pictures for the *Los Angeles Herald-Examiner*'s Scholastic Sports Association, which covered things like track meets and football and basketball games.

One day, I was invited to an elaborate recruiting event called A Day in the Navy, and although I was supposed to be covering the officers and elite guests gripping and grinning on a large cruiser, my friend and I thought one of the smaller destroyers looked like more fun, so we went out on it. For the event, guns were being fired, jets were flying overhead, a submarine fired a torpedo and our ship dropped depth charges off the stern, which rattled the ship terrifically. It worked on me, and I began thinking I should get some life experience before I went to college, so I joined the Navy.

I wound up at the Fleet Air Photo Lab in Japan after completing a course at the Naval Photographic School in Pensacola, Florida. There, I found a brand new Mitchell 16mm camera still in the box, which someone had ordered. At the base library, I found a book called *A Grammar of the Film*, written by Raymond Spottiswoode in 1935; it was a very intellectual study of silent films and Russian film and editing, and it became my bible. That was when I really got interested in filmmaking. At the time, I was making training films, but with sketchy James Wong Howe-style lighting and extreme Orson Welles and Greg Toland camera angles.

Let's talk about style. Where does the look of a picture come from?

I am a visual effects person, which means I need to be a chameleon of sorts. The cinematographer sets the look, and if I am doing shots that must intercut, I have to match that look. I have to find the style and then blend into it. Early on, when I was working with my mentor, Joseph Westheimer, [ASC,] I had the opportunity to work with and pick up little tricks from such greats as James Wong Howe, [ASC,] Hal Mohr, [ASC] and Ernie Haller, [ASC,] who would come by my little studio to shoot inserts, which is another situation where I have to match the scene and the lighting. Having the chance to work with guys like that was priceless.

Essentially, style comes from the drama and the story dictates how the movie should feel. The astute cinematographer senses that and can guide the director toward a look that will make both of them happy. Directors are different, where some are visual while others are not; some are more concerned with the actors and performance, and some others go for comedy. So it is left to the cinematographer to set the look and cause it all to gel. In some cases, when visual effects gets a head start and must start shooting before the cinematographer, I will meet with the cinematographer to understand what he wants the look to be. In those circumstances, he will have to blend into us.

In the digital world, sometimes we have to add characters or objects that aren't in the live-action scene. Other times, we have

to create the environment, and the actors must be shot against green or bluescreen, with the composite happening later. All of these things are part of the world of the visual effects supervisor or visual effects director, which is what I hope we will be called someday, because it is very much like a second-unit situation.

I think that style has classical roots, but it is also a constantly changing thing. For example, we can reference Rembrandt and talk about his lighting style or how there was a movie about Vermeer recently that looked like a Vermeer painting, in which we can suggest that Vermeer set the style of the movie. With digital tools, we have much more of a manipulative palette that should be kept in the domain of the cinematographer. Now and going forward, we will have far more control over things than we did in the simple analog world of printing lights, bleach-bypass processes and the like, where if we changed one thing, everything else also changed. With the digital intermediate process, it is more surgical, so we can add to what we have already done. Knowing that the film will be finished in DI, the cinematographer can take moneysaving shortcuts during production. It all becomes part of the cinematographic process, where the movie hasn't finished shooting until it's finished in DI.

What is the relationship between technique and technology?

In some ways, the medium is the message. If the camera can shoot in color and can record sound, for example, that dictates in a very broad way what we can do with the technology — as compared to black-and-white and silent films. The techniques that can develop around a particular technology can be radically different and perhaps, in the right hands, will produce more effective art. Those who shoot with the technology will dictate how they want it to be modified so it can fit their creative aims.

We are in the middle of a real technological sea change with the advent of digital technology, which began with visual effects. The visual effects arena was the first place affected by digital technology, and it completely flopped the photochemical world

we had all been brought up in. At my old company, Boss Film Studios, we had invented and built — amassed, really — about $10 million worth of analog photographic equipment, including optical printers, animation stands, matte cameras and a film-processing lab. We had hundreds of mechanical devices that, within a matter of months, became obsolete.

The digital world is racing toward us all. But as it does, film technology keeps improving and raising the bar that digital technology must meet if it is to prevail. There are types of movies that don't need really high resolution — if I am shooting *Lawrence of Arabia* in the desert at noon and I want to see every pore in Peter O'Toole's face, then I'd shoot in 65mm or in 35mm with the latest T-grain emulsions and sharpest, most modern optics. On the other hand, if a movie takes place mostly in dark alleys at night and the camera is constantly moving, I could get away with Techniscope or digital 1K because the resolution requirements are much lower. There is a large spectrum in between those extremes, and because stories and visual expectations vary, there is room for all the different technologies.

Sooner or later, I think we will be in a digital world, with analog photography being a thing of the past, but I don't know when that is going to happen and I think it will be a fairly long dissolve. The digital camera will need to rise to where it needs to be — at 4K — before they stop making film.

Do you think this will be the biggest change in film history, or have there been bigger changes in the past?

Sound was certainly the thing that changed film most. Silent movies were very popular, and they did have music in the theaters, such as organ players and piano accompanists. And in big cities like New York, there were theaters with symphony orchestras. People talk, and stories develop through that dialogue. So sound and music changed everything, in terms of storytelling.

And digital will offer a greater ability for the cinematographer and visual effects people to manipulate the film. I welcome the technology and think it will change the basic styles of

moviemaking. But I don't think the complete conversion to digital technology will be heralded as much as the advent of synchronous sound. It's not a drastically overt creative change, and many people will take the new visual delights for granted.

There are some directors who like the idea of letting the camera roll and not calling 'cut' and going to the next take. On the other hand, when shooting with a digital camera, directors can immediately review what they just shot, make sure it is in focus and make sure it is the take they want before they move on to the next shot. Also, the editor can be putting the movie together in the truck, which reduces the need for dailies. We won't need to send film to the lab with our fingers crossed, because we're nervous about getting it sharp on the take the director loved. All these trepidations can fall away.

I look forward to the change. But it will change the protocols of shooting, so it can be a double-edged sword. Now when we let the cameras roll, we wind up with hours of film that someone must go through each day. With digital, we'll need 45 minutes of disc or storage and a few seconds of reload time, not an 11-minute magazine load of film at over a dollar a foot and a several minute reload process.

Color was another paradigm shift in filmmaking. Technicolor had developed a complex, analog process that had the film snaking slowly from room to room, and you had to know just where to kick it to get the color perfect — and it did look pretty perfect. Then in 1953, Eastmancolor came out, which was certainly not as good, but it was cheaper. Technicolor basically put those three-strip cameras on the shelf overnight, though it took some years before Eastman Kodak was able to reach the quality of Technicolor.

I hope that doesn't happen now. I hope that as film gets better and better during its last stride, it is not forgotten. Consider how television, with its sorrowful 525-line standard — which I think was decided on back in the 1930s — has been elevated to a truly remarkable degree. I am amazed at how the engineers have been able to work within that limited standard to bring the old NTSC to a point where it competes with HDTV. The digital world will

have to do the same. And once we become digital, we might be able to shoot at higher frame rates than the 24 fps standard that many movies have been shot at.

Photochemical visual effects were often like getting into the ring with a sumo wrestler who sometimes threw us out of the ring. It was a tedious and difficult process with many limitations. The digital world is much more fun — we can really do just about anything nowadays. We can break each frame down into millions of addressable and manipulatable pixels. From blacksmiths, we became neurosurgeons. I, for one, am excited about what the digital world offers and I am looking forward to its future.

Richard Englund, ASC, was born in Fargo, North Dakota. His credits include 2010, Poltergeist *and the original* Star Wars *trilogy.*

Don FauntLeRoy, ASC

Who are you and what do you do?

I'm Don FauntLeRoy and I'm foremost a filmmaker and a cinematographer.

How did you become a filmmaker and a cinematographer?

I picked up a camera when I was in high school in Southern California for this course called "Radio Speech Television," for which I had to make a film. At the end of the year, I had to deliver this finished film, where I had to write it, shoot it, storyboard it, shot list it and direct it. That allowed me to just paint with the camera. I had always played sports, but I could never draw or paint so when I picked up this camera, I could paint.

Let's talk about painting with light, which is sometimes a very pretentious phrase, but what's that all about?

I wouldn't say it's pretentious. I mean, we do paint with light once we get behind the camera and have been given a set. I start lighting from the back of the set, making my darks and shadows and building contrast. Then I come forward to light the scene. It's like an artist with his pallet and canvas.

How does style evolve?

Style changes with each project. I work alongside the director, production designer and costume designer to come up with a

color palette for the look of the film. It's a collaboration between many people. Certainly, cameraman tend to gravitate toward one style of shooting, but I try to make each film a little different so it can become a learning experience for me.

When you walk onto a stage early in the morning that you have to light, what's your thought process like?

When I arrive, the first thing I do is gather everybody and ask for a rehearsal. I give the set to the director, the artists and the actors and I watch from various angles and corners. Then I decide whether there will be light if it's a day scene, where I might see if there's a window that I can bring light through. But it's that rehearsal that tells me exactly what I'm getting into, in terms of where the light has to come from and what has to be done.

What about technique and technology? Does equipment influence your style or vice versa?

Not only equipment, but also manpower. I can only do so much with the amount of time I'm given. I'm not a big fan of HMIs and I try to stay away from them unless I'm going for a really harsh, metallic look. I'm a bigger fan of Tungsten light, particularly for night exteriors, which certainly affects the whole look. As far as cameras are concerned, I tend to use Panavision equipment because I grew up with all the guys who started in the business 30 years ago and are now the big sales reps for the company.

Let's talk more about lighting. Tell me about the differences in look between HMIs and Tungsten.

Tungsten light is a much prettier light that's much more natural. If I had my way — and I try to on every film — I would always carry at least four arcs, which the producers don't like, because they require a lamp operator for each light, but that light is just more natural. HMIs have this harsh, metallic quality — it's like slamming somebody with light. It doesn't want to wrap and by the time I diffuse it, I don't like the harsh color.

Do you stay on top of the technology of lighting?

The ASC dinner meetings bring in new equipment and I try to go to seminars as well to see new equipment and what its uses are and how it looks. I'm a firm believer in really trusting the people I work alongside of, since I'm not the one who's dragging the cable and setting the unit up. I work in light values, so I know where I want the light to be and what it should look like. I would certainly suggest a unit but, if my crew can give me the same look with a unit that's easier, more efficient and faster for them to work with — because, unfortunately, most of the projects I shoot are done at a very fast pace — I'll leave it up to them. I won't let them undercut me, but I like big, lovely units coming through the silk nice and soft. I like to utilize my people, such as my gaffer and key grip, so it's a collaboration and everybody has to give their ideas, though I'm the one who's going to make the decision.

Take us through a particular show and how its style evolved.

I did *Jeepers Creepers* and *Jeepers Creepers 2* and kept the style the same for both films. The director, Victor Salva, and I sat down and looked at various films to come up with our look. For the first film, I lit three-quarters of a mile of a road at night and for the second, I lit up a mile of road for various scenes. We didn't want a blue look that people use for moonlight, so I used three Super Dinos on each tower and had the VNSP 1,200-watt fire starters — two rows of those, then two rows of mediums and two rows of wides. We not only lit a mile of road this way, but lit it almost three-quarters of a mile across. When I stood in the middle of the road, I had a perfect 2:8. It was so even and pretty.

How many of these condors did you use to light this?

I had a condor every one-eighth of a mile apart — 450 yards back was how the mathematics worked out, where 450 yards was the middle of the road where I read 2:8. I used the same process on the second film to actually light up a mile of road, except that I had a couple more towers on the top for a little fill

light for when I shot the other direction. The production took some of my equipment away because of money constraints, but it still worked out in the end.

Don FauntLeRoy, ASC, was born in Pasadena, California. His credits include A Year Without a Santa Clause, Seven Days of Grace *and* Jeepers Creepers.

Steven Fierberg, ASC

Who are you and what do you do?

I am Steven Fierberg and I am a cinematographer.

How did you become a cinematographer?

I started out in Detroit. Some friends of mine got cameras and we got into still photography. Then another friend, Bill Meyer, got an 8mm camera and made a movie. I liked it, so we started making movies together. Every summer we would make a silent film. One of us would shoot while the other would act and direct. I would edit with a crude splicer, and we'd play music next to the projector as best we could, as there was no sync sound.

We did that every year, and it kind of undermined my idea of what I had thought I would do with my life. I was good in academics and could have had a more stable and reliable career. In the culture of the city I grew up in, the dream was to be an automotive engineer or, if you had to be on the line, at least be in a union shop. I could have gone beyond that to become some kind of professional, like a doctor or architect.

When I went to college and announced to my family and friends that I was trying to decide if I should go into filmmaking, it seemed to them like I was considering jumping off a cliff. We knew no artists in Detroit, and Hollywood seemed — appropriately enough — like a fantasyland. Frankly, my image of it was the Disney Magic Castle that appeared at the beginning of Disney's Sunday night movie. Going to college in California was

a big decision for me. I took classes, but I was also seeing at least ten movies a week. When I did have free time, I was in the library reading *American Cinematographer* or studying whatever I could find about film.

Len Berk, a graduate student sensitive to my torment, got me a two-day job on a graduate school documentary carrying the tripod for the cameraman. We were setting up on the roof to shoot the Chinese New Year parade. Suddenly, I looked over the edge and saw this big Panavision R200 camera. I went down to look and Gene Hackman was there, and I caught his eye, and he nodded· at me. His acknowledgement that I existed and the excitement of the film crew had me grinning like an idiot for an hour. Then I had this premonition of walking down the street at 44-years-old and seeing a movie crew shooting, and thinking that I had never even tried to do it.

That was not an image I could live with and in that moment the die was cast. From then on, I would do everything I could to become a filmmaker. Years later, I realized that the day I had run into Gene Hackman, Francis Ford Coppola and Bill Butler [ASC] were shooting *The Conversation*.

Where does style come from?

Style should come from the story. If I'm shooting a really good script that is character-based, I let it go through me and try to figure out what I feel. When I read a script, I write ideas that come to me and then start looking at images — such as paintings, photographs and other films — to find images that speak to me, which I present to the director to see what he or she thinks. We try to find a look that feels like what the movie should be. I also make crude drawings, take stills and eventually shoot tests with the film and camera we will use. My goal is to present to the director an image that could be in the movie before we start shooting it.

A large part of style, which is really subconscious, is lens choice. In one film, style might come from shooting with a wide-angle lens, and in another it might come from shooting with a tele-photo lens. When I have done action movies, the director and I

might decide not to use any lenses between 30mm and 75mm because they're boring. *Entourage* is usually shot with a 40mm, 50mm, 65mm or 75mm, which emphasizes the characters while the background goes by in a blur.

When I did *Secretary*, we started out wide, with a 14mm, to show how unstable the character perceived her environment. The body of the movie, which was about two people, James Spader and Maggie Gyllenhaal in a room, was shot almost entirely with a 32mm lens. We didn't change focal length within the scene. This added reality to the very intimate, beautifully and truthfully written scenes about behavior that was sometimes shocking. If we needed a close-up, we would move closer and I think, on a subconscious level, that added to a sense of really being in the room with the actors. Consistency in lenses grounded the audience's perception that what they saw could really happen.

When we change focal length within a scene, there is a subtle disconnect for the viewer. We should be aware of that, because sometimes we want that. In something like a commercial or action scene, for instance, where we want to entice the viewer, we may shift from an extreme wide-angle lens to a telephoto lens. That catches the audience's attention because it is a change in perception. There I'd want to dazzle the viewer with things like wide-angle and super-telephoto because, if I shot in the normal way, the product might be revealed for its mediocrity or the stunt for its unreality.

On the other hand, if I am shooting a scene where I am looking at very subtle things that the characters are doing, I wouldn't change the lens because I'd want to create a world that feels very stable so that viewers can look at these things the way a regular person does. A normal lens makes viewers feel like they are in the room seeing what the actors are seeing.

Telephoto isolates a person from the background and blurs it. It can be used as a way to concentrate on the character, to separate him from the background, to hide the details of staging, to smear and blend the background colors, thereby making a prettier and more unified image.

When I first started out, I only did dramatic films and I didn't like commercials, because I thought the content was less "real." I did features for a long time and I got pretty good at lighting. But, in retrospect, my shots were really dull. Finally, I spent two years just doing commercials and music videos, and it was truly a great thing for me, because it opened me up to shots and images. Now, when I go back to dramatic work, I am more creative with my use of lenses, so I like having done a mix of things. If I could do it again, I would do what people like Gordon Willis [ASC] and Owen Roizman [ASC] did and shoot a lot of commercials before starting to shoot features. A lot of ASC members started this way, and I think it is good way to go and that I would have learned faster if I had done it.

On a movie, I come up with a look and then spend three months doing the look. Then, a year later, I see how it worked. Whereas in a commercial or music video, I try something for a day and see it two days later so I can say, "That was good, but now let's try this." I can grow really quickly that way, because the turnover of ideas is so fast. It is like when D.W. Griffith was doing one-reelers, he would do one every week, so he learned much quicker than the year it can take to get one feature made.

Let's talk about technology.

Film stocks have gotten faster and lights have gotten smaller and brighter. When looking at the history of filmmaking, people originally lit with hard light, so that they could get a lot of depth of field. In black-and-white, with perhaps some diffusion on the lens, that looked great.

The transition to color took a long time to develop a new aesthetic. In the '70s, with imbition printing and a slow, contrasty stock, cinematographers started bouncing and diffusing the light to lower the saturation and avoid the very shadows that made black-and-white look so good, as color does not usually look good with totally sharp black shadows. Also, more films were being shot on location, necessitating, in some cases, smaller lights. All this added up to shooting at extremely wide apertures, where it was hard to get depth of field.

This required a whole new style of staging and shooting. It was no longer easy to compose in depth, even in a far more conservative way than Greg Toland [ASC] did. Even having a person seated at a table with someone standing in the background now became impossible to get in focus. This contributed to invention, the constant use of the pull focus shot and more frequent cutting, with more close-ups, rather than playing shots in a master and, especially, two shots with depth. If you take a look at *Casablanca*, many of those two and three shots have far more depth of field than we use now.

But technology has again advanced, making more things possible. Now we have faster emulsions and very small and bright HMI lights. We can actually have much more control over depth of field and make choices about the apertures at which we shoot, allowing greater freedom in staging while still being able to use soft light.

Also, the contrast range, sensitivity to color temperature and range of color of film have gotten so much better. When I shoot film now, if it looks good through the camera, it will probably look good on the screen. When I started out, if a layperson walked on the set and said it looked great, I immediately called the gaffer over to figure out how to fix our mistake. Usually, the lighting would be too contrasty for the film to encompass well. At that time, a large part of our training was learning about how the film captured, which was really quite different from the eye. There was a lot of craft involved, requiring a lot of precise measurement, particularly in regard to color temperature.

Advances have rendered much of that irrelevant. Now if something is "off" color temperature, it comes out as a beautiful golden glow or a luscious blue on film. In the old days, such mistakes would render scenes an ugly ruddy yellow or crude electric blue. Nowadays, film loves color temperature variations and the contrast is very similar to what is seen with the eye. Especially with telecine or DI — if it looks good on the video tap, it will look at least that good in the final product. For that matter, there wasn't even a video tap then.

An improvement that might not really be an improvement is the reduction of visible grain, which makes the film smoother and, ironically, more like video. If I look at a painting by Van Gogh, I don't just see the hayfield, I see his brush strokes. In film, I should also be seeing two images at once — say, an actress' face and a constantly moving, sharp grain pattern. This sharp grain pattern allows the face to be somewhat soft and still look good. When the grain gets too fine, or in video, where they remove the scan lines, we end perceiving only "one" image, which can easily fall into either looking too sharp or too soft, with no good in-between.

In that sense, it is much easier to be a DP now than it used to be. The equipment is better and, if we get it to look good and the director likes what he sees, it probably will look that good in the final product. The craft has been helped, but it requires less craft than it used to. In some ways, we can be a bit less anal, especially now that things can be fixed digitally. I still don't think that way, because when I started filming, I was brought up thinking that I had to get it right. If I did a dolly shot that went through five rooms of a house, exposure had to be perfect the whole way. Now, even in a film workflow without any digital enhancement, they can make corrections as I go from room to room. If it was a half-stop too bright in one room, they can fix it. The same is true if there is a TV antenna in a period piece. Years ago, we had to tighten the frame or find a way to block it. Now we just get rid of it digitally. Time can be saved by using a power window in post rather than an elaborate teaser or flag to take a wall down.

In another sense, these advances make it harder to be a DP, because the expectations are much higher. We routinely do dolly and Steadicam shots that would have been almost impossible years ago. On *Entourage*, we would often go from a dark interior into the blazing sun, pulling F-stop from F2 to F22, and finessing it in the final color correction. On certain films, simply shooting a static master and two close-ups can be unforgivably boring.

Let's talk about the psychology of different lenses.

A wide-angle lens has a different effect than a telephoto lens in many different ways, such as how the face is rendered and how, if an object moves closer to or farther from the lens or just shifts in the frame, it will look edgier than it would with a telephoto lens. It is a creative tool that will feel very different from a telephoto lens even with the same framing. On *Secretary*, we started out wide because the feel of the story was unstable and, over the course of the movie, we did not have any shot with a lens above 40mm until the last 10 minutes, which was when Maggie Gyllenhaal achieved a state of bliss. For that, we used a 75mm lens, which looked so lush and pretty that we started laughing with glee. It was funny because it was something we had denied ourselves for the entire film, so when the viewer finally sees the actress that way, it has a lot of impact.

Steven Fierberg, ASC, was born in Detroit, Michigan. His credits include Entourage, Secretary *and* Kingpin.

Michael Goi, ASC

Who are you and what do you do?

My name is Michael Goi and I am a director of photography. I'm a member of Local 600 in California and a member of the ASC.

How did you become a cinematographer and why?

When I was 7-years-old, I was invited to a friend's birthday party and for entertainment, he showed 8mm digest versions of *Dracula* and *Frankenstein* on a projector on his wall. I had certainly seen movies before then, though I had never seen the mechanics of what went into a movie. I became transfixed by that little piece of film with the pictures that were dancing as they went into the gate of the projector. It was like magic to me that these still images could turn into motion pictures. I remember my friend pointed to the wall and said that the movie was up there, and I pointed at the projector and said, 'No, the movie is over here.' That was it for me; it was the start. I like to say that I have the world's worst memory, but that was a vivid memory of when I got the bug.

I first became interested in cinematography, specifically, when I saw *The Graduate* at 8 years old, by accident. I went to a cartoon matinee and, not knowing what the next showing was, I stayed and it turned out to be *The Graduate*. I don't know what it was about the photography by Robert Surtees [ASC] that struck me, but I had never seen anything like that before — where scenes played out in total darkness and I couldn't see the characters all the time. The characters were stretched to the edge of the frame

and, unknowingly, that became my first heavy influence in cinematography. I ended up watching *The Graduate* more than 125 times in movie theaters. The Playboy Theater in Chicago showed it as the all-night show starting at 2 o'clock in the morning on Saturdays, and I used to bug my parents all the time, 'Take me to see *The Graduate*. Take me to see *The Graduate*.' My parents patiently took me to see the film over 20 times in two years. By the time I was 10, they told me to get on the train and go see it myself. So I would go every month.

The next big influence was probably *Days of Heaven*, which happened while I was at college. It came at a time when I was trying to decide whether I wanted to be a cinematographer or an editor, and the images and the visual storytelling power of that movie were so enormous that it clinched the decision for me.

Tell us about your background.

I was raised in Chicago and went to Columbia College in Chicago, where I ended up teaching cinematography and basic film techniques for three years. I had an interest in documentary originally, and I shot a lot of short and feature documentary projects for PBS in Chicago. That was very fulfilling, because I love those instances where I can tell a story in a situation that is happening immediately, as in *Medium Cool*, and see how quickly I can react in those situations. Unfortunately, that didn't pay much, so I ended up shooting commercials and doing fashion photography in Chicago before I decided to move to Los Angeles to concentrate on features.

Tell us about your feature work. What was your favorite project?

I don't know that I have a favorite feature project. There was one I enjoyed working on immensely called *What Matters Most*, which was a fairly low-budget film shot in Vega, Texas, which is a town of 800 people. It was the first movie for director Jane Cusumano, who was being treated for breast cancer at that time. I had already agreed to shoot another feature film, but Jane's producer, whom I had worked with previously, asked me to shoot her movie because they needed someone who could keep

the production going when she had to go in for chemotherapy. The film was a real family affair, with Jane's husband Jim supplying the financing and her daughter Polly playing the lead. I agreed to shoot the film, and Jane and I had a wonderful time making it. For someone who had never directed before, she had fantastic ideas. I could see her struggling to listen to every word I said to her during difficult, painful days, but she trusted me completely with her movie and her dream. After color timing *What Matters Most*, I was in Morrocco filming when I got the call from Jim that Jane had passed away. He said she was able to see the final answer print a few days before she died, and she was so happy and proud of this legacy that she could leave for her family. She told Jim, "Please tell Michael thank you."

What is the future of cinematography, in terms of the role of the cinematographer?

When I think of the future of cinematography, I'm reminded of a seminar in Florida at which I spoke. In that seminar, one student stood up and said, "Don't you think that with all the digital cameras and digital formats that your job as a cinematographer is obsolete?" I asked what he meant and he said, "Anybody who picks up a digital camera today is instantly a cinematographer." I said to him, "So if I give you an electric guitar, would you instantly become Eric Clapton?" The reality is that there is no magic pill for capturing visuals today. There are a lot of different formats, with their own pluses and minuses. The trick is to find the right medium for the script. Cinematography has a rich future ahead of it, regardless of format. What really counts are the ideas and how they are interpreted.

How does technique influence technology?

Technology and approach to subject matter go hand in hand. Throughout the history of cinema, we've seen new innovations in shooting movies that are predicated by the kind of equipment available and the directors who use that equipment. In the '60s and '70s, with the new lightweight cameras, we had directors who wanted to take them on the road, stick them in cars and put them in bathrooms. As technology evolves and

gives us equipment that is lighter, easier to shoot with and faster to use, we're going to see experimental shooting by people who want to take that equipment to the edge and see what it's capable of doing. Both these things feed each other. The latitude of that stock saved the production tens of thousands of dollars when we only had six minutes of twilight left to shoot a two page daytime scene with four pieces of coverage. It was so dark when we finished shooting that my camera assistant fell off the pier because he couldn't see the ground anymore. But the film's latitude enabled me to have an image that looked like day when it went through color timing. Knowing the capabilities of the technology your working with gives you the ability to push the limits.

Can you give us an example from your own work?

In terms of choices available, I finished a movie in South Africa, and the producers wanted to shave a few dollars off the budget. There was talk of shooting it in high-definition, but I suggested shooting it in Super 16mm instead, which ended up being a great choice, because it gave the camera mobility in difficult situations — swamps, rivers and other tight places. It also enabled me to shoot with Kodak 7218, the 500 ASA stock.

Michael Goi, ASC was born in Chicago, IL. He attended film school at Columbia College, Chicago. His credits include My Name is Earl, Judas *and* The Fixer.

Stephen Goldblatt, ASC, BSC

Who are you and what do you do?

I am Stephen Goldblatt and I am a cinematographer.

How did you become a cinematographer?

I was a still photographer. From early on, I had a camera around my neck from the age of 11 and was earning a living with it by the time I was 18. One of the ways I did that was to go to film sets and take stills for magazines in England. I was crazy about film and segued from photo school to being a professional photographer and, while working as a photographer, I also managed to get into the Royal College of Art film school in London. While I was a student there, I shared a studio and did rock 'n' roll still photography and photojournalism. I found the still photographer life to be very solitary. I enjoyed the atmosphere in the film studios and wanted to be part of it, so I went to film school.

Describe your artistic background.

My artistic background is obsessively photographic. I have been shooting photographs since I was young and still do today. I am fascinated by the darkroom practices, platinum printing and fine art photography. I am adept at it; I have a darkroom and platinum setup, and I am also very concerned and involved in the transition from analog to digital, digital printing and computer-generated negatives, as they help me use the new technologies in film.

How do they help?

The process of developing a negative I shot myself — when I am developing the high range, low range, mid-range, highlight and making a print and, specifically, previsualizing the image as a still photographer — helps me very much when I am looking at a scene I will photograph for a movie, because I bear in mind that it will go to print eventually or a digital intermediate process. With the image, I am basically doing the same thing in film as in stills.

What determines the style of a movie?

The script determines the style; it is the driving force that should inform what the cinematographer, director and actors all do. The mark of a great cinematographer, like that of a great actor, is that he or she changes according to the script. I may bring a framing or sensibility to each project, but the style should come from the narrative.

How do you adapt from one style to the next?

Making stylistic transitions is not an ABC process to learn. It's got nothing to do with learning in the building block sense, but has everything to do with being sensitive to the influences that come to bear when we are talking about an image. Whether our background is in painting, still photography, graphics or music videos, everything becomes a great melting pot. It is the brain that seems to sort everything out to get us to a particular look.

Is it experience or observation?

It is everything — what we love and what we have seen before. It is the mystery. I don't know if I should analyze it too carefully or if I should even be worried about it. Photographers and cinematographers have an instinct for light, and it is important to be open and allow our instincts and subjective impressions to guide our eyes.

How does technology influence technique?

I don't know that technology affects what I want to do. Certainly though, the beauty of the new film stocks from Kodak and Fuji are the icing on the cake. They make it possible to get what I want, allowing many happy accidents to occur.

I always loved the story of how, in theory, backlight was invented and of course it was not invented as such. It was used in painting for centuries, but in the silent days of film, it had been characteristic to just use front lighting, soft north light or direct front light. Mary Pickford was photographed by Billy Bitzer at a lunch break in backlight with her curls aflame and that came up in dailies and changed history — it was a happy accident.

Happy accidents occur while we are doing the one thing we think we want and something else happens and shows us another way through. Obviously, equipment like Technocranes changed how we can imagine a scene. The most influential tool is the Steadicam, however, as it has transformed the blocking of film and how we shoot. But before the Steadicam, there were wonderful handheld cameramen who were executing the same sort of ideas, just a bit bumpier.

Can you give an example of a happy accident from your work?

On the set, when the guys are moving lights around, I watch, because it is interesting to see the light move and change. I love to be open and flexible; I find new ideas fun. Of course, that's not always easy to move the whole thing in a new direction if I have something pre-rigged. It drives some people nuts. I enjoy working with directors, like Mike Nichols, who really want to be in the moment and like to improvise. I also enjoy working with technicians who can grasp another way of doing something. It is exciting.

What else are you most excited by in the business?

The acting and the story. For me, being present at rehearsal is everything. That is what gives meaning to my work. Without

the writing and performance, it is an exercise in style over substance, and we have enough of that without me adding more to it.

What is the difference between style and substance?

Style could be characterized, if you are being facile, as mere gloss. Is a woman beautiful because she wears a certain lipstick or her hair is done a certain way? Is a man attractive because he has on an Armani suit? Is the character interesting or is a Botox baby face interesting? You can make up your own mind. One of my favorite photographers took pictures of old English philosophers, and I loved the character in their faces — the lines and the life in them. They are substance, as opposed to what is normally photographed, which is often mere style.

Stephen Goldblatt, ASC, was born in South Africa. He attended film school at the Royal College of Art in London. His credits include The Cotton Club, Angels in America *and* Charlie Wilson's War.

Robbie Greenberg, ASC

Who are you and what do you do?

I'm Robbie Greenberg and I'm a cinematographer.

How did you get started as a cinematographer?

I sold my car, bought a 35mm Nikkormat still camera and devoted several years to taking black-and-white photographs. I was inspired by the work of photographers like Alfred Stieglitz, Edward Weston and Paul Strand. I studied those photographs upside down as abstract images — in the same way the photographers originally framed them through their view camera around glass.

Working in the darkroom and then using a 4x5 camera to learn composition — by framing upside down through the ground glass — while studying those masters' photographs opened my eyes to the importance of the subject in relation to the photograph as a whole. I began to think about the way an image is constructed of areas of light, shadow and dark within the frame. Most of all, I was impacted by the range of emotions evoked in each of their photographs. It was my dream to be able to do that on film.

I lived in Berkeley, where I became involved with a loosely associated group of filmmakers, one of whom had a 16mm camera. Before long, it was a fixture on my shoulder. We shot documentaries, educational films, concert films and early music videos — anything to hone our craft. It was a great way to learn, but I yearned for the control over the lighting and camera movement

that wasn't possible on documentaries. For me, narrative films had limitless opportunities for visual storytelling.

How did you learn?

Although I had no formal film school training, I was an avid student of films and spent years after school and on the weekends at New York's art theaters, like the Thalia on the Upper West Side. Day after day, I haunted the Pacific Film Archive in Berkeley to study the films of François Truffaut, the French New Wave and British directors like Karel Reisz.

Aesthetically, I cultivated an awareness of light in my life and in my work. The direction of the light, the color and intensity, harshness versus soft, glowing backlight — all of this stirred deep feelings within me. Every day, I woke up obsessed with discovering different ways of reproducing and controlling light in my photographs and then on film. For years, I shot small, low-budget independent films. Each day on the set, I would push myself to find ways to create the light as I saw it in my head, no matter how limited the resources were.

In 1983, I was fortunate enough to shoot my first studio film: *Creator* with Peter O'Toole. The time, equipment and crew that I had dreamed of were suddenly all there for me. Now all I had to do was use it properly. To this end, the crew was my greatest asset. I found generous and talented people in each department who were willing to help and teach me how to achieve my visual images. I give credit for much of my technical skill to the crewmembers I've worked with over the past 25 years.

Tell me about some of your favorite projects.

Two films are particular favorites of mine: *Sweet Dreams*, directed by Karel Reisz, and *The Milagro Beanfield War*, directed by Robert Redford.

Sweet Dreams, a film about the life of iconic country singer Patsy Cline, starred Jessica Lange and Ed Harris. The experience of working with Karel Reisz and this amazing cast was like a master class in filmmaking for a young cinematographer like me. I

went home each night feeling that I'd done my best work, eager and charged up for the next day's shooting. Every one of the 87 shoot days was like that for each member of the cast and crew. Karel was an extraordinary man and a consummate director, as you can see from the film, which is as relevant today as it was when it was released.

The Milagro Beanfield War, is a mythic tale about real estate developers and a water rights dispute in rural New Mexico, that was taken from the very popular book by John Nichols, who was also one of the screenplay writers.

Robert Redford had a great appreciation for the magical light of northern New Mexico. He gave me the opportunity to create a naturalistic world enhanced by the constantly changing weather patterns. We kept the entire cast with us on location every day. Once, when we were shooting a scene in the bean-field, I turned around to see storm clouds moving in fast and blackening the horizon. Etched across the sky was the most vibrant rainbow I'd ever seen. We swung the camera around and captured a dramatic moment made more powerful by the storm.

For a New York City boy, who grew up with concrete play-grounds, to be photographing those mountains — exposed to a new phenomenon of light and the raw power of the natural world — was life changing.

How do you approach lighting a scene?

My choices begin with the script and the director's interpreta-tion of it. We collaborate with the production designer and the costume designer to create an overall approach to each scene and for the film as a whole. Every decision is motivated by the emotional intent of the scene and how it serves the storytelling. Preparation is the most important aspect of the filmmaking process. Taking the time to work out these decisions in advance and creating a plan to execute them is the key to accomplishing the scene.

Talk to me about your style and how it influences the tools you choose.

I think all of us would like to say we don't have one particular style. Once the visual look of the film is determined through collaboration with the director and the production designer, I choose the equipment necessary to accomplish the job.

I may use similar types of lights and cameras on each job, even similar diffusion materials, but I don't necessarily use them in the same way each time. Many of my choices are made intellectually but, when it comes down to it, so much comes from instinct. The script gets you going. However, your own personal experiences have a great influence over the choices you make, whether they're conscious or unconscious.

The new programs being broadcast on cable television seem to be broadening the scope of the movies that cinematographers are getting. What do you think the ultimate influence is going to be on cinematography?

I believe that having feature film cinematographers shooting films for cable networks will raise the profile of those films. The standard of excellence that we bring to our film work will become the norm in cable television and future cameramen will be inspired to push the limits of their craft and technology to the next level.

Do you approach feature films and cable films differently?

No. I've recently finished a film for HBO called *Iron Jawed Angels*; it is the third one I've done. In each case, I approached the project in exactly the same way I would a feature film. There are limits, in terms of shooting time, that present challenges, but there's also an opportunity to expand creative limits in lighting and camera movement that's encouraged by studios like HBO.

Let's talk about the future. Where do you think cinematography is headed?

We're going into uncharted territory by virtue of the limitless possibilities of the digital world to re-create any image directors

and cinematographers can conjure in their heads. The more sophisticated the technology becomes, the more seamless the effects appear. I think we will have opportunities to use all of the formats: 35mm, 16mm, 24p, HD and others yet to be invented. Each will have its own best use. Cinematographers will be able to choose the format that matches the type of project they're doing.

I heard someone jokingly say that film is the best digital storage medium that there is and that film is in its digital age.

It seems to be the case. At this point, film is still the medium of choice for projection of the final product. If you look back at the past ten years, you'll see the history of the digital revolution in every film you watch.

What was done as traditional matte paintings 15 years ago is now live-action against greenscreen with digital mattes. I remember working on a film that needed a matte painting in the background. The technicians came out with a camera on a pedestal that was so unwieldy it couldn't be moved. We had to do it that way because of the need for absolute stability. The technicians used black paper on glass to mask the area where the matte painting would be. It was quite an ordeal to light and shoot — and frustrating to have only a static camera.

Nowadays, it's absolutely seamless. We're able to move the camera on effects shots with the help of motion control and three axis heads. We can do breathtaking stunts and make them look believably real, thanks to the new computer-generated imaging techniques.

Are you lighting differently for green screen?

No, not with respect to the storytelling. The visual images always come first. I light the greenscreen so the visual effects supervisors have what they need to make the effects absolutely seamless.

How do digital mastering and digital intermediate affect the role of the cinematographer?

The ability to alter the original intent of any photograph or scene certainly changes quite a lot for the cinematographer. It's about creative rights. Many of us worry about the loss of control of our work. I've been fortunate enough to participate in each of my projects through the final print stage, and I do not want to give that up.

We're not paid for our work on the digital intermediate, as we were never paid for timing answer prints. Nevertheless, this is an extremely important part of the project and the only way we have to maintain control is by being with the film throughout the process. It's remarkable to see what we can do with this new technology — it's inspiring.

Any closing words you'd like to leave us with?

The future of cinematography, with its limitless possibilities, is breathtaking. The quality of the workmanship is still in the hands of passionate cinematographers whose visual storytelling will be limited only by their imaginations. I think we're in for a great ride.

Robbie Greenberg, ASC, was born in New York City, New York. His credits include Sweet Dreams, The Milagro Beanfiled War *and* Even Money.

Ernest Holzman, ASC

Who are you and what do you do?

My name is Ernie Holzman and I am a cinematographer.

How did you become a cinematographer?

I started out by taking still photographs when I was a kid, which I developed and printed at my house. I was about 15 when I started and, like many people at that age, I had no idea what I wanted to do with my life. At one point, I wanted to be a photographer for *Life* magazine, like W. Eugene Smith, who was one of my childhood heroes. However, in my senior year of high school, *Life* folded, though it's since come back into publication.

Then, one night, I dreamt a movie that was very realistic and took place on another planet, with battle scenes and great, other stuff. I woke up the next morning and thought, "Movies! I will become a cinematographer." So I went to New York University film school. It was funny because, on the first day of class, the teacher asked, "Who wants to be a director?" And everyone's hand shot up except for mine. I still feel that way and I am very grateful I was able to fall into this business. Cinematography is great work, which they actually pay you for.

After my experience at NYU, I knocked around New York for a bit and then came out to Los Angeles to go to the American Film Institute. George Folsey [ASC] was running the photography department at that time and was a marvelous teacher. I learned a lot about lighting from him and from the workshops we did at school. Then, during my second year at AFI, I did an intern-

ship program because I had known Rob Hahn [ASC] at NYU, and he had done an internship with Conrad Hall [ASC] on *Marathon Man*. That struck me as a really cool idea — to do an internship with a DP. Jordan Cronenweth [ASC] was doing a picture at the time, so AFI contacted him through the guild. Jordan was a real gentleman and he was kind enough to invite me to observe the photography of his film *Cutter's Way*. That was in 1978 and we became friends. Ultimately, he brought me onboard his crew as his film loader. That is how I started off in the business.

Let's talk about style.

The word style evokes such bizarre notions. In terms of style in the movies, one has to reflect on the fact that the movie industry is this wonderful combination of high finance and art. When I read a script or photograph a film, I stay conscious of the story and am very aware of the ideas I get that pertain to a lighting style or effect I might have seen someone else do. I try to always remember how much time I have, where I'll need to be and, of course, the director and the actors who are in front of the camera. I maintain a very loose attitude when I approach the photography of a film, so when a director or actor has a good idea, I like to be loose enough to implement it.

The style of my lighting probably came out of doing work in television and commercials, where I worked with directors who didn't want to wait for relighting or anything else for that matter. I learned to incorporate the lighting of big spaces into my initial setup, so I wouldn't have to relight later and could just move the camera. I am a great rationalizer and believe that rationalization is the key to successful lighting. For instance, if an actor walks into a very bright or dark area, I let it go because it's an organic movement and part of the scene, but it is also cost-effective. I stay very aware of time when I shoot because, while we are shooting on the set, there is more happening behind the scenes and in prep that has to also be addressed.

If a director loves a small room at a practical location, that determines how I approach the lighting and photography, which is based on the physicality of the place and limitations that I am

given. A lot of my style comes from what I have to work with, what the budget is, how much time I have, what equipment I have and what I can fit into this place. The whole thing is governed by the piece of story we are telling and what the actors are doing. It is a wonderful stew that comes from these elements, so I don't think of myself as having any particular style, other than the fact that I have worked for very impatient directors who wanted to work quickly, so I tended to light with very big lights and small bulbs, which is something I heard Gordon Willis [ASC] say in an interview about *The Godfather: Part II.*

How would you light this interview?

To make me look like I have more hair.

What is the relationship between technique and technology?

I might not be the best person to ask about technology, as I am not a very technical cameraman. I am very comfortable in photochemical work, and I've been doing it for enough years that it has become second nature for me to come to the set, look at something and light it. One way of describing my technique might be the phrase, 'less is more,' because I don't bring a lot of stuff to a party and I'd rather see what evolves through rehearsal and prep with the director before I introduce the options.

The director might say he wants to use a big crane. I would ask him why and he might tell me he wants to be 30 feet up to get a good panorama. Then I might tell him we could do that with a few parallels and that we don't need a crane. The more options one introduces to the mix, the more confusing things can become, and I like to keep things very simple.

My lighting style is simple and basic, and I don't like to glitz things up. I always turn lights off rather than turn them on, which is something I heard a great gaffer by the name of Earl Gilbert say. I don't go into a production thinking about all the equipment I can bring. I actually think about the equipment I can keep away, because I don't believe in a lot of equipment.

Equipment is certainly important to have, but my philosophy is to be just to the left of center in bringing in stuff, because good storytelling is organic and has a certain elegance to it.

Cinematography in general is a very organic process, which I just let happen. I try to be a governor of sorts as this big machine rolls through production, injecting certain things at appropriate times, and letting the drama take place. If I am told I can't have a certain piece of equipment that I know I need and that a director has requested, I will work it out and achieve the effect with a different piece of equipment or let the director haggle it out with production. I believe in organic filmmaking and that everything we do as cinema artists should be done to support the story and the process.

What does organic mean?

Organic means extending the reality that we are trying to portray on the film. An organic element is one that comes out of the connection that I make with the director and with what we have available to us and with what we are trying to achieve. My approach to cinematography has always been to be as organic as possible, in terms of preparation and execution. Organic filmmaking is what comes out of everyone on the set at the moment we are filming, and I have to keep myself from putting my hand in the cookie jar too many times, which means maintaining a 'less is more' attitude and finishing on schedule.

Ernie Holzman, ASC was born in New York, NY. He attended film school at New York University and American Film Institute. His credits include Miracles, Citizen Baines *and* Cora Unashamed.

Judy Irola, ASC

Who are you and what do you do?

I am Judy Irola. I am a director of photography and I am also the head of cinematography at the University of Southern California (USC).

How did you become a cinematographer?

That is a long story. In the '70s, I was a secretary at KQED, a public TV station, and I watched the people come out of the film department every day, carrying silver cases and wearing Levis, and I didn't want to wear nylons anymore so I started working with the film department on the weekends — moon-lighting, if you will. Then they were forced to move me into the film department because I was never at my desk being a secre-tary, and that's when they trained me.

Are you from out here?

I am from Fresno, California, originally, but I was in the Peace Corps in the '60s and when I came back in '68 there was revo-lution in the streets. Many of us came back to San Francisco because that is where we had been trained, so I wanted to get involved with what was going on. I didn't know that I want to be a cinematographer as much as I knew I wanted to be involved in films that were about social justice. At the time I started, it was the beginning of the '70s and feminism was rear-ing its head, the antiwar movement was heavy as were civil rights — there were all kinds of issues in this country that I

wanted to be a part of through making films about them. People were making socially significant films in Europe and I felt we should be doing it here as well.

Let's talk about documentaries.

I have shot documentaries for 30 years and it has been the hardest thing for me to give up, but my body is not as agile anymore and my arm is asleep after all these years of carrying first an NPR and then an Aaton. But it's the sexiest thing in the world to have a 16mm camera on your shoulder and be in Mozambique, Kenya or Havana and realize you are having a relationship with people.

Carrying a camera and viewing the world through one eye — although you do keep the other one open to see what is going on — your point of reference is with the one eye through the lens. You zoom in and out, focus, see what is going on, and you become intimate with your subjects, which is what I think makes for a great documentary cinematographer.

What determines style?

The story dictates style. I don't think you can make a dark film, even though you may want to light it that way, when it is a comedy. A script determines style and I think it is the job of the director and the job of the cinematographer to stay true to the script. It means style in every way: wardrobe, production design, lighting, choice of lenses, etc.

How does technology affect technique?

Four years ago, at USC, we moved from Super 8mm to digital in the first semester. The second semester is in 16mm film, and it is astonishing what the students didn't know coming into their first film class. I was talking about depth of field in one of the first classes and most of them had no idea what I was talking about. That would never have happened if they had worked in Super 8. Then I asked them if they knew the difference between a 10mm lens and an 80mm lens and they did not, so we had to revamp the beginning of our second semester.

There is a difference between moving the camera in for a close shot and moving the camera 30 feet back and zooming in or putting on a longer lens so you have less depth of field. So you have to make these choices. Is this a wide-angle shot? Is this a close-up? These are technological issues you need to be aware of.

What do you tell your students when they ask you how to become a cinematographer?

There are very few who come into a film school with cinematography on their minds. They are going to be writer-directors in the beginning. In their second semester, however, when they start to shoot film and learn to use a light meter they are scared, but by the end of the semester, there are a number of them who — even though they had difficulty learning the technology — fell in love with it. By their third semester, they begin embracing it; and by the fourth, they are shooting so many films for other students that it is a natural progression. When they get out, we help them build a reel and get an agent. Mainly they continue to work on films with each other. Film schools are like "mini-mafias." You go to one school or another, whether NYU or USC, and then you're out in the field and there is someone who graduated from your school; most likely you will get the job. They know the curriculum and that they can count on you.

What do you get out of teaching?

I started teaching in 1992. I had just moved here from New York, and when I had lived in San Francisco in the '70s, I was in a film collective that was dedicated to making political movies. Then when I moved to New York, there was this whole film community of filmmakers who had that sense of community I needed. When I moved to LA, it wasn't there anymore. I have a lot of friends in film, but there was not the sense of community I preferred.

USC asked me to start teaching and I did, not thinking it would last and presuming it would be once in a while, but I not only found community with the students, but also with the rest of the faculty and the administration. They are wonderful people.

Most of the faculty came out of independent film, and I find a great sense of community with them and continue to be more and more involved. Everything is generational, anyway. Someone once said to me, "You are training all these young cinematographers. They are going to take work away from you." And I said, "Fine. It is time to continue life and for everybody to make changes."

How do your life experience influence the way you shoot?

For me, it has never really been about the technology. I have friends who have struggled very hard to be cinematographers. I come from a Basque community in Fresno where I grew up in a very strong family and, visually, it was very fascinating — not only the community itself, but our sense of culture, where we were all sheepherders.

I was trained in the documentary unit at KQED and the cine-matographer who trained me was an excellent documentarian. I would watch and edit his footage as well as be his camera assis-tant. He was very encouraging and, at some point, I picked up a camera and started filming people. It was so natural and I had no trouble learning how to use the light meter. We worked in foot-candles in those days, but I found it was very simple.

Cinematography came very easy to me; I don't know why. Being the daughter of sheepherders, I never owned a camera or knew what any of it was, but I liked the intimacy and that is why I continued shooting documentaries for so many years. It was a way to travel and see the world and it was thrilling. Now I like to stay home with my dogs, but I feel like I made a contribution, which is important to me. I made movies about steel workers, women's rights and civil rights, and I got to participate in all these people's lives.

Being a documentary cinematographer is the epitome of being a voyeur. It teaches you to block a narrative, so that when you are blocking a scene with a director, if you worked on a lot of documentaries, you already know how people walk and talk and that when they make dinner, they don't stand still in one place.

It is really a great training ground. You learn to see available light and where it comes from. The training in documentaries was the foundation for my work in the narrative format. *Northern Lights*, my first feature, was shot in black-and-white in North Dakota and won the Camera d'Or prize at the Cannes Film Festival in 1979. In 1993, *An Ambush of Ghosts* garnered me the Cinematography Award, Dramatic Competition, at the Sundance Film Festival.

Judy Irola, ASC, was born in Fresno, California. She is head of cinematography at the University of Southern California's School of Cinematic Arts. Her credits include Northern Lights, Working Girls *and* An Ambush of Ghosts.

Mark Irwin, ASC, CSC

Who are you and what do you do?

My name is Mark Irwin. I'm a director of photography.

How did you become a director of photography?

I started off taking pictures and making movies when I was a little kid. I went through public school and high school as the audio-video geek, projecting slides and films. I ended up attending film school in Toronto and started in the film industry there, which was very small at that time. I started shooting documentaries, industrials and educational films — anything and everything I could lay my hands on. My first shot at a mainstream feature was a wrestling film called *Blood & Guts*. The producer on that film went on to do a drag racing film in the AIP tradition and the director of that film was David Cronenberg, who really went on, and I went on with him, to do *Videodrome, The Dead Zone, Scanners* and *The Fly*. That put my foot in the door of the Canadian film industry.

How do you arrive at the look of a picture? Where does style come from?

The look of the picture comes from the story. Case in point were three films I did for director Wes Craven. The first was Wes Craven's *New Nightmare*, which was his last Freddy Krueger movie; the second one was *Vampire in Brooklyn*, which was an Eddie Murphy vampire movie; the third was the first *Scream*. They're all part of the Wes Craven genre of horror. The first one

was centered around a family in their home and their son's room. That story and location told me how to bracket the lighting. To shoot horror films, I have a very rigid philosophy to not make every scene look dark and moody. A lot of DPs and directors might prefer to smoke up every room and keep things dark, scary and full of mood while the kid, for example, is simply eating breakfast or sitting in his classroom. But that makes it harder to scare people, because we can't turn off the lights when they're already off. If we set the baseline in a kitchen or a true living environment and then introduce something evil, however, something darker can come of it.

I don't know if that's too poetic, but when it came to Wes Craven's *New Nightmare*, we started off being soft. I have an aversion to hard shadows. I literally can't stand them on the set unless I want to make a meal out of them with a slash or a pattern or some emphasis coming out of that shadow or that hard light. Otherwise, I prefer either soft cross key or soft top light and definition with soft or hard rims. The baselines start with something simple, like a home where it's safe. Then the lights go off and we can start playing with darkness, with ratio, with the key to fill getting higher and higher — less information, more shadows and more contrast. Then, halfway through *New Nightmare*, I got carried away with camo netting and ended up putting leaf patterns and Dr. Caligari-types of patterns on the walls.

I always say that we, as DPs, have to come into every situation with everything in our back pockets. Going into any film, we literally have to know everything: what the director wants, what the producer wants, how this is going to cut together so we know what the editor needs. We have to know the hairstyle, makeup, wardrobe demands and the visual effects. From that point on, we are free to learn. For instance, when an actor turns his head and does a scene one way as opposed to a different way, I can shift not only the key or camera angle, but I can bring some light to his eyes. Then, when the scene turns the other way, I can eliminate things and add visually and viscerally more darkness and more suggestion of evil. That's the case in Wes Craven films.

The same was true with the Eddie Murphy film, *Vampire in Brooklyn*. We had a lot of crypts, vaults and fire-lit scenes, but at the same time, there were scenes in nightclubs and police stations where I kept saying, 'I've got to go back to this baseline. I can't keep it dark and moody. It's got to be real here so that later I can throw people into the dark.'

With *Scream*, which was made in 1996, it was a whole baseline for teenage horror films of that time. We deliberately showed a high school, video store, mini-mall — all these things people can relate to — and then allowed things to get scary after dark. We didn't go to some crypt or some place that Freddy came to. The evil was inside the characters. I can emphasize, embellish and actually elevate their character and character shifts by lighting or, in this case, unlighting or relighting. It's a pretty easy thing to bounce light off the floor and say we're in a scary scene. But it's another thing to introduce something that wasn't there before in the same room, whether it's a living room or a kitchen in a suburban house. In *Scream*, we had the guys holding guns and knives that were dripping blood when 10 minutes earlier they were chugging beers in the same room. So I want to be able to have all that technique in my back pocket and play it toward the characters.

You've done a lot of horror movies.

I would love to say I've done a lot of horror films. I was pigeon-holed and I was happy to get into doing *Videodrome* and *Scanners* in the '80s. I eventually tried to get out of that and have succeeded. I ended up doing *Dumb & Dumber, There's Something About Mary, Road Trip* and *Old School* and have found one truism for cameramen — for all filmmakers, in fact. It's a lot harder to make a comedy. I should say it's a lot harder to make a funny comedy than it is to make a scary horror film. The same is true with action films. I did a Jackie Chan movie in Hong Kong, so I've been there.

To get people to react a certain way to horrific things — I don't want to say it's a cliché, but let's just say it's a tradition — there's predictable lighting and camera placement involved. But when

it comes to doing a comedy, it isn't about just making things brighter. I have shot successful comedies with actors who have been successful as comics in the past, but produced films that were not successful as comedies because it's hard to make everybody laugh at the same thing. Some people can, like Jerry Lewis or Jay Leno. For me, making horror films is a lot more fun, phony blood notwithstanding. Comedies are a lot harder, especially when there's the inevitable interaction between actor, director, writer and producer who all say, 'I know funny and that's not funny!'

How do you light for comedy?

I like to keep comedy real and really not exaggerate things. There's a source in every scene, location and setup, and I try to pull it out and wrap it around somebody's face. That's as real as it gets. Comedy comes from a real person saying things that lead to a comedic conclusion. When Ben Stiller fights with a crazy dog in *There's Something About Mary*, the room was just a room where crazy things happen. I don't have the funny filter or the funny gel pack or the funny grip truck. It's just real people doing real things that hopefully end up being funny, but not because of the lighting.

How do you light for horror?

Horror lighting has a lot of its own rules, in terms of what we see and don't see, and creating thick enough shadows to hide things and then reveal them when the time is right. Sometimes that comes from a plain old hard light, which works well to define things. I grew up watching and making documentaries and understanding lighting from a realistic standpoint. I'm not a big fan of theatrical lighting, so I try to source something hard. I like directional soft light. I can get a nice, soft wrap and yet have it stop with a lot of negative fill — a wall of two or three 20x solids. That's not uncommon.

I also like to play around with different ambient light that's two stops under the key. In terms of color temperature, if the key is 3,200 degrees, then the ambient is 4,000 or 5,600. The rims and

the fill are all different tones and colors. I also like pools of light, so that it's sectional. If I light a set or cross light it soft enough, I like to bounce into a big source, like a 12' x 12' Griffolyn, and then diffuse it with something called Silent Frost. That's my favorite, because it wraps around everything. If I don't fill at all, or if I fill with two stops under the key with color to give it an ambience, then I can start playing around with little pools of light to fill eyes or to accent clothing — to take away some information so that when someone's head turns, he or she has a little extra glint in the eye. I feel more comfortable base lighting a room that has a feel to it, which I can then embellish, instead of creating pools of light for every single spot.

It seems that the forefathers of cinematography could take away information and then reveal it, just with a head turn. Back then, there was a lot of cutting with hard light. That tradition is gone. Since a lot of sets are locations now, there are obviously no green beds or grid; there are no perms and not a lot of other ways to rig lights at a distance to get a hard shadow.

What other differences do you find between then and now?

Traditionally, older Hollywood movies were shot with hard light because everything was shot in black-and-white, so the hope of having color separation didn't exist. They needed light and information, and hard light was the best way to do that. It probably evolved from stage lighting, the open-faced lamps, to fancy Fresnel and condenser lenses — a lot of the things we've since brought back. Back then, things were expressed much easier in black-and-white, when a Marlene Dietrich hard key, with a little nose shadow and one on her chin, looked normal and classical, like a Hurrell photograph portrait.

Then David Watkins, Frank Tidy and a lot of British cameramen started seeing things differently. The understanding of light and seeing are two different things. Shooting a film, seeing an image and reproducing what we're seeing and the feeling we get from that sight is important. David Watkins was the first — they used to call him 'bed sheets Watkins' because he took brute arcs and

10Ks and bounced them off the set into sails from sailboats and bed sheets stitched together to get a wonderful wraparound soft light that we now take for granted. Now we use Kmart lights and fluorescent tubes as complete lighting units.

My gaffer and I have designed, manufactured and patented fluorescent lights that we use all the time. They're just a part of what we see. But at the same time, when we say 'I really want a crisp, hard shadow to do this,' it's hard to find. I can't get as hard of a shadow out of a Fresnel, though the beam projectors that Mole makes are wonderful. My gaffer and I designed a light called the GCL, which is a shortened name for what we literally called the garbage can light. For it, we took a 5K lens, which has filaments all in a line, and turned them sideways, so that we had one single shadow instead of these filaments. Imagine a bare bulb in a bulb holder. We turned it sideways and cut the bottom off of a steel garbage can to keep the light from spilling everywhere. As a result, we got these incredibly hard shadows.

But I really feel like seeing things in a soft-light way. In fact, I remember seeing *Yankee Doodle Dandy* on television in this pastel type of color. It was soft and incredible. It looked like it was shot on Agfa, though I realized that it had been colorized. It was black-and-white film that was sourced in a soft, realistic way and then brought to life in color.

We have to remember the transition from black-and-white into color. I think producer Harry Cohn had a mandate at Columbia Pictures that nobody could shoot over a F2.8 because he didn't want to pay for bulbs or for air conditioning. So they were stuck at, I think Tri-X was ASA 320, which is fast now for color film, but color film then was ASA 5. They had to go from black-and-white, where they finally got enough mood, could bounce lights, diffuse them and play around with softer contrast, and then step onto a stage where they had ASA 5, ASA 8. They had to go back to hard light and really express things strongly. So it was an evolution followed by a devolution.

Now color film stocks have evolved to such a point where, depending on the lenses and the location, we might not need

any lights. We can shoot on certain streets in certain cities and just have a little card fill for the actors. If the scene is set in a car, we can bounce a little off the cigarette ashtray and we're rolling. To me, that's illumination — it isn't lighting. When I shoot on streets like that at night at ASA 500 at T1.3, I have many more flags and solids up that take away ambient light and actually cast another double, triple or quadruple shadow from the street lights that are now at three or five foot-candles. These are measurable amounts. With two foot-candles, if the set's lit to five, that's a 2 ½-to-1 ratio. So I start taking away the 7-Eleven sign that's across the street; I flag that out, which is a luxury compared to where things started with color film.

Do you think that as technology has advanced, technique has followed?

It's hard to know which came first — the chicken, the egg or if we just had a chicken omelet. We won't know what went into the frying pan first. Cameramen want to express things within a range that they feel comfortable in. Producers also want to do things in their range because time is money. Therefore, if we take time to be creative, we cost more. So what's the secret? Do I want film that's ASA 1600 out of the box? There are demands, and the legacy of the demands that come out of making movies probably do not add up to a straight line between creative requirement and technological achievement.

Where do we go from here in cinematography? Are we headed for disaster or is there hope?

The hope, collectively, in our future as filmmakers is based on the fact that we tell stories with pictures. Somehow, we've found a way to connect with an audience, in this case, the people who will pay to sit in the dark. I tell my crew that this is the only reason we're here: to give people a legitimate reason to spend $20 on two sodas and a vat of popcorn. That's why we make movies. People write novels, they write magazine articles and all kinds of other things that communicate with an audience. But the information that moves someone is completely different. We can look at *Finding Neverland, Ray, Titanic* or the latest *Star*

Wars and find a story there that will attach itself to an audience. We are the people who translate the story into pictures, even if we only have a Bic lighter as a source of light. It doesn't really matter. We have to be one of the layers of filters that the story editors deal with, on top of the assistant directors and everyone else who is an artisan in the filmmaking process. Not an artist per se — because, apparently, those are only allowed to be the people in front of the lens — but the rest of us are the hewers of wood and the drawers of water who are literally in the shadows of a film set. We're the ones who help communicate the story. The writer had the story, the producer nurtured it, the director helped translate it to the actors, and we're the ones who tell it through the matte box onto the celluloid and, eventually, into the theater.

The reality is that there is a bottom line to every enterprise, whether it's making semiconductor chips or SUVs on an assembly line. We are lucky to be separated from that, in that there is an emotional connection in our work. It isn't a business transaction. The collective emotion makes a difference. I see films and television shows, even documentaries, that don't have a passionate connection to the subject, and that makes a huge difference in their reception. There are machines used in the making of films, so there have to be people attached to those machines, because it's only people who are going to watch the by-product of this machinery. The same way that people who make semiconductors and SUVs derive something from it, our source of inspiration has to come flooding, bouncing off the screen and into the hearts and minds of moviegoers.

Mark Irwin, ASC, CSC, was born in Toronto, Canada. He attended film school at York University in Toronto. His credits include Bat*21, The Fly *and* Kingpin.

Johnny E. Jensen, ASC

Who are you and what do you do?

My name is Johnny Jensen and I'm a cinematographer.

How did you become a cinematographer?

Originally, I was educated as a mechanical engineer in Copenhagen, Denmark. I immigrated to this country to look for gold. It came in little pieces, but I finally found the pile. I had been involved with racecars in Europe when I met Fouad Said, who was building a truck that fit into an airplane and carried all the equipment to do small films. He had done the *I Spy* TV series. He wanted more power in the generators, so that's where I got involved in developing the motor and eventually in building the truck. So I got on the road, got on a film set, looked around and decided to pursue becoming a cinematographer.

How did you make the transition from mechanical engineering to cinematography?

First of all, it took a while because of the unions in those days. It was basically father-son. So I stayed with Cinemobile for a while and got contacts in the business and eventually got in the union as an assistant cameraman.

Let's talk about technique, technology and style. How does equipment affect style?

Let's take it back to the Cinemobile and the equipment that went into this truck, which was a Ford Econoline truck that was

very, very small. We didn't have Mitchell cameras; we had blimped Arriflexes, which were smaller. We used Colortran lamps and not Fresnels. It was a hard light that you couldn't cut with flags because it didn't have the lens in front, so you'd bounce the lights instead. So a style evolved from having very little equipment — by necessity, basically.

What about today?

I am, ironically, being a mechanical engineer and very mechanically minded, not very influenced by mechanics and tools. I find that I use them strictly as tools, but I do keep up with whatever there is, in terms of equipment. I would, however, never design a style because there's equipment available. My sense of style comes from many other different things. Basically, they're choices. I will use the equipment to help my ideas format into a style, but they will be secondary. In other words, my inspiration starts with a script. If it touches me, then I will have something to say about it. That's not necessarily what you need to do on a job, because you have a director and you have a writer and it's an individual interpretation.

You look to the director to see if he sees it the same way you do or if he sees it entirely differently, which might or might not be interesting. It might be totally contrary to how you see it. If there's a conflict of ideas, nothing and no mechanics can bridge that and I won't do it. However, if you find a common ground, it may be helped by the choice of what equipment is available. I rely on old-fashioned aesthetics of storytelling and how it's going to be done pictorially. That might be how the style evolves out of the story. Is it a picture that has a lot of women in it? You may need to use filtration for one particular woman, so you then need to change the look for the whole picture.

Give us some examples of your favorite films.

One of my favorite films that started with an absolutely great script was *Rambling Rose.* It was shot in the south, happening in, I think, the mid-1930s, maybe 1934, and women were the priority of that movie, even though it was told through a boy's eyes during his experience coming of age. It was written by Calder

Willingham and it was basically an autobiography. I was working with mother and daughter in the script, and I wanted to make the mother, Diane Ladd, look pretty. I chose to use filters and, consequently, filtered the whole movie to changing degrees so that it would fall right into the whole picture. I also chose to shoot it with sepia tone filters because, at that time, which was unlike now with what we can do in this digital age, I wanted browns in there and they had to put it on the negative. This idea came from having to photograph women, and the choices of filtration were made and the look of the picture changed accordingly.

Tell us about the digital age of film.

I just finished another period film that takes place in 1950 and is based on a true story about the U.S. soccer team going to the World Cup in Brazil. A lot of the picture takes place in St. Louis, which was the hotbed of soccer, particularly in an Italian neighborhood where a lot of the boys who made the team came from. So, with a lot of soccer being played in this film, we shot 670,000 feet of film on 3-perf. There was going to be a lot of green in the movie and I didn't want a green movie, so I chose to shoot it on 3-perf and I basically forced the studio into doing a digital intermediate so that I could play with the secondary color spectrum.

What does that open up for the cinematographer?

There were a lot of things that were new to me. I had been an absolute advocate of film dailies. I have shot television with video dailies and had never been happy. To me, dailies are what you feed on for the next day's work. If you don't have that gratification, something is lacking. This time, however, because we were shooting 3-perf, we couldn't project the dailies. So I went for high-definition dailies and projected them with a hi-def projector and I was enormously pleased. I just color timed off of the dailies for a hi-def preview, and I have never had a film that looked that good for a preview. This was a new experience, which was very pleasant. I'm looking forward to doing the digital intermediate because I'll work off the negative. You know we

have all done these after the movies for television release and had all the tools to deal with, whereas the process of timing a picture for an answer print is archaic and hasn't changed in 50 years. So we're in for finer quality and a much wider range of using the tools to come out with the final project.

Johnny E. Jensen, ASC was born in Copenhagen, Denmark. His credits include Rambling Rose, Rosewood *and* Grumpy Old Men.

Francis Kenny, ASC

Who are you and what do you do?

My name is Francis Kenny, ASC and I am a director of photography. I am sometimes called a cinematographer. My profession involves the design, then implementation of space and light in the visual medium of filmmaking. In other words, I shoot movies.

How did you become a director of photography?

In my senior year at Hofstra University I met a professor, David Hoffman, who introduced me to filmmaking. I went to work for him immediately after graduation. He taught me how to shoot.

How did you start shooting your first stuff?

Our company purchased several 16mm and 35mm cameras. I started shooting documentaries for David Hoffman's company Varied Directions. The company became extremely successful and with that success I was afforded the opportunity to shoot. At first my work was second unit but within a year became the first unit. I decided to shoot feature films after meeting and working with Ed Lachman, ASC. Ed gave the opportunity to operate the feature film *Desperately Seeking Susan*. After that experience I decided to move to Hollywood and shoot features. I was very lucky to get a great script for my first feature, *Heathers*.

What is your favorite thing about cinematography?

My favorite thing about cinematography? That is a tough question. I guess the greatest emotion about cinematography is the feeling I get in the core of my soul when I execute a beautiful image that is metaphorical, translucent, beautifully composed, well lit as in being natural, and powerful. So powerful that it not only helps tell the story but hits my soul emotionally. It is almost like the feeling of falling in love. I love being able to visually translate the written word to an image, or series of images without the image appearing false. I ask myself the question, how can I best describe what a certain character is feeling with space and light. My references come from literature, paintings, films from great cinematographers, and of course my own life experiences. Visual metaphors surround us every moment of the day. It is in our dreams. Cinematography translates the mind's eye in to images. Perhaps every experience in life translates itself to an image. I guess it's my attempt to explain life. My favorite thing about cinematography is the ability to translate emotion.

What determines the style of a picture?

Cinematography is a left right brain job. It is a collaboration of many people. All who base their artistic judgments from the written words of the script. The Director is the person who determines the style by either having a specific vision or seeing something in a cinematographer's work that helps illustrate the words on the page. This process involves a tremendous collaboration between the director, production designer, custom designer and the cinematographer. All of these people work together to achieve the vision of the director. It is a team.

How do you come up with the look of a picture?

Lot's of meetings, discussions, screenings, art references, illustrations, "life" that is right in front of our noses, are the beginnings of a "look of a picture".

Where does style come from?

The word style implies an aesthetic choice. All great cinematographers have a unique style all their own in their process of creating images. In order to achieve a style, that could be called original, a cinematographer must know his tools and how to use them to create the desired image. Remember, cinematography is a left right brain job. It requires the ability to visualize an abstraction then use a tool to achieve that abstraction on to a physical medium for someone to see. It is having a visual point of view.

What is the relationship between technique and technology?

Every year, there is a new tool that changes the way we shoot movies. Technology makes our jobs easier with our struggle to translate words to images. Technique is how you use the technology.

How does technique affect manufacturer response?

Because filmmaking is such a passionate art form most good manufacturers of film and digital equipment are extremely responsive to making our jobs easier. Kodak, Sony, Panavision, Arriflex, Red, all of the good manufacturers are creating better machines and devices to make the technique easier. In most cases, changing the technique to achieve an image.

From other works of art?

I would simply refer to a Joesph Campell line about the hero's path being walked before us. The labyrinth is fully known. Our references are in the details of a human eye, a sunset, a dirty sidewalk, a beautiful woman, a strange hat, a flat tire, it goes on and on. Life is art and it is all standing right in front of us. From this we borrow after we learn to use our tools to translate the thoughts to an image.

Francis Kenny, ASC was born in Indianapolis, IN. He attended film school at Hofstra University. His credits include Ascension Day, Scary Movie *and* She's All That.

Richard Kline, ASC

What's your name and what do you do?

I'm Richard Kline and I'm a cinematographer.

And how'd you become one?

I started as an assistant cameraman at Columbia Pictures in 1943. I worked there for a year and a half, then joined the Navy for two-and-a-half years, after which I went to college for three years on the GI Bill. I then spent ten years as a camera operator and have been a DP for 44 years.

How did you get your big break?

I did features all my life. I did some television, too, as a camera operator and assistant. A producer named Bill Frug did a pilot and wanted somebody new and different, so he asked his three favorite directors whom he could upgrade from an operator to a DP, and all three said me. I met him and that was it. I was really lucky to be in the right place at the right time.

What do you like about being a DP?

I love the industry. I love every phase of it. Being a DP is extremely rewarding, without a doubt.

And you're a Californian, right? You guys always seem so happy.

I'm a true Californian: I was born here and have been a surfer all my life. California is God's country — we have the best of the best and the best of the worst, and they are both unbeatable.

Tell me about style and why a picture looks the way it does.

I think the word style comes after the fact. Generally, I'm assigned to a picture by the director. Either I've been recommended or he's seen some of my work. Whatever the case is, he arranges a meeting with me, but before the meeting, I insist on reading the script so that I can discuss the project intelligently. The director might have his vision to discuss or ask my thoughts about the look. Together, we might hash over other visual approaches and hopefully come to some mutual conclusions. We must feel comfortable with one another. If assigned to the film, we might view films for style examples, discuss paintings and shoot tests. It helps to be on the same wavelength, because filmmaking is a team effort, a collaboration. As cinematographers, our duty is to use imagery to accentuate the story and performances, create the appropriate moods and, above all, protect and properly photograph the performers.

In the '40s when I first started, the directors staged the scenes and actors to the camera, and mostly with stationary cameras because, back then, the camera had very limited movement capability. Today, directors can move all over the place, which can be good. They can also use the equipment's fluidity to their advantage. Technology has come a long, long way.

Let's use *Body Heat* as an example of change in style and technique.

Body Heat was Larry Kasdan's first attempt as a director. He was a writer for both features and commercials before that. I was filming at Warner Bros., where he had his office. He asked to meet with me to describe the project; he gave me the script, which I read that night, and then we met the next day. He selected me to do the film, even though it was just a brief meeting. I look back now and realize how fortunate I was to be a part of this very effective film.

To finalize the style for *Body Heat*, Larry suggested watching *Double Indemnity* together and, needless to say, I agreed with his instincts wholeheartedly. Larry wanted fresh actors and had newcomer Bill Hurt already lined up. He interviewed many women and finally tested eight, including Kathleen Turner, who eventually got the female lead. Larry certainly achieved his goal, with fresh actors, both absolutely perfect for their respective roles. *Body Heat* was a healthy collaboration, but we had some inclement weather problems, as we filmed during one of Florida's coldest, rainiest winters ever. We also had about 40 nights of shooting, a body strain under the best of circumstances.

One visual challenge was to create the film's steamy atmosphere. I used a variety of softening diffusion and fog filters that blossomed to subtly create the sweltering atmosphere. Because of Florida's cold spell, the crew and I were dressed in heavy, warm jackets, whereas the actors were skimpily clothed and sprayed to give a perspiration effect. They were always professional and good spirits. I admired them.

It sounds to me like you have to improvise a lot.

Filming is always full of zigging and zagging. My few set conventions are: 1) get a good rehearsal with the actors, 2) establish their positions, and 3) discuss the shots with the director. I also light the light source first. If it's an interior, I light the windows or fixtures and then complete the rest of the lighting balanced to the source. I don't read a meter until I complete that. Then, I choose an area I want to expose for and meter that. The toughest challenge for me has always been to match a retake or shoot additional close-ups later. Reproducing those exact visual moments is difficult.

A lighting blueprint I incorporate is emphasizing where in the frame a viewer's eyes should be focused. To use an analogy, I equate the tennis cliché 'keep your eye on the ball' with film, though in film it's changed to 'keep your eye on the screen.' But where on the screen? I had a tennis coach who taught me to look at a specific place on the ball. He drew a face on the ball with two eyes, two ears, a nose and a mouth. He showed me

that when you hit the ball on the nose, the ball travels flat; hit it on the left ear, it travels swirling to the right and so forth. The same theory is to draw the viewer's eye to a specific area on the screen where the storytelling is occurring. That can be achieved using a certain lens — a focal length that is sharp on the desired subject, leaving the periphery softer; a wardrobe or set color value that draws the eye; or light and dark or a pattern in areas that help emphasize the moment. It's all done by individual choice and feel.

Talk to me about working on *The Three Stooges*.

As an assistant cameraman and camera operator, I worked on 25 or 30 *Three Stooges* comedies, which was truly an amusing pleasure. They were lovely people and great characters and wonderful raconteurs. I didn't work with Curly, only with Mo, Shemp and Larry. Even though they were good friends and two were brothers, they often bickered: "You're hitting me too hard! Why'd you have to hit me so hard?" There was never a dull moment.

The director, Jules White, who directed most of the episodes, had a limited sense of humor and thought he was directing Shakespeare. He wore an ascot and directed through a hand megaphone, usually screaming direction around it and often loosing his voice, then asking for pity, which he never received. Often, he was just as amusing to watch during filming as were the Stooges. The sets looked like a garbage dump or war zone at the end of the day after pie throwing and the many other sight gags. Working with them was truly a highlight of my career.

Speaking of characters, tell me about Orson Welles and the billboard.

The highlight of my career was when I came out of the Navy in the summer of 1946. Columbia Pictures called me to come back to work as an assistant cameraman and asked if I could leave immediately for Acapulco. My answer, of course, was yes. The film was *The Lady from Shanghai*. Orson Welles was the director and the film was with Rita Hayworth, his then wife, and some of Welles' Mercury Theatre. The icing on the cake was the pres-

ence of Errol Flynn, though he was not in the film. The production leased his yacht and he came as the skipper. He was unbelievable to be around. He was the man's man of all men — classy and ruggedly handsome, witty, devilish and much more. Errol's yacht was named Zacca, but he had so many dames in and out of his yacht that we referred to it as the "cock Zacca."

Orson was a never-ending source of excitement and enjoyment. He was inquisitive, curious and interested in everyone and everything. I followed him around like a puppy dog and listened to everything he said. He was the most interesting person I've ever been around. There was a studio executive assigned to keep the picture on schedule, which it never was. His name was Jack Fier, a very tough man with a great heart. Jack was bald, had a booming voice, carried a swagger stick and looked like Erich von Stroheim. He and Orson had an ongoing conflict — actually, a friendly enemy one-upmanship.

As an example, when we returned from Acapulco and began shooting on stage, Jack barged in one day and asked Orson, "Do you need the treadmill tomorrow?" Orson asked, "Why do you ask?" Jack answered, "It's Saturday and it means the treadmill crew will be on overtime." So Orson answered, "In that case I'll definitely need it." Orson always got the best of Jack until the next to last day of filming when Orson personally painted a banner that he hung outside the stage that read, "There is nothing to fear but Fier himself." I thought nobody could top that but Jack did. The next day Jack posted his banner outside the stage that read, "All's well that ends Welles."

In those days, the studios were loaded with similar antics and loads of great wits and characters who played unbelievable pranks. The studios were more like family and it was tolerated. I was lucky to be around then and still feel lucky to be a part of this great industry, an industry that has been very good to me.

Richard Kline, ASC was born in Los Angeles, CA. His credits include Star Trek: The Motion Picture, King Kong *and* The Boston Strangler.

Fred Koenekamp, ASC

What's your name?

My name is Fred Koenekamp.

What do you do?

I'm retired now, but I was a director of photography, or cinematographer.

How did you become one?

My father was a special-effects cameraman. When I grew up, I was really an aviation buff. I really wanted to be in the air and fly and I did. I took lessons and so forth. I really hadn't thought that much about this business yet. In the old day I used to work a six-day week, so I would go to the studio with my dad on a Saturday and watch him work. It was particularly interesting because he was doing effects things, like miniature trains and miniature airplanes or whatever, which was fun stuff to watch. World War II came along and I went overseas in the Navy, and when I came back I was thinking about aviation, but a job opportunity came up at RKO studios as a film loader, which in those days was where you started. Also, I had met a young lady, and was seriously thinking of getting married, so I decided I would not go back to school. I would take this job and get started. It was funny, even then as I went into the loading room, I liked working in it because it was the camera department at RKO. And in those days, all the majors had camera departments in the studios. RKO's was a really good one, because it was not only a camera department — they had the camera machine

shop there, the still lab upstairs and the special effects with Linwood Dunn [ASC] all in one building. So it was a rather interesting place to be.

Really what started me thinking about the business and got me turned on to it was, as a film loader, one of my jobs was to go up to the sets in the afternoon to pick up the exposed film and bring it back to unload it. Well, the more I got on the set, the more I wanted to hang around and watch them work. It was really beginning to be fascinating. People were running around and all doing different things. I got to know a lot of the assistants very well at the studio, and they would talk to me when I'd come on to sets. It got to the point where I would have a hard time leaving the sets because it was so interesting there. I decided, OK, I want to get on a set; I want to get out of that film loading room and down to a set. Well it took a few years for that to happen, because the studios were very up and down at that time right after the war. You'd work a few months, then you get laid off, and then you come back for a few more. It was kind of crazy for a while. It took about five years, almost six, before I got promoted to assistant cameraman. That was right on the RKO lot.

My first picture was a picture called *Underwater*. The old cameraman, Harry Wilder, was the cameraman on it. It was directed by John Sturges and starred Jane Russell, who in that day was Howard Hughes' big lady of his life and so forth on the set. So that was my first break: to work on a set and become an assistant cameraman. I was really fascinated because we did underwater work and I got to learn how to scuba dive and how to do underwater work and use underwater cameras, and that was really fun.

We finished that picture and, lo and behold, there wasn't anything coming up right away at RKO, but MGM Studios called RKO. Remember the old Ester Williams water pictures they used to do? They were doing one of those, and they needed an underwater assistant, so I went over there. This is my famous story. I went there for a month's work and I ended up being there for 14 years, which I loved, of course. It was a great studio.

I really loved being over there and of course they had a great camera department.

How'd you get your big break as a cameraman?

I was still at MGM and had been made a camera operator and worked at that for a few years. Business slowed down, and I went over to *Gunsmoke* as a camera operator. About four months after I got over there, I got a call one day on the set, and it was from the head of the camera department at MGM. They said, "There is a producer over here who would like to meet you, and maybe we can line you up to be promoted to first cameraman and shoot his TV show." So I said, "I'll be there in a minute." I did. I went over and met the gentleman and the first show was a marine story, a Marine Corps story called *The Lieutenant*. It was in black and white, of course. I went back over to the studio and started to prepare to shoot this, and the big producer on the show was a gentleman by the name of Norman Feldman who went on to be a big part of my career, so I'll get to him in a minute. We went ahead and shot *The Lieutenant*, and obviously it was the thrill of a lifetime.

There's a story that I like to tell, if it doesn't take up too much of your time. There was a cameraman over at MGM in those days named Bill Daniels [ASC], and he was probably one of the biggest cameramen of his day in Hollywood. My first set looked like a great big open barn. It was actually a courtroom, but it just looked huge, and how can you make a big room like that be interesting? And how do you light it fast, because they'd already drummed into me — "you're going to do television and you've got to do 12 pages a day." I looked at that set and I was leery of it. That first week of prep going in there, it was a little spooky. How are we going to do this and make this look halfway decent, but do it fast? Well, Bill Daniels happened to be in the camera department, and I started talking with Bill, who was not really a warm type of person in that sense. But all of a sudden, he said, "Come on. Let's walk down to the set and I'll look at it with you." So he did. He walked down to the set with me and he looked at it and he came up with some projections about how to hang some little coops with some silks or things around them

to keep the walls down and so forth. He gave me a lot of good little hints. And I always remembered that. Here's a real big-time cameraman who took this new kid and his first set and just got him through it. It worked out fine. We got through the days work and we went on and kept shooting like that. But I just always remembered that of him.

You grew up in what was probably the most exciting era of cinematography. How did the styles change, and how did the equipment make it change?

Let's go with equipment first, because that'll end up changing the style, too. When I first came to the business, nothing had changed in years. The guys were telling me about, "This was the same thing we've had for years" way back when. The lighting was all heavy, huge and big. Everybody was still using big arcs. We didn't have crab dollies or anything like that. At RKO, when I was there, two guys in the special effects department built the first crab dolly. That was the first one built in Hollywood. And, of course, Chapman Fisher and people like that have taken it over. That was kind of a fun thing. It was an exciting piece of equipment, because nobody had ever seen anything like that. They weren't laying track anymore; they were laying plywood. It was a whole new ballgame.

After I became a first cameraman, the changes really began to happen. The first thing that really happened was, of course, Panavision, which is a company that I admire a lot. I think they've done so much for the motion picture business and the cameramen. I also had the privilege of working as the first assistant cameraman on the first Panavision picture ever made, which was *Raintree County*, so I've been with them since their day one. Camera equipment changed drastically. They went from BNCs and God knows what else. RKO had its own blimps. MGM had its own blimps. All those were little things that they had in the business. Then, all of a sudden, here came Panavision with the first reflex camera. I kid the new operators with, "You don't know what you missed not having a finder on the side and a foot of reflex to play around with." That was a big boon to cameramen, camera-wise.

Then lighting was a big, big thing that we needed to change, and they did finally start changing it — with Mole and people like that. They made lighter units to work with. Then the biggest boom that happened in lighting was the HMI lighting. HMI lighting, to me, was just a fantastic step in the right direction. On my last few pictures, we never carried an arc anymore. It was all HMI. Now you've got great lighting equipment, great camera equipment, and people like Chapman, Fisher and some other companies out there have built wonderful camera booms and dollies and so forth. So yes, in the last 20 or 30 years, there's been wonderful equipment brought into the business, and I think it was a big boom to all of us.

In what ways did it help us?

It helped you in a lot of ways. The most important one was lightweight equipment — easier to move around, easier to work with on the set. Let's get another step into this. We have to give Eastman Kodak a lot of credit. Over this same period of years, they kept improving, improving, and they're still doing it. They're still constantly coming out with new films. And they're so fast now they're almost too fast. That was a big boom. When I was first starting in television as a cameraman, I worked at 200 foot-candles. In those days, I worked with foot-candles. When I ended up working, on my last picture, I was working at 20 foot-candles and still working at a 3-stop. Those are your things that help everybody in the business. It's time. It's money. And it's much easier to work with and much nicer to work with.

Does improvement of equipment only allow us to work faster, or were there other benefits as well, in terms of style? Did it change the look of the picture?

I really can't say that it changed the look on a picture that much, because it's basically trying to achieve the same thing that you're doing on the screen, but it just made it easier to do. Nicer equipment certainly. It certainly was easier on the stars, because you were working at much less foot-candles. You didn't have to burn everybody up and have such hot sets. That certainly was a big boon.

You probably got better performances out of the actors.

I would certainly think so. The set got a lot cooler. I can remember the old days when it was so hot on the set. The sets would just get so hot. That's a big step.

What about the ability to go handheld, which you couldn't have done before?

Well, I was always a handheld fanatic. I really liked handheld work, and even as an operator, I used to use the Arriflex and use it a lot. My first big television show was *The Man From U.N.C.L.E.* series, and we used the handheld camera on that a lot. I had a great operator. He just was strong and husky, and he could really handle that camera. We started something that I think has played a big role in how they shoot films today. As you recall, way back, all you could do if you needed a close-up of somebody in a car or on an airplane or anything like that, it would be process photography. Well, they couldn't afford to do process on television. It's time consuming and so forth. So my operator came to me and said, "They want to do some running shots in a car." He said, "Let me try something." We took a piece of sponge rubber and put it on the hood of this convertible car. He got on there with an Arriflex, and they had just come out with the first FAY light. The FAY light at that time was just a single one-bulb unit. It was an exterior light, which was fine for what we were doing. We put batteries in the trunk of the car, and I got on there with him on the hood and handheld the light, and that was, to me, the start of the poor man's process, as we call it today. Of course, it just got improved from then. It was great what the grips and other people built and came up with, with all the wonderful platforms to put cameras on to make running shots. Process has almost become a thing of the past.

You were like a human car mount.

I was a human car mount. I guess you could say that, yes.

Let's talk about good crews and having fun and enjoying yourself.

It's amazing. Many years ago, right after I became a cameraman, a very famous cameraman at that time was named Charlie Lang [ASC]. Charlie was talking to me one day, and he said, "There are two things I'd like to tell you, Fred. Save your money, but surround yourself with a good crew." In my speeches to students, I tell them, "I didn't do very good at money, but I lucked out on crews." What he said turned out to be the most sensible piece of information he could have possibly given me to think about. From the very beginning I had good guys. I had such a great operator and good assistants. When you work year after year, month after month, and the hours we worked on a set and on locations, you're with your crew really more than you are with your family, which is a strain, but that's just the way it worked out. It was terribly important to me to have people around me that not only were good at their jobs, but guys you could talk to during the day, and maybe even kid about here and there and go out in the evening and have a drink together or something on location. I made it a point to have guys I felt real comfortable with, and it worked out wonderfully that way.

Just to show you how good I thought of the guys, I had three young kids I started all out as assistants, and they went on to become first assistants. All three went on to become my operator, and today all three of them have become first cameramen. That's a nice camaraderie among your own people, to know that they went ahead and did well. It's a good feeling. To walk on a set in the morning and have your first cup of coffee, my grip used to always have my chair right there for me, because I used to keep my script in the chair. I had one script at home and one script at work in the chair. And that was his routine in the morning.

Operators are, to me, probably a cameraman's best friend, if you really think about what they can do. Good operators, you rely on them for composition; you rely on them to see things you might have missed. And something very important, you rely on an operator to have a good feeling with the director. After all, he is the director's eyes. That's what it amounts to. At the end of a shot, who do they all look at? They look at the operator. You needed an operator who could say, "it was great" or "this didn't look quite right" or "that person lined up." They need to come

out and express themselves. I just love good crews, and I just love to have them around me.

Talk a little bit more about relationships with the crews. How about with the gaffer and the grip?

Oh, it's same thing, of course. I had a gaffer — a gentleman who's not with us any longer. He was with me for 22 years. And he was absolutely excellent. Our wives knew each other. We became good friends. We'd go on location and our wives would join us and things like that. It was family almost. The grip was in that same category, a really good grip. I know some cameramen might not agree with me on this one, but I say that the reason I love a good gaffer, particularly, was if we got the setup, if we'd already rehearsed a scene and knew what it was going to be, I could rely on a good gaffer to start working on the background or something like that while I — because I loved to lay the camera out — would lay out dolly shots or boom shots or whatever it was that we were doing. Then I would join him and we would start lighting people in the foreground. Also, by having somebody who's been around you for a long time, they get to know you and what you want and how you're going to act. That certainly makes it easier.

Take us through the process of laying out a shot for a movie. How does an idea get from the script onto the film?

Over the years, I've had many young cameramen ask what I could tell them was the most important thing to learn and think about as a young cameraman. I have a very set thing in my mind about this. I learned it myself the hard way over the years. You've got to know the script. That's number one. Read the script two or three or four times. Make notes in it. Try and know that script as well as the director knows it. The next thing is get to know your director. One director may be fantastic. He wants to be with you; he want to talk to you. Another director may just want to kind of push you aside. That does happen.

I'll take a director like Franklin Schaffner, who was my favorite director. He was a perfect easygoing gentleman who was just a

wonderful man to be around. He was not only a very knowledgeable man, but he knew the script inside out and he could rewrite. We had a routine going on the five pictures I did with Frank. We would sit in his office and go through the script, page by page, and that way you could make notes in it, like this is going to be a multiple camera or this is going to be a low-key. Frank made a real nice comment after two or three pictures with me. He said, "One reason I like working with Fred is, by the time we start shooting, there's not that much conversation. We've got it all pretty well ironed out." That's fine, because I like to work like that. I like to think ahead as a cameraman — to know what is going on next week and the week after.

To lay out a shot, the first thing, of course, is the director will bring in the people and the assistant director and so forth. By this time, you should know the script very well. The director will rehearse the actors and the assistant cameraman is out there giving himself marks and so forth. By the time they've rehearsed it, you've already watched and you've already started to put things in your mind, like where you want the camera, if you're going to use two cameras or one camera, if it's a boom shot or a dolly shot. Then you begin to think about lighting. Is it going to be a fully lit shot? Is it going to be a low-key type of situation? Is it going to be a backlight situation? All of these things are going through your mind when you're lining up a shot on a set. Once they've rehearsed and they've given it to you as a cameraman, you really are in charge. That's one of the fun times. Again, when you have a good key grip or a good gaffer or a good operator who has been with you for a long time, which was the biggest break of my life, they all start working together. They know what is going on. Nobody stood there and looked at you and said, "What's the next move?" You don't want that. You want things to get moving, get organized and line the shot up.

For beginning film students who don't know, can you explain the difference between high key and low key?

If you're doing a dramatic scene — let's just say it's a love scene — two people in a room. You'd want it to be romantic. Now we're going to get into the low-key side of lighting. You don't

want to blast a lot of front lighting in there and burn them out and make it uninteresting. With low key, you get half-lights on faces and a little backlight on the hair to bring it out, particularly on women. I think every cameraman will agree on this one: Your backgrounds are what drive you crazy. Are they out of balance? Are they too bright? Are they too dark? It's funny, because you wouldn't think that the backgrounds would be that big a thing. I always found that a background could get away from you, because by the time you start lighting people, a little bit of that light is going to drift back into your set. You don't want to pull it away from your people. You want the people to be what the audience is looking at. I don't personally believe in getting so dramatic in light that you lose eyes and faces, because eyes are the key to the actors telling the story.

Let's talk about the varying styles of pictures that you've done.

That's a topic that's come up with me before. It's kind of hard because I didn't ever want to be one of these cameramen who said, "Well, he's a Western man or he can do musicals or he can do mysteries." I wanted to take the job that came along and be able to do it, and not be stylized to the point that you got stuck doing that kind of thing all of the time. Every picture that I got, I kind of played it by what I thought the script deserved, or the feeling you should put into that story for that script. Some scripts are really hard to light the way you'd like because they're talking scripts where people are just standing around talking. To me, that was always the most difficult to make more interesting. I love action pictures. I've always loved action pictures, because it gives you something else to go to besides dialogue and people talking to each other, not that talking isn't important.

When we did *Patton*, this was an interesting story to me from the very start because I was in the Pacific during World War II. I didn't work in the European theater, but we knew of Patton. We read about Patton. He was in the newsreel. He was in magazines. To get that script and to do that story was a fascinating project. People have said since then that *Patton* really isn't a war picture; that it is the story of a man, a general, a great general, and I believe that to be true. Of course we didn't have HMI lights and

things like that in those days, so we had to use our arcs and some of the older, heavier equipment. That was also in 70mm. I don't think there was a particular style to that picture.

Then you take a picture like *Papillon*, which is a different story. It's the story of a man again. Here are two pictures that are stories of people, true stories, but *Papillon* was more of a depressed, down type of thing. The guy went through such hell in his life in prison. In that picture, we played up the cells and the feeling in the jungle. I wanted it to look as miserable as it really was. Fortunately, we got to take a trip down to the real Devil's Island to photograph the prison for the title backgrounds. Of course, it's all shut down and rotting to pieces down there, but still we saw it. It was a fascinating, interesting thing. To think that people lived there, it was unbelievable. Those pictures are two opposites, in the way they feel and the way they look.

Then we did a picture like *Islands in the Stream*, which again was Franklin Schaffer. That picture to me — from the very beginning reading the script — I just felt this picture should be pretty, as pretty as possible, because it was not a heavy, dramatic story in the sense of tragedy or people being hurt or warring. It was basically, this man, his lonely life and his kids. They had this beautiful house that they built over in Kauai. How else could you photograph it? It had to be pretty. I came up with a filter pack on that picture that young students might be interested in. As you know, working in the tropics, it's so bright and so pretty, and everything is so blue and green and the clouds are so white — it's too much! So I came up with a filter pack. I used a quarter fog Harrison filter and a half coral with the 85 on the camera. What that did was take the curse off of the overall brightness and sharpness. It wasn't enough to notice it, because I don't like that look either, where you've always got a fog filter on. It was just enough. That worked very well in that picture. I used it both on *Papillon* and *Islands in the Stream*.

The other thing I would like to mention is that I experimented in *Islands in the Stream*, because we had night work and I asked the director if he would be interested in doing day-for-night if we could make it work. He said, "Definitely," because he wanted

to see the beauty out there. Besides, if we had shot where we worked at night, you wouldn't have seen anything. It was just too far away. It was new to me. Other cameramen may have done it; they may be ahead of me. But I decided that day-for-night, the problem was as you underexpose some stops to bring everything down, you lose faces. So I overlit the faces. Even George Scott said, "What are you trying to do, burn me up?" There was so much light in there. I was using nine lights, but it worked because, proportionally, it all came down. When you underexposed it, it all came down together, so you still saw your faces against the background. To me, that was an interesting thing in that picture.

What has been most rewarding in your career, and what would you like to pass on to others?

To start out with, you'd have to really work in the business a few years to find out what a fascinating business it really is. When I think of all the interesting and great things and the locations that I got to go to, which I would have never done in any other business. That alone is something to think about, because I've been around the world. I get quite a number of letters from across the country and even some from Europe asking just what we're talking about now: How did you get in; how did you start? It's very tough to tell somebody how to start in the business today. The way I came into it, they don't have that kind of a setup anymore. I think young cameramen will find this to be so rewarding once they get past the getting-into-the-business part, which is the tough part. I know that.

The business is changing. I hear this from everybody I talk to. The politics may have changed, but as a cameraman it hasn't changed. You're still a cameraman and you're still going to do the kinds of things that cameramen do.

Fred J. Koenekamp, ASC was born in Los Angeles, California. His credits include Patton, Papillon *and* The Towering Inferno.

Matthew Leonetti, ASC

What is your name and what do you do?

Matt Leonetti. I am a director of photography in the motion
picture industry.

How did you become a director of photography?

I started as an assistant cameraman back in 1965. I worked for
five years as an assistant, three years as an operator and then
decided I should become a director of photography. I started on
some test commercials for Ford, and prior to that I had shot a
low-budget, nonunion movie when I was an operator. That gave
me a chance to get some experience, and after I did the commer-
cials I went and did a movie of the week called *The Elevator* for
Universal. That was my first official long form.

**How did you get training, how did you learn the tricks
of the trade?**

I felt it was important to sit by the camera and watch the people
I worked with — the cameramen, the operators — so I watched
them light and saw what they did with the camera and with the
lights. I'd think of how I would do it if I were in their position
and then I'd go to dailies and look at it and evaluate it. I used
the same process when I was an operator. Over that eight-year
period, I tried to put a little bit of it into my mental computer
and see what I could do with it in my own ventures.

**In 30 years of working, what have you learned about
lighting?**

I guess a few things, one being is that if you have a full face, the light needs to be farther to the 90-degree area as opposed to with a person with a little thinner face, for which you want to be a little closer to the 60-degree area.

Pretend I'm a film student you're trying to teach a few secrets of the trade to. What advice would you give?

The first thing I learned from an old-time cameraman assistant was that I should always keep one ear out for the set and one ear out for the cameraman. I would try to do that so I could know what's going on around me at all times. It's a bit of set etiquette, and it actually helped me become a better cameraman, because I could anticipate things. That's one of the things I learned.

Another thing was learning to work in foot-candles. I learned that from gaffers who grew up in the '30s and '40s. Working in foot-candles was very important, because it's a lot more accurate than F-stops, especially in the days when there were only analog meters. If I'm working in 35, 40 foot-candles, and I'm off five my exposure would be off, I'm actually off ¼ of a stop, which means the printer points change, and the look can change.

I also learned about balance. My dad, who was a gaffer in the business, taught me that photography is balance and separation. I try to balance the person and the set, and I've always been a fan of letting the person stand out in the set. When I do that and have the set lit in the background, I almost get a 3-D effect. I remember once I was doing a movie, and I was lighting streets in New York, and the producer looked at the film and said, "It looks like 3-D!" That's because I lit the foreground — sometimes I let the middle drop off — and I also light the background so there's a depth. That's the basis of my photography that I have tried to adhere to and follow in most of my movies. I think it has worked out quite well.

Can you provide examples from some of your movies about how you arrived at their look?

I start with the story. I read the script, of course, and I think the photography has to follow the story; it has to enhance the story.

That's how I approach it. Obviously, if I have a comedy, it will have a different look than a picture I did called *Poltergeist*, which had a lot of effects — some mechanical effects, some visual effects. I set in my mind what I want it to look like, what I want to see on that screen at the end of the day, and I take the information and knowledge I have and use my equipment, personnel and lenses and apply all of them as tools for the particular film. For me, it's a vision, and I think if you don't have a vision, you'll never see the end product as you want it to be on that 50-foot screen.

Matt Leonetti, ASC was born in Los Angeles, CA. His credits include Breaking Away, Fast Times at Ridgemont High *and* Star Trek: Insurrection.

Matthew Libatique, ASC

Who are you and what do you do?

My name is Matthew Libatique and I am a cinematographer.

How did you become a cinematographer?

I got into cinematography pretty late. I didn't know what I wanted to do until I was about 20, which was when I was introduced to filmmaking through an organization. At the time, I was an undergrad at California State University at Fullerton. I loved films, but they weren't something I entertained as a profession. I remember watching *The Conformist, Do the Right Thing* and *Last Tango in Paris*. When *Do the Right Thing* came out, there was this energy in filmmaking that just swept me away and I became enamored with cinematography, realizing that the director wasn't the only person on the set. And I gravitated toward camerawork.

How did you get your big break?

I did a film called *Pi* with a director I went to film school with named Darren Aronofsky. The film cost $30,000 and we made it with the goal of entering it at the Sundance Film Festival as a midnight movie, but it became a cult hit and, all of a sudden, people like Joel Schumacher rang me to shoot for them. Soon after, I was shooting my first studio feature.

Though the beginning of my career as a cinematographer was in music videos. When I got out of film school, I knew I was not going to make a living doing films, so I concentrated on building a short-form career.

Do you bring any of that experience to what you do now?

Music videos were the ultimate training. My early mentors were Ed Lachman [ASC] and the late, great John Alonzo [ASC]. They always talked about their days doing documentaries. I never did documentaries, so music videos were my training ground that taught me technology and let me study different references. I grew as a cinematographer by virtue of the fact that I was doing a different project every week. Those experiences also built my stamina, because it is like running a marathon every day — working 14 hours and executing countless setups.

How is technology related to style?

Style is born out of the director's vision, the screenplay and the characterization of the actors. The technology is just a reaction to whatever we deem as the atmosphere or language of our film. Ultimately, we seek the technology and methodology that best serves the collective vision.

How does style happen?

It happens through the deconstruction of the script as well as becoming familiar with the director and how he or she wants to tell the story. I try to build a visual language by separating structural aspects of the story, like the character arc, and then putting them back together using techniques of palette, contrast, texture, movement and light quality.

Can you an example of how the look of a certain picture evolved?

In *Requiem for a Dream*, the film went through three seasons, starting in the summer, transitioning into fall and then ending in the winter. A way for me to distinguish between the three acts was to exploit how Tungsten stocks render color temperature. Warm filtration and lighting to 2,500 to 3,000 degrees achieved the optimism of summer; 5,000 to 5,500 achieved the excitement of fall; and lighting with cool, white fluorescents achieved the eventual despair of winter. That was an easy way for me to create a language so that the audience could feel a transition

occurring in the film. It was a story about everyday people who dream of a better life and end up somewhere unforeseeable. My goal was to make the audience forget what the beginning looked like by the time they reached the end.

How about another example?

Phone Booth is a film I shot in 14 days. That film was just naturalism and all I did to create that world was shoot Tungsten film in daylight with less than 85 correction, so I could render it cooler than normal and time a lot of cyan into the print. I began the film shooting in 5245 and on telephoto lenses, but as the character deteriorated and his 5 o'clock shadow began to appear, I pushed the cameras toward him with wider lenses. The film is a morality play, and I tried to gradually introduce more texture into it. By the end, I was shooting 500-speed film and pushing the film two stops.

How about one more example?

Pi was a situation in which we did not have the means to do color, so we did black-and-white, and I didn't really have the crew or expensive production design to create the look of the film. We looked at films like *Let's Get Lost* and graphic novels like *Sin City*, and we did a test with black-and-white reversal, so the look was really born out of necessity, and it worked out.

Let's talk about technology.

One of the things that is shaping the look of films is the changes in film stocks. Kodak has done an amazing job of providing new print and negative stocks, and in looking at contemporary films, there is a consistency because of the Premier and Vision print stocks. When I look at a film like *Elephant* or *Phone Booth*, the film stocks are truly what set those looks apart — from a lower contrast 500 stock in *Elephant* to a higher contrast one in *Phone Booth*. It is a way to distinguish one's film greatly.

What about lenses and cameras?

Cameras don't matter to me, as it is the lenses that really matter. Cooke and Primo lenses are fantastic, but there has been this movement recently to go back to using Zeiss Speed, Cooke Panchro, Baltar and Kawa lenses. All of those are available, so it is really about the ideas. We have to know about the technology that is out there and how to use it to benefit the ideas.

Processing is also important. Talk to Beverly Wood at Deluxe and she will inform you about how to get certain looks through photochemistry. I love things like the Technocrane and Arricam, but we can also shoot a beautiful movie with an Arri BL4, so I don't get too enamored with new technology. Another thing that has changed cinematography is Kino Flo because practical locations were embraced and ceilings were going back onto sets.

What is the biggest aspect of style?

That it doesn't get in the way. Sometimes, a lot effort is wasted on unnecessary style, which can diminish the power of the story. I am attracted to certain looks that grab me, but the danger is that we have to make sure the style is serving the purpose of the story.

What about commercials?

Commercials are about selling something, so I don't place as much importance on style, in terms of what the story is trying to say. As cinematographers, it is a place where we can experiment.

What is your philosophy on cinematography?

Cinematographers are storytellers and it is our job to visually articulate the story.

Matthew Libatique, ASC, was born in New York, New York. He attended film school at the American Film Institute. His credits include Requiem for a Dream, The Fountain *and* Everything Is Illuminated.

Stephen Lighthill, ASC

Who are you and what do you do?

I'm Stephen Lighthill and I'm a cinematographer.

How did you become a cinematographer?

My first love was journalism. I went to Boston University. All the cool students were film students in the school of communications. I actually got interested in still photography first and worked for a couple of small weekly newspapers in Connecticut. Out of that grew my interest in documentary films, which is where I've spent most of my career. I also started shooting television news.

Was this in Boston?

I did a stint in the army in the '60s and then moved to San Francisco, where I was a stringer for the evening news for Walter Cronkite and CBS. It was a great time to be involved in journalism, because San Francisco was a happening place on a cultural and political level, so that was my real graduate school — shooting news and documentaries. In the days when I shot for CBS, we shot on 16mm film. On the network level, we had a three-person crew. I had a camera assistant and a sound person, so it wasn't the one-man band thing it is today. I fell in love with lighting and actually learned to light by lighting faces and shooting long interviews, where I could stare at my mistakes through the viewfinder for hours. I learned portrait lighting the hard way. After doing the news, I got into long-form documentaries, which were mostly historical.

What are the differences between lighting documentary and long form?

The techniques for documentaries and features overlap and inform each other. Often, documentaries are emulated by fiction films. In documentaries nowadays, I'll often see re-creations of fictional sequences, so both schools inform each other. Growing up in the '60s and '70s, I ran in the street covering riots and demonstrations with a camera on my shoulder, so minimal equipment was my starting point. When I crossed over into low-budget features, that naturalism was the first place I went. It's where I go back to as a starting point even now. I love naturalism. I love the way the real world is, and it's hard to improve on the real world and the way that great lighting can occur by accident.

How has your particular style evolved on projects?

I've found myself shooting hour-long dramas quite a bit since the '90s. That is very fast work with schedules that are six to eight days of shooting per episode. We are producing 46 minutes of show in that time, so my techniques have to be practical ones. They have to be things that I can execute in a reasonable amount of time. That's what informs a lot of the technique. Having said that, on every show I do, I establish my own style.

Also, the dirty little secret about series work is that we're on the same sets and locations a lot, which allows us to really refine the style of the show as we go on. We can get great-looking work done because it is, to a certain extent, repetitive. So we get the opportunity to create a look that's all our own. That look grows out of the story and the characters. In television, the actors are in charge of the characters much more than in any other fiction form, because of the nature of the way the work is organized. The producers and directors are not on the set as much as the actors and the crew, who are led by the cinematographer. Thus, we create a special relationship with the actors, where the work grows out of the story they are telling, how they like to tell it and the physical issues with each actor. Some actors need to look harsh and others might be older actors who need to be taken care of in others ways. We use the whole range of techniques, including using beautiful soft light, all sorts of filters and other things that help us define a character.

Talk to me about technique and technology.

There's an interaction between technique and technology, which varies according to the project. For example, I shot a TV series called *Nash Bridges* for which I did a Steadicam move that was approximately six-minutes long. It went from an exterior through an interior, turned around 180 degrees and went out to an exterior again. We took 40 minutes to set up the lighting, and we shot it in five takes. It aired as one continuous shot. It had four aperture changes that were done by my camera assistant during the shot, but I always knew I was going to supervise the post and Telecine — which was really tape-to-tape and not Telecine — and that there would be places I could smooth out the aperture changes and darken the skies on the exteriors. I always had that as part of my plan and, without having that, it would have taken me much longer to light it. Knowing that I would have a daVinci Color Corrector with Power Windows added on to help me later, there was a tremendous amount I could do to make that scene work. And I did it quickly because I knew the tools.

Why should the cinematographer stay involved in post?

My argument when I talk to producers about keeping me involved in post is that the company works more efficiently if I supervise it. It works more efficiently, because on set, I know when I skimped on a little bit of lighting or when something was off in the exposure, which I did knowing I would deal with it in tape-to-tape. At the same time, when I'm in tape-to-tape, I'm fast at making decisions because I have the whole vision of the episode in my mind. Also, I can make decisions that someone who wasn't there for every scene might fumble around with, saying, "I color corrected this scene here a little dark and I have to go back now." But I know the whole trajectory of the story and the way I've lit it. I do color correction really quickly and that's what I say to the producers: "You want me in there." I usually go in on my day off and I just have to indicate to the colorist what I want on essential scenes. We usually do the first few moments of each scene and then, once we have a good relationship going, he can complete it.

One of the things happening is that a lot of people and producers are saying, "How about we shoot this in DV?" And I say, "Do

you know what V stands for in DV? It stands for video and it hasn't changed that much. It is still cumbersome and not as good as film." There's a lot of press for DV because of the computer age we live in now and the fact that digital capture is pushed by companies that are driven by their sales to the consumer market. What doesn't get press are the great strides made in the making of a palette of film stocks that are greatly improved and available to cinematographers. Camera companies, including Arriflex with its new Arricam, are making amazingly compact and efficient pieces of equipment. For me, it's very easy to convince a producer — whether we're shooting in 16mm or 35mm — that I can do it faster, cheaper and better if we stay with film. The future for cinematographers has stunning opportunities because the equipment is so flexible and capable. Film stocks are getting better as well, and everything in film manufacture is done by computer and that frees us up tremendously, because we can have special orders of stock runs.

Where do you see the future of cinematography going?

I see the rigid lines blurring between preproduction and production and between postproduction and production. I also see the cinematographer doing much more work in preproduction to help design the way projects should be put together, both visually and technologically. I see more of us getting involved in postproduction, particularly in using the tools of postproduction to make the film more efficient and visually exciting.

We have to stay involved in all three areas, and when we do, our job as cinematographers will change remarkably. We're going to gain a tremendous amount of responsibility. The cinematographer knows — we go from project to project and we have a really global view of technology. We know as well as anyone what the best tools are for the story that's being told.

Stephen Lighthill, ASC, was born in Springfield, Massachuessett. He attended film school at Boston University. His credits include Vietnam War Story: The Last Days, Ishi: The Last Yahi *and* She Spies.

Bruce Logan, ASC

Who are you and what do you do?

My name is Bruce Logan and I'm a cinematographer. I direct the camerawork for motion pictures, and I specialize in visual effects and all things technical.

How did you become what you are?

I started off as an animator. From the age of 12, I would sit in my attic bedroom, churning out thousands and thousands of animation drawings. My father then bought me a 9.5mm stop-motion camera, and I was finally able to photograph all these drawn images, which became tiny little pictures, one after another, which is really the miracle of film.

When I left school, I showed the films to an animation company and was hired as a rostrum cameraman, operating an animation camera. From there, luck took over and I was hired into the visual effects department of Stanley Kubrick's *2001: A Space Odyssey*. That two-and-a-half year work experience became my film school and my first feature film credit. When the movie ended, one of the visual effects directors, Doug Trumbull, returned to California and hired me to work for him in his new special effects company. From there, I picked up a 35mm camera, got some good breaks and started shooting long-form feature films.

Tell us about the 9.5mm camera. Is that the one with perforations in the center?

Yes, it is. The 9.5mm is a French gauge with a negative area almost as big as 16mm by virtue of the fact that the picture goes all the way to the edges of the frame and the perforation is in the rack line, between the frame. This arrangement works really well until the claw slips and puts a big gash down the middle of the picture.

What is a rostrum camera?

A rostrum camera is basically a down shooter, usually an Oxberry. It's what most animation is shot on. Animation cells are stacked in various layers, either against a backlight or on a geared table, and are front lit. A platen — a big plate of glass — holds the cells flat, so I can then shoot one frame. Then I take the cells off and twist a bunch of knobs to move the artwork and the camera. Then I do it all over again, one frame at a time. Then the phone rings and I have to try to remember whether I just moved the table and changed the artwork or whether I just shot the frame. That's the worst part.

Let's talk a little about technique and technology. How are they related?

Technology definitely drives technique, in that what we have to go through to get an image always influences the way it looks.

What about style?

Style is an individual artist's take on things; it's his unique vision. But that, too, is influenced by the challenges we have to overcome to get the image. When I was a beginning cinematographer, my style came out of ignorance. I didn't know how to light and therefore shot in natural light situations. I chose natural light situations that could work well for the image. People looked at it and went, 'Wow, that's really different.' This was when film was 50 and 100 ASA, so natural light images were much harder to shoot. So that became my style.

Then I got involved in lighting and visual effects. At the beginning, I wasn't pleased with my lighting, but I started learning how to light by replicating natural light situations with studio lights. In visual effects, where I have to build up my F-stop to incredibly

high apertures, getting that natural light look was difficult. But it was something I became used to, where I was able to bring my natural style into the visual effects arena. I hate the restrictions that are usually imposed when shooting visual effects; I hate that locked-off camera. I always want the camera to be moving during the effect, because I want it to look as natural as possible.

Can you expand on the concept of matching someone else's existing style at a much greater stop?

When I shoot with fast lenses at wide apertures, there is a lot of ambience that is self-filling. When I get up to very high F-stops, everything needs to be lit and filled. In order to key someone with soft light at F11, I need to create my own soft fill to keep the same natural look of fast lenses and new emulsions.

Let's talk some more about technique and technology.

I think, as cinematographers, we try to not let technology influence our technique, but it does. In this digital age, lighting is different, and the difference is between lighting for a chip versus lighting for film. I enjoy lighting digitally because it's here and it's new, not because I think it's better than film.

What about the digital age of postproduction?

I shoot a lot of television commercials and most of them originate on film. It's incredibly liberating to expose a negative and then have the ability to do virtually anything to it — in terms of contrast, color correction and diffusion — during electronic postproduction. The DI process is something we in the commercial production world have been doing in the Telecine bay for many years. It's very exciting to have these kinds of controls for feature film finishing, too.

What is process photography?

Process photography is when the background behind the actors is changed using first-generation photography. Instead of being matted against the greenscreen and composited later, the background is put on the negative at the same time as the foreground

actors. There is no waiting to see if the greenscreen is going to turn out or if the perspective of the background picture is going to work. I specialized in this kind of process photography earlier in my career.

One of the pictures I shot and directed the visual effects on was called *The Incredible Shrinking Woman*. Although it had many visual effects shots, there were no optical printer composites, and everything was created in-camera. A lot of it was rear-screen, which is a good technique as long as the background image doesn't need to be greater than 18 feet; any bigger and you'll soon run out of light. For a bigger background image, front-projection is the preferred technique. Front projection is a technique that uses a beam splitter. The projected image comes from the projector that's situated next to the camera, through the beam splitter. The projected light goes to the screen, which is made of glass beads, then comes back on exactly the same axis, travels back through the beam splitter and into the camera lens. With this technique, the projected light loses almost none of its intensity.

I once did a commercial where I wanted to project some reflections into the tank and sheet metal of a motorcycle. I was shooting in Prague and there was no rear-screen process equipment available, so I hung a digital cinema projector in the air, pointing it down at the rear-screen suspended above the bike. I had very little light, but by shooting the camera at 4 seconds per frame and moving it very slowly, a good effect was realized.

Why did you need the beam splitter? Why couldn't it be slightly off center from the lens?

I had to use a beam splitter because the glass beads are extremely directionally sensitive. If the projector had been side-by-side with the camera, the reflective angle of projector beam would have been off slightly and the reflection from the glass beads into the lens would have lost about 90% of its intensity.

Bruce Logan, ASC was born in London, England. His credits include Tron, Batman Forever *(Visual effects DP) and* The incredible Shrinking Woman *(Special Visual Effects supervisor).*

Isidore Mankofsky, ASC

Who are you and what do you do?

I am Isidore Mankofsky, ASC. I am a cinematographer.

How did you become a cinematographer?

As with most people in this industry, it was a combination of luck and desire. Still photography was my first love, and I thought that everybody who picked up a camera thought they were a photographer, so I then thought about cinematography. Now it has come full circle, where everyone who picks up a video camera thinks he or she is a cinematographer and, of course, that is not the case. Then came four years in the service during the Korean conflict, which was actually a war, but they called it a conflict.

When I got out, I went to photography school in Chicago and worked in a laboratory, developing and printing film. Then I went to California to the Brooks Institute of Photography, and that was where the luck came in. Toward the end of my stay at Brooks, I got a call from a TV station in Reno, Nevada, which gave me a job. In Reno, I got to shoot my first couple of documentaries and some stills and also work in a lab; I really got my education there. Then I went back to Chicago, because Reno was really not my cup of tea, even though I did a lot of work there.

In Chicago, I had a number of jobs and another lucky incident got me my major start. I was playing handball one time and my opponent, who was working for a producer at Encyclopedia Britannica, told me they were looking for a cameraman and asked if I wanted to interview. So I got a job at Britannica and

worked there for nine years on staff, where I did more than 200 films, both narratives and traditional documentaries. The first year, I did a half-hour film every two days for a total of 161 films. Then I started freelancing and it went on from there.

How does style happen?

First of all, I would like to say that I don't have a style. Whatever style I have is determined by the story and its desires, and I pride myself on being able to deliver that. If I limited myself to a particular style, I would get pigeonholed as someone who only does comedies, for instance. The style is determined by the story and script. Unfortunately, when some films get started, they seem to take a life of their own, but sometimes the plan we start with doesn't work out. But it's important to start out with an idea in mind and try to pursue it in the film.

Take us through how you would light a particular scene.

When scouting the set with the director, I first get a feel for the set and how it looks and how I want it to look, as far as hard or soft light or style goes. I discuss that with my gaffer and ask the director and hope he knows what he wants. The director will usually give a broad outline of the direction for the scene he wants to shoot, and I try to lay that out. Because most of the films I do have a short prep time — TV shows get about one to two weeks, and for most of my features, I don't get the six months of prep most people get — so I make the most of the time I do get, meaning I have to make a lot of determinations early on during the scout.

For *Somewhere in Time*, a romantic period film I did years ago with Christopher Reeve and Jane Seymour, I had to figure out how to make the period time and the present time have a different look. At that time, Fuji film had a very soft, kind of pastel look and Kodak film was very high in contrast, so I used the Kodak for the contemporary and the Fuji for the period. The lighting style I discussed with director Jeannot Szwarc, who was a terrific guy and great director; on the earlier parts, we used harder light with little or no diffusion on the camera, and in the later part, we used a lot of diffusion in some areas as well as a lot of soft and bounce light.

All of this was determined in advance. Jeannot was very specific in what he wanted and I executed it, and that is how I determined the lighting for that particular film.

Let's talk about technique and technology.

Technique and technology obviously affect the look of the film, but there is also a direct correlation between the budget, time and equipment used. If I have a lot of time and money, I might use something like a Technocrane or balloon lights or — more sophisticated tools that are wonderful for the cinematographer. But I can't always afford those, and I try to not let that affect the ultimate outcome of the film. What I try to do is figure out how to do things without the expensive equipment, and it is a challenge, but somehow it gets done because 90% of the films can't afford the technology of the wonderful new equipment we have today. Every time I see a new piece of equipment, I look in envy and hope somebody will let me have it for Christmas for my next film, though more often than not, it is just not possible. The advancement in film technology by Kodak and Fuji is also just amazing.

When I started shooting, the ASA of film was ten, of reversal color film, and it had latitude of about one stop, so I really had to know what I was doing. Now we have 500 or 800 ASA, and it is almost unbelievable that they have been able to advance it that far. Also, the range structure and latitude have increased to the point where some cinematographers think the latitude is too high because they can see into black areas they don't want to see into. I don't agree with that. For about 70% to 80% of the films I shoot, I like to flash the film, which I guess is an idiosyncrasy of mine because I like to decrease the contrast. Also, postproduction has evolved to the point where it is incredibly beneficial to the cinematographer, especially with going straight into the digital world from the world, where we can manipulate the image in the digital domain. Things have gotten wonderfully easy for the cinematographer.

What is flashing?

Flashing is basically fogging the film, and it tends to add a bit of light to the dark areas of the scene. If there is no light to begin

with, flashing is not going to give exposure to the dark areas. I use it to decrease contrast, especially in the older Kodak stocks, which tend to be quite contrasty. It also adds a bit of a pastel look to the film. I have used it on about 80% of my films, but I don't always use it because sometimes it is not called for and can defeat the purpose of the look.

Early on, flashing was done in the lab and I would tell them what percentage I wanted flashed, but of course each lab had a different idea of what 10% flash was, so I had to test it unless I knew the lab I was working with. That involved the film being handled an extra time, so there was always the danger of damaging the original negative. Then some British cameramen came up with a rather elaborate flasher and from that evolved Panavision's Panaflasher and Arriflex's Varicom, which attaches to the front of the lens and has light filters and a ring of lights on the outside of the lens. That causes a halo similar to shooting through a car window, but I can use a polar screen to take out the reflection.

The Panaflasher works differently, where the flasher fits either on the top or back magazine port of the camera, depending on where I have my film magazine, and I have a bulb with a lot of diffusion, which I can tune. With experience, I've learned how much of a flash I want to use. It is much better than going to the lab and using chains of color, because I can increase or decrease it while shooting, so I find it a very useful and timesaving device, though it is not used very often anymore.

What was the original flasher?

The original flasher was called the Lightflex. It was a piece of plastic that fit in front of the lens and it tended to scratch. It was made by a British cameraman, but then bought by Arriflex, and it evolved into what is now called the Varicon. Then Panavision came up with its own flasher, called the Panaflasher.

Isidore Mankofsky, ASC, was born in New York, New York. He attended film school at the Brooks Institute of Photography. His credits include Somewhere in Time, The Muppet Movie *and* The Jazz Singer.

Clark Mathis, ASC

Who are you and what do you do?

I'm Clark Mathis and I'm a director of photography.

How did you become a director of photography?

Both my parents worked for NASA during the space program. I was destined for a life of science, but in junior high and high school, I became very burnt out on that. In one class, a very progressive teacher allowed me to get out of writing a paper by shooting a video. Back then, video technology was just coming to the home market and was very cumbersome, awkward stuff. Invariably, it took me 20 times longer to make the video than it would have to write the paper. I remember cutting it together between two very old VCRs and thinking that 30 minutes had passed. I was getting hungry and looked up and saw that six hours had actually passed. At that point, I realized that I never really lost track of time doing calculus. But doing this film was something that took over me, and I felt that it was so creatively fulfilling. And, ironically enough, a lot of the science and engineering that had built my foundation during my youth definitely applies today to being a director of photography. It's a nice marriage of both halves of the brain.

How did you become a DP? Did you go to film school?

I had this program that allowed me to go offsite and basically go to college, as far as physics and math went. Part of the requirement of that program was to intern with a local professional. NASA was nearby, as were a lot of military hospitals, so invari-

ably many of the locals went into a scientific discipline. But I read the fine print and thought that if I could intern at, say, ABC, I could use professional editing equipment. There wasn't a paragraph in the fine print that prevented me from doing that, so I interned at ABC, and within three months, they hired me as an editor. I was in high school and was editing things that appeared on the nightly news. I went on to be the midday editor and at night, after my shift was over, I would go out with the photographers and be in charge of batteries and carry their equipment. For whatever reason, even though I started in editing, I was always drawn to shooting, framing shots and being in the field. In high school, I started shooting for the television station the Discovery Channel, which led to documentary work as a director of photography in college.

So you never went to film school.

No, I never went to film school. I was lucky enough to gain a lot of practical experience. I went to college at Duke University and studied engineering. In my off hours, I was shooting for the Discovery Channel as a DP. Eventually, I realized I could make a living doing this and convinced my parents not to disown me if I transferred out of engineering and finished college as an art major.

Where did you go from there?

One job led to another, as is usually the case. I segued from documentaries into more narrative efforts, the occasional independent feature, music videos in North Carolina, and then I decided to move West where I have continued working as a director of photography.

Talk to me about style.

Having roots in the documentary world, I try to react to the environment around me. But style is also a combination of the script, story and director. I'm a firm believer in collaborating with the director and trying to realize his or her vision. I have recently focused more on storytelling and less on the selfish act of lighting and camera movement.

Tell us about your work in television.

I was fortunate to get my second ASC nomination for the pilot of *Medical Investigation*, which was a show on NBC. The director and I looked at films, still photographs and other references to arrive at the show's look, which turned out to be a combination of all those influences as well as the show's script and location.

I enjoy embracing the color of an environment. There's often a need to balance light sources, color-wise, to fit everything nicely within a very narrow range of the color spectrum. But I like to reflect — especially for the content of a scene — by marrying the color within an environment with the scene being shot in it. Night interiors and exteriors are a favorite of mine. In an urban environment, there's the disparate Mercury-vapor and sodium-vapor light. Instead of trying to neutralize the green inherent in that with the renegade fluorescent or cold or warm fluorescents, I put a very neutral source in the shot, whether it be a key or even a background light, that shows the viewer that this full spectrum of color is intended. It's been really exciting to embrace that and go with it. And viewers seem to have become more receptive to having this really wide spectrum of color as well.

Talk to me about camera movement in documentary style.

On the pilot for *Medical Investigation*, we chose to separate the storyline into two distinct areas, because the main character essentially leads a double life. He has a family life that he gets stability from, and he has his professional life, which can change at a moment's notice. We wanted to reflect that with the camera movement. Drawing on my documentary roots, I chose to do his investigations of the medical anomalies in a more handheld, reactive fashion. I hesitate to say it was intentionally rough.

One of our goals was to not have an affected, handheld style to it. We wanted to treat it more like a documentary, which played into my roots. We found ourselves shooting rehearsals to search for a more honest representation of that style. God bless my assistants, who agreed not to put down marks for the actors. We

gave the actors a lot more freedom in their scenes and, for me, it became a more reactive exercise and really drew me into the scene, almost like I was another actor.

Another challenge was that, on the second take, if the actors did the same thing as they did on the first take, I couldn't telegraph where I should go. I had to essentially create a completely reactive environment where I had amnesia about what needed to happen in the scene. That was a really amazing thing to explore. Contrast that with the lead's home environment, where we started on the baseball field, which was shot in very locked frames, with a dolly and head — a very controlled environment that was warmer and had a monochromatic palette, as opposed to the diverse palette I talked about before with regard to the night interiors and exteriors. That was a really good example for me.

I'm a firm believer in contrast. As much as a story has an arc and the actor has a character arc, I want the photography to have an arc. It's fun to have a distinct style I can be recognized for, but I enjoy being a chameleon or trying to be, where each project is different. Each script is different, and starting with that blank page is the most enjoyable and satisfying thing to me. I try to lose myself in that.

Do you find that technique is influenced by technology?

I like for the concept and approach to come first and the technology second. In the case of the pilot, I used Arricam's lightweight and studio-mode cameras. Those were the perfect choice, because with so much handheld work in the more investigative portions of the show, the Arricam was the best-balanced handheld camera. It allowed me to put it on my shoulder for 14 hours and not experience fatigue. It might seem to be a very simple statement, but I can't be involved creatively in a scene if I'm sweating, trembling and anxious for the director to call 'cut' so I can sit down. The equipment influences that greatly.

We were also dealing with very low light levels, and the Arricam has a superior viewing system and video tap. Its progress in that regard has allowed many more choices, such as the ability to shoot in low light, but still allow for the director and people watching

the video monitors to see. Technology is hand in glove with concept choice, although concept generally comes first.

What emulsions did you use?

We used 5218 for most of it and I think we used 29 also. My thinking of film has changed a little, because so much is now being done in the digital post world, as well as with the digital intermediate. I think of film more as the best storage device. As far as ones and zeros go, nothing can beat film, because film is great. Technology is evolving and, very soon, products will be competitive with each other, but right now film is amazing, the 18 and 29 especially.

For instance, 29 is a lower contrast film stock. Normally, we'd want a higher contrast image in the end product, but what I found was that 29 stored more information because it was a little flatter. We could add the contrast later, as opposed to starting with a higher contrast stock and having to take the contrast out. Also, the 18 was good for the extremely low-light photography. I found that it could be pushed electronically — in some ways with even better results than photochemically pushing it. It allowed us to shoot and really embrace the environments.

There's a shot where our protagonist is driving to the hospital while he's on the phone. He basically has a discussion in his SUV about the decisions he has to make at the hospital while he's in transit. For that scene, we wanted to create a sense of depth, so the audience could experience the world around him as if they were moving in the car, too. To achieve that, the normal options are the poor-man's process, where we have lights flashing around him and create a matte situation where we can composite in whatever background we like. Or we could have done it practically, on a process trailer or towed by an insert car. But I wanted to create an urban environment where we could really be a part of his experience. It was more difficult to do logistically, but the films stocks and lenses we have today allowed me to have very minimal fill light and experience the passing lights as they were overhead in the street.

How did you get the contrast back?

I worked with Dave Hussey at Company 3, who is an amazing colorist. He brought so much to the table artistically. He was able to, at the turn of several knobs, adjust the toe or the shoulder and really drop the blacks back down while maintaining a nice range in the midtones, which allowed us to have our cake and eat it, too. That holds true for the digital intermediates as well. It's an interesting marriage of the electronic and the photochemical.

Are you saying that film might be the ultimate digital storage medium?

It is. It's the most durable and has not become obsolete. You'd be hard pressed to find a one-inch tape machine. Hard drives become faster, less expensive and the storage demands render yesterday's hard drives obsolete just because of speed. Right now, there is a bottleneck in digital technology as far as storage goes. The chips and sensors in many of the new digital cameras can absorb an astounding amount of information. The bottleneck is storage.

How do you maintain control of the product when the studios just want you to shoot and not necessarily schedule you to be a part of post?

Unfortunately, it's a privilege rather than a right to go in and time my own film. I recently shot a movie for Showtime called *Edge of America* and convinced them to allow me to color correct the movie myself, which they built into the budget. It was my first high-definition project, and I drew on my roots as an editor and my familiarity with the postproduction environment to actually assemble a full resolution, high-definition system in my study. I not only did the offline version, but I posted the 1080 24p version of it at my own house and color corrected it. As slow and cumbersome as that was, I wanted to do it to establish a precedent.

As it becomes easier to do on the desktop computer, the editors begrudgingly find themselves now, whether in the Avid or another popular system, showing directors the look of the film in our absence. Great editors have a great eye, but we, as ultimate authors of the image, need to maintain control. I don't think I'm the best or the fastest colorist, but I wanted to estab-

lish a precedent, because even though it was a union show, I got permission to color correct the footage, and that's something cinematographers should have the first right of refusal to do if we're so inclined. It passed QC, it aired on Showtime, and it was spat out of my computer in my study.

So the workflow is final cut?

I did both offline and online with Final Cut Pro and a third-party hardware card, which enabled me to absorb the high-def. I had a RAID array of about a terabyte and even that wasn't enough. I ended up with about four terabytes of render files, because I had to deliver the anamorphic version, which is the ultimate theatrical version, as well as the 16-by-9 version. It was basically assembled from off-the-shelf stuff. I had a G4 Mac, which is not even a G5, because I had to commit before the G5s were shipped. At that time, Final Cut 4 was about three weeks old. It was sort of cobbled together — definitely not a straight line between A and B.

How did you feed the high-def signal into it?

I used a CinéWave card, which has an HD SDI input, and absorbed it through that interface from a high-def deck.

Tell me about your workflow.

Things in the postproduction world are moving at an astounding rate. The technology that exists in the post world now enables cinematographers to have an input in the final rendering of their images. It's analogous to what still photographers have had for years, which is the printing of their own images and having that personal, almost private moment of rendering the symphony from the negative.

In terms of my workflow, I acquired in high-def, down-converted to DV quality footage for the offline edit, and I edited as well. After the offline was conformed with the EDL, I redigitized the high-def footage and went to work doing color correction and compositing. The thing that sang to me was that the Da Vinci is faster, but the tools on the desktop are more power-

ful and broad ranging. I'm able to do 99 layers of power windows, where the Da Vinci is very limited. I can do any geometry and I can do motion tracking. Those things usually need to be done with a Flame or Inferno — all sorts of very dedicated pieces of equipment. But if we're willing to wait and render, we can accomplish all of that on our desktops at home, at least the full high-def resolution. There are several Mac-based 2Ks. Silicon Color has one that is based on a Mac that is 2K and 4K grading. The pace at which these things are moving is amazing.

What does this mean for the cinematographer of the future?

The good news is that the interfaces are more and more intuitive, which is great because, let's face it, we are the keepers of one of the more arcane and difficult arts to master. We can and should roll up our sleeves and familiarize ourselves with some of these post tools, because they have final say over our images and will have a greater impact as the years go by.

Clark Mathis, ASC, was born in Hampton, Virginia. His credits include Rocky Balboa, Starship Dave *and* Happy Endings.

Robert McLachlan, ASC, CSC

What is your name and what do you do?

I'm Robert McLachlan and I'm a cinematographer.

How did you get started?

I came out of a not-very-good film school at the age of 20. There, I made a seven-minute film about a 100-year-old peanut butter machine that was going to be decommissioned. It was located in the department store where I worked part-time. I thought somebody should make a film about it because it was very filmic, as it had lots of gears, conveyor belts and moving parts. So I made this film and it won some awards at film festivals. This guy who ran a big food conglomerate said, "I've been looking for somebody to make films for me for ages. I need one about asparagus and one about eggs. How much?" I quoted him the going rate for shooting industrial films at the time, which was $1,000 a minute. This was back in the late '70s. I used the money from that job to go out and buy myself a little camera so I could start making films. That turned into a company in Vancouver called Omni Film Productions, which I've since left, though it's still in business more than 25 years later.

From there, with an Arriflex payment to make, I just kept working at it and shot everything I could get my hands on. I didn't care what it was — whether commercials, documentaries or industrial films. I did a lot of work for environmental films for Greenpeace back then, which allowed me to see the world. I traveled a lot and kept the camera working. It really was really a matter of, 'No job too large or small. Free estimates!' Eventually

that led to a low-budget feature, which led to some television dramas. Then, for most of the '90s, I was shooting episodic television. I shot about 300 hours of episodic television between 1989 and the late 1990s, with a few TV movies and a couple features in between. That segued me into feature films.

Talk to me about the contrast between your early days doing documentaries to the features you do now.

One of the great things about documentaries is working with very limited resources. A lot of times, my partner and I took turns co-directing, doing the sound, shooting the picture and then editing when we got back. I think most cinematographers respect work in all types of photography, but we particularly enjoy work that's gritty and real, in terms of how it's photographed, where we really get to the essence of the subject. There's probably always that part of us that wants to shoot glossy Hollywood movies as well.

In my work back then, I was always thinking about how I would make this project get me my next one, which should be a little better and bigger than the one I was on. At that time, I probably didn't think it would work out, but now, 25 years later, I'm shooting Hollywood movies. I learned many lessons while shooting documentaries, especially about how to travel and work really light. It also gave me the chance to work with people all over the world, some of whom probably wanted to harm me physically — though I've never had anybody shoot at me. More than anything particularly technical, I learned how to work with whatever natural light was available and make it work for me.

Another thing I found was that when I had the camera on my shoulder for long enough and was shooting and shooting, I developed a second sense about where people were going to move and where the best place was for me to be to record an event. I developed a sense about where I should be to tell the story the best. That's something that has stuck with me to this day, because when I watch a bunch of actors working a scene on a stage, that instinctual training of finding the best place to photograph kicks in.

I found that coming up as a student — as a neophyte cinematographer — there was no better training than to just shoot, shoot, shoot. It didn't matter what it was. I just photographed it and filmed it, regardless of whether it was a commercial for a car dealership or a rock video or a really meaningful documentary. Those experiences serve me well for my cinematography now.

Let's talk about style. What makes a picture look the way it does?

Style starts with the script, then it evolves into the location. Sometimes, for episodic TV, the DP may not be involved in choosing the location. Other times, I'll come in late or the location will change or I won't get the chance to see it ahead of time. In those situations, I have to walk in knowing what the story is that needs to be told, and I have to let the location speak to me and dictate how it should be photographed. One of the biggest mistakes that beginning cinematographers make is they come in with a preconceived notion about how the whole thing should look and then impose that look on the locations.

For instance, one of the things I saw a lot of, following *The X-Files* and *Millennium* a few years back, was this kind of dark look for the sake of the dark look that broke out all over the place. In the case of *Millennium*, there was a very good reason for it: It was inherent to the story and to the carefully chosen locations. That's another reason why it's important for cinematographers to shoot a lot when they're young and beginning. They can get that experimentation out of their systems — like shooting a movie where everything is super soft light from one side or where everything is very dark and gritty — because in those situations, being a little self-indulgent won't harm the finished product. What that teaches them is how to do those things so they can be used later when it's appropriate. A lot of cameramen might get an opportunity to photograph a movie and they'll want it to look like *Collateral*, but it's not *Collateral*. It's something else. But they'll still impose this look on the movie and it won't serve the movie, or help tell the story or involve the viewer in it.

What about technique and technology? How does the equipment we use affect our style?

Advances in equipment have definitely affected our style. Having a camera that can as easily do a ramp as a 435 was a huge advance in technology. I certainly used to try it with my SR with the manual speed control knob and a hand on the lens barrel. Sometimes it worked, sometimes it didn't, but I got some cool stuff. The efficiency of lights and the throw have profoundly affected how we work. Film stock now is so incredibly good. I don't know how anybody can make a bad-looking movie with film stock being as good as it is now.

I recently finished a movie with a lot of African-American actors in it called *King's Ransom*. It also featured a male and a female who had extremely pale skin and were blond. Once upon a time, that scenario would have been a nightmare to light and get everybody looking really good. But with the new low-contrast Kodak Expression film stock and a little bit of judicious cutting of the light, I ended up with a movie where everybody looked fantastic. That particular movie wasn't finished with a digital intermediate, but if it were, and everything was on that negative, I could have tweaked it even more to make it a more seamless, beautiful film where the actors looked great, which was one of the things we needed to have happen in that movie.

Can you explain what a speed ramp is for those who don't know?

A speed ramp is used more and more nowadays, though maybe people don't realize that it's happening. It's where the shot will suddenly go from the normal 24 frames per second to extremely fast motion or extremely slow motion. Once upon a time, that kind of thing had to be done with a very expensive optical in postproduction. Now it can be done in-camera. Of course, anything that can be done in-camera, on the set, is usually better and it certainly saves the production money.

Are speed ramps written into the script?

I'm prepping a suspense thriller movie where the screenwriter is also a director and the producer-writer is also a director, so they're real filmmakers who've written speed ramps right into the script as a story point. For a scene when a girl passes a sign

that portends of things to come, the script specifically states that the camera should ramp down to 64 frames a second as she passes. They were very specific about it and have basically written it editorially in their heads, so they know what they want.

Does having a new technology sometimes have an effect on the story or the technique?

New technology can affect a story or a technique, but we've got to think about how we can use it appropriately. Again, the trick is not to use it gratuitously, but to use it to impact the audience. One of the new technologies I've loved ever since it became available is the iris control and variable shutter on the Arriflex, which allows me to control the exposure with the shutter while changing the iris. To use it, I would light a set to a T11, which has a very deep depth of field, and then close the shutter and open the iris so that it went to a T2. That appears to suddenly isolate the character from his or her surroundings. It doesn't look like a focus pull, because the focus barrel is never touched. It's an extremely subtle effect.

On a different movie I did the opposite, where the focus was isolated, with the lens wide open to create a very narrow depth of field. As I opened the shutter and closed the iris, the background came into focus very subtly, which is a version of the old Hitchcock trick of dollying in and zooming out at the same time, though it's much more subtle. In the scene I used that technique for, the lead character was being pursued by a character in the background, which, all of a sudden, came into focus and drew the viewer's eye toward it as it sharpened. It's a great tool that, again, should be used selectively at the right time.

What other techniques do you use?

I love to go from 24 frames to 21 or 22 frames in an action sequence, which is a very subtle change. Going back and forth in speed for an action sequence is something a lot of guys are doing nowadays, though they might not talk about it. But that effect can really heighten the impact of a scene. I've worked with a lot of Hong Kong directors who are masters of shooting off-speed. If they have an action sequence that is 40 cuts long,

222 Cinematographer Style

maybe two of those cuts will be at 24 frames a second, and the rest will be at different speeds, depending on what's happening within the frame. I learned a huge amount from them about those sorts of things.

Another wonderful thing is varying the shutter opening and, again, using the iris to compensate for the exposure as the shutter moves. That allows a character to shift into another mode or do something that suddenly makes the audience feel a bit unsettled. It's a very interesting trick that brings about a very sharp, staccato kind of thing. Even if it's done during a close-up while a character's lips are moving, he or she will suddenly become very sharp and heightened. It's amazing how much of a difference that can make for shots of movement, even if they're as small as a mouth or head turn. It can go from normal speed and normal shutter angle down to a 45- or 90-degree shutter angle during the shot and then revert back to normal again. The audience won't even know they've been manipulated. They'll just think that there's something weird going on with the character. Again, it's just a little something to set people on the edge of their seats if that's what the scene calls for.

Explain what the different shutter angles do and how that all works.

Different shutter angles can affect how sharp the image is. I don't know what genius came up with 50 frames a second and 180-degree shutter, but that's what we're all used to watching. For any frame shot that way, there's a bit of motion blur in it, which helps the persistence of vision get the impression of movement. We can change the shutter blades within the camera as they're spinning and make them wider, which creates only a minimal effect, or we can go a lot tighter and take them down past 15 degrees. Usually 45 degrees allows for quite a profound change of image quality. And we've all seen it done in the battle scenes of such films as *Saving Private Ryan* and in the opening battle scene of *Gladiator*. Since this technology has become more available, it's broken out like the plague in a lot of action scenes. It gives an image a very staccato, very sharp, crisp, violent feel.

Another thing we can do now is shoot a scene at very slow

frame rates and then print it back. It's something we've been able to do in television for a long time, because we could just retransfer at the speed that we shot it at. For example, if I shoot a sequence at six or 12 frames a second and then transfer at that speed — which, of course, we can now do digitally in motion pictures as well — I'd get a lot of motion blur, even though the scene would take place in real-time. So that's a tool that can speed action up or make something feel faster or more subjective. It's not something we'd want to do for an entire movie, but for precise moments, it can be a wonderful storytelling tool.

Talk to me about the Clairmont Strobe System.

When I was shooting the TV series *Millennium*, the director, Chris Carter, wanted the lead characters' visions and flashes to look unlike anything we'd shown the audience before. During our prep, we would turn the camera on and off and had a little thing we called the "stop-popper" that we could use to pop the iris open and closed. We usually lit to quite a high stop, so that the editor would have flash frames to cut on. Typically, these scenes were full of violent movement because they came from a killer's point of view.

Then we got the Clairmont Strobe System and keyed one side of the scene with the strobes and the other side with normal Tungsten light and shot it at 12 and six frames per second. Of course, because 12 or six frames per second is a slower shutter speed, we'd get a lot of motion blur, but on the side that was lit with the strobe at $\frac{1}{50,000}$ of a second, we'd get a very blurry, fast-moving, violent image that was also a super crisp, sharp image. It worked incredibly well. I was getting phone calls from guys all over the world asking me how I did that. They thought it was something done in post, but it was actually a very simple thing that was done on set.

Years later, when I was shooting a movie with a huge amount of action in it, I strung every single strobe that was on set up on a truss and used it to backlight a guy who had superhuman powers during this scene when he was running down a street. His front light was all conventional light, and I shot him at 12 frames per second, so there was lots of motion blur but he had a

totally crisp outline. It's a look that can't be achieved any other way.

Can you explain Hong Kong style?

It's all about the shot, the pieces and continuity. For North American filmmakers it's more about the pieces. The first time I shot a big action sequence with a good Hong Kong director, it took a couple days before I realized that it actually was going to work. As a Hollywood filmmaker, my first impression was that it was going to look like shots of a bunch of junk all over the place, but these guys were brilliant and proved me wrong. Most of those directors are also master editors, and that's where they make it work.

Why does their continuity work?

Their continuity works because it's cinema and action is probably one of the most cinematic things where we can create whatever kind of continuity we want in the editing room if we have the pieces and they flow together well enough. They seem to really understand that. It can be incredibly valuable to watch. Early John Woo films, for instance, are a film course in themselves.

Are we overusing continuity?

In this system, we're sometimes overly concerned about continuity. The problem occurs when there is a veteran script supervisor riding roughshod on a not-so-experienced director, and even if the director knows instinctively that something could work, it's amazing how often he or she will get overridden by the script supervisor. I think that's unfortunate. Continuity mismatches can sometimes be editorially or dramatically useful.

I once filmed a scene of a violent dispute between a husband and wife in which I deliberately crossed my axis in the middle of it, which made the scene much more unsettling and harsh. That's an instance where it was better to not be so bound by the conventional rules. Breaking a few rules — when we know why we're breaking them — is great to do sometimes.

Rob McLachlan, ASC was born in San Francisco, CA. His credits include High Noon *(TV),* Millennium *and* Willard *(TV).*

Charles Minsky, ASC

What is your name and what do you do?

Chuck Minsky. I'm a director of photography.

And how did you become a director of photography?

I started right at the bottom as a production assistant. I was an assistant to the lowest assistant. The first movie I worked on was in 1971. It was a low-budget movie shot in San Diego, California. After a week, they needed somebody to carry around camera gear for the assistant cameramen and I was elected. The assistant cameraman forgot a matte box and had me run back to get it, but I couldn't find it and it took about an hour before he realized that he had left it at the studio. He was so embarrassed that he had yelled at me that he made me his assistant, and I carried around his camera cases for two and a half months after that. I fell in love with it. It was the best thing that ever happened to me, because I had no idea that this existed. At that point, I had been out of college for three years and just fell into it.

Tell me about the riding crop.

A couple of years later, I worked as a PA on a movie called *Bunny O'Hare*, and the director was an old-school kind of guy who had a riding crop. He used to actually hit people with it — affection- ately — but he did it at the most awkward times. Like if a grip was floating a flag, the director would reach over and put the riding crop right underneath his chin or under his arm. The guy would jump and everybody would get a big laugh. Of course, the grip would be embarrassed, so the crew hated it and hid the

crop several times. The director would make a big stink about it and wouldn't roll the camera until somebody found the riding crop. It was embarrassing and awful, yet he kept doing it. I think they went through about three or four riding crops on the movie. It was a learning experience.

How did you go from that to being a DP?

I did some very bizarre movies as an assistant cameraman. I was a loader and assistant cameraman for a guy who would hire eight people for his crew. He needed one electrician who could actually tap into the power box, and then everybody else would just do whatever was asked of them. I knew a little bit about the camera from my early experiences, so I just hung out by the camera and everybody else would run off and be the grip or makeup person. But I stayed with it. We wound up shooting three cameras, and I operated one of them, though I would load all three. I would do the assisting for all three cameras if I could. I'd set the F-stops and then the producer would operate one camera, the cameraman would operate another camera and I would operate and follow focus on my own camera. I did that for *The Thing With Two Heads* and *Chain Gang Women*, which were both great movies.

After that, I slowly worked my way up. I became a second with Matt Leonetti [ASC] who actually moved me up to first. Ray Villalobos was the camera operator and I was the assistant. I was also a camera assistant with John Toll [ASC] for a long time. We did *Urban Cowboy* together and at the end of it, John, who was the camera operator, moved onto another job and I moved up to being camera operator with Ray, whom I was with for about three years. We did movies like *Nine to Five* and lots of television.

About three years after that, he asked if I was ready to move up to B-cameraman, and of course I said was ready, so I moved up on a job that he didn't want to do, called *Radioactive Dreams*, which is an interesting movie. Suddenly, I had three camera crews, 15 electricians and 15 grips. It was a huge lighting nightmare, but it was also fantastic, though I think I slept maybe one hour a night during those six weeks. That was my start in being a director of photography.

Now let's talk about look and style. Take us through the process from preproduction through shooting.

The process is a constant change, like the film process itself. I start in one direction and keep honing, changing and adjusting it. I always try to start with the story. Maybe it's from being a social worker or just being interested in people, but character and story are the most important things. I don't like movies that are all about the look, because they wind up overwhelming the movie with style, and that loses something.

The beginning of the process is discussing the script with the director. We just sit down and find out what the core of the movie is — what we want it to feel like, how we want to photograph it. Do we want to use long lenses? Do we want to go wide angle? Do we want to be low? I worked with Robert Aldrich on a movie, and he was always low with all of his cameras. He had two cameras, one on top of the other, and he was always shooting up. Joe Biroc [ASC] who was his cameraman for nine or ten movies, always was shooting ceilings, and he got to be really good at it.

But I first try to find what the core of the story and the different characters is, whether they want color or not, or whether we want to play them in half-light or put them in shadow — however we want to see them in the film. After that, I go out and see the locations. I try to go to locations as often as I can and, if possible, I'll take my still camera and photograph them. If there's a big scene in the story, like one on a bridge, I will photograph the bridge with a movie camera during different times of the day, just to see how it looks. I'll show that to the director, and we'll discuss if he wants wide angle, or maybe a 200mm or 500mm lens. Then, we'll define the look of this visual character, which is the bridge.

I did a movie in New York for which I had to shoot on a bridge, so I went down and shot it a bunch of times. In the film, the bridge was portrayed as the link to the rest of the world. We used a wide-angle lens and things would always be captured in the distance. I'd go out and shoot at sunrise and at different times throughout the day. Then I started talking to the director and gaffer about how much time we had and what time of day

we wanted to shoot. For instance, if the director wanted to shoot the sunrise over the bridge, we had maybe 20 or 30 minutes. In that case, we could shoot the master very quickly and go in for additional coverage. We could shoot the coverage first and then do the beauty shot. But however we do it, I try to find the best look for the movie.

What about lighting?

I'm very much a naturalist lighter. I like to have definite sources, and I like to know where those sources are so I can work with them. When I was an assistant cameraman, I worked with a man named Melvin Sokolsky, who was a brilliant lighting cameraman as well as a director. We started using fluorescent lights in the '70s before everybody else knew about them. I worked with him for six years and learned a lot about not only which type of light to hang, but also how to hang it. If a grip hangs a light, he could hang it in such a way that I can't adjust it. That might be good for him, but not necessarily good for me. I have to learn what he's doing because if I'm going to take time to light something, I'll need the ability to modify it.

What do you want to do when you grow up?

That's a good question. I was a social worker before I got into the film business, and I did that in downtown Los Angeles for an organization called Aid to Families with Dependent Children. It was a great job, politically. I believed in what I was doing, but I realized I wasn't that great in that system, so I left. Yet I always liked the idea of helping people and think that's an important function of anybody who has gotten wonderful things out of life. You have to give back. I'm very interested in doing low-budget films where the story is wonderful. Director Luis Mandoki has a movie called *Innocent Voices* that is phenomenal. I love making movies like that, so I try to make movies with Garry Marshall. I also try to make television that I think has value and is interesting, with good characters and storylines.

Charles Minsky, ASC, was born in Philadelphia, Pennsylvania. His credits include Pretty Woman, Guinevere *and* Dutch.

Kramer Morgenthau, ASC

Who are you and what do you do?

My name is Kramer Morgenthau. I am a director of photography.

How did you become a director of photography?

I did not go through the traditional route. I was not a very good camera assistant. I did pretty much every job I could on a film set to study and learn what I could. I also studied other people's work: photography, classical art and art history. After being on the film set for a while, I started to gravitate toward the camera and began shooting things for free, such as student films.

My first break as a cinematographer came from shooting documentaries. Through that route I was able build a reel and get to the point where Jon Fauer [ASC] called me up and asked me to come talk about my craft. It has been about 15 years since my first paying job as a DP in New York. It wasn't overnight. It was a calling in life that found me. I discovered I had a natural instinct for visual art.

What did you do after college?

I had a friend who was working on a low-budget horror film in South Carolina, and I went there and worked as a PA. Eventually, I came to New York and got a job as a PA on an *American Playhouse* production. I was being paid very little and sleeping on a couch at a friend's house. By the end of that job, I was loading magazines. It was a nonunion situation, and that was pretty much it.

When I first got out of school I didn't think I was going to be a

cinematographer. I just wanted to make films, work in films, make documentaries and make the world a better place through cinema. My transition into cinematography was partly an extension of what was happening to me as an individual, where I realized that the world was not such an easy place to change and that the change needed to happen more within. I found that working in a visual art is a good way to divorce you from the more literal aspects of life, such as politics, and working in a more personal and nonverbal medium — very much like music, which was my first love.

When you look through the eyepiece, do you suddenly get transported into a fantasy-like world?

I can cancel out everything when I look through the eyepiece. I am attracted to the visual aspect of filmmaking, and I as if I can feel the words people are saying and express them visually; I can create an organic, parallel narrative with imagery that goes along with the literary narrative, and that is a big thrill for me. It is an intuitive thing that just happens.

Where do the ideas come from for a look?

The ideas to visualize a script can come from anywhere, but hopefully they originate with the director. I think the director should have a vision in his or her mind of how the picture should look. It is my job to draw that out. In that process, I will try and get as much time as possible with the director to sit down and talk about how he or she sees the picture. Also, at that point, the production designer has already been onboard and is usually a huge part of the collaboration. I do a tremendous amount of personal visual research, which I find to be invaluable. It is important to reference more than just other films, because if we only reference what other cinematographers have done, it's hard to break new ground and it's hard to be true to yourself and the story; what they did on a film was right for that film, at that time, for that story, with those actors, on that day. What I do should be an emotional response to the film I am making. I like to reference painters and photographers and any other form of visual art, from graffiti to graphic design to web-based art. In terms of photography in particular, I look at fash-

ion, fine-art and commercial photography, because I think that is more at the forefront of visual language and whatever is going on in pop culture. The visual language avant-garde of today is not necessarily narrative feature films, so I use magazines and Google a lot to search for images.

I just finished shooting a pilot called *Over There*, which is about the war in Iraq and features soldiers in combat situations. There was a tremendous amount of photojournalism out there already that I could look at for the pilot. I could have just gone out and rented *Three Kings*, which is beautiful and on which Newton Thomas Sigel [ASC] did wonderful work, but I needed to come up with what I saw as appropriate for this picture. That is not to say we didn't look at other films. We looked at *Saving Private Ryan*, *The Thin Red Line* and *City of God*, but the majority of my inspiration was real combat photography.

Where did you shoot that and how did you incorporate combat camera styles?

I shot that in Chatsworth, California, in a hillside bowl and also partly in Lancaster, California, so everything had to be created within the world of the lens, using things such as filtration and stocks. It was done on 16mm film. The only direct reference I took from combat photography was using adapted night vision lenses on the camera. We shot an entire six-minute scene in intense green night-vision, which is so surreal-looking.

Did you shoot the whole thing in 16mm?

We shot the entire pilot on Super 16mm, 16:9.

Are we seeing a resurgence of 16mm? What are its advantages and disadvantages?

There is a resurgence of 16mm right now. However, this documentary might be out there for years for people to watch, so maybe it's a wave right now but not necessarily forever. It is bouncing back, and in this situation — particularly because we were shooting a lot of handheld — it was the perfect medium. Was it better than HD for this project? Yes. The camera was equally portable. I was using an A-Minima, which is just as

portable as any HD camera. I also used an Iconoscope, which I could literally put on the end of a stick and run with. The Arriflex 16 SR-3 High Speed camera was the workhorse.

16mm is great for some situations, and I generally opt for it over HD because there is a quality on film that we will never get electronically. I think someday, electronic motion picture photography will surpass photochemical photography, but people still paint with oil paints and present traditional theater. The project should dictate the medium. Many people, myself included, have a tendency to get wrapped up in the hype of emerging technologies. But what really excites me is the application, the project, the film, the story, the actors, the director. What are we trying to say? Why have we chosen to make this film at this time? What we made it with won't matter in 20 years; the story is the universal, timeless element.

Where is the future of cinematography headed?

Cinematography is a very young art form when you consider the entire history of art. Filmmaking is only 100 years old, and it will continue to evolve. It has evolved so much in the short time that I've been around. I can't say traditional cinematography will always be around, and maybe we will light one day with a computer or even with our minds in a virtual-reality situation. But there will always be a role for visual storytellers.

Cinematography is changing, and that is exciting. I think digital capture will eventually surpass photochemical photography, and in some ways it already has. It's amazing to me that film capture is the only modern form of recording that is analog-based: Everything else is digital, and there has got to be a reason for that. Photochemical capture is soulful, and there is an inexplicable magic to it that I hope is around forever. But some things are inevitable. Technology marches on, and humans will continue to find new ways to express themselves.

Kramer Morgenthau, ASC was born in Boston, Massachusetts. He attended the University of Rochester. His credits include Fracture, The Feast of Love *and* The Express.

Hiro Narita, ASC

Who are you and what do you do?

My name is Hiro Narita and I am a cinematographer.

How did you become a cinematographer?

It took some time for me to become a motion-picture cinematographer. Originally, I was more interested in illustration and graphics, then moved onto stills, before finally moving into film — first into documentaries and then into feature films.

How did you get into motion-picture photography?

As an illustrator, I dealt with single images. Looking at a single image for long periods of time became incredibly frustrating. I began to think in sequences of images to tell stories. The obvious extension of that was motion pictures. So after finishing my contract in the Army as an illustrator at the Pentagon, I came back to California and decided to move into film work. I worked first on documentaries as an assistant cameraman, a lighting assistant and assistant editor until I was capable of making a film myself.

Where did you do your documentaries?

Much of my documentary work has been done in the San Francisco area. Early on, I apprenticed for a couple of years with film director John Korty, who, at that time, had a small group doing documentaries, children's films and, occasionally,

a low-budget feature. I brought my graphics skills to the group and learned basic filmmaking, editing, animation, lighting and, eventually, how to work with the camera from John and the others. I was lucky to get such a broad and deep apprenticeship.

Tell us about your illustration background.

Even as a child in Japan, I doodled endlessly. I wanted to be a painter and looked forward to beginning such an adventure, but once I started art school I realized that making a living as a painter would be unlikely, so I enrolled in graphic design and illustration — a compromise with more commercial possibilities, I thought.

Do you bring your artistic background into your current cinematography?

Having a graphic design background is very helpful in film work. I think students of cinematography should have a solid understanding of the elements of graphic design such as composition, color, tone, scale and their deep psychological effects and the management of these effects. This is fundamental to all image-making, whatever the technique or the medium. Technologies come and go, but the underpinnings of good image-making remain.

Let's talk about style.

One of the benefits of art school training was the constant pressure to explore the creative urge, go further and redefine goals and standards. Early on, we were told to do drawings of a subject until we were happy with the drawings. Then we would pick the best one and present it to the instructor. He would then dismiss that one, tell us to throw it away and do another one that would be better than the one we had thought was best. This taught me not to feel precious about my work or my ideas, what I thought was beautiful or not, and to seek better than my best.

Take a movie like *Never Cry Wolf*, which involves vast landscapes, several kinds of animals, changeable weather, glaciers

and tundra, old people and different cultures. When I read the script, certainly I imagined what it might look like, but these, like most preconceptions — even well-researched ones — came largely out of my own memories, experiences and desires. When I arrived, it was vastly different. The style of the film just grew out of working together. I don't think the director and I ever discussed "the style" of the film. It grew out of spending day after day on the tundra, appreciating the light and being open to what was there rather than being held back by our own preconceived ideas. I think there is a danger in immediately concentrating on style when we read a script, as that can lead to imposing our personal memories on a story that we might really want to discover.

How do the tools or technology of film affect style?

Perhaps because I've come from a different field, tools are just tools to me. When one uses watercolor, fresco or oils to paint, it is certainly true that the results may differ because of the limitations and potentials of any one tool, but I think the underlying emotions portrayed will be the same, no matter what one uses. To some extent, we are at the mercy of technique and technology, but we also influence them. We should not confuse the limitations and potentials of different media with our own blindness or vision. What we choose to portray, in terms of storytelling, is up to us, not the machinery. So I'm less attached to the characteristics of the tools than to the elements of expression.

Let's talk about vast jumps in technology.

In my lifetime, we have gone from black-and-white, through color negative and reversal, magnetic video and now to high-definition digital media. Before my time, filmmaking moved from silent movies to talkies, a far greater change in technique and process than today's shift from film grain to digital pixels. I don't like comparing these changes in terms of which is best. I think we should just use whichever technology serves a specific situation best.

When I was working on *The Rocketeer* — which required a lot of visual effects, complicated camera moves and cranes — I thought about Fellini's *8 1/2*, a film I first saw before I entered filmmaking. There is something in that film that really has stayed with me. Until I saw *8 1/2* the third or fourth time, I didn't notice there were lighting changes right in the middle of scenes for no apparent reason. I think I didn't notice them because they were such an integral part of the film, and that is the kind of thing I am so fascinated by. When I analyzed what about *8 1/2* was so fascinating beyond the incredible imagery, I realized that technical things don't have to be perfect. *8 1/2* is full of imperfections, like crude camera movements and out-of-focus shots, but they added to the immediacy of my experience as a viewer.

I don't want to become trapped in the complexities of production by simply articulating technical conventions or tweaking corrections masterfully. I want to manage the techniques with a lighter touch, with people who are not 100% technically oriented. Because out of a certain organic looseness — an approach that might not be conventionally correct but is emotionally right — viewers can have visual experiences that they really can't pin down, yet that touch their hearts.

Does knowing the technology allow you to walk around it?

I may not be the right person to ask that question. I don't pursue every technical innovation in detail. Of course, I know the characteristics of all the tools we use and how to apply them; that's a matter of craftsmanship. I know how to deal with the timers in the labs and can talk to them for hours. However, if you asked me how to load every camera on the market, I couldn't do it. Nor could I explain the fine points of how the optics of Cooke lenses or Panavision Primos are engineered. My primary focus is elsewhere.

What is most important to you then?

I don't know. I do know that I don't want to become rigidly attached to my own idea of a given story or script. I want to

blink. I am quite fascinated by blinking, by how, with each blink of our eyes, we are actually gathering a new picture, a new load of impressions to add to what we already know or feel.

It sounds as if you blink 24 times a second.

Figuratively, I do. I think we all do to some degree. When you have an idea, unless it is some incredible inspiration, it's not really new, is it? It's usually something resurfacing that you have seen, heard or experienced already. I want to open my eyes anew. I want to have, as Michelangelo Antonioni said, "One eye opened to the outside, one eye opened toward the inside."

I want to go beyond my old impressions, discover what's out there, then take that connection and apply it to the film at hand. To me, that is the fascinating part of storytelling, the magic in the process of filmmaking, and why the tools, as necessary and wonderful as they are, remain secondary.

It sounds like you are foremost a storyteller and then an artist.

It's true I approach film that way, with the storytelling first. Then I ask myself how to visually represent the experience and realize the director's vision. Should it be a wide shot or a close-up of someone's fingertips? Or perhaps a shot from behind? Talking heads are not the only way to show human emotion and experience. You have to allow room for the viewer to participate.

There is a current trend to put as much as you can on the screen. This is an outgrowth, I think, of the fabulous potentials of the newer digital technology. The resulting images can be enormously grand and powerful, but they also can be somewhat confining. Sometimes too little is left to the imagination. I think the viewer is more strongly connected to stories in which they participate in the process of storytelling by using their imaginations, like old radio. What's unlit in the corner and what's off screen beyond the frame line are also a part of the viewing experience, and are sometimes even more powerful than the fully seen. For me, there is a continual interplay in filmic storytelling

between what is manifested on the screen and what is suggested. If you look at movies from the '30s and '40s, you will find many masterful examples of this. They knew how to bring a story to an audience and how to bring an audience into a story.

Hiro Narita, ASC, was born in Seoul, Korea. His credits include Never Cry Wolf, The Rocketeer *and* Shadrach.

Michael Negrin, ASC

Who are you and what do you do?

My name is Michael Negrin and I am a director of photography.

How did you become a director of photography?

I grew up in the business. My father, Sol Negrin, ASC, is a cine-
matographer as well, so I grew up on film sets and, fortunately
or unfortunately, caught the bug to be a filmmaker early on. I
used to get out of having to do written assignments for school
by doing them on film. My dad was my teacher and he started
me off with still photography and basic darkroom work when
I was nine years old. I started shooting with his Bell & Howell
Filmo at twelve. I don't think I ever had any ambition other
than to be a cinematographer.

What determines the look of a picture?

In most cases, I develop the look for a project by reading the
script. For commercials, the ad agency usually has a predeter-
mined visual approach in mind, which is sometimes borrowed
from other things, like the look of a particular movie or music
video. They make that pretty clear upfront. There are other
cases, in commercials, where it is a storytelling type of script
that allows me freedom to interpret the look based on the
location and nature of the spot. Very often, I determine the
look of a piece based on the location, where I just walk into a
room and maybe find great natural light that stimulates my
thought process. If the sun was doing something interesting

when I scouted the location, I might also try to retain that when we set up the shoot.

When you walk into a dark studio at the beginning of the day, how do you go about lighting it?

If I am doing a day interior and there are windows on the set, I ask the electric crew to put a source through one key window for the rehearsal. It may not be the right light ultimately, but that gives me the chance to look at something beautiful and to see the actors in that source. That will usually start me with ideas, because I don't like looking at a rehearsal with fluorescent or mercury vapor overhead house studio lighting.

How does technology influence technique?

Things that have come out over the years, such as remote heads, the Technocrane and Steadicam have certainly had an influence. Also, the postproduction end has changed, with digital intermediate offering us all of the color-correction techniques that we have had in NTSC video, which is basically an unlimited palette. The problem becomes choosing wisely based on what best serves the project.

For example, I love camera movement and sometimes it is appropriate, but there are some films that are better served by static, iconoclastic imagery, with yet other films that might require a mixture. We have to also watch the actors rehearse to see what should or should not be added to a scene. In *Citizen Kane*, there are a lot of shots that just let the actors have the frame. But nowadays, we see a lot of camera movement in motion pictures, which is probably influenced by music videos and can merely be a substitute for a bad script or bad acting. I was doing a TV show, which will go unnamed, where even the lead actor was concerned with how boring the dialogue was. We tried to help the situation by shooting with Steadicam and creating these long camera moves through hallways in the hospital with lots of extras crossing in front of the lens. That sense of frenetic activity in the shot made it seem like there was more going on.

Did it help the show?

It helped the pacing. Had it been shot in a traditional style, people would have tuned out right away. But with the other way, if someone was at home clicking around the channels on television, he would have seen a lot going on and maybe have given the show a chance. The average television audience's visual vernacular is pretty good these days. People can recognize static, boring television in a few seconds of channel hopping, and they look for visually arresting images when looking for a show to watch. Shows like the *CSI* franchise have a music-video-influenced look, which really stands outlook, with its New York, on the street, documentary style, which makes me stop for a few moments to get a feel for the story.

What is New York style?

New York City has a huge influence on the way we shoot. There is a lot of traffic and pedestrian movement there, unlike Los Angeles. New York is a walking city and people are constantly window shopping, which lends itself to long lenses, where I might shoot down Fifth Avenue for five blocks and pick two people out of the crowd and follow their dialogue as they weave through thousands of people. That distinctly says New York style.

The only other city where I have had a similar experience is Hong Kong, which is very crowded and has that same feel. It is also a city that was built very densely, big and high, so there's lots of shadow as well as contrasty light, which is another distinction of New York, where people walk in and out of very bright light or deep shadows. Another interesting thing about New York is its many reflections and how, when the light kicks off of a variety of glass windows on different buildings, it can cause this very artificial-looking light in which the light can reflect in five different ways depending on the time of day. It is spectacular.

How could this affect the look of a film?

If I took actors up to the 50th story of a New York City building, assuming it has good windows with great views, it can be pretty powerful. They did that in Ron Howard's *The Paper*, which made the shots feel so open and simultaniously so claustrophobic. The film was set in the offices of a newspaper, and the audience could see New York in many different directions because of all the windows in the shots. They did these dolly moves that would pull back from the skyline and reveal a conversation between characters, which showed both interior and exterior at the same time. That was a pretty amazing feat that gave the audience a lot of visual texture to work with.

Do any other cities have styles?

San Francisco is unique because it is a cosmopolitan city with high and hilly roads that look interesting up and down. Films with chase scenes through San Francisco really take advantage of the hilly topography and enable a DP to have low-angle shots that look up a road that peaks when, suddenly, a car jumps over the top of the hill seemingly out of nowhere. Using a long lens looking up a street, without a view past the horizon line, can make for interesting scenes.

In terms of where to shoot, whether it is New York or Los Angeles, a city's signature architecture has a lot of influence on how to shoot, what lenses to use and what type of contrast to go for. New York has a very contrasty look because of the canyons of buildings there, which can become characters in the film. The choice of city has a huge impact on style, and the architecture and energy of that city are going to impact the look of a film, whether it is a crowded city like Hong Kong or a more desolate cityscape like L.A.

Michael Negrin, ASC was born in New York, NY. He attended film school at New York University. His credits include Life, Saving Grace *and* The Riches.

Sol Negrin, ASC

Who are you and what do you do?

I am Sol Negrin and I am a cinematographer.

How did you get into the business?

I was interested in photography and I was very fortunate to go to a high school in New York that taught film and stills, and that is how I got into it. It was one of these maverick schools, probably the only one at the time in the United States. This was back in 1943-1947, in that period.

How did you get your first job?

I was fortunate in my last year of high school to get a job with a small film company. They were an industrial outfit that did early commercials, and I did everything from sweeping the floor to projecting the film.

Where did you grow up?

I grew up in New York City. I was born and raised there.

What is the New York look?

The New York look, to me, is a very raw look. It has a candid appearance, not as glossy as the Hollywood product. I know when I did *Kojak*, we did the series in a way that I felt captured New York all the way, both gritty and glamorous. The least fill light worked satisfactorily, as far as I was concerned. We used

minimal lighting on the interiors, where we tried to capture the mood of the locations.

On the subject of technique versus technology, how does equipment influence the New York look?

At that time, I worked a lot with Cinemobile only because, in New York, you couldn't use the big trailer trucks and the larger-type vehicles to bring the stuff into the city. It was objectionable at that time, but now it's entirely changed; you have everything you want, as far as equipment is concerned. But you had to work in a very moderate fashion, because you had to move quickly and you couldn't occupy the area as much as you would like to, so locations were kept to a minimum, but you worked a four-corner type of setup, meaning you could set up on the street and turn east, west, north or south and make it look different. That was a really economical way of getting around and shooting an episodic series. You selected your locations, but you made the most of them.

What do you mean by raw look?

I would say that shooting without all the major equipment, such as the big arcs, the large lighting equipment and the things that would go with it, like silks and all of that. Instead, you would leave it as is, but you would have to know where to shoot. You're not going to shoot the shady side of the street with a hot background, you would probably have to shoot the shady side all the way through.

Let's talk about style.

You talk about the raw look — New York is that way. No matter what you do, you leave it as is, and that becomes your image. I think that is the New York look. Making comparisons and all that, it's just the idea that it is not as polished as some of the things we normally do on other films, and I think that's what makes a lot of the difference in productions that are shot. I'm not saying it's like that all the time, but there are certain definite appearances, that when you shoot in New York, you get a different kind of a look.

I know Owen Roisman, when he did *The Taking of Pelham One Two Three*, he captured a certain type of image and that was a raw look. Doing a series like *Kojak* or even *Our Family Honor*, you captured a certain image that was different. Today, many of the new shows try to replicate it, like *Law & Order* and *NYPD Blue*, trying to get a New York look, even though *NYPD Blue* may be shot on a backlot, they are still trying to maintain a continuity of that look, and I think that is important. I don't want to say it's a style; it's just part of the technique, and the fact that you don't have some of the amenities as far as equipment makes a difference, too.

Tell me about your teaching and shooting with some of your students.

I teach now at a small college in Long Island called Five Towns College, and they were just starting a film program. They had a large video program and they asked me to, more or less, start the film program. They went through basic cinematography, and now they will be going into advanced lighting and cinematography. I have been very fortunate, as one of my students from a few years ago is now a producer and I've done some work for him, and we worked very well. He's a very bright individual.

While there are some people who are totally interested, you will find some individuals who find it too difficult to make it. It's a challenge, let's not kid ourselves. Those who really want to make a career in this industry, whether they're going to be a cinematographer, director, writer, editor, whatever — the point is, if you love something, you pursue it. I find these younger people have the capacity at this point, and I admire them for it. I am enjoying it, too, because I am giving back what I got and I'm being educated at the same time, because it keeps me up with the new technology and the new equipment. So teaching has benefits in many ways, because you are able to transmit that information back to the younger people.

Tell me about technique and technology. How are they related?

Techniques are involved with the technology. We are going through new phases at this point. We still have film, but now

we are also going through the digital electronic aspects of it. Each one requires a different approach when shooting. I feel it is similar, but you may have to approach it in a different fashion. It is a challenge both ways, and since we have picture capture in both media, I think style, technique and technology are all involved at the same time. The aesthetics may not be that different, but you still have to know what particular piece of equipment will do the job.

You have a son in the business, right?

I have a son, Michael Negrin, and he has done remarkably well. He is a director of photography and lives here now in California, and he has worked for me. He started as my operator in the beginning and had a very short stint as an assistant, but wanted to move up. His first big project was doing Billy Joel music videos, which helped get him some awards and further his career. He has a good approach, is quite knowledgeable, has good taste and aesthetics. It's nice to see the second generation successful.

Why do you enjoy teaching?

I feel it is a good way to take some of the things I have done and reapply them to the students involved. The students are always willing to learn and to go ahead and do their thing, and I find some of them are really talented. And, to me, that's the result of teaching and that is very important.

Sol Negrin, ASC was born in New York City, New York. His credits include Kojak, The Last Tenant *and* Women at West Point.

Woody Omens, ASC

Who are you and what do you do?

I am Woody Omens and I am a cinematographer and I think I do pretty well but I'll let other people judge that.

How did you become a cinematographer?

I started in art school and somehow found my way to a still camera, because I was painting my first year out of art school and needed a camera to take pictures of the paintings. So I bought a Pentax and the rest is history. I was seduced away from painting because I fell in love with the photographic image. Then I picked up a motion-picture camera, which was actually an old Keystone my dad had used to take pictures of me when I was very young, and I said to myself, "I don't need stills, I need movies!"

In Chicago, Aaron Siskind wanted me to study with him at the Institute of Design and get a master's degree in still photography, but I said I wanted to do film and he said he couldn't help me. So I came west to the University of Southern California (USC), and the rest involves getting into the industry just as anybody does, paying dues, doing commercials and assisting and operating, and working my way into television, then movies of the week and then with another break, I was working my way into features.

Where did you go to art school?

The Art Institute of Chicago.

Why did you want to be a painter?

My interest in painting began when I was between 8 and 12 years old, and I just drew pictures all the time. I went to art school on Saturdays and could never put down a pen or brush, but there reached a point when I did put down the pen and the brush because the camera overrode everything. But I haven't given it up; I still paint.

Let's talk about style.

As I look at a little dapple of light on my shoulder, it might remind me of Conrad Hall [ASC] who was the master of the found accident and a man who capitalized on those discoveries, always awake for them and always attuned to finding things that are occurring in the environment. Style isn't something you can buy or wear like a suit. Style is something that's earned through hard work: reading the script, listening to the producer, listening to the director, listening to actors, listening to the writer.

In a sense, when I read a script, I hear the voices that are speaking through the script. And the style evolves out of being aware of what the people around me and the script expect out of me, so I have to be attuned to what is there and be awake. Conrad is my hero in that respect, in that he would admit if he didn't know or understand. He didn't light up until he got the message and found his way to be in tune. Conrad somehow managed to make every movie distinctly different, because he was listening and watching and hearing and waiting for the right elements to somehow bubble up in his consciousness. He had to be a listener first, or a watcher first, a team member when it came to perception. His style grew out of paying attention to details.

Where does your style come from?

As far as style is concerned, before I realized what Conrad's method was, I intuitively did my best to understand what my directors needed, what my actors needed, what the script was asking me to do and what the dialogue seemed to suggest. I tried

to bring to my film, not my ego, but rather some kind of gift that was expected of me. If there are style differences in my work, it is because I was trying to understand what was put on my plate. That's why my style varied.

Probably one of the most successful explorations of style grew out of my work with Eddie Murphy in *Harlem Nights*, because that was Eddie's debut as a director and, afterward, he said he was never going to direct again. I wish he had continued directing because I liked him and I liked listening to him. He wrote the script, and I liked feeling the textures in his script. He gave me enormous freedom to present many different ideas and he chose, selectively, the ideas that he needed. It never insulted me if he turned something down, but I always felt I could express what was on my mind about the style elements that were right for *Harlem Nights*. I went in to make a presentation to him about color design and actually dropped the hint that we could make the movie in black-and-white. He started to go for it, but then I said I was only kidding, because I realized that might have been just my wishful thinking.

As far as the style of *Harlem Nights* goes, I gave up the notion that black-and-white was effective and showed Eddie a color design plan. I said, "Black skin tones should be the most interesting color in the film," because the cast was 90% black. Whatever sets and wardrobe were doing, I proposed they be on the second or third level of interest in any frame, so that the skin tone became the primary color of interest because your eye goes to the skin first. This dictated a number of decisions with Larry Paull, the production designer, and the picture looks different from anything else I've ever done. I would like to think that wasn't because of those sets or costumes, which were gorgeous, of course, but that it had something to do with the sense of color, which the film needed. If that is style, then so be it. I don't like 'style' as a term because it sounds like a paint job from the outside. I don't paint from the outside. I paint from the inside, and that's why I liked Conrad's thought process. It was internal; it grew. He let things surprise him on the set. And we all love to go to the movies to see what the surprises are.

One of the pleasant things about working on *Harlem Nights* was that Eddie asked me to appear in the film as the ring center announcer in the scene with the World Championship Heavyweight fight, so I got into a tux and they gave me special glasses, which I liked. The extras couldn't figure out why the guy with the meter was suddenly in front of the camera. That was kind of fun, and I still get a residual check for about $12 a year for that scene.

Let's talk about style for young people.

My thoughts on style for young cinematographers, filmmakers, editors, writers and anyone who is new to the game is that if they think of style as borrowing from another artist, that is a mistake. I think cinematographers have to learn style the hard way. They learn it by growing it internally and letting it bubble up from the inside. It is not a suit you can put on or a coat of paint you can put on a building. Young people today, as they go into their careers, should know that style can never be about surface and they will never get it easily.

People go to the painter Edward Hopper for style because he is so inspiring. He is a darling for filmmakers, because his work has atmosphere and mood and a sense that a scene is about to begin. There is always a character at the edge of his frame about to move or who has just finished moving. There is a sense of having stopped time out of a movie. That is Edward Hopper for me. I love his style, but I'd be a fool just to grab it and copy it and request it to be art directed into a film. That is not enough. There is a spirit to Edward Hopper and a spirit to Conrad Hall that can't be stolen. Cinematographers have to feel it themselves and hope that it comes out of their intuition magically when they need it.

Is Edward Hopper an honorary DP then?

Absolutely. I have taken my students to the art museums in Los Angeles, and I point out certain painters who should be made honorary members of the ASC. There are, of course, the old stand-bys like Rembrandt. Who doesn't want to emulate his simplicity of single source lighting? That is almost a cliché because every-

body talks about the genius of Rembrandt's lighting, but I'm not so sure they understand the single source lighting he did.

Other painters I would make honorary cinematographers include Georges de La Tour, who painted some of the most magnificent scenes of candlelight. In fact, one of my students, Matt Jacobson, actually replicated de La Tour's Magdalene painting, which is at the Los Angeles County Museum of Art. Matt found a way to hide a light behind a book and actually made a startling capture of the feel of the original. If Georges were here, he would be smiling and might be saying, "I could have been a cinematographer, too."

The painters who inspire me love the light and you can sense that in their work. I think there are 500 years of painting history melting into 100 years of cinematography. To me, it is just a continuum of the same kind of sensitivity to light. In a sense, painters and cinematographers are cut from the same genetic line. They are special. So de La Tour, with his candlelight, is mystical and unique. He gives us a sense of overexposure and underexposure. It is latitude. Painters stretched the latitude just as we, as cinematographers, try to.

Johannes Vermeer is the master of the single-source light. I mentioned that Rembrandt was a single-source guy also, but you never saw his source. It is said that Rembrandt's source was light filtering down from some interior windmill window that he never shows. But with Vermeer, his windows are included in the paintings. You don't see out, but they are there, and he loves to have his source included. Cinematographers learned a lot from him in that sense, as they did about depth of field. Vermeer is not a selective focus kind of guy; he is going to carry focus like Gregg Toland did in *Citizen Kane* — from the front to the back.

Vermeer was a 'deep-focus thinker,' partly because he did studies with the camera obscura. It provided the depth of field that would render images with sharpness everywhere. So the idea that he was doing this hundreds of years before photography means that groundwork was being laid for cinematography. From the camera obscura via painting, there are photographic

clues in Vermeer. But Vermeer was not a copycat. He was not just copying what the camera obscura shows; he surpasses that. He may have used a camera obscura to give him a guide, but in what he captures in the performers and in their attitude, of the way they are thinking and feeling, he is a dramatist, a director, a cinematographer. He is also managing hair, wardrobe and makeup — doing the whole thing.

Let's talk about our next honorary DP, Claude Monet.

When I think of painters I would like to make honorary members of the ASC, I would, in a second, write a letter of recommendation to the membership committee for Monet, because Monet taught me a great deal about color latitude and atmosphere. He captured subtleties of color and light way before any camera or film stock could possibly reveal what is very well understood now about the infinite subtleties, tonalities and reflectivities in an environment. He saw all that without a camera to aid him. Someone said Monet was "only an eye, but what an eye," and that summary is what makes him such a great potential cinematographer. That is why I would want him to be an ASC member.

Monet gave us such a sense of light and life in shadows and highlights and, most of all, the sense of environment which all cinematographers try so hard to capture — the sense that light is not just a blast in the face, but rather it's full of subtleties that are affected by this floor, that ceiling, that wall and the ground outside. Monet knew and understood that. When we got to highly sensitive film, the things he had known without the camera were obviously clear. So now, there is no excuse for cinematographers not to be geniuses of lighting. They have access to great new film stocks that are sensitive to those subtleties, as well as great digital cameras, which, day-by-day, also gain in sensitivity to pick up the subtleties of environmental lighting and the reflectivities coming from every different direction. So as far as Monet is concerned, he would have made any electronic or film camera sing.

What can cinematographers learn from Monet's use of light?

What I was told, as a young cinematographer, was to study nature and understand what is going on with that ultimate single light source, the sun, and learn everything I can about color temperature and lighting shifts and mood shifts throughout the daylight. Then, if I was any good at that, I might be able to transfer it indoors. But what do we do today? We go inside, see a bunch of lights and say, "Let's use them all!" We screw up the very thing that Monet was telling us works, namely the subtleties and reflectivities that are all around us, radiating from every direction. That makes him a great cinematographer.

If I were going to do a film about Monet, I certainly wouldn't want to copy just his style; I would have to find a way in the story that is organic and is developed out of what the script about him would need, about what the director and actors would want the script to be. I really want young filmmakers and cinematographers to pay attention to this point. I don't want them to dress up with "exterior" style, like clothing or paint on a building. They have to find a style by thinking through what the material is really about. Monet watched nature. He wasn't just an eye; he was a thinker.

Let's talk about cinematography's relationship to art.

I don't think we will ever get tired of going to painters for inspiration. I guess what I really do when I look at painters and cinematographers is try to know not just their style, but also the way they feel.

The value in looking at painters and cinematographers for a new cinematographer is not so much to copy the lighting or composition, but to understand what that artist is doing to make the audience feel the way they do. It isn't a matter of just taking the surface image great painters and cinematographers create. It is a question of discovering what they felt, what got them to produce the images they produced. What was it that set them on fire? Sometimes, reading the story of a painter's

life will reveal that. I think getting behind the scene is what a young cinematographer's job is really about today. It's about being a good detective and getting under the surface to see how the person was thinking.

Woody Omens, ASC, was born in Chicago, Illinois. He attended film school at the University of Southern California, where he now teaches as a professor emeritus for the School of Cinematic Arts. His credits include An Early Frost, Harlem Nights *and* Coming to America.

Daniel Pearl, ASC

Tell us who you are and what you do.

I am Daniel Pearl and I am a director of photography.

How did you become a director of photography?

It was kind of roundabout. I was 13 when the skateboard was invented, my friends and I spent a lot of time on our skateboards. I grew up in Upper Saddle River, New Jersey where we had beautiful rolling hills and newly paved streets. I got so comfortable on the skateboard that I eventually — for some reason still unknown to myself — decided to buy an 8mm camera to shoot my friends skateboarding. I did that for a few months, making random shots of them passing by and also with myself tracking along on the skateboard. I wasn't really telling a story, just making what I thought were cool shots.

Five years later, in the late '60s, when the whole hippie thing was going on, I was a student at the University of Texas in Austin, and I became very interested in what was happening with the light shows at the local psychedelic rock venue, the Vulcan Gas Co.. It was a very layered process of gyrating oil art and slides. Seeing my opportunity to get involved, I retrieved my 8mm camera when I went home on my first Christmas break and began to shoot various Man Ray-like images to integrate into the light show. Very abstract stuff, the sun through a crystal borrowed from a chandelier, my hand moving back and forth in front of a close up of a car headlight, etc. At the same time, I was not interested in the pre-med program my parents were encouraging me to pursue and instead was totally wrapped

up in the world of cinema classics that were available to me at the University of Texas. I was seeing two or three movies a day, every day — Fellini, Bergman, Kurosawa — it was all I did.

At the end of my first year, I was not getting good grades as a pre-med student. This was during the Vietnam War, when if you got kicked out of school, it was straight to the jungle, and that wasn't very attractive. I was desperately looking through the rather thick course book for the next year, when in the very last section I found the Department of Radio, Televiision, and Film. Keep in mind this is 1968, and although I'd never even heard of a film school, and couldn't imagine what it would be like, decide it was the place for me. On the first day of film school, the teacher said the class was going to make a film together and asked if anybody had ever worked a camera. I said I had, and was selected to be the cinematographer. We went out and made a short Western in black-and-white on Plus-X Reversal film shooting with a 16mm Bolex. I was very fortunate in that I nailed the exposures. We shot in forests and wheat fields and had nice, dramatic Texas skies. The images looked great and the compositions were strong, and I basically became the staff cine-matographer at the school almost overnight. I think that grow-ing up with my father, who was a mechanical engineer, and my mother, whose main interest was painting contributed greatly to my early success in our very technical art form.

Tell me about the differences between shooting features and commercials.

In commercials, we're telling a story in 30 seconds to a minute, so we really have to drive the point across quickly and coherently. In features, it's the opposite, where the storytelling is laid out and takes time for the drama to build. I tend to go much more "poppy" or contrasty, with the look of commer-cials and really concern myself with the graphic nature of the images. There are a lot of shots and quick cuts, so the image has got to read quickly. If it's a 1.5-second shot, I have to make sure the viewers get the content in 1.5 seconds. We manipu-late the focal point and complexity of the images to accomo-date the fast editing pace.

The majority of commercials I do are vignette-type commercials. There might be a lot of what appear to be non sequiturs, but a general, grand theme also needs to be communicated. For instance, there could be a shot of someone trying to catch a butterfly, and the next shot could be of someone looking through a microscope, and then there could be a person jogging on the beach. Frequently in these types of commercials, there is one or maybe two shots per scene, which is the antithesis of feature making, where we settle into a scene, shooting lots of coverage of numerous set ups to allow the director and editor to later shape the pace and emphasis of the scene.

How do technology and equipment influence your style?

Technology, in a lot of ways, is everything. In music videos and also in commercials, to a certain degree, we try to get new looks that haven't been achieved before. The best way to get that is to exploit new technology, which I try to pursue as much as I can. I'm often on a panel at various tradeshows, so I'm there annually to see what the manufacturers have that's new. I also encourage my gaffer, key grip and first assistant to attend events like Cine Gear Expo to see what's new. I have them get back to me in case there's a product I might have missed or if there's something they have strong feelings about and think that we can experiment with in our work. It's good to see what's new and what we can use for its intended purpose or maybe even for the opposite of its intended purpose.

Some of the best things I've come up with in music videos go completely against what the directions might say. Case in point: The singer Mick Hucknall of Simply Red has a very ruddy complexion. I had photographed him before and his complexion had been a bit of a problem, and I was scheduled to shoot a video in Malibu with him, which the director wanted to shoot in black-and-white. I love shooting black-and-white — it's just not a day-in, day-out thing. My procedure was to go back and think about black-and-white filtration using color filters for black-and-white photography. I looked through the Kodak or Tiffen listing — I forget which — and came across the blurb on

the Red 25 filter, which said "never use on skin." I thought about it for a moment and realized that because there was a lot of red in his complexion and the filter would pass a lot of red light, that it would bleach-out a bit. It was perfect. I put on the heavy red filter for the shoot and Mick never looked better. Even though it said never to use the filter on flesh tones, it completely cleared him up.

What's an example of something you might see at a trade show and then use on a job?

When I go to tradeshows, I'm most interested in lighting, particularly the quantity and quality of light that can come out of a new instrument. I look at what shape it has, what the catch light might be like and I consider its ease of use. In this day and age, the biggest change in filmmaking that I see happening is about economics and how we are more conscious about speed and the budget. Companies are out there doing everything they can to bring in jobs for us to shoot. But at the same time, the economy is tight, so profit margins are being cut more. Because of this, I'm always trying to find things that will advance the art while letting me do it quicker, so I can eliminate any potential overtime. As cinematographers, we have a responsibility to do our job not only well, but also expeditiously.

What do you think has changed over the years?

Everything has changed. When I started 35 years ago and filmed the original *Texas Chainsaw Massacre*, there were only a handful of Arri BLs and Panaflexes in the world. For that movie, we knew we wanted to shoot in a handheld, cinéma verité style and thought we could afford to rent a state-of-the-art 35mm camera in 1973, but it wasn't available to us. We ended up shooting in 16mm and blowing that up. At that time, the grain structure was not considered adequate for a blow-up on the existing negative stock, so we had to shoot on ECO, which was a color-reversal stock with ASA 25. Today, we have 500 ASA stocks that can easily be pushed one stop, and as long as we're pushing to get a good exposure, there are no doubts on the push. We effectively have 1,000 ASA films, but even before a push, to be wide open with a lens, these films need $\frac{1}{16}$ the amount of light required

on the slower stocks, which is huge. Whenever we can work in this lower light level, we can be much more painterly and not just, "Bam! There's the light." That works on a lot of levels, depending on the subject and what needs to be communicated. The technology for this is very helpful and allows us to shape the light more, or use more diffusion, bounces, cuts and gels — all the things that take away light.

The new lights are massive, too — way bigger than they were 20 or 30 years ago. We have 18K HMIs, and 20K Tungstens; we have large quantities of light that are easy to move around, which we never had before. Lenses are also faster. It's common now to have T1.9 lenses; 1.3s are available to us; 2.8s with 11:1 zoom ratio. It's incredible. For the most part, these technological advances involve things getting bigger, becoming more light-sensitive, putting out more light or requiring less light, which allows us to be more efficient.

If I have to shoot in a room with a big picture window looking out to a sunny exterior, I'll want to balance the interior light level to something close the exteror portion of the frame. I'd need a lot of light, especially if there's glass, because I'll have to position the light to come in at an angle that doesn't reflect. It's the difference between blasting someone with lights pushed in close for intensity as opposed to caressing them with the light from big lights further away.

When I started out in cinematography, one the first things I always wondered about was whether there was enough light. On the original *Texas Chainsaw Massacre*, we had a zoom lens, a 9.5 – 95 that was a T2.8 the maximum aperature of which I named Yes. If I turned to the assistant and said "Yes," that meant I had enough light to shoot. Back then, I always worked against whether there was enough light. Of course with time, once I mastered the quantity, I then started to deal more with the quality and direction.

It's funny, but I find that directors don't like to be under too much light. They might say, "It looks a bit bright to me in here,"and I'll reply, "It's all relative and it's all about the ratios, and if you turn to me in an hour and say you want to shoot 120

fps or that you need a 45-degree shutter angle, it's got to be this bright. Would you rather I knock it all down, then re-light it when you want something else?" And the director will say, "No, no, no. I'm glad you mentioned that because I do want to shoot some 120 fps." They always pull that out at the last minute. The directors I work with tend to work in lower light levels. I often shoot beautiful women in music videos, some of whom are considered the 'divas,' and they can be tough assignments. If I'm doing a beauty close-up, I want a shallow depth of field, so I'll knock all the lights back, which is very odd for me, because once I've become accustomed to the higher light level, the lower level looks dull to me, so I'll want to lower the light level in a different way and use an ND or different shutter angle.

Talk to me about digital intermediates and the most recent Texas Chainsaw Massacre.

I was hoping to do a digital intermediate when I was hired to photograph the remake of *The Texas Chainsaw Massacre*. I always thought we'd go that route because the director, Marcus Nispel is someone I've done a lot of commercials with, and that has basically been his world throughout his career — everything he's done had been color graded in a telecine suite. He wanted a desaturated look, where the greens weren't too bright and the skies weren't too blue. I assumed it would be digitally mastered to finish, but that's quite a costly process, and I was told before we began principal photography that we would finish via the conventional photo-chemical process. With excellent advise and help from the people at both Technicolor and Deluxe, we ultimately applied a skip-bleach process to our release prints to desaturate the colors a bit and chunk up the blacks to get the look we loved for *Chainsaw*.

Where do you see cinematography heading?

We're moving forward to make better images, and we're moving in the direction of making things look more modern. I think that, absolutely, digital intermediate is the way to go, because otherwise we are bound by the laws of chemistry and physics. Audiences see looks every day that are flat-out unachievable

through any other process but digital intermediate. If I shoot a commercial or music video and want something to look what I call *National Geographic*, which to me means it's well photographed yet also a realistic rendition of the subject, I'd finish it with a conventional process. However if I'm after something hyper-real or alternative looking, I'd take it to telecine or digital intermediate, which is the only way to get the look I'm going for. It allows me to alter the color bias, or choose one color and adjust it without affecting the other colors. I can separate the highlights, mids and shadows and run them up or down individually or alter the contrast. Basically, it's like Photoshop, where I can do the same things to a moving image that I can to a still image. The tools are incredible, but we have to know what we want. Otherwise, it can become quite a quagmire. It is common for people to go into a telecine session and be dumbfounded for the first few hours of looking at things, because they can do anything and give any kind of look in just a flip of a switch.

If it's going to end up on TV, why shoot music videos or commercials on film?

The advantage of shooting film is its range and control. If I take the original negative into the telecine bay, I can isolate and deal with colors, alter contrasts, resize or distort the image to give it a squeezed anamorphic look — whatever is necessary, I can do it. If I shoot electronically, however, I record on tape and then I am in tape-to-tape world, which takes me to the same basic set of controls that they use to control the telecine machine, but I'd still be locked to the inferior properties of tape. I wouldn't have that range of tonal information,resolution and data that the negative captures.

If I intend to finish digitally, which is being done more with music videos, commercials and many features, I'd still need to shoot on film because film captures the most information and range of tones. Even though I may manipulate it later electronically, I still need to get as much of the data as I can into the machine. It's like having a negative that you'd make a photograph with. You can manipulate the negative to alter the look of

the photograph, as opposed to just having the positive print of the photograph and trying to change it. Once it's on tape, we've lost a huge percentage of the dynamic range, which limits where we can go.

Daniel Pearl, ASC was born in Bronx, NY. He attended film school at the University of Texas. His credits include Aliens vs. Predator – Requiem, Frankenstein *and both* Texas Chainsaw Massacre *films.*

Wally Pfister, ASC

Who are you and what do you do?

I am Wally Pfister and I'm a director of photography.

How did you become a director of photography?

I started out working at television stations. I began as a production assistant at a small TV station right out of high school. I worked my way up at this TV station to operating the studio camera for the local news. I moved from there to being a news cameraman and did that for a couple years. Then I left the station and moved to Washington, D.C., where I did documentaries for a number of years. After a few years of that, I was looking for more of a challenge so I applied to the American Film Institute in Los Angeles. I got in — this was in 1988 — and went to their two-year cinematography program.

When I left, I started working in every capacity with some of the people I had met when I was there, like Janusz Kaminski and Phedon Papamichael [ASC]. We were all working together at producer Roger Corman's factory, where I worked as a gaffer, grip and dolly grip. I then started shooting second unit for both of those guys before branching out on my own. I began doing my own smaller-budget movies as a director of photography and also worked as a camera operator for a number of years for Phedon Papamichael.

More and more, I began making the transition over to being a DP full-time. I shot my first movie as a director of photography in 1990 for Roger Corman on a horror picture called *The*

Unborn. It involved a mechanical fetus that was killing people and, in typical Roger Corman fashion, it was tacky and hilarious at the same time. I really cut my teeth and learned the trade on the films we did with him, shooting second unit on films like *Slumber Party Massacre Part III.* It was usually part IIs and IIIs — a lot of exploitational stuff. I hammered around with that for a couple years, then did some kid films, which were all in the low-budget range, under $5 million.

I struggled and worked my way through the low-budget pictures until I did a movie in 1997 called *The Hi-Line,* which helped get me to where my career is now. That was a small film made for under a $1 million that went to Sundance. Director Christopher Nolan saw it when he was there promoting his first film, *Following.* Subsequently, he hired me to shoot *Memento* based on my work on *The Hi-Line. Memento* was really the film that kicked things off for me. Following that, I did another picture with Chris Nolan called *Insomnia* and a third called *Batman Begins.* My work with Chris really set things in motion and allowed me to get some of the other projects I've done.

**Let's talk about style and the look of a picture.
Memento was certainly momentous in how it looked.
Tell me about that.**

The style is based, first and foremost, on the material. The most important thing is the narrative. Our job is to take that narrative and translate it into imagery. That should be our primary goal and, secondly, we should showboat — put out an image that we consider great photography, outside the lines of the story. But it's most important to respect the narrative.

I tend to like dark, moody themes in scripts, photography, painting and lighting. I just prefer that side of things and always have, even in the films I liked as a kid. That is the style I like to light in. In fact, when I have the choice, I find myself staying away from projects that don't allow me to play in that area. If I'm careful about choosing based on the narrative, I'll choose the style of narrative that I like to photograph, which is moody.

You said something really interesting that nobody else has said before in your comment on showboating. How do you stand out from the pack?

The most important thing is the narrative and we have to have respect for it. I say that, because I don't want to shoot a film that I wouldn't go see in a theater. That's how I judge the material and it's very important to me. As I read material, even if it's already attached to a strong director, if it's not interesting to me or won't make a good movie, I try not to do it, because it's important that we as cinematographers respect the art of photography.

The showboating is because, for our own fun, we need to put interesting imagery up on the screen. If we just follow the narrative and work in a formulaic fashion, then it will look like everybody else's work. I always try to challenge myself and push the envelope somewhere. I also encourage the people who surround me to challenge me. Directors whom I work best with — and this is certainly the case with Christopher Nolan — will discuss things with me repeatedly until we arrive at the right way to do things. The photography and lighting generally falls into place through that. Then it becomes a matter of, to what level should I elevate it? In terms of showboating, do I push style into it? I try to push style into it when appropriate. I wouldn't push if it's going to appear forced or run contrary to the material.

In commercials, it's a different story. I've done a lot of commercials recently, and style really gets pushed there. The photography in commercials is much more important as a storytelling tool than it is in narrative. That can be both good and bad, but wonderfully original things come out of commercial photography — as long as it's not all following the same trend. Then it all starts to look the same as well.

Talk to me a bit more about style using examples from your own work.

I generally try to amp up the style level when I work. I did *Insomnia* and then *Laurel Canyon*, both of which I consider to be naturalistic films with naturalistic lighting, particularly *Laurel*

Canyon. For *The Italian Job*, which was more of a studio popcorn picture, I felt it needed a bit of style and snap. I went into that wanting to play and mix colors more than I had in previous films; I wanted it to have a little more lift and contrast.

A lot of *The Italian Job* was day exterior, particularly the car chases, which provided great environments where I could have fun. The opening of the picture was a heist that took place in a palazzo in Venice, which we built on the stage. It was a fantastic set built by a production designer named Charlie Wood, who is just really talented. Having good sets makes the job so much easier, because we can be buried by bad production design. In this case it was fabulous. And it was my favorite part in the film, because it had a classic-painting lighting to it — a Vermeer or Caravaggio kind of style. I contrasted that soft lighting with the lighting of the tunnel set that was also built, where the truck crashed through, which was more stylized. There were pools of light in that set, in addition to backlight and the usual smoke and mirrors.

But I tend to default to a more naturalistic style. Looking at those scenes doesn't scream of having a big style with huge backlights three or four stops overexposed. They're much more contained, because I get antsy if something screams out as being too stylish. I try to keep it within a world I can understand. Maybe that comes from my many years spent in documentaries, but I prefer this kind of style and lighting.

Talk to me about technique and technology. Do the tools of the trade affect the way you shoot?

Technology is constantly changing, both in camera and lighting equipment. In general, I care more about technology in lighting equipment than I do about the cameras themselves. However, with the advent of new cameras like the Arriflex 235, which I haven't yet seen but am dying to check out, is something that opens new doors for us. Every time there's a new technology that comes along, there's a change and an adjustment period, which generally works out for the best in the end. Ultimately, technology benefits us and allows us to do new, more interesting things.

The other thing that can be helpful is sometimes exploring different cultures where we can find technology. I shot *Batman Begins* in England for 11 months and saw some things over there that were different from what we use here — simple things, like four-by-eight frames of diffusion, are very common there. People generally don't carry those in their trucks here; they're something that have to be made or built. I really enjoyed using them on the film, even though it's completely low technology that I just hadn't been exposed to much. By going to different cultures as much as possible to experience our business, we can learn new tricks.

Why are you more interested in lighting than in other technologies?

Matt Leonetti [ASC] has a company called Leonetti Company that invented a simple dimmer system to overcrank the PAR 64s. I use it a lot with my gaffer, and it's great to have that extra bit to boost a light. It can also take it a little bluer. Mole-Richardson reintroduced its MoleBeams, which are an old technology that I really love and use a lot. The other fun technology is the SoftSun, which is just an enormous soft-light source.

Also, I enjoy really cool frames, like this one I saw in Canada, which was a 12-inch by 12-inch frame that folded in half. That's not a new technology, but one from a different culture again. Those kinds of things really excite me more than seeing a board on a camera that has all these bells and whistles that do this and that when I punch them in. I prefer the tools I can really get my hands on.

When might you need to use these lights?

When we're shooting night exteriors, we generally need a large, foundational source of light. We use Bebee lights a lot, and I like to use Condors with either a 20K on them or Maxi-Brutes or Dinos. I could use anything from a NightSun, which is a bank of 18K or 12K HMIs; to a Bebee light, which is a bank of 6K PAR HMIs, or 36 6K PARs, which I could point in different directions; to something as simple as a 20K on a Condor. I generally put it up and either use it as a backlight or try to

soften it up and use it as a sidelight or even a three-quarter light on a subject — the subject being a large night exterior or possibly an entire city street.

On *Batman Begins*, we had an airship hanger in the English countryside that was 800-feet long, 400-feet wide and 180-feet high, in which we built a city. We built 10-story buildings and streets in there and just created an enormous city. It was a monumental achievement to light that, because we were basically lighting one of the largest indoor sets ever built. We basically used the same techniques we would have for a night exterior, which were Condors with large light sources on them.

Where is cinematography going from here? What's great about being a cinematographer?

Cinematography is a passion for me. For any of us who really do our jobs well, it's a passion for and a love affair with light and what can be done with light, composition and camera movement. Where is it going? I hope it continues to be respected as an art form and as a craft that's important to the storytelling process. New technologies are a bit intimidating, because it seems like we're heading away from film and traditional film imagining toward the electronic medium. I don't know when that will become the norm, but it's certainly at our door, which is both good and bad. In that, it's important for us to keep control over the image and continue to have the respect that we currently do in our craft. We have to preserve that. Where do I think cinematography is going? I think it will always remain as an art form that's necessary and part of the storytelling process. There's a sound bite. Finally.

Wally Pfister, ASC was born in Irvington, NY. He attended film school at American Film Institute. His credits include Momento, The Prestige *and* The Dark Knight.

Robert Primes, ASC

Who are you and what do you do?

My name is Bob Primes and I am a cinematographer.

How did you become a cinematographer?

I had a great love of music and the arts and I wanted to work in a more abstract medium than words. Music was my first love, but I didn't have the chops for it. I was touched by stills, *Life* magazine, photography, cinematography and movies in particular. I wanted to try to touch people the way I had been touched by so many artists.

How did you make that first bold jump into cinematography?

I had a dream about Gandhi and his spinning wheel and the *Life* magazine pictures of Margaret Bourke-White. But my dream was animated. Not only did the spinning wheel move, but the camera moved around it, and I took that as a sign that I must add the dimension of motion to my still photography.

How has your style evolved?

Style is difficult to speak about, because it is intuitive; I don't think one sets out intellectually to create it. I think you look at tens of thousands of images, both natural and from other artists, certain things click and there are certain things you try to emulate and, of course, you fail but then you confront your failure, which is the best teacher you have. What I hope I have

learned is that when you are in a movie with characters, story and complex layers of choreography, visuals, subtexts, character arcs, etc. — you don't want the photography to say, "Hey, look at me," as if it is its own thing. I think photography should be supportive, where you have simple, single source lighting and strong, bold compositions. You should see the movie and not be consciously aware of how much the cinematography is emotionally supporting the story. The first time I see a great film, I'm not that aware of the photography. I need to see the film a 2nd time to consciously appreciate the cinematographer's work!

Do you take pictures to show the director and to establish a style?

I use a still camera and sometimes a camcorder. The best scout I can do with the director is with a camcorder on the set. The director and I can brainstorm, block the shots and figure things out. One of my jobs is to give the director confidence that we are seeing things with the same eyes.

How has your style evolved in a particular movie or in a particular scene?

A movie I shot in 2003 originally called *Getting the Man's Foot Outta Your Ass,* but later changed to *Baadasssss,* was a story about the making of an historically important film called *Sweet Sweetback's Baadasssss Song,* made in the early '70s. It involved psychedelia, street people and the real life of black people in the United States, as opposed to the "Sidney Poitier-ism" of the black experience that the Hollywood movies of the time were depicting. When we went to make this movie, we decided it should be boldly saturated, in your face and pay homage to the visionary experience of the early '70s. That concept influenced everything we did. Often, the colors and much of the overall experience had to have a mystical or psychedelic quality to it that reflected the consciousness of the time. We were always thinking in terms of this energy and presence. It brought back some of my experiences in the early '70s.

You actually remembered them?

I don't know if I remembered the actual experiences, but I remembered the mood and feeling of them.

A few years ago, I was given a script about a lady who keeps killing her husbands. It didn't seem to have a lot of substance and I might have turned it down if I had any other work offers at the time. I thought about what style I could use to get a handle on this, because I normally have a realistic style, but there wasn't anything realistic about this. I thought about what they might have done in the '40s or '50s, and I developed a modified film noir style, but in color. I used a lot of source four lights to put patterns on the walls, painting shadows and trying to make it look more theatrical than realistic. I was pleasantly surprised by the results and it added some new looks to my palette.

I am a huge fan of Conrad Hall, and one of the reasons is that his movies don't look alike — he does not have a "Conrad Hall style." Rather, what he does on each movie is go deeply into the script to find a style that is appropriate to that picture. I try to benefit from his admittedly intimidating example and read the script and hopefully find enough tools and techniques that I can invent something new. It keeps me closer to the edge where I think we do our best work.

I believe that lighting and composition are two sides of the same coin. Lighting has a force and direction, and composition should also have a force and direction. This subliminally directs the audience to the story element that's the point of the scene. I believe a strong force of single source light is inherently powerful and any light that opposes it, such as a fill, weakens it. If you have to fill in light, do it from the same side as the source. I think of both lighting and composition as forces with both power and direction.

Let's talk more about composition.

Centered compositions are often static while unbalanced compositions can be kinetic and create tension. When the viewer's eye is close to the frame line, the subconscious awareness of that great visual mass pulling at your peripheral vision creates a heightened state of involvement. That is one of the reasons that carefully

composed compositions should never be cropped or reframed for economic convenience. Cinematographers are not "recording" scenes, they're "interpreting" them.

One of the reasons I love to work in digital is because of the precise, nonverbal visual communication you have with the director. Because you can see exactly what you are getting with the accurate monitor, you can be bolder than your comfort zone might otherwise allow. Your learning curve is now instantaneous, so you can try something crazy and bold and the director can see it with you.

The other tools I love these days are what you can do in post with power windows, secondaries, etc. Also, the "paint" tools in many digital cameras allow you to create powerful looks on set and then light specifically for that look, with the director able to accurately monitor the whole process.

I believe a cinematographer should always be interpreting, never merely recording and your work should reflect a point of view reflecting your personal core values. I believe your biggest job is to overcome your own personal inertia and try something new. You are always looking for ways to push your personal envelope. You should understand the script so thoroughly that what you come up with isn't just something showy, but something appropriate.

Some people presume we look at the script and can then immediately make lighting plans, diagrams, etc., and then go execute our design. In truth, I get my inspiration from things I see in everyday life, in nature, in museums and in the movie I saw the night before. I enjoy discovering something on the set by accident. I love the idea of a little randomness and unpredictability in each take. Sometimes I can't solve the puzzle until I see the actors block the scenes in the actual location.

Robert Primes, ASC was born in San Francisco, California. His credits include thirtysomething, My Antonia *and* Baadasssss.

Anthony Richmond, ASC, BSC

Who are you and what do you do?

I'm Tony Richmond and I'm a cinematographer.

How did you become a cinematographer?

I always wanted to make movies and it's all I've ever done since I left school at 15. I joined Pathé News and was a messenger boy running up and down Wardour Street with cans of film. One thing led to another and I got a job as a loader for Danziger Studios, where they were making B-features and churning one out every nine days. In those days, when you worked for a camera crew, you worked for a DP as his operator, his first and his clapper/loader, known in America as the second, and you worked as a team. I was permanently employed by Danziger, but they brought in other DPs and I happened to meet one. He liked me and took me to Hammer Studios, where I worked on two or three of the Hammer horrors, such as *The Gorgan, The Curse of Frankenstein* and *The Devil Ship Pirates*, which was with John Wilcox.

Then we went on to do a pretty big picture in 1960 in Israel, *Judith*, a picture with Peter Finch and Sophia Loren, which Daniel Mann directed. There I met a young cinematographer who was directing and photographing the second unit with Nicholas Roeg, and on his crew was Alex Thompson. Straight after that, Nick asked me if I would like to do his next movie as his assistant, and I said yes, and that happened to be *Dr. Zhivago*. I worked with Nick on *Dr. Zhivago* until he left *Zhivago* and I stayed on with Freddy Young. At the end of *Zhivago*, I

bumped into Nick in Madrid — we were both still there — and I stayed on in Madrid on *A Funny Thing Happened on the Way to the Forum* with Nick Roeg. Then we came back to London and did *Fahrenheit 451*, with Truffaut, and *Casino Royale*. Then the last picture I pulled focus on was *Far From the Madding Crowd* and that ended in the spring of 1967. And John Slessinger made a documentary about the six-day war and he asked me to shoot it for him. That was the first thing I ever shot on my own and then I came home and immediately picked up a pretty large picture for Paramount, which Basil Dearden directed called *Only When I Larf,* based on a Len Deighton novel.

Then I was very lucky as things just fell into place. Jean-Luc Godard asked Nick Roeg to shoot a picture for him, but he told him he wasn't doing that anymore and that he was trying to get his own movie off the ground and he suggested that he look at my work, so I got the Godard picture, and then went on to join Nick in Australia on *Walkabout*. And the rest, I suppose, just came one after the other from then on.

What was the Godard picture?

The movie was *Sympathy for the Devil* or *One Plus One*. There were only 12 shots in the movie, of which ten run in their totality ten-minutes long. We used Panavision PVSRs. A lot of the shooting was done in a recording studio in London, and the Rolling Stones were actually recording the track for *Sympathy for the Devil* live, so we had to shoot them. It was lit in such a way and the tracks were laid, and each shot was ten-minutes long and we had these long tracks all around the studio. Then we did the same in the junkyard with the Black Panthers. It was really interesting.

Were these 360 dolly moves?

They were 360 dolly moves. We went all over the room, in and out, snakes and the camera would still pan around. That was the first time we used a video come-through, which Joe Dunton — who now has his own company but was working for Samuelson's at the time — developed and we used it on the Godard picture.

Let's jump ahead a bit. Tell me about your last picture and what camera you used.

The last picture, *Havana Nights*, which for all intents and purposes is *Dirty Dancing 2*, although it is set in pre-dirty dancing Havana 1958, the time of the Battista/Castro revolution. And I used Arricams.

Why did you choose Arricam?

I've always used Moviecams, so Arricams were a natural progression.

It seems that as cameras have evolved over the years, technique has changed with them. What do you think has happened?

I think the major thing is that the cameras are so much smaller now that they're much easier to use. You can get them into places we could have never gotten a camera into 10 or 15 years ago. They're very light and perfectly balanced if you want to go handheld, and they're very quiet. The combination of the Arricam now with Cook lenses is as good as it gets as far as I'm concerned.

Could you compare that to the big equipment you were using on *Dr. Zhivago*?

In *Dr. Zhivago*, we used rack-over BNCs, which are huge cameras with side finders. In 1960, the only reflex camera was an Arriflex 2C, which had the three lens mount with the anamorphic on the front. Nowadays, basically, an Arricam lightweight is almost as small as a 2C. You put that on a Steadicam and away you go. We're doing fantastic stuff. The biggest thing is the size — the smaller it is, the easier it is to use and even though it's tiny, as long as you treat it with a lot of respect and put it on a proper head, it's absolutely fantastic.

What about film stocks? How have they changed over the years?

Drastically. Film stocks are so much faster. When I started lighting, like a lot of other people, film stock was 50 ASA. Now we

can shoot our interiors at 400 or 500 ASA and still have a relatively fine grain. Not only negative stocks but positive stocks have gotten so good. That's why you have a lot more people shooting Super 35mm as opposed to anamorphic, because you've got a finer grain negative and you've got a really good positive stock, and combined with the flat lenses, some of which are vastly superior to the anamorphic lenses, the loss is not that great.

When you walk into the studio at the beginning of the day and the set is totally black, how do you approach lighting?

Well, I've already seen the picture in my mind. It's almost like you walk into that dark stage and you see it — it's there. I can see it and I try to get it to look like what I see in my mind, which is sometimes a little difficult. I would assume every cinematographer has a different approach to how he looks at a movie, in terms of style.

For me, I feel that I am the director's eyes. It really is my job to put his vision on the screen. Generally, he will have been involved with the movie for many months, probably years before the cinematographer is even hired, and he has developed this vision. It has been his life; it's his passion for that length of time and I think that, when approached, when one gets the movie you want to find out as much as I can from him about how he feels that his movie should smell, how it should look, what he wants to see in the shadows. From there, we work together and, obviously, as I said, my job is to put his vision on the screen and help that vision and enhance it and probably make it a little better for him. Every movie is different and each one should be treated differently. I like to think that, as a cinematographer, I don't have a style. I've shot many different movies. I've done some comedy, high drama, low drama — all sorts of movies — and rather than either do thrillers or just do this or that, I've been able to change.

Tell us about the last movie, *Havana Nights*. What were some challenges or some things that were interesting on that film?

There were a lot of challenges on that. First of all we had a very short schedule. It was a 45-day shoot, which really is not long these days. We shot the whole of the picture in Puerto Rico, which in itself is a pretty difficult place to shoot. They don't have a lot there, so we had to take all our own equipment. We had to use a local crew there because they get so much money back from the state, and shooting in Old San Juan is really an impossible place to shoot; it's a bit like shooting in Venice, Italy. You can't take trucks in, so base camp is at either end of Old San Juan and everything else is put on dollies. So it's really difficult and those are the challenges and the sun is in those narrow streets just an hour a day.

Tell me about some of the technology that was helpful to you when shooting *Havana Nights*.

We used a lot of Steadicam and the lightweight Arricam on a Steadicam is absolutely fantastic. We also threw it up on Technocranes with various hotheads or remote heads. We did a lot of dance numbers, and we couldn't have done it any other way. For me, the combination of the Arricams, Studio and Lightweight and the Cooke lenses is just fabulous.

What cameras did you take on the shoot? How many?

I took two Studio cameras and one Lightweight, and we didn't have one problem, not one scratch or piece of dirt. It was just fantastic.

Could you tell me about how the lens data system works?

[Laughs] You should ask my assistant.

What does it do for you?

It doesn't do anything for me quite frankly, but I know for a lot of other people it does. I know my assistants love it and the great thing about the new Arricams, instead of the Moviecams, is that the assistants were always bitching and moaning because it wasn't like Panavision, where everything sort of mixed and

matched. It was all a mismatch of bits of Arriflex here and a bit of that there, but it seems, with the new Arricam system, that everything is perfect and that's great. I'm not a very technical person. I light by eye and I leave the technical things to my assistant, although I do like to change the shutter now and again and change the stop. With Arri lens control system with the Arricam, everything is so easy. I can do it from my chair when I'm watching the monitor.

How do you do that?

I've got an Arri lens control system. It's remote and I can sit in the chair and I can see as the camera is panning when the stop change should come and I just change the stop remotely.

Who was your camera crew on this?

My operator and Steadicam operator is a wonderful man named George Richmond and the focus puller is another Richmond. They just happen to be my sons and we've been together for ten years. I guess nepotism is OK if you keep it in the family. They're very good. I'm always embarrassed to say that I work with my sons, meaning that I didn't get them the jobs. Other people trained them. George worked with Alex Thompson for many years and my other son has worked for many other cinematographers. I feel very lucky when they're available and I can use them. George is a superb camera operator, stroke Steadicam operator, and my other son is a wonderful focus puller.

Are they like my kid, who thinks the old man doesn't know anything?

What's interesting is I guess most kids view their parents as being rather idiotic, but working with my sons, they show great respect. I guess I'm lucky.

What about the other way around?

I have great respect for them. They're both absolutely superb. If they weren't, I wouldn't use them. They're really at the top of their field.

In terms of equipment these days in the movie business, the only side I know — features — that middle management and the studios are playing a big role now with their number crunching, and I think it's very sad that equipment houses are put through what they have to go through, forcing them to undercut other companies just to get a job.

There are a number of companies in Los Angeles that a few years ago used to be very good and reputable but, I won't mention names, one wouldn't touch now because they've undercut so much that their equipment isn't in good shape. There is just not enough money to service the equipment, and I think that something has to be done in the business about that, not only with camera equipment but also with all other equipment, and certainly with lighting equipment. Some companies are giving quarter-day rentals or quarter-day weeks, which is insane. I think that and the ridiculous hours that we work are things that have to be addressed. But I don't see how either is going to be addressed, because that's how the business is going.

You've only got to see the equipment that Clairmont puts out and how it's in top-notch shape. And they have to make some profit to keep the equipment in that shape and it's always a problem. Now when you go in and you're asked to do a movie and you say, "I want to use this company," and the studio says, "We've got to bid it to three companies," and you have a relationship with a company, like I have with Clairmont, you know they're going to help and you want to make sure they're doing OK, both for their future and for our future. Because we, as cinematographers, rely on companies like Clairmont and Panavision to help us with equipment and show us advances in technology. Without that, we are losers.

Speaking of the future, I'm sure you've talked to students or friends of your sons. What do you tell them about how to get into the business and where it is going?

The business is taking a big turn. The numbers of movies being made is far less than before, and there is a great demarcation in terms of budget. You've got each studio doing two or three $120

million or $130 million movies per year, and a host of lower-budget movies between the $15 million to $20 million range, which is now considered low budget. Those middle budgets of $40 million to $50 million are few and far between, and I think that technology is changing. At the moment, I can't see anything taking the place of film, but I'm sure it's going to happen in the next few years when they get these digital cameras going properly.

What film stocks do you use?

I've always used Kodak. I love this new 18 stock that has come out. The contrast level is superb and it has a very fine grain. I like the 84, which has a more European feel to it — it started in Europe, then they brought it over here. I don't think you can go wrong with those two stocks.

Lucky we're doing this interview on 18.

There you go.

Where would you like film to be headed? Does it need to be faster?

I don't think it needs to be any faster. 500 ASA is fantastic, and we can use smaller lights. I don't think it needs to be any faster at all.

What about lights? Have you seen a progression of light development?

Not really. For me, they've never made a light to take the place of an arc light. What I personally have done on the last few movies is not use HMI. I'm using Tungsten, and I'm using Dinos. I've had a lot of bad luck with HMIs. They're always going down or breaking.

What was your favorite film to work on?

I've always loved every movie I've shot for Nicholas Roeg. We have a special relationship that goes back many years and he's probably my best friend. I liked my work on *Don't Look Now,*

and that was a special movie. We shot it in just six weeks. To work on, there was one picture I shot in the late '70s called *The Greek Tycoon*, which was just fantastic, being on the Aegean sea for 16 weeks on beautiful yachts. And there was a picture I did for Fox a few years ago called *Ravenous*, which, sadly, no one liked but it was a good-looking movie we shot in the High Tatras mountains in Slovakia and the interiors were shot in Prague.

What are you doing next?

I'm doing *A Cinderella Story* for Warner Brothers, which we start shooting in two weeks time, starring Hillary Duff of *Lizzie McGuire* fame, who is a hot young actress. My daughter is very pleased. I have a 7-year-old daughter who is very pleased I'm doing *Cinderella* and it will keep me in town for the summer.

You work pretty nonstop. Why is that?

I like to work.

Why do you work so much?

I work so much for two reasons. The first being that it's all I've ever done. I've only ever worked in movies since I was 15. I love to work. It's not a job; it's part of one's life and I would work every day if I could. The second reason I work so much is I'm very lucky. I'm lucky to be offered a lot of work. There are a lot of people that would like to work all the time, but it doesn't always happen like that. Half of it is luck and half of it is love.

Anthony B. Richmond, ASC was born in London, England. His credits include Don't Look Now, Ravenous *and* Men of Honor.

Pete Romano, ASC

What is your name and what do you do?

My name is Pete Romano. I'm an underwater cinematographer.

How did you become an underwater cinematographer?

A long, convoluted trail led me to Hollywood. I actually started as an underwater cameraman in the U.S. Navy. Through a series of events and fortunes, I hooked up with a documentary cameraman who really opened my eyes up to underwater filming, which eventually segued into Hollywood. It was a very circuitous route.

How did you get into building and designing your own housings?

When I first came to Los Angeles, I worked in visual effects with Richard Edlund, [ASC,] though I still had an intense desire to get back to my underwater photography roots. The underwater equipment that was available at that time — the early '80s — was pretty meager and very problematic. There was no video assist, virtually no reflex viewing, and the controls were not really set up for easy focus and aperture changes.

I shot a commercial with an old Bolex 16mm cameras. I would almost call it a pressure pot; it was the parallax view finding, all that sort of stuff. I remember there was one close-up that I had to reshoot because the framing was so bad, and I made a vow then that I would build equipment for myself to further my career.

Once you build the equipment, does it change the way you shoot?

The way I shoot and equipment I use go hand in hand. I look for ease of movement; I want the reflex viewing; I want to be able to adjust my focus and aperture quickly, so I look for all the advantages a topside camera has in an underwater package, because underwater is a harsh environment.

If you have a camera that's lighter and easier to maneuver, does your style change as a result?

Technology changes style because we now have underwater monitors. We have Prestons on some of the lenses of our housings, which allow for remote control of the focus, iris and zoom. The newer cameras, with all of their electronic goodies, have really brought all the topside accessories and functions to underwater cinematography.

How has this newer, lighter equipment changed your job?

Lighter doesn't play into it, because of the physics of being underwater. But the newer equipment has brought all of the above-water technologies to the underwater world, in terms of speed, aperture control and ramping. All those toys are now underwater and it's great to have those advantages.

Can you provide an example of when you would use some of these toys?

I was at Universal shooting a scene for *War of the Worlds* — the one where the ferry gets flipped over by aliens. During the scene, people were in the water falling all over the place, with cars dumping into the water as well. A lot of the shots took place during heavy wave action both below and above the water, especially at the water's surface. In those circumstances, there was no way to handhold the camera, never mind build a platform to keep it dry. But with a remote underwater head, remote camera and a housing and a crane on the deck, I have greater control than I ever had before when I did this type of photography.

Talk to me about your company HydroFlex. It's pretty unique.

HydroFlex really was a means to an end to get me building underwater equipment for myself as a cameraman. It got out of control from there, as these things do. At the beginning, I was building my underwater housings at night and on weekends at Richard Edlund's machine shop at Boss Film Studios. Before that, I had built equipment at the machine shop at Lucasfilm and Industrial Light + Magic. Finally, toward the mid-'80s, when I was involved in Jacques Cousteau projects, I decided that it was time to start buying machinery and build my own machine shop. I built a couple of extra pieces and placed them for rent with Denny and Terry Clairmont of Clairmont Camera. But ultimately, it was better for HydroFlex to do the rentals because of all the maintenance and training issues involved with the equipment. From there, HydroFlex grew into the company it is today.

What is an underwater housing and how does it work?

In simplest terms, an underwater housing is a watertight box that allows me to take the camera underwater to shoot. There are many levels of sophistication for that housing. I could just build a box and throw a camera in it to get my shot, and that has been done before. There's so much history of underwater cinematography. I have a poster collection that probably goes back 70 years with only underwater-themed movies. It really captures the history of underwater with pioneer cinematographers who truly had built the simplest boxes. Thankfully, we're in a new century that allows us to have all the sophistication of above-water tools so we can keep up with production. That helps the success of our shooting and keeps us rolling to get the shots. There was once a time in underwater when there was only a 50% chance that we'd get usable results. I'm trying to make that 100%, and we're doing very well.

What about underwater lighting?

Underwater lighting has changed over the years, because now we can use higher-powered HMI lighting and fluorescents. It's sometimes a challenge to light underwater, because it's an

extremely dense medium, and unless production has stayed on top of water clarity and is able to control it, we're often behind the Magic 8-ball when we get into dirty water. In relative terms, lighting underwater is similar to smoking a set and then lighting it, meaning that backlight becomes your best friend. As light travels through water, it loses its spectrum of red and starts getting bluer, so even with an HMI, which starts as a blue, it only becomes bluer as it travels. Tungsten lights tend to be a little nicer and allow for warmer control.

Let's talk about style and why a picture looks the way it does topside vs. underwater.

In terms of underwater lighting matching the above-water, topside, main cameraman's lighting, that's always a diplomatic process. That requires a lot of sharing, but I am truly there to work with the main cameraman of the show. I have a distinct advantage over most cameramen, because I get to work with other cameramen often, which doesn't normally happen. It's one of the best parts of my job to work with all of these gentlemen, who are artisans, and to listen to them and try to understand what they're looking for in the film I'll be giving them. I offer suggestions on how we can attain the look. I show them things I know will work and see if they like those things, because it is a collaboration. I'm there to help them make their movie.

Tell me about _The Life Aquatic_ you shot with Wes Anderson.

The Life Aquatic will always have a place in my heart. I'm truly one of Wes Anderson's fans, and the opportunity to closely work with Bob Yeoman [ASC] was one of the highlights of anything I've ever done. Bob is a very good cameraman and also a really nice guy. It wasn't an ego or power thing with him — it was, 'How can we get together and make the best possible film for Wes?' That was how our whole relationship evolved. We even went out at night and had dinners and beers. He became more of a friend than a coworker. Bob has a distinct style, and Wes obviously has a distinct style. The framing, lighting and everything else I did aimed to complement what they did above water.

How did you achieve that?

For the underwater, we were supposed to be very deep in terms of the storyline, though we shot in maybe 12 or 14 feet of water only. To compensate, we really had to soften up the light quite a bit so it wouldn't have that dappling effect, which would have given away the shallowness of the water we were working in. We had a lot of backlight that came above in the permanents, which we diffused quite a bit. For my front light, I used very diffused HMI lighting that came in to give just a little kiss and some detail in the actors' faces.

I thought that you shouldn't use backlight for under-water shooting.

Backlight is your friend underwater. It really helps define the subject. If you're in a pool trying to make it look like you're in the Allegheny River or some vast expanse of ocean at night, there needs to be that drop-off, so with tarps on the sides of the pool, a bit of diffusion material in the water and a nice back-light, you're lucky to see 10 feet beyond your subjects. At that point, it's underwater infinite and I can place that film as being in any body of water, be it an ocean, lake or pond. I have the ability to cheat quite a bit.

Give us a lesson in underwater focus, flat port and dome port.

Underwater focus flat port versus dome port? Let's start with the simpler one, which is the flat port. That was what the pioneers used, because it was all they had and knew about. Today, flat port is still a viable course, especially for going in and out of the water. Because of the refractive index of water, I lose 25% of my acceptance angle, so my lens becomes tighter and my subject becomes closer by about 25%. With wider lenses, I can typically get away with that 25% by taping off four feet and keeping my lens at three feet, which pretty much takes me there. For close-ups, where my focus is extremely critical, the rule might also work, though it's better to put a focus chart in front of the subject and do an eye focus and stop down on it to stay on the money. For going in and out of the water, there is a focus shift,

because once I come out of the water, I'll be back to my normal focus. In most cases, my stop should carry that, but with a remote camera, I can always give the focus a little bump to stay in the zone.

The dorm port is a whole different animal that's often misunderstood. If I were to put my dome port on, and my subject was six feet away, I would set my lens at six feet and look inside the housing to see it. In that case, I can guarantee that I'd have to reshoot my entire footage, because the dome port changes the focus drastically and creates an aerial image underwater. In a simplistic formula, the port is about four times the radius of the dome, so to focus underwater with the dome port — at least with the ones that are typically used, which have about an 8-inch diameter — I would set my lens in the housing at about 16 inches. That's a good starting point to do my eye focus. If I can get that under my belt, I would be guaranteed sharp underwater photography.

Why would you use a dome port?

I would use a dome port to maintain the acceptance angle of the lens. It also compresses this aerial image and gives a greater depth of field with the underwater photography, because it's the aerial image, not the actual image, that I'd be focusing on. Also, because of the density of the water, I'd want to eliminate as much of the water between the lens and my subject as I could without distorting the subject and going to a 14 and moving a foot away. Of course, that wouldn't work, so I'd want to eliminate that water to get a cleaner, crisper shot.

If you're dealing with talent and have an assistant pulling focus, how would you pre-calibrate your lenses for the dome port?

I would take a focus chart underwater, put it on a C-stand with strong cross lighting, and then put my camera on a tripod. I would put a reference mark of 1.5 feet, which, on most lenses — Zeiss lenses would close focus that way — would be a reference on my outside ring. I'd have a pencil standing by, maybe on the sleeve of my wetsuit, and I would start to count, '2, 4, 6, 8, 10

and 12.' After about 12 or 14 feet, I would usually stop my focus. Then I'd get behind the camera and eye the focus on the chart for every increment and make a mark on the ring. Once I've calibrated that, I would be ready to shoot.

If things look 25% closer and the assistant thinks the subject is six feet away when it's really four feet away, do you have to make a mental correlation?

That's with the flat port. With the dome port, because I am actually taping off the chart underwater, I would go with my actual marks. So I would tape off six feet and know that I have six feet on my dial from my focus calibration, which would keep me on the money.

Pete Romano, ASC was born Boston, Massachusetts. His specialized underwater photography credits include The Curious Case of Benjamin Button, The Bourne Ultimatum *and* Insomnia.

Paul Ryan, ASC

Who are you and what do you?

I'm Paul Ryan. I'm a cinematographer. I do mostly feature work. I've shot and directed second unit on several big features such as *Days of Heaven, A River Runs Through It* and *The Horse Whisperer*, and also DP'd other features: *A Box of Moonlight, Big Bad Love, Where the Rivers Flow North* and *Easy.*

How did you become a cinematographer?

I studied engineering in college in the East and afterward spent a couple years ski racing. After a several cross-country drives, I ended up in San Francisco. A few Cartier-Bresson and Robert Frank books got me more interested in photography and less interested in engineering. Since I was a pretty good skier, I had a marketable commodity in skiing photography so I worked for a few years for *SKI* magazine as their photographer. Then I went to graduate film school at San Francisco State and went on to begin making films. It was the Sixties in San Francisco and anything seemed possible.

How did you get to where you are now?

I started out as a documentary filmmaker and made my own films on the world of ski racing, where I began a long association with Robert Redford. I later did a documentary on the San Francisco Hells Angels, and another on Salvador Dali.

The influence of the French new wave filmmakers such as Truffaut and Godard and a job shooting stills on *American Graffiti*

furthered my passion for feature filmmaking.

I was fortunate enough to meet Terry Malick through his editor, Billy Weber. Terry was getting ready to do *Days of Heaven* and was looking for somebody to do second unit. He said it was going to be a big part of the film. He loved images and the magic of things happening in the natural world. We had a lunch and he went through the whole script with descriptions that made it come alive. I went to Montana with a small crew for seven weeks and shot endless wheat fields in the wind, people floating down the river, fires at night, and curious looking birds. Terry and the first unit were shooting right across the border in Canada.

Much later, Terry needed to film the opening steel mill scene. Haskell Wexler [ASC] had started shooting it and then had a conflict with a commercial He left, and Terry called and said he needed me to come and finish these scenes. He said, "We don't have any money, but I can give you a couple points in the film." I would have been happy to do it without the points. I finished up the steel mill scenes and then shot a lot more with the actors and Terry, with Ojai doubling for Texas. The film got accolades for its cinematography and won the Oscar that year for Nestor Alamendros. That was a big boost to my career as well, and helped get me into the feature world.

How does style evolve on a picture?

Style is something that can come either from the director or the cinematographer, but, hopefully, it comes from a blend of both. The DP's primary job is to get inside the director's head and really find out what his feelings about the film are, so that they can be translated visually on film. A good DP will bring a wealth of imagery from his observation of life in general, as well as photographs, paintings, imagery and other films that he can put in front of the director as suggestions. Of course the cinematography always should have an overall dramatic intent, however subtle. Sometime that means cinematically underplaying a scene.

Can you provide an example?

I did a picture called *Box of Moonlight* with director Tom DiCillo, who is a very visual director. We had the kind of relationship I really enjoy. He came into the film not with specific pictures, but a lot of visual ideas. The film was set in the contemporary American South, a very working-class setting, which he wanted to be beautiful and romantic, but also "cheesy." That word kept coming up, so I went through photographs by William Eggleston, pictures of an America that most people might overlook —pictures in diners and contemporary Southern homes. Those images evolved our approach to the film. It's important to look at a location and use the framing, color and lighting to take our eye away from the obvious and direct it instead toward what's unusual about the setting, which is often the thing we want to see.

Style can have an arc throughout the film. As the dramatic events change, so can the visual style. I thought this was very evident in *Goodfellas*, where the imagery went from warm comfortable period domesticity to frenetic handheld cocaine paranoia.

Does your engineering background help your cinematography?

It probably does on a very unconscious level. In the end, there's a lot going on technically, in terms of light, movement and the mechanics of the camera. It's good to have these considerations be intuitive rather than having to consciously think things through each time. That leaves more of your mind free to be visually imaginative.

Let's talk about location and style.

As a documentary filmmaker, I was hyper-aware of location, because that's all I had to work with. In theatrical work, I have more control of the environment. But for me, it's always been important to relate the dramatic relationships between the people in the story to where they are — whether they're in a particular room or in the woods or in a city.

One of the nice things about seeing a feature film in a theater is that the screen is quite big. There's a certain polarity that is

crucial to use. I enjoy this aspect, because it's fascinating to have lots of things going on in one image. I sometimes like to put my actors off to one side of the frame and have something else going on of secondary or tertiary interest on the other side. That way, the viewer can make a choice between looking at the actors for a while and then looking at a couple of strange people or maybe a weird sign in the background. They can scan the screen instead of focusing on it as one entity. That's one of the big differences between television and the theatrical experience.

Let's talk about technique, technology and portability.

One of the nice evolutions in film equipment is the portability and freedom of the camera. Manufacturers have done a great job making cameras smaller, quieter, more portable and free of cables and any other sort of encumbrance. Maybe it's because of my documentary background, but these advances have given me the ability to be very spontaneous with the scene and able to make changes at the last minute, in terms of camera movement and framing.

The frame is very important and often overlooked. Light is crucial, of course, but framing can basically cut things out of the frame, or partially include them to create an emotion. For instance, if I'm showing a character in the frame, but the audience can't see what that character is looking at, I can play with that element and make the audience imagine what's going on in the character's head, instead of taking the more conventional approach of just cutting away or showing both things at once.

I think the most exciting element of the video world is the evolution of the off-the-shoulder camera with a self-contained monitor. These used to be consumer items, but now they're good enough for theatrical work. You can make handheld camera moves that would previously require at least a jib arm or steadicam.

What influences your composition?

I mentioned the French photographer Henri Cartier-Bresson, who was a master of composition. Every one of his images had

a very emotional element to it, yet if I extracted the emotion from it, there was still a very powerful graphic in the frame. One of his most famous pictures is of a little boy carrying a big a bottle of wine. There are three other kids strung out down the street and they're all reacting with awe to this boy with the wine. If we took any one of those elements out of the shot, it wouldn't be as strong a picture, because that combination is what makes it an emotionally powerful image. Film has the element of time as well, and when things come in and out of the frame is important to composition.

When I think back of the most powerful films I've experienced, it is usually a graphic image that stands out in my memory. That triggers all the other emotions I experienced at the time and etches it forever.

Paul Ryan, ASC was born in Boston, Massachusetts. His credits include Box of Moonlight, Admissions *and* Steal Me.

John Schwartzman, ASC

Who are you and what do you do?

My name is John Schwartzman and I am a director of photography, also known as a cinematographer.

How did you become a cinematographer?

I was always a good still photographer as a kid. I had my own color and black-and-white darkrooms and found photography fascinating. Much later, I went to film school at the University of Southern California (USC) as a graduate cinema student. That was the launching pad for my career, because it was a place with 200 other people who had a similar passionate energy, except that they all wanted to be directors while I wanted to concentrate on cinematography, so I had the pick of the best talent at USC at that time to shoot for. That is also where I got to explore narrative films and, ultimately, my collaboration with director Phil Joanou earned me a Focus Award in cinematography for my work on his narrative, *Last Chance Dance*.

From there, I had the kind of story everybody else has: I got out of film school and didn't work as a director of photography for many years. The nice thing about USC is that it has a good network of graduates, so I was able to find my way into the business. Eventually, one small freebie led to another, which led to some small second units. The best advice I ever got was from Conrad Hall [ASC] who said, "When starting out, you should shoot when you get the opportunity to and not worry about whether or not you are getting paid, because shooting is what

you did in school and that is what your dream is, and you need to follow your dream and the rest will come."

Talk to me more about your mentors.

Certainly, throughout my career, mentors have been important in my life. As an undergraduate at the University of Colorado, before I really knew I was going to go into the business as a cinematographer, I was taking film courses and there was a professor named Bruce Kawin, who was the first guy to open my eyes to cinema. He showed me that it was more than just going to the movies; he really gave me a passion to want to explore film as a career.

At film school at USC, it was the same thing: Ralph Woolsey [ASC] who taught cinematography, mentored me and saw promise in my work. Caleb Deschanel [ASC] came to speak and saw my work and said I was good and should pursue it. All through my career I have had mentors, up through Vittorio Storaro [ASC] who was my mentor on *Tucker*. They were people who did not necessarily teach me how to do the job technically, but have instead given me a perspective on their passion. Being a cinematographer can be a very lonely job, where we don't get to work with other cinematographers, so it was a unique opportunity to spend time with these masters when I was young.

I remember with Vittorio, I brought my light meter and sketchbook around and he berated me, saying, "That is not what it is about; it is from the heart and it is about the emotion!" I said, "That is alright because you are Vittorio Storaro, but I am trying to find out how bright your backing is in relation to your foreground." I realized later that he was right — it's about telling stories and finding a unique way to do it. We don't need another Vittorio Storaro in the world because we already have him, but if he can inspire someone else like myself, for instance, to do this job in another way, with a voice that moves an audience, that is the ultimate goal.

How did you develop your style?

My style has changed over the course of my career due to a lot of things. I don't know if I could say it is one thing only.

Obviously, the thing that is most important when making a motion picture is the script and, in some respects, it will dictate the style of the film. In the case of *Seabiscuit*, it was a period picture set in the 1930s, so I knew the wardrobe and production design were going to be of a certain palette and those are the broad strokes, in terms of developing a sense of style for a film.

There are many ways to approach a period film — should I have the windows bloom and have that slightly brassy color effect, like Gordon Willis [ASC] did on *The Godfather*? Those are things I discuss with the director. I work very intuitively and would not be described as a highly technical cameraman. I do it all from the subconscious. It is like when I went to an SAT prep course and they said to stick with my first answer. I try not to over-intellectualize things. As I have gone through my career, my lighting has gotten bolder but simpler at the same time. I know what I want to do, not necessarily intellectually, but intuitively.

What do you do when you walk onto a set first thing in the morning?

For *Seabiscuit*, when I'd walk into the jockey's room for a scene, I'd be in Agua Caliente, meaning that it was very hot. Every time I have ever been to Tijuana, it has also been very hot. It is a polluted city and the light doesn't have much color to it. It is bleached out, almost like the San Fernando Valley on a smoggy afternoon.

In any case, for the film, I relied on more exterior lighting, because I didn't have fluorescent lights and incandescent lighting was expensive. It also generated a lot of heat and we had to replace the bulbs often. The buildings we shot in had a lot of transom windows, clearstory and natural light to help do the work, so that was my first cue in determining the lighting of a scene in the jockey's room. Then I thought, "It is probably pretty warm today, so maybe I should bring some strong sunlight in." Then I started building from there. I would think about what the world was like outside the room and that helped me to understand what the light was like inside the room and how the audience would feel when they saw the scene. That is part of what I do as a cinematographer and how I approach things. It isn't just about what is going on within these frame

lines. It is about what the rest of this world is like, and that gives me visual cues for how I should treat a particular set or scene.

How about another example from a different picture?

On *Pearl Harbor,* director Michael Bay brought me a reference book of photographs from the air war in the Pacific. All the prints in the book were dye prints with an interesting and beautiful look, and that became our guide. "Hell comes to Hawaii," we all said, because Hawaii is a beautiful place that we always think of as a vacation land with great white clouds, rich blue skies, aqua clear water and tropical green plants. But our idea was to re-create that world and then deconstruct it with fire and smoke, using black to take all the color out of it — not in a technical sense, but in a storytelling sense — where the black smoke comes and almost makes the movie monochromatic. It was the balance of these two worlds, where we took something like Hawaii, which makes everyone think of a South Pacific sunset, and turned it into a hellish inferno.

How much time do you spend preparing for something like that?

The amount of prep time I spend creating a visual style for a film depends on economics. On *Seabiscuit,* I had a lot of prep time and a lot of access to the director. We probably spent eight hours a day, five days a week for 10 weeks going over the movie. We did not storyboard the movie, but we shot-listed it and if you read the shot lists, you would not see things like, "dolly in on Charles Howard." It was more about descriptions about how the room felt.

There are many different ways to prep for a movie. The most important thing I do is I try to stay in touch with the first emotion I had when I read the script. As I continue along in the filmmaking process, the days become more about logistics, costs and actors schedules, which isn't a perfect world for the DP. That's why it's important to remember the things that were there when we first read the script, before the problems. There are a number of ways to do this. Some people like to storyboard and I have done this in a variety of ways. For instance, I have taken images from maga-

zines and glued them to the back of my script as a reference for what I saw in my mind's eye when I read it.

On *Seabiscuit*, we had a very long prep, and the director and I went through each written word, not so much to determine where the camera should go, but more to determine what our emotional state of mind should be in relation to the day's work for when we shoot the scene. Because once we're six weeks into a movie, it is like answering the bell for the 12th round of a heavyweight fight. We get tired, but we have to remember that the film lives forever. We've got to find a way to stay in touch with the emotion we had that got us excited about the project in the first place.

In the case of *Seabiscuit*, we had a "race book," which was 600 pages long — twice as long as the script — and had descriptions and notes about what we wanted to do for each scene. Sometimes, it was a description such as a "crane shot," but other times, it was a description of things like "out-of-focus flowers out a window, a reflection or water droplets" — things that were very atmospheric and poetically tonal in nature.

How does technology affect technique?

Unlike my predecessors who used to lug around big arc lights and other heavy equipment, we are now in an age where technological developments really aid us in our ability to make motion pictures. Given all these new tools, the question becomes one of the chicken or the egg: Do we modify a shot to suit a certain piece of equipment or do we figure out what we want to do and then find the right piece of equipment? Personally, I take the whatever-tool-gets-the-job-done approach. If we can do the shot static, it is on sticks; if we have to move the camera, hopefully we can do it on a dolly, but if it goes up stairs we might need a Steadicam; and if it is a huge rise, then we might need a crane. Keeping things as simple as possible works the best.

For *Seabiscuit*, when we were trying to figure out how to do the horserace scenes — and there was no question that Stephen Burum and Caleb Deschanel did an excellent job of capturing

the horseracing in *Black Stallion* — we really wanted to put the camera inside the race and we had the disadvantage of having 12 horses, as opposed to two, so it made the staging more difficult, more dangerous and more expensive each time we wanted to run a take. At that time, there were a few new products available to help us stabilize the camera over the bumpy dirt road and I used them to their full extent. But if they didn't exist, I would have found another way to do it. Would that other way be more successful? I don't know.

The other thing is that, as these things become more part of the vocabulary of film, audiences become accustomed to seeing them; they become accustomed to seeing the technology standard of the time. I was the beneficiary of a lot of new innovations on *Seabiscuit*, and hopefully I used them in a way that wasn't noticed as a new innovation. Once the style calls attention to itself, it defeats the whole purpose of what it is trying to do. It is very important that the style of a film be as transparent as possible. I know I am saying this after having done movies like *The Rock*, *Armageddon* and *Pearl Harbor*, which are almost all style. In those cases, if people ever stopped long enough to figure out that an oil driller was on an asteroid that was going to be blown up with a nuclear bomb, they probably would have left the theater. But the idea was to keep it visual and keep it interesting for an audience, and we knew that going in. I am not demeaning the work; it is just that we were meeting a different set of needs for pictures like those than I was on a picture like *Seabiscuit*, which was very moving and emotional, and I didn't want my work to get in the way of the story.

On those other pictures, how did you decide on a style?

On *Armageddon*, I knew part of it would be set at NASA, so all I had to do was go to NASA. It has a certain look to it, and even the word "NASA" brings up images from our collective memory. It was interesting, because NASA looked very 1960s and we thought, "What would this look like if the government gave them $20 billion to update everything?" So we updated the look, but tried to keep the same feel. I worked closely with the production designer to get the look of the space station. For

example, if he made the thing round and I wanted to shoot with a very wide lens, I would ask him if he could build some light sources into the set, so that I could photograph things that are also lighting the set. Those are the collaborations that happen during the process of making a movie.

Also, there is a language for action pictures that are made for kids. Every 10 or 12 years, that style might change and I happened to be right in the middle of it. That language has a fairly big influence, because when I did *The Rock*, it was stylistically different from other pictures done at that time, and much of that came out of my work doing television commercials, where I had to cram as much visual information as I could into 30 seconds. At that time, the emphasis in commercials was on what we might call slick photography: very stylized images with lots of contrast that really felt like they could jump out at you. Taking that understanding into a science-fiction action picture seemed like a natural fit.

Can you expand on the differences between shooting commercials and features?

The difference is that, in commercials, we try to make 30 perfect seconds, with "perfect" being defined by the client. Commercials last for three weeks, features last forever. Features that I remember as being beautifully photographed are films I consider great. There is no question that Gordon Willis' work in *The Godfather*, and maybe even more so in *The Godfather: Part II*, is some of the best cinematography I have ever seen — yet it is even a better film. The fact that his work is stunning and perfectly serves the story without calling attention to itself is what makes it so successful. In commercials, the technique is the story in most cases.

Does it feel schizophrenic going from one to the other?

It doesn't feel schizophrenic because I am a cinematographer; it is what we do. I don't do one thing. I try to do everything and that is the challenge that makes it fun. Also, there are a lot of techniques I have learned from doing commercials that I bring back to the feature world and use in a way that is not self-conscious and might even allow me to do something more

quickly or make choices that might improve the set for the actors. That all goes toward the goal of trying to make a better motion picture.

Let's talk about the digital age of film and digital intermediates.

It is a very exciting time because there are a lot of new technologies emerging, the most prevalent being digital photography, which will soon become digital cinematography. In some form, it already exists in HD, which is a stop along the road because it is not particularly good; 16mm is a better image than HD, and it is more compact and travels better. It is really a case of trading the demons we know with the ones we don't. I am very excited about it, though, because it is just another paintbrush in the jar to paint with. What I like about digital photography is not the similarities, but the differences between it and film, and that is what people need to exploit.

The color timing process is a process that has basically been the same since the advent of color film, when Herbert Kalmus came up with Technicolor. Essentially, we sit there and hold different colored pieces of gelatin in front of our eyes and try to get the color balance right. Everyone by now has probably played with Adobe Photoshop, and computers have become incredibly powerful tools for doing very subtle color correction. Film timing, when compared to digital intermediate, is much cruder.

On *Seabiscuit*, I actually did a digital intermediate and it was very exciting. It was also a bit scary, but I knew that I had the tools to maintain a very sensitive control over the image. Many pictures in the past have used digital intermediate to get a look that is not film-like, where they've gotten the image to live in a color space in which the negative normally does not want to live. In the case of *Seabiscuit*, I wanted to do the exact opposite, which meant I wanted finer tools with which to color correct. That was a really incredible experience where, for the first time, I felt like I truly had control over the image. I didn't want to change the image or use different effects from the windows, I just wanted to use the tools to get the image properly balanced.

When we shoot a movie outside, we deal with the changes in light all day and we always have to make certain compromises to get shots to feel like they were all done at the same time, because, to the audience, the scene might last 30 seconds in real-time, but for the crew who made it, it could have taken two days to complete, maybe with fog in the morning and sun in the afternoon. The digital intermediate gives us the tools to bring that into harmony. For *Seabiscuit*, which had a lot of day, exterior shooting, it was a lot of help and I really am excited about it.

Now that the genie is out of the bottle with DI, it is not going back in again. The issue of who controls the image has been blurred by the DI. Most people, cinematographers excluded, are intimidated by the lab, but the DI suite is inviting for anyone who has adjusted a TV. As a cinematographer, the only way we can protect our work is by having the trust of a director who helps us win those battles. Thirty-five years ago, if a cinematographer had a difference of opinion with a director over how a movie should look, the director would have walked away and let the cinematographer color time how he wanted. Ultimately, whoever pays the bill has the last say. I have been fortunate in my career to have worked with directors who have had strong opinions about having me onboard through the entire process of making the movie, so I have been able to preserve the integrity of what I wanted my work to be. Digital technology doesn't really change that scenario. It may be less expensive to go in and mess around in digital, but with respect to authorship, it comes down to having the support of the director and producer to maintain the integrity of our work.

What does the future hold for cinematography?

I don't know exactly where the future of cinematography is headed, but more than any other craft in this industry, our growth is truly staggering, in terms of the quality of work in the past few years. Now there is no differentiation between a television cinematographer and a motion picture cinematographer. Also, the work I see on all levels is so sophisticated that it is breathtaking. That is a wonderful thing. Right now, we are truly in a golden age of photography and it is a changing period.

Looking at both cinema and television, the level of work is superb. Thirty years ago, a television show like *The Rockford Files* did not look like *Butch Cassidy and the Sundance Kid*. I would argue that *The West Wing* looks as good as any feature out there. They film it very efficiently, because they are so skilled. Technology has certainly allowed television cameramen to make huge jumps, in terms of what they can do in the limited time they have to do it. The aesthetic of a cinematographer has really been fine-tuned over the past five or 10 years — just look at the films nominated this year for the ASC awards. They are all stunning pieces of work.

John Schwartzman, ASC, was born in Los Angeles, California. He attended film school at the University of Southern California (USC). His credits include Seabiscuit, Pearl Harbor *and* The Rock.

Dante Spinotti, ASC, AIC

Who are you and what do you do?

Dante Spinotti. I'm a cinematographer, a director of photography. There are actually different names for this profession. The latest version is probably the one started by Vittorio Storaro [ASC] in Italy. He is thinking of calling himself and everybody else in this profession a cinematografo, which is the movie version of fotografo. Fotografo is for "photographer," and cinematografo is for "cinematographer." In Italy, a word for cinematographer does not exist; what we use actually means movie theater. It's a hard name to get into common usage.

What do you call a director of photography in Italian?

Operatore, which means cameraman, the generic term, and direttore della fotografia, which is director of photography.

How did you become a cinematographer?

I come from an area of Italy that is very far away from any movie industry. An uncle of mine, Renato Spinotti, was actually a cinematographer and director for documentaries and small films. I always admired him. He was a hero to me. He probably gave me my first camera and taught me how to take pictures when I was 10 or 11. I started with a little dark room under the bed, where I processed the film negative.

At some point, my passion for photography made my life in Italian high schools studying Latin and Greek not so successful, and my family had to find some way out for me. Of all places, I

went to Kenya to work with my uncle who was working with East African Film Services in Nairobi. There, I started doing any kind of job, from carpentry to fixing things on the set. I was even a boom man to a German sound mixer on a German feature. I still remember that cinematographer yelling at me, "The shadow of the mike — it's in the picture!" I didn't handle those things so well. I was probably sold as an experienced boom operator, even though I knew nothing about it.

At some point, I started shooting newsreel at the company for UPI and doing documentaries, where I could play every day with the big Mitchell the company owned. That's when I also started reading *American Cinematographer*, because my uncle was a subscriber. I was just about 17 or 18 then, in Kenya, and that was the start.

Where are you from in Italy?

It's a small town way northeast, close to the Austrian border, on the Alps. It's a small region just north of Trieste. There is a very specific culture there, which is a Ladin culture. The language they speak is a mixture of Latin and local idioms. This language or a very similar language is also spoken throughout the Alpine arc all the way to Barcelona and into the Basque country.

It must be similar to Romansh in Switzerland.

It's one of the new Romance languages. A very similar language is spoken in San Moritz and Engadine as well. The area doesn't have a lot of tourism, but it has very solid traditions and cultures, including this language.

You shot newsreels on a Bell + Howell?

I was shooting newsreels in 16mm also and I remember following the East African safari rally for United Press of Australia with a 35mm Eyemo. The camera was so out of shape that I could see the lenses sticking out of the barrel a millimeter. I remember the first time I was given this camera after just three months of being there, with a background only in photography. They told me to go out and shoot something for United Press. At the time,

Jomo Kenyatta was being released from prison and he later became president of Kenya for many years. He was condemned for being a part of the Mau Mau insurgency. I went out in the county to Maralal with a number of English reporters and international press people. I was trying to stand out from these guys with this ill-working Eyemo that was spring-loaded. United Press said the coverage was a little repetitive, but they still paid for it because it was otherwise okay.

How did you work your way to Hollywood?

I worked for a long time in Italian television until 1980. Italian RAI is the state television, and I was based in Milan. At some point, out of the blue, I decided to become a freelancer. I went to Rome to shoot a feature film with Sergio Citti, who had been Pier Paolo Pasolini's assistant for a number of years. He had become a director after being a painter. I don't mean a painter of paintings — he was painting kitchens, dining rooms and houses. Pasolini hired him because Citti knew the Roman dialect and the other local dialects and idioms, and Pasolini needed some help. Pasolini was a genius of Italian culture and Tonino Delli Colli, who was honored by the ASC in 2005, shot most of his movies. But Tonino was not available for this picture, so Sergio Citti hired me. I went to Rome after I had already resigned from the state television station, and I did the film with him. It was one of the first shocking changes in my career; the second one was the move to the United States, and that is a whole other part of the story.

Tell me about the Hollywood years.

At a certain point, I had been in Rome for two or three years doing feature films. Some of my work caught the attention of producer Lucio Trentini, who was working then with Dino De Larentiis. Dino called me when he was opening his studio in North Carolina and asked me to see him. He was looking for British and Italian technicians, collaborators and production designers.

The first movie he offered me was a film with director Michael Mann. I came from Italy with a couple of reels that had some

shots and sequences for Michael to see. Michael saw them, we discussed the film a little, and he said, "OK, let's give it a try." From then, my career in the U.S. started. The next movie I did after Michael's movie, which was *Manhunter*, was a movie with Bruce Beresford called *Crimes of the Heart*. I actually did three or four movies with Dino De Larentiis, and then became freelance again. And I kept switching between projects in Europe, in Italy and some in the U.S.

Is there a difference in the style you'd use for an Italian movie versus a Hollywood movie?

I don't know if you can call it style. It's a different kind of approach. In Italy, we have this huge tradition of cinema in which I didn't participate because I was working in television. We know the Italian comedies and the great Italian movies and the looks of Visconti, Fellini, Pasolini and Antonioni. These movies were made with great concern about their own feelings and culture, as opposed to thinking primarily of the box office success.

I soon found out that Hollywood, on the other hand, has always had a tradition of keeping in touch with the audience. The shots are made in a way that doesn't make the movies that long. They go from cut to cut instead of having a slower pace like European pictures, which also have a greater sense of story. Maybe those are the differences in style.

The Italian school of cinema is very exact and accurate. In general, the way we use the camera responds to more specific requirements of rhythm and speed, of not distracting the audience, of being probably more pragmatic and less careful. But both worlds, of course, are of major importance.

Can you discuss the differences between Italian neorealism and Hollywood?

One of the main issues in Italian neorealism is life and drama in the early years after World War II. The equipment used was very basic, and the budget to shoot those films was extremely limited. Tonino Delli Colli said that he'd look for windows that natural light was coming from and add extra lights from

there. The movies were extremely interesting.

For example, I saw the *Bicycle Thief* and loved the way the movie was cut, especially at the beginning. The director, Vittorio De Sica, and Carlo Montuori, who was the DP, selected these shots for the opening sequence, and I remember being surprised at how amazing their selection was. There were wide shots, medium shots and tight shots. They were well applied to the story, and made it so elegant and precise. It was really brilliant.

After that, there was an evolution, and a number of amazing Italian cinematographers did great black-and-white work that probably peaked with Gianni Di Venanzo, who really transformed the way cinematography was done. He used a very real and very elegant approach. His tonalities, from blacks into whites and grays, were full and very controlled in the lab, but at the same time, he had a strong basis in realism. In some of the movies he shot in Sicily, such as *Salvatore Giuliano*, which was directed by Francesco Rosi, there's a shot of a street where he increased the streetlamps. He put brighter lights in the streetlamps and probably shot very wide. In the foreground, he used very strong side lights on the actors. He brought this to a very high stylistic level, which made the possibilities of visuals in cinematography leap forward.

Where do the stylistic ideas come from for your movies?

Being born, as a cinematographer, in television and documentaries, I have always stayed connected to the reality of situations. When I grew up, but before I decided to leave television, I had plenty of examples in front of me, like Gianni Di Venanzo and later Vittorio Storaro, who made more leaps in showing cinematographers how important it was to have extraordinarily strong images to tell the story.

It's very complicated and difficult, because we can shoot a movie in a number of different ways. It can go from realistic to fantasy storytelling to abstract to musical to comedy. If, as an audience, I feel that the way the story was lit and photographed was not real enough, that can really distract me. So that's an

edge. We can do anything we want in cinematography, but we cannot be more unreal than the story requires. The main tool of cinematography — when compared with other sorts of art expression — is essentially realism. We understand and believe what we see on the screen, because it's something we can easily recognize. It reproduces life. It brings the direction of the emotion to the soul.

Can you give me an example of that realism in your work?

I wouldn't want to be more abstract than the story is, even if it is fantasy. With a film like *The Insider*, for instance, the idea was to achieve a sort of false cinéma vérité. It was a very controlled documentary operation I shot with director Michael Mann. It looked like a documentary but, in fact, was extremely controlled.

I believe that none of us is an artist. The director is not an artist, an actor is not an artist and I am not an artist, but a movie can be a work of art. A director who acts like he's very much the author of his picture — without the collaboration of his writer, his actors, his cinematographer or his production designer — doesn't go anywhere. It's the combination of all the people around him that can make a movie a work of art.

There are many different ways the word "art" is used. Some people use it very sparingly, while others use it to describe anything around. I believe Umberto Eco said that the minimal requirement to determine whether something is a work of art is if the code of communication between that work of art or the artist who made it and the audience has been entirely changed. In other words, we should never look at the same subject or the same material with the same eyes. We have to move forward. In that sense, a work of art is a major step for humanity because we just can't go back. We have to see this material once and the next time look at it in a different way, because it has already been seen and achieved in its old form, which has made a step forward.

I had the pleasure of hearing from the cinematographer who shot *City of God*, that he and the director had seen *The Insider* 10 times. This, of course, was a major compliment for me.

Michael Mann's vision and work on that film was absolutely extraordinary. Now we are talking about the role of vision, which is something we have to consider. Because when we talk about art, a step forward has to be made. Something new has to be said in the way I am talking to you and my audience — about a subject or material, the movie, the story, a human situation, anything.

When you walk onto a dark set first thing in the morning, how do you approach lighting?

It's part of our emotional burden as cinematographers to walk into something new and figure it out. It can be an empty set, or we can be starting a movie or already into the movie and have to photograph one of the scenes. How do we do it? I've always believed that the main search when starting a film is the search for a language. That language is put together by all the decisions that are made — with the first word put on the screenplay by a writer, decisions that have to do with casting, location, how to shoot the movie, how to use the camera, the color, the framing and the lighting. All of that constitutes a language.

Our choices at that point, when we are on a set shooting a scene, will be in front of different realities. Although we'll have this confrontation, we have to keep in mind the overall language that has carried us to that point, the language of the whole film. That will guide us toward decisions. Maybe we'll have to deal with the shape of an actor's hair, for instance. It shouldn't be about prettiness; it should be about how we tell the story. We can think of that language as the style, but I'd rather call it language, because it's as though it has actual words, phrases, sentences, commas and periods.

Does that language connect you with the audience?

Language is something with which you tell you a story. If I am photographing an Alpine guy who comes out of his hut in the morning dressed to conquer a peak in the Alps or Himalayas, I'm probably putting my camera low on a dolly so it can circle around. The guy might be wearing a nice shirt that's red or has squares; the sky could be beautifully blue with maybe some

clouds, with the peaks of mountains covered in snow. For that, my camera would be low.

However, if I am photographing a steel worker coming out of a factory in Germany during the war, I'd probably have a medium lens — like a 50mm or longer lens. He'd be coming out into the cold and fog, which probably makes it more of a compressed image that has this kind of atmosphere. I'd use my longer lens and come in toward his face. So all of these different requirements of storytelling cause a different approach to tell the story, which has the complexity of a language.

Are there emotions to different lenses?

Definitely, yes. I did a film in Italy with a fairly green Italian director who insisted on using wide lenses. I told her that our locations were not that interesting at that stage and that it would be better if we kept our focus on the characters and used the abstraction of longer lenses to isolate them, as opposed to distracting the audience with a lot of information. Wide shots were not necessary, not aesthetically interesting and didn't bring any emotion to the story.

On the other hand, I was looking at the brilliant work of Bruno Delbonnel, who shot *A Very Long Engagement*. With his director, Bruno uses wide lenses all the time, and there is so much coming in from the set that makes that approach successful. So, is there a rule? I don't know, but I don't think so. Rules on this subject were studied by painters during the Italian renaissance. And I hope this doesn't raise another question.

Dante Spinotti, ASC, AIC, was born in Tolmezzo, Italy. His credits include Slipstream, The Insider *and* L.A. Confidential.

Ueli Steiger, ASC

Who are you and what do you do?

I am Ueli Steiger and I am a cinematographer.

How did you become a cinematographer?

I started very early in high school — shooting weird little films with my best friend. After I finished school in Zurich, Switzerland, my friend went off to film school in Vienna, and I ended up going to the university in Zurich. At that point, I did not dare apply to any film school. While I was studying English literature and art history at my university, I started to work on the side in the movie industry, getting jobs as a runner and driver. It was through these first contacts with film technicians that I felt encouraged to apply to film school. I finally left university and ended up attending The London Film School with a grant from the city of Zurich. I spent three of my most formative years in London and then went back home and started to struggle in the industry.

How did you get your big break?

I caught a couple of breaks. Without breaks, nothing happens. My first big break happened right after I returned to Zurich from London. I had been at school forever, and I was 27 at that time. I had never really worked and was broke — no more grants, no more student status. I got a phone call from my film school friend, Fiona Cunningham-Reid. She was lighting a no-budget film that some Oxford students were doing and they needed a camera operator. She said they would pay my airfare, so I turned

around, broke as I was, and returned to England the next day. We were all so green, especially me, probably the most inexperienced of the lot.

The director and I really bonded, and we somehow pulled it off. *Privileged* ended up being bought by the BBC and even got a theatrical release. This little film started off a lot of careers. I have since shot three more films with the director, Michael Hoffman. Rachel Portman, who later won an Oscar, did the music. And the actors did well, too — Hugh Grant, James Wilby and Imogen Stubbs, just to name a few.

My second big break came after having struggled back home in Switzerland, doing every job I could get my hands on: assisting, shooting news, industrials and producing my own documentaries so I could give myself the job to shoot them. At the same time, Michael Hoffman was struggling to get a feature film together that was to be shot in Utah. He had developed the film at the Sundance Lab, where he became a protégé of Robert Redford.

Every time I had a bit money, I would fly to the States to scout locations with Michael for his project. Four years later, it finally got financed, and Robert Redford was producing it through his company. All of a sudden, this small project became a major independent film. I thought there would be no way they would let me, an obscure Swiss cinematographer, shoot this film. But of course I wanted to be there at all costs. The producer finally agreed to let me shoot second unit.

The film was called *Promised Land*, and it starred Meg Ryan and Kiefer Sutherland. They didn't hire a DP until two weeks before shooting, and then that DP got fired 10 days in. I was asked to take over for a couple of days until they found a replacement, and after they found their next cinematographer, Michael Chapman, ASC, they kept me on. I am sure it was because I was so cheap! So I ended up finishing the film with Michael Chapman standing by in case I screwed up. This got me my first credit as a director of photography on an American movie. I did not even truly realize then what a big break that was for me. But it meant that for the next film Mike

Hoffman directed, I could be hired as the cinematographer from the beginning. This is how I got my start shooting in the United States. I was very fortunate.

How does style happen?

I believe a movie has to find its own style. It somehow decides by itself what it wants to look like. I try to stay open at the beginning of a film project, and I listen a lot. I walk about and pretend I would know even if we — the film and I — are still searching for the style. It can be found through the tools we end up using or not using. But mostly, of course, style comes through getting a feeling for the story, the locations and the communication with the director.

For example, I did a quite stylish film, one of my earlier films, called *The Hot Spot*, which Dennis Hopper directed. I was very nervous because this was my first American film where I did not know anybody on the crew. Haskell Wexler, ASC, was supposed to shoot it, but for some reason dropped out and I got a phone call in Zurich asking me to do this movie.

During the short preproduction phase, I did not have one conceptual talk with Dennis; we talked about art and all kinds of things, but never about the movie itself. So, for some reason, I just decided I would do what I thought was necessary for a film with "hot" in the title. Thinking back, I was very audacious and I don't know how the hell I dared to do that, but it turned out very well and I am proud of the film. Also, I realized that Dennis was a great actor's director. A lot of the blocking and coverage came down to me and the script supervisor, Marita Grabiak, who was one of the most supportive script supervisors I have ever worked with. Between the two of us and Dennis' vision, we were able to get the coverage needed.

It was all about communication. I found, very early on, that I had to show Dennis things rather than explain with words. He had a great ability to see, even with a very rough rehearsal, whether the scene would work for him. It was a great lesson for me as well, in that it taught me to find the right way to communicate with a director. With Dennis, it had to be

completely via visuals. With every other director I worked with since, though, it might be different.

Does equipment influence style?

Equipment really does influence style. One example of a piece of equipment that influences the look of a film for me is the Technocrane. I first started to use this brilliant telescoping crane arm on *Godzilla*. It was difficult for me to get production to agree to carry it on the film for the whole shoot, because at the time it was very expensive, and the line producers didn't want me to use it. But I saw that this piece of equipment had a lot of potential and, furthermore, this was a huge movie. I had never had the chance to use the Technocrane before; this was 1996. Since now I had talked everybody, including the director, into wanting it, I was thinking that it better work because my ass was on the line.

It all did work out beautifully in the end. From day one, this piece of equipment started to influence the look of the movie. All of a sudden, we could move the camera very easily and conceive shots that otherwise would have been too time consuming to set up. We could try out moves and change our minds without losing a lot of time. Tracks would not have to be moved, rigs could stay put, and we could adjust the length of the telescoping arm.

Do you have a particular approach to lighting?

I did a film called *The Day After Tomorrow*, in which we had big storm sequences. We decided to shoot all the day exteriors on the stage because it was just not feasible to do it outside. Roland Emmerich was the director and we ended up shooting in Montreal on a huge stage, one of the biggest in the world. With my gaffer, I thought about how to go about lighting it. I really believe in natural lighting so I thought we would just start very simple with just a top light, and that is what we ended up doing.

In the film, basically all the scenes are lit with only a soft top light. It sounds simple but not when you have to rig it on such a

huge stage. We ended up having 3,000 2,000-watt bulbs up there, all on dimmers. I wanted it to look cool as well, but it would have cost half a million dollars just to put gels up there. My key grip knew of a company that was dying silks so we ended up getting some silk dyed half-blue. It ended up being simple.

We were shooting days and sometimes I had to do it by speed. I shot most of it on a 4-stop, and if I shot 60 fps, I really had to pump a lot of light in there. For me what was interesting was that it was a simple concept but it was also complicated to do. I had great riggers and a great crew who built it for me, and production had enough money to pay for it. It was a wonderful setup, because on this huge stage we produced incredible storms with all sorts of paper snow of different types and endless backing.

We had one scene with a blizzard at night, and our two actors were sitting in a tent in the snow and it ended up being one of my favorite scenes in the movie, even though it was actually almost not shootable, because how do you light a dark and foggy snowstorm? We had to light from above to hide the source, so we used three 2Ks above and 100-watt bulbs underneath, inside the tent, which were dimmed down 35% with me shooting at a 4-stop. We had the snow going, and with the forced perspective in the end it was hard to tell where the light came from. It is a good example of lighting that can only be done on a stage, but I bet nobody thinks it wasn't shot for real.

Ueli Steiger, ASC, was born in Zurich, Switzerland. He attended The London Film School. His credits include The Hot Spot, Singles *and* The Day After Tomorrow.

Tom Stern, ASC

Who are you and what do you do?

My name is Tom Stern and I am a director of cinematography, rather recently minted. Before that, I was a chief lighting technician for about 30 years.

How did you get into the business?

In the '60s, I had a Nikon F and a Kodak Retina Reflex prior to that, shot a lot of Tri-X and Pan-X film, had a little Durst enlarger, did stills and enlargements and read Ansel Adams books, understanding about 60%.

How did you learn about lighting?

Through stills, I was forced to learn about illumination — like underexposure and overexposure and how to get a nice, tight feedback loop when whatever I did either pleased me or didn't. When I started working professionally, I was blessed with a couple of mentors. There was one guy named Ron Alexander at Stanford University, where I got my master's degree in film, who was a wonderfully ethical, great man from the Canadian Film Board. In the outside world, I met Urs Furrer and did his nonunion work, because I was outside of the union structure at the time. After that, the business becomes about the generosity of the people in it, who can provide wonderful learning experiences. Owen Roizman [ASC] taught me to see in a tenth of a stop, and Conrad Hall [ASC] also taught me how to see and feel. What's important is having an understanding of what we experience so when we see dailies or are lighting a set, we can bring

an idea or feeling to sum up what we're doing and distill it into a learning experience. One of the things I learned from all these greats is that it is a quest and that the day we don't learn something is a wasted day, which is the engine of this profession.

Who are your other mentors and what did they teach you?

I've worked with Bruce Surtees quite a lot, who is wildly under-rated and is a manifestation of the pendulum theory of inter-generationality. His father, of course, was Rob Surtees [ASC] who wore a necktie, so Bruce had long hair, may or may not have taken LSD and had a Harley Davidson, and would basically throw himself into things with wild abandon. I shot a Clint Eastwood film with him, and Bruce came in on a Monday morning with an epiphany — an ingenious idea — and said, "We are shooting six-day weeks, so today our limit will be six lights, and tomorrow it will be five lights." I asked, "Do you know what we are shooting this week?" And he said, "No, I don't care." So by Saturday, our limit was one light and it wasn't a bad exercise. In fact, it was a cool thing to do once in a while.

Let's talk about serving the story.

The idea of cinematography in general and at its highest level needs to serve the story, but I don't think it is a one-to-one mapping. The story is best served by the literature, meaning the spoken or written words. Cinematography expands that into a visual, fluid construct and adds the element of time. All I have been doing is features, which I like it because of the literary aspect to them. In particular, a project derived from a book really pleases me, because I'll typically read the script, which is a distillation of the novel, and then also read the novel which, on an artistic level, is not subject to the time constraints of film. I pick up on the story's resonance and subtext by doing this — not so much in the sense of the film's semantics, like a master, reverse master or whatever else it takes to make it work — but more about the arc of the story.

In the films I've seen, there are shots with no narrative content that are incredibly pregnant with meaning. I want to achieve

that, because it is a realization of the potential art of photography or any sort of visual art, be it photography, sculpture or painting. I do not want to slavishly serve the story, because that can be constraining. It is like doing a visual interpretation of a ballet and setting up a fixed camera in row eight in the center to replicate the visual experience of the person sitting in that seat. To me, feature films are not about that. For example, on *American Beauty*, Connie Hall pushed in toward Annette Benning when she was about to freak out in a scene, and that was his choice that had no representation in the script. It was something that he, as the cinematographer, brought to it.

How do you go about lighting?

In the feature film environment, what is interesting is the preparation phase when I get the material early and get an opportunity to have conversations with the director to really understand where he or she wants to take the material. Depending on the kind of money that ends up on the table, I might get a lot of preproduction time to look at spaces and see the weather and light change. I could end up walking around aimlessly, which can turn out to be very informing.

For example, I finished a film that John Turturro directed called *Romance & Cigarettes*. We filmed in Rosedale, Queens, which is a suburb near JFK Airport. We were walking around the area and I found this exquisite fence that we ended up using as a background for a dolly shot. Because I've done a lot of documentaries, I've gotten used to not having much time and finding the things I need to use faster. I keep the material in my head while talking to the director, so once the interpretive elements come in, such as the actors, I'll be busy looking at staircases and lights to set up the shot.

Ideally, the relationship with the director should be curiously intimate, with a mash of responsibilities. By the time the actors come onboard, the director and I have been looking at and discussing things, deciding on palette issues with the production designer, and from there, things start to form. Philosophically, what I like to do — and I think I caught this terminal disease from Connie Hall — is defer any decision or

previsualization until we are right there shooting. All the roads converge toward a valley, but we are not really there until we are there with everybody onboard. I might have thought things out prior to the shoot, but I don't commit fully until the moment. For instance, if I know I'll be shooting a sci-fi picture on Stage 29 at Sony, I know to have it pre-rigged. Or if we're shooting a morning scene in the kitchen, that comes with obvious constraints. Most of the earlier decisions on film stock, aspect ratio, lenses and lighting have also been worked out at that point. But I prefer to wait on a lot of other decisions until the actors are working in the space with the director.

In *Mystic River*, for example, there was one scene set in a kitchen with Sean Penn, Laura Linney, Kevin Bacon and Laurence Fishburne. I didn't want to do what a lot of other people would have done for such a scene, and I was looking for a different way to handle it. I really had no idea how to work it until the actors were on set. With Clint Eastwood directing, we don't do the typical rehearsals; he lets it just fall into place naturally. On set, it became clear to me that I could do that scene with one light and still fit in with the style that was developing for the film. I think a film's style comes from itself. In my approach of working, the style develops as things get going. It's like, lo and behold, I open the oven and there is my style for that particular movie.

Talk to me more about how style evolves.

A film undergoes a process of becoming itself, because when things start out, there is no film. For a film I started recently, I have 250,000 feet of negative that's not exposed yet. So far, I shot maybe 20,000 feet and exposed 14,000. It is like a worm, where I don't know exactly where it is going to go. I listen to and fine-tune it during the first week or two. During that time, I am not that pleasant to have around, because I am in anguish trying to listen to it. The correct next step is always determined by the prior steps, and when nothing is quite clear and we are shooting things out of context, it can become like a three-dimensional game of chess. It would be easier to go in with reference stills and say I am going to do a certain thing, but I don't tend to work that way.

What is the relationship of technique and technology to all this?

Technology should serve technique, and technique should serve art. If we get that out of order, we have really screwed up. A novelist tells a story with verbs, nouns and adjectives, and though there are movies that are completely about the visuals, on the films I have done, I try to bring the visuals to a story that already exists in the mind of the author of the novel, the author of the screenplay and my boss, the director. The story also exists in the minds of the artists interpreting the roles. The beautiful thing is that we don't all have the same idea, so there is a dialectic that happens between us. I'm sure there are circumstances when there is one parent figure supervising things, but on the films I have been fortunate enough to work on, there is a lot of dialogue and no one person is always right. It shouldn't be my way, it should always be our way. Otherwise, it is a total failure. If I can get a consensus about a shot that seems right for Sean Penn and Clint Eastwood, then it makes sense and we'll do it. But if I can't get a consensus, it is probably not a good idea and we won't do it.

Let's talk about the director-cinematographer relationship.

That relationship is intrinsically collaborative at its best. And what I said a moment ago about the consensus — if I feel an inability to collaborate with a potential employer, it would be a very poor fit for the project. That relationship must be professional, like doctor-patient, lawyer-client and even priest-congregant. We really need to have a mutual trust. If we can't, then one of us will be unhappy. In the case of Clint Eastwood — whom I have worked with as a cinematographer and gaffer for about 25 years — he brings a unique style to his work and, not only do I know that style, I respect it. Ultimately, he makes the decisions, but if I didn't feel an empathy toward his choices, I would not be executing them. In general, every director and situation places certain demands on the cinematographer, and it's important to recognize that there is no right or wrong way. Sidney Lumet is probably going to work differently than F. Gary

Gray, and they both tell their stories and create their art in unique ways, and that is what makes it so strong.

What is the Clint Eastwood style you were referring to?

With Clint Eastwood, we work organically. In terms of technology, technique and art, we totally subjugate technology and technique. For instance, in *Mystic River*, probably half of the takes in the movie were single takes. What that means is that Kodak made the film right and the camera functioned correctly. There might have been the odd hair in the gate, but we removed that digitally. It also assumes that the focus was correct and that I did not bracket exposures and a whole list of other assumptions similar to the ones we might make when we get on an airplane to New York — that the engines are maintained and the pilot knows the way. That is how Clint likes to work. It is an example of him saying, "You're all here because you are the best at what you do. Now do it." That really becomes a proscenium for all the artists involved. Technically, if we can't get it on the first take, we have something to work on. Other directors prefer a more measured advance toward the goal, where we might do five or seven takes, which is also dandy. Again, there is no right or wrong way.

Though I think that type of cinéma vérité shooting is not very philosophically sustainable for feature films, it's good for the actors, because if they think that the first take is their only shot, they get right on it and do a good job, which is one really nice thing about Clint's approach. Most of them love it, though others like to build up to a great shot and feel their way around. I end up visualizing that setup very quickly, as I'm pretty familiar with Clint's cinema semantics by now. I stay ahead by knowing what we will be doing in four or five shots from any given point. Otherwise we can get buried.

How do you light these scenes so quickly?

I don't light them to be fast, I just light them fast. It is a matter of seeing. In the past six months, I have probably shot a half-million feet on 5218, and after all the sunglasses and town cars have been put away, the DP is in the lab until four or five in the

morning looking at stale doughnuts and watching this stuff go by. Because of that, I learn the way emulsions respond and can train my eye to see this happening, which establishes a certain directness in my approach. In another sense, it puts technique and technology off to the side because I have absorbed them.

I shoot anamorphic a lot and have a set of C's. I know the barrel distortion of my 35 and my 30 and I know that the minimum focus of my 40 is actually inside what they say it is. And I know this from looking at a lot of film. If I may spend two hours a day doing homework looking at work print, I'd have to work very hard to do what I do. I love the feedback aspect of it, where I do an act that has an effect. I need to understand that act and effect, because that allows me to light very fast. I might calibrate the meter once every five or six years, but I end up just seeing it. It is like cooking with teaspoons and measuring things, where some people use a quarter teaspoon of salt while others just grab some salt and throw it in. I am the kind of guy who throws it in.

Tom Stern, ASC was born in Palo Alto, California. His credits include The Changeling, Mystic River *and* Million Dollar Baby.

Vittorio Storaro, ASC, AIC

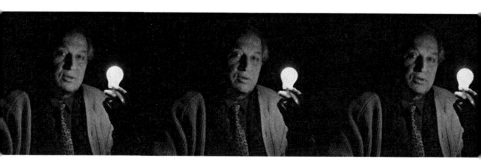

What is your name and what do you do?

My name is Vittorio Storaro and I am a cinematographer. I'm not a director of photography.

Why not?

Because 'director of photography' has two major mistakes in those words. A movie is like an orchestra. There is only one conductor, only one director in the orchestra. There isn't another director for the actors or for the style. Photography, which is writing with light, is expressed in one single image. In film, we express ourselves in cinematography, kino, movement and motion. We need time; we need rhythm. We need some kind of wave to tell the story, like in music. In photography, the photographer expresses himself as a photographer; in cinematography, that is the cinematographer.

How did you become a cinematographer?

I was lucky because my father had a beautiful dream. He was a projectionist in a very big company, Lux Film Company. He probably dreamt of being part of the images he screened. And he put that dream on me. I was lucky that the dream was contagious, because it became my own dream. Since then, I attended several photography schools until the Italian Film School. I realized that my life is really about the search into the mystery of light.

How did you get into the film school? Was there a lot of competition?

My problem was that I was too young. The school required students to be a minimum of 18-years-old and I went there when I was 16. They told me, "You are too young." I had already done a five-year course in photography, so I practically had no other school to go to. But I found another smaller film school and went there for two years.

John Schwartzman, ASC, said that you were his mentor when he was a film student and you told him that he should just trust his emotions, and he said, "That's all very well and good when you're Vittorio Storaro."

You always are yourself. I always was Vittorio Storaro in my life. When somebody says to you that you can't do this or that until you reach a particular level in your profession, I don't believe it. When I started, I was nobody, but I was always myself and think you should be always yourself. I've had young cinematographers tell me many times that they couldn't do something or maybe refuse a project until they are a certain type of person, but the truth is they can do it now. I always did.

On my first film, *Giovinezza, Giovinezza*, I was doing tests for actors and working in a very simple way to understand what the movie was supposed to look like. Then I found myself uncomfortable with something the director asked me to do and I was forced to do it. I was 28 at the time. At the end of that day, I said to the director, "Goodbye. I don't think I'll come back tomorrow, because you don't need me. You only need someone to light one light so you can see what is in front of you, but not in any particular way. So I don't think I'll come back tomorrow." I had been married two years before and already had one daughter. My wife was expecting another child and we had only $50 in the bank and I still said no.

The director, Franco Rossi, was great. He said, "No, Vittorio, forgive me. I didn't mean to change the way that you are supposed to work. This is what I expect from you. I just needed to completely light the figure of the actor because I have to understand it myself." That was wonderful, and we went on to do a beautiful movie together. And I was still Vittorio Storaro then, even on my first film.

You said the other day that we really have to love our jobs and when we stop loving them, the feeling is gone.

I did *The Spider's Stratagem*, which was the first film I did with director Bernardo Bertolucci, who told me at the beginning of filming, "I remember you, Vittorio, as an assistant with me on *Before the Revolution*. I loved so much the way you approached your work. I know that now you are a cinematographer and have already done two movies. I would love you to do this movie with me. It's a very small movie, but I want to do it in direct sound, because, to me, sound is at the same level as images."

In Italy at that time, we did not use direct sync sound. We had no money for the film and the crew was very small. We shot it in 16mm and had done some tests that we went to see in the laboratory, and I said to Bernardo, "This picture requires a much higher quality than this. It won't work." He was watching these tests, too, and agreed with me, so we picked up the box of film and threw it in the trash can.

We needed a very big camera to do direct sound at that time, and we carried it ourselves to our locations. I was worried because I couldn't use the laboratory I wanted, because we had already started with a smaller one. After the first day of shooting, we received the dailies and they were very bad. I was shocked, because I was not expecting something of such poor quality. I really panicked and said to Enrico, my camera operator, "Enrico, take the new dailies and go to Rome. Go to the laboratory we were supposed to use, because I don't want to continue with this other laboratory." I told Bernardo that the dailies were bad because of the laboratory and had Enrico go to Technicolor Rome to work with Ernesto Novelli, whom I knew already.

During Enrico's journey to Rome and then back, I had one day of shooting when I was totally insecure and totally panicked. I had lost the love for the craft and started to worry that the exposure was not right, the filter was not correct, the shot was not in focus, and that everything else was not precisely the way I wanted it to be. It was 24 hours of a living nightmare.

Marilù Parolini, the writer on the movie, said to me, "Vittorio, in photography and cinematography, we have to deal with the mystery of the system itself. If we lose this link between ourselves and the creativity, we are lost. We need to keep the incredible love for what we're doing." I've remembered that line ever since. When we love what we do so strongly, we never have fear. But when we start to be in doubt and when we don't have the strength to experiment and go beyond the limits of the technology we already know, we become trapped. And if we're trapped, then our fantasy, freedom and intelligence become locked. If we're locked, we can't do cinematography.

Each one of us, regardless of our profession, in every moment of our life, receives energy from all over the world that surrounds us. At the same time, we're also sending energy out. This energy is why, when we watch an image on a screen, we feel some kind of emotion. That's because the light, shadow and color that bounces from the screen and arrives to us isn't only seen with the eyes. We see with our entire body. We are a photographic film practically. Light is energy, so these vibrations that arrive to our bodies change our metabolism and our blood pressure. Film is able to register these emotions. It is much more sensitive than the technicians tell us.

Why do your movies look the way they do?

Movies are a collective artwork, not a single one. They cannot be made by a single person. I often encounter people who tell me they want to do a movie by themselves. Cinema is really called decima musa, the tenth muse, because it's nourishing itself with the other muses — literature, painting, dancing, philosophy, sculpture, architecture. Cinema today is an art form that combines all of the other different art forms. Each one of us involved in making the movie gives what is in our own minds, in our own culture, background and education. No doubt the script was written by somebody who knew literature. No doubt the composer who wrote the music lives his whole life with music. No doubt the art director knows the "scenography" of the film, meaning he knows how to write

with the set. Cinematography is writing with light in movement, but it's what we are writing about that's most important.

When I did my first film, *Giovinezza, Giovinezza*, with Franco Rossi, I realized that I was too well prepared with the technology of being a cinematographer. I knew every single technical element very well, but I didn't know why or when I would use it. I realized that unless I prepared myself in a more balanced way and knew the art form better, I wouldn't ever know what I was doing. I needed to learn every different possible human expression. I needed to learn the meaning of the light and color I was using. I knew how to do things, but I needed someone else to tell me why I did them. From that moment, I realized that I had to, step by step, build my knowledge of literature, poetry, architecture, music and philosophy. Step by step, I tried to realize the meaning of everything, because it is all very important, especially the product we make at the end.

We create our own style in any expression. In cinematography, we need to know, whether in an unconscious or conscious way, who we are as people. For anyone in any profession, we take ourselves outside of the creativity, sensitivity and knowledge we have. We express all of our feeling in one specific art form, because we are trying to answer our own questions about the meaning of our own lives. That's how we create our own point of view that's very specific and personal. We are the coauthor of the film and images for that simple reason. Every single cinematographer doing the same scene would shoot it in a different way.

Most of the time, especially in the beginning of our careers, we are in an emotional state. Only after we become more conscious of who we are do we understand the reason why we do something with a specific light and color. It's to investigate what our lives mean. We put our signature in every frame, because just changing the color temperature in one single light changes the emotion in our minds completely. Just a little movement can change the mood into a deeper introspection or move it into the intellectual world.

We should know why we're using shadows and why we might go completely black. Shadows mean not knowing, and light means knowledge. Light is inspirational to human beings and belongs to consciousness. Darkness belongs to unconsciousness. The relationship between light and darkness is very important. If I am fully lit while saying something very specific, I'm facing knowledge. If I'm facing toward a darkness, that means I have doubts. There's something I don't know, but would like to know. I've studied this for 30 years and have put my knowledge into another art form, which is writing, in *Writing with Light*, a three-volume book.

When we put things in relation to each other, we start to create a balance between two different elements. Through our expression, which is cinematography, we try to understand who we are and what our life means. I discovered through cinematography that my expression is a search for balance. I always seek the two different sides — light and shadows, conscious and unconscious, male and female — in order to understand why they are separated. Only through this journey was I able to go completely toward the light. I started to go into the children of shadows and light, as Leonardo Da Vinci called them, into the colors. Those colors gave me a different emotional level.

Only when I started to separate light and shadows, color by color, did I realize that I could know them. I could put them together in the equilibrium of elements. This is what my life means now. I discovered that through this incredible journey of searching and experimenting. I never did not open a door of mystery. However knowledgeable we are in the technology or art of our profession, we'll never know the end of our journey. That is what's great. Every day is a discovery. Every day, we should be ready to open a new door of mystery to discover something new. This discovery is the meaning of our lives.

Is this "writing with light" conscious or unconscious on our parts?

The main difference between the word photography and cinematography is that, in Greek, "photo" means light, and "graphy" means writing, whereas the "cine" in cinematography

means kino or motion. Cinematography means writing with light in movement. Photography is much closer to a modern expression of painting, where the photographer must be sensitive enough to express himself in a single image.

I'm not a very good photographer. The photography I have in my trilogy book are not very good photographs, because I've been trained to be a cinematographer, which is somebody who needs more time and images to express himself. We need to know our literature of movement. Any writer writing a book knows his own style in the same way that we know how to change a light or use a dolly or crane or zoom. We know our own music and rhythm that can create a specific kind of story.

To say we "paint with light" means we use the knowledge of painting, but with our own wave that moves us from one place to another. We're more connected with literature and music in that way. If a writer uses words to write his story, if a musician uses notes to give emotion to his story in music, we use light to visually write our stories.

Talk to me about the difference between writing with light as opposed to composing with light.

Once we understand the main concept of the picture, which we get from the main lead, the director, we can use our tools — shadows, light and colors — to write the entire story with light. The director gives us the right emotion to convey to the audience, because the audience, in order to follow the story, needs to receive similar direction.

We should never forget that cinema is a language of images. The images impact the audience and give them some kind of vibration. Through those images, they receive the music and the words. And when taken together, those vibrations lead them toward a specific emotion. If those are in balance, then we can make a good movie.

Some say that style comes from the script or the location or emotion of the time. Where does it come from for you?

Cinematography is a very solitary and personal journey. Of course, everyone expresses himself through the profession he belongs to, but, at the same time, cinematography does not exist without a story or without a direction. But even though the director leads us all in his direction, it's necessary for us to have a personal need for expression. The style of Vittorio Storaro comes from my own personal need to understand myself and what my life means. Only through this need can I use my knowledge, creativity and sensitivity to perform. I can give this to the project and director, because I need the chance to express myself. It's up to the director to draw out the best of his crew to tell the story, but our style comes from our personal inner side.

Can you give us an example?

We first need to understand the main concept of the story and translate it into a visual concept that we can present to the director. If the director accepts the concept as his vision, we start to believe in this vision. I begin by putting, on paper, the philosophical concept of the picture. From that moment on, I'm the one writing the script, scene by scene, and finding the single idea that's important in every scene. The writer usually tells us about the scene being during the day or night, but during the day, we have the aurora, dawn, morning, midday, afternoon, sunset and dusk. There are so many different moods and elements we can use.

I try to rewrite all of these moments with this in mind and try to find a color wave — what Sergei Eisenstein called the "dramaturgy of color," which is the chance to move from one scene to another through the color spectrum. I try to see how I can use that concept in the locations and scenes, and how I can move from place to place in a way that gives support for the main concept of the story. I put that into the script and draw a plan for where I will ask the gaffer or console operator to put the lights, so they will also know what they are supposed to do.

I also think that if we really believe in a way a scene is supposed to be, magically something will happen to turn it into what we believed. Because when we love and believe in something very

strongly, it's going to happen for us. For example, when I was shooting *The Last Emperor*, there was one scene that was written to be cloudy, but when we got to set, it was a sunny day. It was the scene when the emperor was being thrown out of the Forbidden City. The day we arrived on set, I was a little exhausted because we had already been around China and had almost finished the entire movie. It was one of the last sequences, and I was thinking that my concentration and energy was done, because my work was almost finished.

The sky was incredibly sunny that day, all blue and without a cloud. I said to myself, "Well, maybe this is the way this scene is supposed to go." I finished the morning work and went to lunch. I remember watching the dailies in my mind during lunch and not being very happy with the work, because it was not in synch with what I wanted.

After an hour of lunch, we came back to the set and the sky was totally black. The director Bernardo Bertolucci and the producer Jeremy Thomas looked at me and said, "Vittorio, do we go home?" I said, "No. It's perfect." I imagined the sequence with the emperor playing tennis with his court in plain sunlight, which we had already shot that morning. Then, the soldiers would arrive with the general to throw the emperor out of the Forbidden City. At that moment, a big cloud would suddenly cover the sun up completely, turning the sky black. It seemed wonderful and I knew that this was how we were supposed to finish the sequence.

Bernardo was worried about how we would combine the two sequences. "Don't worry," I told him. "Tomorrow we will finish the sequence. We can catch one moment where a cloud goes over the sun and we can match them." Bernardo said, "OK, Vittorio. If you believe it, then let's do it." And we went on to shoot part of our sequence that afternoon.

The next day, we had a totally blue sky with a big sun in the middle. Bernardo asked, "Vittorio, what do we do? Do we reshoot everything?" I said, "No. Tell me which shot can go between the sequence we shot in the morning with the sun and the one we shot in the afternoon with the clouds." Bernardo

said to shoot the sequence when the soldiers arrived with the general. Then I had the gaffer and key grip prepare the dolly and get everything ready for the shot. I told Bernardo, "Today, I will probably ask you to stop everything we're doing so we can run over and shoot the shot with the soldiers and the cloud." So we continued filming, and I was using every possible thing I could to create the cloudy mood. I used screens and tried to close up the blue sky.

Suddenly, I looked up and saw a little cloud coming. I said to my second camera operator, "Go to the dolly and get ready." To the assistant director I said, "Prepare your people for the scene." And I said to Bernardo, "Let's go over there for one moment. I'll tell you when you can say Roll." I asked everybody else to be ready. Looking at the sky, I said, "Roll anytime, Bernardo!" So he rolled the camera and said Action. The scene was full of sun. The soldiers arrived and the camera followed them. And then, during their movement, the sun was covered by a little cloud.

Now we're getting into technique and technology. Does technology affect how the film looks or is it the other way around?

Light is knowledge. Knowledge is love. Love is freedom. Freedom is energy. Energy is all. Without light, we can't have an image. Light is the only chance we have to see what's inside of ourselves. We can put the light over here or over there, front or back. And where it's put changes everything completely. Any cinematographer using light can tell the story — he can write with light.

Light is the beginning, and our lenses capture this light, while the film records it. The camera, along with the director, gives us the chance to compose a story in a space. One problem today is that cinematographers forget about composition when framing a shot. When we shoot, only the specific space can determine the art, like it does in painting. Otherwise, it is totally free.

Today, we have the chance to compose an image that expresses cinematography as an art form. And we should defend this art form, because when we do wide films that are later transferred to

television, they become mutilated on their sides. Their composition is changed. And when that happens, the style of the movie is changed, which changes the meaning of the movie itself.

When I worked with director Carlos Saura, I focused on this problem. The chance for Carlos to express his Spanish culture was through dancing and music in the films *Flamenco* and *Tango*. In our work, it was essential that the frame, the composition stay the same. But we realized that moving an image from one art form to another would change it completely, which is why we invented Univisium, which means "unique vision" in Latin. That idea came from looking at Leonardo Da Vinci's "The Last Supper," because Leonardo was searching for a divine proportion. The divine proportion for him was one by two. I realized that that was the great meeting point between cinema and television, between the very epic picture on the big screen and the very intimate one on the small screen. If we can reach that point in cinematography, we will advance our art form, because that will show respect to every single coauthor of a film — from the director to the production designer to the cinematographer to the camera operator. Today, it's a nightmare that our image can change according to where it's being displayed. It's like taking a finished painting and cutting it according to the size of the wall. It is really impossible for us to continue this way. By preserving the image, we also show respect for the audience, because they have the right to see the image properly, in the way it was shot and conceived. Univision Univisiium has given us the chance to use the entire film.

Film is still the most important element and material with which we can express ourselves. It is so powerful and has such value that it is ridiculous for us to waste it. In using the total film area just for images, from perforation to perforation, we can achieve 24mm — two to one is 12mm. But we can put frames much closer to each other to save value. Instead of the camera running out of film every 11 minutes, we could save 25% on time, materials, shipping, developing and printing. That is a great value, because from the moment that we conceive the image to the moment that we develop the print, we must store it. In the storage area, we can save 25% more

space, because any storage must have an original negative, an interpositive, an internegative, a separation, a master, a sound-track and a print. This amount of film has a lot of empty space in between the frames that we can save. Univisium, for both cinema and television, can give us the chance to express ourselves better, and it would also be more economical for the industry.

I'd like to talk about color. Do you go through different phases when you're using one color more than another, like Picasso did? Or is the color influenced by the script and mood?

Honestly, I did have a blue and orange period. That was when I was very innocent, when I was expressing myself emotionally without really knowing the symbology of color. Probably between *The Spider Stratagem* and *The Conformist*, I had the idea of blue. In *The Conformist*, the feeling in Rome in 1930 was very claustrophobic, because it was a very political time. But mainly the blue came out of the separation that the leading character feels, because he was trying to be different from who he really was and trying to show only one side of himself. He was being a conformist, hiding something that was part of his personality. This separation between light and shadows was very clear in the film, and the two sides were kept in separate harmony. When the character went to France, that represented his freedom; it was where anyone with some political problem could go to think and speak freely. The chance then was to open the light and shadows and have more harmony, where he could embrace color for the first time.

Colors are really, like Leonardo Da Vinci said, the children of light and shadows. At that time, I didn't know why that was. I didn't know I could use one color over another. I went through an emotional state to use the color blue, which is what I thought the meeting point was between the dusk and the artificial light. Those two created a conflict of two different energies, which brought out a blue mood. But I didn't know that blue meant freedom, that it stood for the concentration of intelligence in that time. I was going for a kind of emotion and felt that Paris was supposed to be seen that way.

I spoke to the director, Bernardo Bertolucci, and said, "Bernardo, I'd love to do the entire dancing sequence in this blue way." He said, "Vittorio, I understand what you mean. We have only a few days to shoot the entire sequence before Christmas time, so we'll be filming from eight in the morning until seven in the afternoon. Do whatever you want to do." So I organized every possible filter for the window and finally, at the end of the journey, I realized what I had in mind.

Tell me more about Paris.

After I discovered the great emotion of blue in *The Conformist*, I needed to go even deeper into the possibilities of this vibration, of this color. In movies I did after *The Conformist*, I tried to investigate the possibilities of blue until I started work on *Last Tango in Paris*. At that time, I was in Rome filming *Orlando Furioso*, and I was going to Paris every weekend to see Bernardo and location scout for *Last Tango in Paris*.

I was so excited for the chance to see Paris in the winter with all its lights on. The artificial light, when it was on during the day, created this conflict between the artificial and natural energy of the city, turning the light orange. It gave me a feeling that was totally different, almost opposite and complementary to the blue of *The Conformist*. Orange had a warm feeling, representing the womb of the mother, which was the city of Paris embracing us. I felt that the atmosphere was magic. Suddenly, I saw that the same city in a different story could have a completely different mood. I told Bernardo that it would be wonderful for the film. That orange color gave the warm feeling the story needed.

Back then I honestly didn't know the meaning of orange: the connection between the color and the father figure, the mother's womb and the feeling of passion. But I felt it was right. In other words, a period of a certain color that we may have in our lives — in painting, photography, cinematography — mainly comes from some emotion that brings out our inner need to express ourselves in the direction of the color. Only after *Last Tango in Paris* did I feel that I was completely bathed in this color.

I also used orange in *Identikit, Giordano Bruno* and *Malizia* because I discovered different levels of the color that I liked, just as I did before with blue. Until *Apocalypse Now*, I confronted these two colors, which really represent artificial and natural energy, in order to present the conflict of two different cultures. Superimposing one on top of the other creates a major conflict.

After *Apocalypse Now*, I felt I needed to know the color theory in a more conscious way. That's when I stopped working to study. I believe it's very important, particularly at the peak of one's career, to stop and think, to do research, to experiment, to study and understand why we've done everything the way we've done it. We need to understand the meaning of what we're doing; we need to realize why we are at that specific moment in our lives, with all the knowledge we've accumulated, and try to go as deep as we can into our creativity. Because at that moment, we have the chance to fly into another universe, into another step, into another level. In fact, after one year of research and study after *Apocalypse Now*, I was able to go directly into another world — the world of color — and that was wonderful.

You seem to recognize the role that tools play in the evolution of the art. Can you talk a little bit about that?

About 30 years ago, I was experimenting with light in every film I did, watching the organization of the light's tonalities and worrying about the balance between the shadows and the light. What was tricky was that the light could be captured with one type of lens and a lot of different types of film; then it's developed, printed and screened in various ways, which can dramatically change the look of what I saw in front of me when I filmed the scene.

Luca Ronconi, the director of *Orlando Furioso*, asked me to do theater work with him. I realized this was something I wanted to do, because it would finally free me from the tools and technical elements of film. Even though I know how to choose one lens over another, one film over another and one camera over another, I knew that they still could never exactly reproduce what was in front of my eyes. So I did theater for one season to

learn. After that experience, I learned how to perform directly in front of an audience using only light.

But I also discovered that my own creativity was not complete unless it was captured by a lens, a film, a camera, a developer, a printer, a projector and put on a screen. I realized that I was really a cinematographer and I wanted the chance to choose one lens over another and one film over another, so I could capture different wavelengths and create different moods. I wanted the chance to develop and print, and go to the laboratory to use a color timer.

Ernesto Novelli and Carlo La Bella were essential in helping me complete my theater experience. Though since then, I refuse to do theater work unless it will be recorded, because the cinematographer's work is only complete when the image has been captured. It could be captured on analog, digitally or on film. The recording device doesn't matter so much, but it has to be recorded on a medium and screened.

Does the lens help create an emotion?

Without the lens, we don't have an image. If we don't have an image, we don't have film. It is like Leonardo Da Vinci's concept of the camera obscura, which really imagined the possibility of the lens. Giambattista della Porta perfected the camera obscura, adding the lens. The lens made the image more precise, in terms of what the external world was about. It wasn't just a ghost image; it was an image that helped painters paint by following any line they created in the camera obscura. It helped the photographer invent photography, and it helps us perform our cinematography.

What is the future of cinematography? Where are we headed?

Since the first piece of graffiti was drawn in a cave, the journey of the visual arts has taken us through drawing, paintings on wood and then on canvas, photography, cinematography, the electronic and digital image and computer graphics. More and more, through our work as cinematographers, we have the

chance to move from matter into pure energy — like the famous formula $E=MC^2$.

Step by step, the matter has become subtler, because when we consider the technology we used 20, 50, 100 years ago, we can see that the physical elements of the equipment were reduced and will continue to turn into something very minimal. But there is one thing that has never changed: the idea. The idea doesn't care whether we do it on stone, wood, canvas, film or something electronic. The idea is what remains, because it is energy, it is part of ourselves. $E=MC^2$ is what our life means.

Vittorio Storaro, ASC, AIC, was born in Rome, Italy. He attended film school at Centro Sperimentale Di Cinematografia in Rome. His cred- its include Apocalypse Now, Reds *and* The Last Emperor.

Rodney Taylor, ASC

Who are you and what do you do?

Rodney Taylor and I'm a cinematographer

How did you get started?

I got started by doing live television sports in Chapel Hill, North Carolina, with Michael Jordan. It was a lot of fun, and I think it was a great way to develop camera skills.

Was it video?

It was video, and it was great because I got to get my hands on a camera right away. I was a handheld cameraman, and it was just great looking through the camera and making instant decisions about composition and focus. So that was a good background, but I realized pretty quickly that I wanted more, so I moved to Los Angeles and started pursuing cinematography.

You've become known for Imax and large format films. How did you get started in that?

I got started in Imax with a call from Mehran Salamati, who was a cinematographer, and we went off and did *Ring of Fire*, for which I was a camera assistant. The first time I saw those images on an Imax screen, they just blew me away and I knew I wanted to be involved with that.

What are some differences between shooting large format Imax and regular 35mm?

Well, there are some technical differences, but I've tried really hard, as a cinematographer, to close the gap between shooting Imax and shooting feature films. I really try to approach every Imax film the same way I would a feature. The important thing is to take inspiration from feature film cinematographers and create a look for an Imax film that will tell the story — and tell the story emotionally — instead of just trying to blow people away with a big screen.

How do you arrive at a style for a particular project?

It starts with the written word always. Then I often look through still photographs to draw inspiration and, of course, the location is very important. I try to imagine what it is all going to look like. And then I try to get into the story and bring an emotional level of that story to the screen.

Can you explain Imax cameras?

When I shoot Imax, I shoot 65mm film and it goes through the camera sideways, like VistaVision. Each frame is 15-perf, so it's a very large negative. It's like shooting Pentax 6-by-7, 24-times a second. It's an incredible technical achievement just to be able to move the film through there. It leaves us with a very large negative that is projected on a huge screen, five or more stories high. And the image is amazing.

Why don't you shoot feature style?

When I shoot an Imax film, I'm looking through the camera and imagining that I'm sitting in the theater looking at a very large screen. I try to shoot it from the point of view of the audience. I want them to experience this themselves, almost edit themselves, so they can look from one character to another or from a mountain to a horse. They can see it all in one shot. It's not as necessary to do it feature style with coverage. I think there has to be a very compelling reason to cut.

Tell us a little bit about moving the camera, rigging and getting it around.

That is the biggest challenge. With Imax, I want to rig the camera on moving objects, because I want to give the audience that Imax experience of camera movement. That's really key for these films. A few years ago, I had to rig these 100-pound cameras that were enormous. But recently, Marty Mueller developed a camera that weighs about 60 pounds, so I can start using better motion-picture tools that are out there, like the Libra Head, which I use on almost every film now to stabilize the image for Imax. I also use the Steadicam whenever I can.

You can do a Steadicam with a 60-pound camera?

We strip it down to a 500-foot magazine. For just the film alone, 1,000 feet of 65mm is 12 pounds, so a 500-foot mag drops that down to six pounds. We also remove the viewfinder and whittle it away until we get it down to 40 pounds.

What kind of crews do you go out with when you shoot for Imax?

The crews used to be really small. It would generally be me, a camera assistant and a key grip, and we would pick up local people along the way. But in the last few years, the films have become more sophisticated so we're working with larger crews and sometimes Hollywood style crews. But that really depends on the subject matter. There is a greater variety of Imax films nowadays. They used to all be nature films exclusively, but now there are sports films and concert films, and I've even done dramas in Imax.

Talk to me about shooting anamorphic and your experience at Sundance.

Obviously, shooting anamorphic is very different from shooting Imax, because the Imax frame is almost square. Imax is about 1.33, but anamorphic is spread out to 2.40. For composition, anamorphic is my favorite format. I love playing with that wide screen, where I can shoot two or three characters talking at once, and the audience can look at whomever they want to look at. Of course, it's also great for landscapes.

On *Swimmers*, that was a real challenge with some very small houses we shot in. It was a low-budget film, as a lot of Sundance films are, but I was determined to shoot widescreen for that film, and I thought anamorphic would be the best choice.

Let's talk about style.

Style develops out of the script. From reading the script, I figure out what the movie's going to look like. I also have conversations with the director, of course, and the locations are key. I fell in love with the eastern shore of Maryland, which we shot for *Swimmers*, which I wanted to give a sort of not sharp look to. That "mist on the water" look and desaturated colors were important for that film.

As far as technique and tools go, I try to not think about the tools, but rather what the story is that I want to tell and how I can get there. Obviously, the tools are wonderful and they help tell the story, but it's always first about telling the story.

For example, I had to do a battle scene for *The Legend of Loch Lomond*, which was an Imax film. I really wanted it to have this feel of ugly weather and a little bit of darkness. It was a daytime scene and we were shooting in Scotland, so I thought, obviously, that we would have the most beautiful day on record in Scottish history if I decided to shoot during the day. And on our budget, we couldn't afford to move the day around because of all the extras, so we went ahead and rehearsed all afternoon.

So it was the only nice day in the history of Scotland?

I just assumed it was going to be a beautiful day, even if we really needed this ugly weather. So I told the director that I wanted to go in at two in the afternoon and rehearse everything, if it was sunny. That way, we would know exactly what we were going to shoot and, once the sun went down, we would start shooting it. He said, "OK, this is important for the script. Let's do it."

At two o'clock, there was not a cloud in the sky. We started rehearsing and the executive producer, who was Scottish, came

to me and said, "This is the first time in the history of Scottish filmmaking that someone has not been shooting when the sun is out!" Sure enough, when the sun went down, we started shooting with a high-speed stock and a bunch of ND filters. Then I started pulling filters out as we went, but we were far enough north that we still had a lot of time to shoot. If it had been sunny, it just wouldn't have been right, and everything would have been too clear. But in the end, we got the sequence we needed, with a look that fit the mood of the film.

Rodney Taylor, ASC, was born at Sea Level, North Carolina. He attended film school at the University of North Carolina at Chapel Hill. His credits include Swimmers, Home of the Giants *and* The Legend of Loch Lomond.

John Toll, ASC

Who are you and what do you do?

I'm John Toll and I'm a cinematographer.

How did you become a cinematographer?

I've always been interested in photography. From the time I was very young I owned cameras, and I learned how to use a darkroom when I was 10 years old. I always stayed interested in still photography but never pursued it professionally. While attending college in Los Angeles, I got a job working part-time as a production assistant for David Wolper's documentary company. Naturally, I became interested in joining the camera department and eventually began working as an assistant cameraman, then an operator, and eventually a director of photography.

How did you make the jump from documentaries to features?

It was a natural progression. As you make your way through the business, one job leads to another. I loved doing documentaries, but the idea of doing feature films was the real goal. I worked on television shows, commercials and eventually had the opportunity to do features.

In terms of style, what affects the look of your work?

I think photographic style should come out of conceiving, designing and creating a visual approach to any particular story.

Hopefully, it has its own unique character based on that story and will look different from what you've done before.

Take us through the process of determining the style for a particular project.

In 1993, I did *Legends of the Fall*, which was based on a novel by Jim Harrison. Several years before I was involved in this film, I had read the book on which it was based and became a fan of this story and its characters. The book is filled with incredibly rich and detailed descriptions of the setting and the environment where most of the story takes place, which is at a cattle ranch in Montana. The first time I read it, I remember vividly imagining how the characters and settings of this story should look if it ever became a film.

It was a couple of years later that I received the script and was invited to meet with the director, Edward Zwick. Although the script was based on the book, it deviated a bit in that it had a much more romantic theme than was in the novel. Even so, I thought the original basic ideas I had imagined as a visual style for this film were still valid. Coincidentally, I had seen a book of still photographs that a *National Geographic* photographer, William Allard, had shot over 20 years called *The Vanishing Breed*. He had basically documented the lifestyle of contemporary cowboys in a beautiful and powerful way. His photographs were shot with natural light in rich Western environments. It was like seeing the images I had imagined when first reading *Legends*.

Although it depicted an entirely different historical period, I thought these photographs were a great reference for the photographic style that would be right for the film. I took the book to the meeting with Ed. He was able to see what I was proposing as a style for the film and agreed that it was appropriate for the story he wanted to tell. That was essentially the origin of our ideas for that film's photographic style.

However, because the script was a more romanticized version of the original story, the photography slowly took on a more romanticized feeling than I had originally intended. But story drives the

look of a film, and during shooting I find that I constantly make adjustments based on how a story is progressing, sometimes without being totally conscious that I'm doing it.

What else affects style?

Sometimes style comes out of pure necessity. The first feature film I did as a director of photography was *Wind*, with director Carroll Ballard. I had worked as a director of photography on many commercials and had shot a TV pilot and a movie of the week, but I was dying to do a feature as the director of photography. I met Carroll while we were working on a commercial together; he was preparing to do a movie about America's Cup yacht racing. He started telling me how excited he was about doing the film and how they were going to shoot on board 12-meter yachts. He was either going to go to New Zealand or Australia and use some of the boats that had been in the 1987 America's Cup race, and he planned to choreograph and stage races on the water and try to shoot in the most severe conditions.

Carroll was sharing his excitement with me, which I thought was great, but while I was listening to him describe what he was going to do on this picture, I began thinking about how difficult it was going to be. He told me he had a commitment from a director of photography he had already asked to work with him on the picture, and I simultaneously felt disappointment and relief that I wouldn't have the opportunity to be involved. At that time, my personal experience working on smaller boats was limited and not very successful, in terms of the motion factor.

We were sitting on a plane together coming back from location and talking about his film and the films that I had been doing. As we got off the plane, he said there was a slight possibility the schedule might change and, if it didn't work out with the other DP, he might give me a call. Sure enough, they pushed the picture and the other DP had a conflict and had to drop out, and I got a call from Carroll asking me to go to Australia and do the picture. Of course, I said yes. Having the opportunity to work with Carroll on a feature was a dream fulfilled, but even as I was saying yes, I was also thinking that I had no idea how we were going to pull it off.

When I got to Australia, we discussed various ideas on how we might approach working on the boats, some of which we tried and others we rejected immediately after doing some tests on the water. However, right from the beginning Carroll believed that, because of the amount of space available to us and the degree of difficulty working on the yachts, we might need to use handheld 35mm cameras and essentially shoot in a documentary style. During prep, I tried doing some elaborate rigs and tried to come up with sophisticated camera mounts, none of which worked due to the extreme nature of the sailing conditions.

Ultimately, what we did was acquire two 35mm Aaton cameras, which were small, lightweight, sync-sound cameras. At the time, they were pretty new and there were only 15 in existence, so we were lucky to get our hands on two of them. We made waterproof fabric covers to completely cover the cameras and also designed and built matte boxes, which could blow nitrogen onto the lenses to keep them clear of water. This was necessary, because the extreme conditions of wind and swell that would make the racing look exciting also meant that we were constantly going to get inundated by waves.

Out of necessity, we created a system where we could shoot with handheld sync sound cameras that were waterproof up to the point of actual submersion. We then choreographed entire races and the specific maneuvers that would take place during an actual race. The boat crews were made up of professional sailors who also worked as actors in the film, and they handled the boats exactly as they would when actually racing. To shoot the races, we simply went on board the boats and went sailing with a minimal amount of our film crew, both Aatons and our regular actors. We shot scripted sequences as you would in a traditional feature film, but what evolved as a shooting style was a documentary-type shooting where most of the angles and specific shots during the racing were improvised, as would happen if shooting a real documentary. As a result, the footage took on a very real sense of exciting authenticity.

What are some other examples of improvisation?

I think all filmmaking, in some way, is creative improvisation. You are constantly improvising every day, but certainly not making it up as you go along. Obviously, the more organized and prepared you are, the more efficiently you can proceed. But I believe you can do so while being open to new ideas and opportunities. Improvisation is a worthwhile filmmaking technique that allows you the freedom to fall back on your own creativity and not be restricted by rigid preconceived ideas.

Let's talk about lighting. Someone described the lighting style in *The Last Samurai* as something you could feel it.

That is a great compliment to the film, because most of the ideas for the lighting in *The Last Samurai* came out of the feeling of the light at one of our locations in Japan. We shot in a 1,000-year-old Buddhist monastery called Engyoji Temple, located in Himeji, Japan. While in prep, we were lucky to spend quite a bit of time there. Most of the buildings at the monastery were originally built before the introduction of electricity and were designed to make use of natural light. At particular times of day, the interior light was absolutely stunning and had a rich but diffused natural quality. The main concept for the visual design of the film was to re-create the look and feel of 1870s Japan. So in my mind, what I was seeing at the monastery in Himeji not only looked great, but was also the perfect reference for the overall look of the film. I wanted to bring the feeling of the light of Engyoji to all of our locations in Japan as well as those in Los Angeles and New Zealand.

Let's talk about maintaining continuity in three countries and two hemispheres.

We began shooting in Japan and then moved to Los Angeles and then to New Zealand. In all three countries, it was necessary to maintain continuity in the lighting. This was particularly difficult in both Los Angeles and New Zealand because the exterior light in both of those places was dramatically different from what we had shot in Japan. I wanted an indirect but very rich feeling of light, but when we arrived in Burbank, as expected, the sky was blue and the sunlight was hard and contrasty.

Normally, cinematographers love contrast, but in my mind lighting is mostly about creating contrast, and I had decided that this particular type of contrast was not what we wanted for the movie. Lilly Kilvert, our production designer, had selected the New York Street set on the Warner Bros. backlot and converted it to be a 1876 Tokyo street. Very early in prep, I had decided to try and diffuse the hard sunlight. I asked key grip, Al Laverde, and his riggers to come up with a plan to put large pieces of diffusion over the entire street. The set was built as a long street with two large intersections on either side, and it was about 800-feet long, which meant 800 feet of diffusion material. Designing and building a system capable of supporting this amount of material was a real challenge, both in terms of technology and expense.

Expense became a serious consideration and, at one point, I considered abandoning the idea and tried looking for alternatives, but there was no easy solution. It wasn't simply an esthetic issue of trying to create a certain photographic look, because there were very real practical considerations as well. The set had been built on a street that was very narrow and, as the sun moved during the course of the day, the light on the set would change dramatically. This created enormous lighting continuity issues. We would get shadows in the morning that would cover the entire street. Then, as the sun moved, the street would become half in shadow and half in sunlight, and as the sun continued to move, the sunlight and shadows switched to opposite sides of the street. This effectively meant there was no possible way to create a continuity in lighting for wider shots in extended sequences, and trying to control the light in tighter shots would have been extremely time consuming. The extra time required meant we probably would not have stayed on schedule. This was obviously something to be avoided.

So, because of both aesthetic as well as the practical reasons, I convinced everyone that we should rig as much overhead diffusion as possible. Al Laverde and his team did a great job of supervising the design and construction of the rig holding the diffusion, and it all worked even better than I had hoped. In the end, it looked great and saved us an enormous amount of shooting time.

How do you achieve rich and soft lighting, as opposed to just soft?

The diffusion material diffuses the light, which gives it a soft, even quality, but it can also take away contrast. So in addition to diffusing the light, you need to shape it and give it contrast. This comes through taking away some of the light and finding ways to manipulate the remaining light to create a sense of shadow, but not the hard shadows one sees with direct hard light. I created what we call negative fill, which is basically an attempt to create shadows by shaping the light and giving it texture.

Where do you think cinematography is headed?

The same type of technological change that is affecting all aspects of our lives is influencing cinematography, and cine-matographers are using digital technology to create and manip-ulate images in new and interesting ways. New technology is supplying us with tools that allow for new techniques, and this is fantastic. However, the history of cinematography is about cinematographers developing and using new tools that allow them to fulfill their role as visual storytellers. The primary goal — telling stories with images — hasn't changed. It's only the tools that are changing.

John Toll, ASC, was born in Cleveland, Ohio. His credits include The Last Samurai, Legends of the Fall *and* Wind.

Amy Vincent, ASC

Who are you and what do you do?

My name is Amy Vincent and I am a cinematographer.

How did you become a cinematographer?

I started out in the theater arts department in college, where I was a lighting designer doing Shakespeare plays and modern dance performances. We had film requirements, film history being one. It was the silent films that I was introduced to while at university that made me want to shoot — F. W. Munau's *Sunrise* probably being the most inspirational.

When I moved to Los Angeles, my first job in the film business was winding through old silver nitrate prints at the Warner Bros. archives. From there, I worked as an assistant editor for four years, then found my way into an internship in the camera department. Then I came up through the ranks of the union, the old-school union way, loading mags, slapping slates, focus pulling, then operatorating and now I am a cinematographer.

Tell me more about your training.

Coming up through the ranks through the old-school union way was invaluable training, because I got to work with a number of excellent cinematographers, including John Lindley [ASC], Robert Richardson [ASC], John Schwartzman [ASC] and Bill Pope [ASC]. My years of camera assisting were an invaluable experience. Then I went to the American Film Institute to do the master's of cinematography program at a time in my career

where I needed to find out if I had what it takes.

Tell us about AFI.

I am actually doing a film with the director I did my thesis film with 13 years ago, so it just goes to show that the contacts I made there, I took with me. They also try to replicate the real-world working environment, in terms of how projects are set up and the collaboration involved.

Did you have any mentors?

My training really came from the cameramen who I worked for as an assistant and an operator.

How did you get your big break?

My big break came with *Eve's Bayou,* my first movie as a cinematographer. I had shot a million short films for free and was a bit over that phase of my career: borrowing equipment and getting my friends to work for free on the weekends. When I met director Kasi Lemmons, we had a special connection creatively, and she invited me to shoot her short film *Dr. Hugo.* It then took three years for us to get the financing for *Eve's Bayou*, and when it came, the producer Cotty Chubb, who had made the short film with us, made me part of the deal. It became a contractual thing for Kasi and I to be kept together, because it is common for a first-time director to be put in with a more seasoned cinematographer. These days in the business, that is the way we get our opportunities: by bonding with a director and having that creative collaboration and that dedication to the relationship. It is very hard to get going in the business without these established relationships.

If we look back in history at the director-cinematographer collaborations, they have produced some great masterpieces, like Bernado Bertolucci and Vittorio Storaro [ASC], Orson Welles and Greg Toland [ASC] or Roger Deakins [ASC] and the Coen brothers. They all stick together, and that is something I have been fortunate enough to do.

How do you collaborate to decide on the look of a film?

There are a lot of levels to the collaborative process. The first one starts with the director and that is the primary relationship. I execute the decisions of the director, and hopefully we come to those decisions together. Different directors have different ways of working. Some have very strong ideas and others look for a lot of input. Then the collaboration goes through every department and every crewmember. I collaborate with the production designer and the production manager to find the perfect sunset, the costume designer and the second camera assistant to make sure the camera reports are in my pocket before I leave each night — all of those things are part of the process, which includes everyone.

Where does style come from?

I'm probably going to give the same response that many of my colleagues would. The visual style of a project comes from the script. It comes from the story and the director's vision of that story, and we are the guardians and executors of that. There might be certain things that one cinematographer has had more opportunity to do, such as an action film as opposed to a quiet family drama, but we are all executors of the vision of the story to be told, which is in the script.

How do you decide on the style of a particular project?

Each script will have certain things inherent in it, which ultimately inspire the look of the film. For example, *Freedom Song* was set in a very specific time in history: summer of 1961 in Mississippi during the voter registration movement, which was a very grassroots movement. There was a huge amount of historic reference material to look at, including Danny Lyon's photographs. On that project, we decided on the style after reviewing photojournalistic archives of that time period, so it was very much based on reality. We shot in North Carolina, which is not exactly Mississippi, but shares some distinctive traits, such as the quality of the humidity and the density of the

foliage. Having a historically based project immediately gave us a jumping-off point, in terms of deciding style.

Eve's Bayou was a different story, in that the director told me she wanted it to feel like a children's storybook, where everything is bigger and prettier than it is reality. The search for the locations was inspired by that. We probably looked at 25 different houses before we found the one that became the Batiste family home. There were certain logistical things we needed to find, such as having the water be right by giant trees with hanging moss to give the story its sense of magical realism, but still with a foundation in reality. In the film, there are all these dreams and visions that provide a big escape from reality, like being able to see into the future and memories of the past. Kasi Lemmons and I developed a strict and rigorous visual language for the story, which shouldn't necessarily be apparent to the audience when they watch the film, but it helped us make the decisions. For instance, Aunt Mosel's memories of her dead husband had to look different than her visions of the future in order to keep the information of the story going.

I also did an anamorphic feature called *Kin*, which was never released in America unfortunately. It took place in the Namibian desert, where the sun comes straight up into the sky and then drops down pretty fast, which obviously created a very different look for the film than *Eve's Bayou*. The story is set in a time after years of drought and the climate was a part of what was happening. We incorporated the dryness of the desert and the heat of the sun into the look of the picture.

I also did *Jawbreaker* because I think everybody needs to do at least one high-school murder movie in his or her career. The inspiration for the look of *Jawbreaker* really came from the production designer, Jerry Fleming, and I thinking about circles, because jawbreakers are round. Then we got this thing going about shiny, hard candy and just took it from there. It's weird that inspiration for a film's look can come from everything — from Danny Lyon's photography to a piece of candy.

What is the relationship between technique and technology?

I was fortunate enough to come up in a time when cameras were smaller and film stocks were faster. Those were the two things that really changed the way people shot films. How we use tools and technology is what makes us different. It is the ideas in our head and our unique vision that counts, because we now have the tools necessary to create every shot and whatever feeling or emotion that we want.

The budget, of course, carries with it some limitations. For instance, I'm about to do a film in Super 16mm because of budgetary concerns, but we're also going to do a digital intermediate, which opens up another realm of possibility. When Kodak's 5218 film stock came out, it made Super16mm a viable option again and opened the door for some of the smaller-budget things I do, in terms of being able to shoot film and retain photochemistry in the work while staying in the range of the budget assigned to the project.

There is a coming together of all technologies now. It is not a question of whether digital will take our photochemistry away; it is the merging of all the technologies that make the work interesting, because digital helps us, especially during the post-production end of things. It is important for us, as cinematographers, to remain on top of these technologies and to find new uses for them. The idea of doing Super 16mm, a lower-budget format, with digital intermediate is exciting to me.

How is it being a woman in this business?

Times have changed and it is no longer an extraordinary thing to see women in the camera department. There are still only a handful of women in the ASC, but opportunities are opening up. I have had the pleasure and privilege of being helped along the way by almost everybody I've encountered. People want us to succeed. I was invited to join the ASC probably several years earlier than I would have been were I a man. I have found that most people want to see us succeed, and I have had many opportunities because of that.

Also, I get a lot of attention for what I do, which is great and very empowering. I am a cinematographer, but I am also a sister, a daughter, a woman, a friend and many other things, and who we are as people allows us to bring our own unique sensibilities to the work. That is what makes directors want to hire one person instead of another. I want to be clear in saying that being a woman has actually helped me and has made me excel in my profession. I have been given opportunities and have been treated very well. It is an interesting time in our business, with independent films gaining power, and I believe my opportunities to shoot interesting material will continue, primarily in the independent world, because that is where I feel empowered and where the interesting stories are.

What do you tell young ladies who want to be cinematographers?

I encourage young women to avoid looking at the statistics, which are daunting. If they were to look at the five active ASC members who are women or the total of six since 1919, they might decide to become veterinarians instead of cinematographers. But if they can avoid those statistics, move forward and shoot as much as they can and collaborate with the people who have an open mind and want to work with women, they can succeed and will be helped along the way by everybody because they are women. It is a position of power. It is definitely not a position of oppression.

Amy Vincent, ASC was born in Boston, MA. She attended film school at the University of California Santa Cruz and American Film Institute. Her credits include Hustle and Flow, Black Snake Moan *and* Eve's Bayou.

Index

Breinigsville, PA USA
08 October 2009
225482BV00001B/2/P

9 780935 578348